Information Guide on Photography

Steve Daniels

Published by RWG Publishing, 2021.

While every precaution has been taken in the preparation of this book, the publisher assumes no responsibility for errors or omissions, or for damages resulting from the use of the information contained herein.

INFORMATION GUIDE ON PHOTOGRAPHY

First edition. July 27, 2021.

ISBN: 979-8201384470

Written by Steve Daniels.

Table of Contents

A Career In Fashion Photography

———

We see them everywhere, in Magazines, on the Run Way, in advertisements on TV. They are the flimsy women strutting their stuff or extra standard Beauties with their hot looks blasting their superb whites while wearing the most current Styles from the most smoking Designers. We are talking about the plan models of today, yesterday and tomorrow. They are any place we look, anyway who conveys them to us? Their photos are gets with care and precision, resistance and that extraordinary quest for style, concealing and lighting association. I'm talking about the style photographic craftsmen.

In the plan circles notable names like Mario Testino (adequately maybe the most blasting name out there) and Eva Mueller (photographic craftsman for Fashion Magazine Allure) are correspondingly as looked out in case not more, those individuals strolling their heading into our aware.

High Paychecks and appeal's Lifestyle of hob nobbing it with the rich and famous might be the dream of various energetic shutterbug, in any case it's hard to show up at the splendid Staircases of the outstanding style houses and magazines. For every one talented picture taker, hundreds are left panting at the walkway, simply dreaming about the second that their photo will be picked.

Here several hints for the novice and visionary of dreams in start in plan photography. Study your subject. You can never learn enough. Scrutinize and look at any style Magazine you can get your hand on.

There are fantastic books on Fashion and style photography open. Amazon.com has a certifiable hidden gold mine available.

You several great cameras, stand and a lighting structure. Ceaselessly guarantee that you have a ton of film and batteries open. SLR and electronic cameras take particular photos, so guarantee you track down the best for your field.

While introducing your work, in a perfect world to give a chance you should have a portfolio accessible, basically if the editor of the plan magazine needs to see trial of your work. I promise you in case they consider working with you that will be a reality.

The sharp, splendid photos of a 4X5" straightforwardness show of your work to its best effort. If you have successfully had a dissemination, paying little heed to if, it's anything but's a little neighborhood magazine/paper or a test a tear sheet (from a genuine perspective a sheet you eliminated from the magazine) capacities honorably. In case nor is close by a good amazing 8 X 10 "is acceptable as well. You need to guarantee that you have something like 20 photos in your portfolio and preferably different styles. You need to show your inclination in full figure or just inadequate body parts.

Remember, style fuses pearls and embellishments. Occasionally a watch from a famous maker on the slender wrist of a flawless woman is a good plan shoot. If you are pursuing the position, be prepared to desert your Portfolio for a comprehensive time period, to a great extent as much a little while. I would admonishment you to make copies and have a couple accessible. This ends up being helpful when showing your work to different people for thought for configuration work.

In the hour of present day development, it is ideal to show your capacity as a plan photographic craftsman online too. Set up a site; present your photos to challenges. Submit them to an online style presentation. This helps with getting your work seen and people can see what kind of work you truly do and can achieve for them.

Most editors are looking for your person in the photos you take. Each style photographic craftsman gets the soul of the plan and it's anything but a surprising way. There a few great "how to start" destinations on the net. You may wish in any case http://www.fashion.net/howto/photography/or http://www.stylecarrer.com/fashion_photographer.shtml. Most importantly, if this is your dream, don't give up. Proceed to endeavor and I want to see your photos on the facade of my next hot style magazine.

Adobe Photoshop

A ll through the whole presence of photography, there has never been a period that we can achieve such great results in modifying as has happened in the old age. Furthermore, remembering that there are a lot of instruments that the PC and web have made available to us to overhaul and change the photos that come from a photo shoot, none can top the reputation and power of Adobe Photoshop. The program has gotten so indistinguishable from adjusting and having effects that the articulation, "to Photoshop" has become an activity word that approach to overhaul or change an image.

We can "Photoshop in" new outfits, additional items or even people to a shot where it was basically unreasonable already. So if you need a picture of you heartily welcoming the president, you don't have to go to Washington to get it, just "Photoshop" your image into the image of the president and it will look as real like you had been there.

Additionally, we can "Photoshop" out things from a picture we would rather not see there any more. So if you have a genuine flaw, that can be disposed of. You can even dispose of a redirecting individual from the establishment of the shot. The program is refined so much that these photos are possible and you genuinely can't tell the change has been made.

Photoshop has gotten such an acknowledged standard for photo dealing with that if you are setting up a photography studio or business, a copy of the item is just probably as crucial as Microsoft word or PowerPoint. The valuable thing about this item is that it is

speedily open and a numerous people acknowledge how to use it. So if you feel unsteady about adjusting one more PC application, you can almost certainly find a student, someone at the optional school or maybe the center school that knows Photoshop in and out and can help you start off your use of the item moreover.

However, Photoshop has not for the most part managed this characterization. The program was made in 1989 by two kin, John Knoll and Thomas Knoll. While the kin made Photoshop for custom uses they had by then, it wasn't a long time before the market ability of this item got obvious. Thusly, being wise money managers, John and Thomas set up a little association called Adobe and began assignments in 1990.

Adobe has been a splendid outline of how to gain ground in the age of the web. Today very few of us who use the web don't think about Adobe. You no doubt can't find a PC that uses the web that doesn't have a free copy of the Adobe peruser on it to examine PDF records. The PDF configuration is one more delineation of how this little association has made and a while later expected authority over a particular market of online business.

To genuinely get gifted at using Photoshop, the important thing to do is probably find a copy to play with. Like most PC applications, you can apparently find a copy on a partner's PC just to fiddle with it's anything but's an energy for the controls. Then if your buddy is a wizard at Photoshop, let the individual being referred to show you a bit of the certified "wiz-bang" things they can do with Photoshop using comparative menus you were just tinkering with. This little Saturday evening test could change you into a Photoshop enthusiast forever.

From here on out, you would do well to download a copy for yourself. You can get an evaluation structure that will give you most

of the features. Regardless, you really perhaps need that if you don't know whether you will buy a copy. Since Photoshop rules this market, you probably will buy a copy so you may save some mistake and purchase an approved copy right away. As of now, you will probably wind up playing with the item for expanded timeframes essentially making some great memories and that is unbelievable. In any case, don't dismiss the advantage of taking some organized classes in photo changing using Adobe Photoshop. These classes can reveal to you the simple courses and the most ideal approach to gain by the item.

From here on out, your inventive brain is beyond what many would consider possible to how you will use this instrument to work on your photographs for your customers. Besides, you will really need to respond vigorously when someone says, "that is okay, you can just Photoshop that and fix it straight up."

Sincere Photography, Taking Pictures Of Your Friend Without Their Attention

Sincere photography is by definition taking pictures of individuals when they are unconscious. Some portion of the fun in photography is surprising your human subject's so your photos have more feeling. Picture takers who work for magazines, similar to Time Life, have had the option to have sincere chances of their subjects. I consider most us can recall the highly contrasting photos of Africans and others bringing about more feeling from the watcher. Making open efforts may show up simple in spite of the fact that there are not many strategies in the photography world that will make the authentic shot worth something beyond a preview of companions.

First and obviously most significant is to keep the subject in see while they are not focusing. The following stage is preparing your eye to get the occasion. You must have the option to move quick, however with plan. You need to have your camera set for the image before you are even mindful you will snap the picture. The most ideal approach to do this on the off chance that you have an advanced or programmed camera is to keep it on the legitimate setting. Manual cameras take minutes to center and can free the sincere shot if your subject gets mindful of you.

Sincere photography depends on the light; notwithstanding, you may not generally will pick the point. The point could be the place where you are remaining at that point. As a picture taker of open photography, you know the significance of picking the best point at the right second that is conceivable.

9

The whole place of real to life photography is to acquire the unguarded snapshots of an individual's feelings, regardless of whether it is tears, joy, love, or different feelings. While it is valid, you need to have light, point, and a decent camera to get the shot notice. Most picture takers are prepared eyewitnesses. Their eyes will meander over the groups, scene, or other setting looking for the ideal shot. They will consistently have a camera prepared. It very well may be amazingly hard when you are taking photos of your companions since they will in general be more associated with the discussions or action.

The way to taking open photos of your companions is to draw them away from the way that you convey a camera. In the event that they fail to remember you convey the apparatus, they are almost certain going to act normal. A few companions will in general posture before the camera while others will stay away turning their backs when you prepare to snap a picture. Realizing your companions will help you track down the most ideal approach to make genuine efforts without their insight.

Noticing, having the camera prepared, and understanding the essentials of photography will yield you better outcomes when you pursue a genuine shot. Presenting or getting some distance from the camera will detract from the shot you expected to accomplish so hanging aside or somewhat ahead can have you the chance you may require. Profiles make incredible real shots in light of the fact that the individual won't understand you are snapping a picture until you have effectively tapped the catch. Authentic photography can be quite possibly the most compensating crafts of photography, yet in addition vexing when the subject knows about the camera. Continuously recollect the camera when going out with companions.

Picking A Photography School

There are numerous spots you can learn photography, yet what is the perfect spot for you? Sure there are online schools and courses, yet they will not give you the hands on data you need. You need different understudies and the instructor's eye to improve as a photographic artist. The online classes do have their applications for example giving you the essential data to contemplate. It very well may be hard to pick the right school. Some require suggestion while others are separated of universities.

The data you wish to gather from a photography class will settle on piece of the choice for you. For example in a school setting that doesn't spend significant time in photography will offer the essential levels, yet may not offer you a temporary job with an expert picture taker in your field. In the event that you are searching for photography as a leisure activity these essential level classes will frequently give you the data you need to create pictures you can be glad for.

Particular schools similarly as with any others will take into account more data on a particular point. Most particular schools will permit you to work with an expert to become familiar with the points of interest of your calling just as grow your insight. This assists you with learning faster and study the procedures utilized in photography while having hands on experience.

The most ideal approach to pick a photography school is to choose what you need from your photography. Whenever you have concluded that you can continue forward to discovering how to apply. Some photography schools are essential for a studio and take

into consideration anybody to pursue a class. Different schools expect you to go to a school or college first for essential photography and assistant before you go on to the specific school.

Looking through online will lead you to the schools accessible in your space and the nation over. You will actually want to discover the application just as portrayals of each class they offer. The locales will likewise list the capabilities you need to go to the school and what classes you should take to turn into a photographic artist. Albeit the experience you get from a homeroom is better, online classes show you what you need to know.

A few classes that you should will be in lighting, creation, and different fundamentals. Contingent upon your field you will then, at that point need to fan out in considering approaches to catch the subject. Like representation photography you should get points, light, equilibriums, and how to evoke the responses you need from the subject. Computerized photography is the better approach to take photos and there are a couple of various strategies to gain from the more established manual cameras.

Photography schools can help you become more adjust at taking photos. You may choose you need a little assistance to venture up from being the simple to use type to a more confounded camera or you may conclude there is a profession for you. There are numerous kinds of schools for you and online sources will help you discover it. Online photography classes can be useful for you learning strategies, however you will in any case need others to help you discover your eye for craftsmanship. In the event that you have worked with manual cameras in the past possibilities are you will need to take an advanced photography course when you switch.

To address one more sort of school we need to dig into submerged photography. Most universities and other photography schools

related with studios don't have some expertise in submerged photography. It is normal best to search out a jump school for an essential course. You may choose to dig further and track down a submerged photography school. Submerged photography has consistently been a one of a kind and fascinating diversion or calling. Seeing the consequences of your work resembles nothing else one can envision. At the point when you take a gander at the shading and the astonishing perspectives, you will comprehend submerged photography more.

Picking A Subject In Photography

How might you understand what photos you will take? Is it genuine that you are going to a family assembling? It is protected to say that you are going out for a trip and want to see some normal life? There are various requests with respect to photography. You should have a reason of photography methods to give the best photograph and once you acquire capability with those procedures the subject will be reliant upon you. Most photographic craftsmen whether they are capable or tenderfoots like you will have a medium they work with. It is something almost identical with various subject matter experts; you have painters, stone carvers, sketch specialists, and significantly more. Photography is craftsmanship and in this manner requires an eye for the right photograph.

How might you comprehend what subject you will shoot? This is where your tendencies lie. If you wish just to take pictures of untamed life, you should believe that the subject will appear. Plainly you can go to a characteristic life park like the Rocky Mountain National Park and want to find subjects. Consistently it will depend upon the season. Elk and Deer are more perceptible when they plummet the mountains to mate and eat. Birds will reliably be open, anyway the kind of birds will vary. If you are in Alaska chances are you will get a couple of chances of shooting a Bald Eagle, while in Florida you may find heron or cranes.

Exactly when you are practicing techniques you should pick your subject as requirements be. A lot of us are figured out how to the space around us. Scene photography requires the usage of the land you have around you, with the exception of on the off chance that

you are venturing out to some place new. This is another critical reality to picking a subject. You are either limited or you have the whole world at your feet. It will depend upon your traveling limits. For the current we will follow precious.

At the point when you pick your medium you will then go searching for subjects. The subject that tends to you is what you should choose to shoot. If a tree and the packs it's outlined interest you, you should check the lighting of the space. Picking which highlight shoot from will in like manner make the decision with respect to the matter. The lighting may not be ideal for the subject you have picked and the contrary side of the subject may not yield the best picture.

To pick a subject you will require a fair eye for detail and discernment. Routinely the best subject isn't the one you can see with a plain eye. Have you anytime looked at a tree and found a spider web stowing away in the leaves? If you look closer you may even find a bug. A spider web can make a phenomenal picture not simply considering the procedure expected to have the web show up in your photo with the rich strings, yet furthermore the case of a spider web. We are intrigued with an animal that can make a reasonable model.

Again your eye is the best device for finding a subject. How you pick the subject will depend upon what is open, the point and the light. Moving step by step through a space, for instance, scene will help you with choosing the subject. Looking under leaves or shakes is routinely valuable to finding something new and remarkable. Nobody can truly tell where you will find a picture just holding on for you to click a picture. A couple of gathering and animals do things that will not until kingdom come happen and this is where you need to have camera open. A large number individuals

fascinated by photography pass on a camera with them any place they go. If this sounds like an inclination, a veritable penchant changes into a side interest and an expected compensation if you become incredible at taking the right pictures. As you improve at taking the photographs, you would then have the option to start showing your photographs for others to see and maybe buy.

Computerized Or Print Which Is Best In The World Of Photography

———

Before, you essentially didn't need to settle on a decision between some other photography techniques than film. Everybody had a film camera and everybody either figured out how to foster their own film or took it to their nearby processor. Presently, you do have a decision and numerous individuals who are utilized to film wonder, which is better. Today we have film cameras and advanced cameras. Here are the upsides and downsides to utilizing both computerized and print photography.

The Pros of Digital

Advanced cameras are extraordinary for the vast majority. Maybe the best thing about a computerized camera is that you have moment admittance to the photos you have taken. At the point when you utilize an advanced camera, you can quickly see the image that you just took and decide if you need to re-shoot that specific subject. Furthermore, when you take computerized pictures, you can undoubtedly download the prints to your PC. You can store your photos, improve them and print them on your printer. Also, advanced prints make for simple stockpiling. You can shoot a huge number of advanced pictures and store them several plate. Contrast that with the containers of printed pictures that you likely have in your home.

The Cons of Digital

There are numerous cons of utilizing advanced also. For instance, advanced pictures are effectively lost. On the off chance that you

resemble the vast majority, you likely download the photos to your PC and do nothing else with them. In the event that you don't back up your computerized pictures to plate, everything necessary is for your PC to crash one time and you have possibly lost many significant pictures. Numerous individuals feel that advanced pictures don't have similar look and feel as film prints. Therefore, most expert photographic artists actually really like to utilize film, rather than advanced. Computerized pictures can likewise get expensive in the event that you print them out at home. A decent quality printer paper, in addition to hued printer cartridges for your printer can add up rapidly. .

The Pros of Film

As referenced before, numerous expert photographic artists actually really like to utilize film to advanced. On the off chance that you take pictures for leisure activity, you can change your film camera to get the specific look that you need. This isn't generally the situation with computerized pictures. A few group like to utilize a film camera, so it constrains them to have their photos grown immediately. Maybe than leaving your recollections on a circle, you must have your print pictures printed. You will consistently have them in your grasp to take a gander at.

The Cons of Film

It appears to be that film cameras are losing prevalence. Film isn't pretty much as advantageous as computerized. He should hold on to have pictures created before you can see them down is likewise costly and having pictures handled, adds additional cost. Moreover, when you use film, you should have everything on your roll of film printed out. You don't can look through and erase terrible pictures on the spot as you do when you utilize advanced.

When considering film over advanced, one is actually no greater than the other. The decision has more to do with your own inclinations than everything else does. In the event that you are thinking about purchasing another camera, take a gander at both film and computerized to figure out which ones are ideal for your utilization. I have three advanced cameras, a 35mm camera and a standard film camera. In the event that I needed to decide, I would pick the computerized due to the alternative to see pictures immediately. This way you know whether you are catching the picture the manner in which you planned as well. I have been gotten to ordinarily with fluffy pictures, missing heads, etc. Something else is with a computerized camera, on the off chance that you need glasses, you will in any case be in center, where similarly as with a 35 mm center camera, you may have an astonishment, fluffy pictures, and you may never discover another chance like that again.

Advanced Photography The New Way To Taking Photographs

Photography is a workmanship. It takes practice, expertise, and an eye for the unforeseen. Not all individuals will set aside the effort to examine a scene, untamed life, building, or other subject to track down the secret profundity inside, yet when they do regularly they will discover incredible significance in the photograph they take. Photographic artists spend their lives searching for new and various approaches to shoot a subject. Advanced photography is only one better approach for snapping a photo. There are numerous benefits for working with advanced photography.

The darkroom is out the PC printer approaches for the majority of us utilizing advanced photography. We can send our photos to every one of our companions with a couple of snaps of the catches. Advanced photography simplifies snapping a photo, by wiping out a portion of the mystery. With the LCD screen on a computerized camera you would now be able to see the photograph you just took without pausing and hour or more to see the film create. We are not, at this point restricted by film limit, yet by memory cards. Most memory cards have 32MB or 1GB relying upon the amount you've spent on hardware.

Computerized photography can incorporate the expert cameras with the trading focal points, manual setting or it very well may be a basic simple to use camera. Regardless of whether you are searching for an expert grade picture or something your companions will giggle over advanced photography has made taking photographs simpler. As I said before we can see the image before we at any point

print, and furthermore a great deal of advanced cameras will permit you to trim and save the photograph prior to printing.

Advanced cameras can be all sizes from a key chain camera to the expert. We have all had a great time with computerized on our telephones. In the event that you are more keen on the expert side of photography the principal advanced camera you pick ought to have tradable focal points with a high goal. It tends to be programmed in the event that you feel more OK with light settings, anyway most have ISO settings, gap, and screen speed decisions also.

Like with more seasoned photographic artist setting up your shot is a large portion of the good times. Deciding the settings you need to use for light is the other. Setting up your shot actually expects you to have an eye for the surprising or for making the uncommon out of a typical scene. Stroll around the subject and search for each conceivable point, you may even choose to take a few photographs to pick the best point. This is the place where computerized photography outperforms film cameras without fail. Whenever you have seen all points and taken photographs you will check whether the impact you needed is there. It's anything but a quicker way for you to figure out how to set the screen speed and opening on a shot and use lighting since you see the outcomes while you actually taking a gander at the scene.

Advanced photography may not seem like it would in any case utilize that load of abilities you mastered on your old camera, yet this is certainly false. Rather advanced photography upgrades your learning while you are still at the sight. Rather than extended periods of time in a darkroom or holding up in line you can get the image you need right then, at that point. It positively gives more towards get-away photographs when you can check whether your thumb is over the focal point or the camera lash is standing out or

more regrettable somebody just strolled before you. Computerized photography like all things has advanced to help us experience another way in photography.

Blasts in the Sky

How would you photo a blast? All things considered, with regards to a firecrackers show, it takes a lot of preparation and expectation of what you will require. Notwithstanding the way that a light show is a preplanned occasion, that fantastic second when the firecrackers detonate in the sky is as yet a brief moment when everything needs to turn out appropriate for you to get the ideal photo.

Presently clearly, there are some hardware gives that must be ready to have your camera set up and prepared as well as at the legitimate settings to catch that second when all magnificence releases in the sky. So from a gear viewpoint...

. A mount. The action of the firecrackers is sensational to such an extent that except if you balance out your camera, the shot will be obscured and inadmissible to you and to whoever you may wish to offer it to. The mount ought to be effectively movable and flexible so you can make changes on the fly.

. A screen discharge that capacities remotely.

. Equipment to work around evening time as that is the point at which your subject will happen. You can get a head mounted electric lamp at any setting up camp store so you can coordinate the light at the camera and still have two hands allowed to deal with your hardware.

. A versatile seat as there will be some pausing. Whatever else that will help you brave the stand by like food, water, music and so on ought to likewise be essential for your arrangements.

Since the firecrackers blast is abrupt and quick, you should have the option to change the screen speed and have the camera set up to respond to manual concentration so you can utilize your eyes and ears to know precisely when to snap that shot.

The way in to an extraordinary or a progression of incredible firecrackers photos is area. You need an area that has a remarkable vantage point perspective on the piece of sky where the most move will make place. This implies you may have to take a situation on a scaffold, on top of a structure or on a slope away from the groups that come to see the show. This won't be not difficult to track down so start early. It's anything but off the mark to "scope out" your area days ahead of time and show up hours ahead of time to get that spot as yours.

Experience will be probably the best instructor as to the right area as well as how to set your camera center and shade rates and how to situate the view from the got area so you can catch the rocket right now of blast. So discover approaches to do some training takes shots at different light shows before you set off to do the "manager" shot. Ordinarily small time baseball clubs have firecrackers shows and they would cheerfully allow you to take photos of the show in return for a couple of free shots. Here you can try different things with your analysis and get your orientation prior to setting up for a bigger show.

When the show gets in progress, expect the blast that you need to catch. Try not to snap the initial five minutes of the show yet utilize that chance to affirm that you have the right sky area explored. The best occasions to catch the shot are just before the blast which you can time by the sound of the rocket going up and the normal time before emission.

With some experience you will get your intuition about where and when to snap that ideal photograph and when you are done, you will have some stupendous shots to incorporate with your portfolio or to show gladly. Also, this will prompt much more work shooting blasts in the sky.

Discovering Photography Online

Taking pictures isn't the best way to litter our dividers with photography. There are the individuals who are not keen on being behind the camera, however like the workmanship. On the off chance that you have pondered where you may track down some magnificent prints with an expert touch, yet don't have any desire to go to the displays you should take a visit through the online world. Numerous individuals who assume pictures position the photos online so anyone might see for themselves. This assists you with acquiring redesign and possible customers for photography work.

The online world is brimming with photographic artists holding on to be found. Spots like deviantart.com, eBay, and other online exhibitions exist for the comfort of discovering new photos for you home. Essentially by putting the words photography, photos, or prints won't lead you to the more expert prints on the web. While looking through online you should utilize explicit catchphrases. These catchphrases take you to image of a particular sort.

In the event that you are more intrigued by untamed life it is ideal to utilize those watchwords alongside photography. Another downside to web based looking is getting the item from a legitimate source. You need to ensure that your Visa data is protected, that the transportation will be moderate and fitting. How they transport the print is additionally significant you need to ensure a delivery organization won't harm it. The main thing about transportation prints is they require some protection to guarantee your venture has security against harm, expected lost and burglary when conveyed.

There are a few hints you will need to follow when shopping on the web. Maybe the main tip is recalling that you are seeing the print filtered into the online store. This implies you are not in the exhibition to look at the print and dissect it to the full degree. You will need to be a little careful if the photos are grainy or they seem to have imperfections. It is normal best to shop online at workmanship displays with a standing. These organizations for the most part have incredible notorieties and offer diverse transportation techniques and protection.

To discover suitable locales you will need to comprehend page rank. Google positions the website pages to give you a thought of the pages with the data you need just as telling you the locales legitimacy. The higher the page rank, the more traffic the site has seen. Enormous realized sites may offer more pictures and quality picture from a respectable assistance or business.

It very well may be hard to track down photography exhibitions online that will really sell their prints. It's anything but a brief period and exertion, however the outcomes are frequently great. Simply looking for catchphrases may net you photography strategies or schools instead of exhibitions to buy from. On the off chance that you have a most loved craftsman or display chances are you can enter their name to discover the prints you are searching for on the web. In the event that you are expecting quality prints, however don't wish to pay for a craftsman's name you may need to put in a couple of hours to discover the perfect photos.

Online exhibitions are simply one more way innovation has gotten helpful for us all. Discovering photography online to buy can be troublesome in the event that you are searching for a dark craftsman or print subject. You should look with explicit watchword or themes to discover prints. In the event that you are

keen on Alaskan photos of natural life you should limit your sure by referencing the state. We as a whole discover photos add to a homes style. Exhibitions are frequently the way the majority of us discover photos in light of the fact that we like to see the prints very close, anyway online is the new way for accommodation. So the following time you wish to change out your homes stylistic layout you may look online for thoughts if not the item to fulfill you and your families needs.

Legal Photography Used In Today's Society

A s the gathering pushes closer around the wrongdoing area and yellow tape gets stayed nearby the spot of murder, thievery or various kinds of mercilessness, negligible white chalk people get drawn around a body and its reshapings there from the sidelines with a pack and lighting equipment comes the routinely ignored at this point genuinely extraordinary individual of our Articles. The individual is a critical piece of every assessment, with their sharp eye for detail and the industriousness of Job in the hustling around that never fails to happen as the most current bad behavior gets marked, stored and named.

I'm examining the Forensics Photographer.

Next to taking fingerprints, cleaning the wrongdoing area and stowing evidence carefully to bring to the legitimate sciences lab and later the Court room, Photos are a critical piece of every bad behavior assessment and later as confirmation in Court.

Criminal science Photography is an amazing Tool to assemble and stock Data too. Now and again a compass of the natural elements with the Camera signs in Images which would some way or another or another would have been dismissed or disregarded. The Person in the third line of the onlookers. That destroyed piece of glass in the shadow. Our clamoring Patrol Officer may have not seen it, anyway our Camera Lens has gotten it.

Conceivably the fundamental things in Forensic Photography is the sharpness of the Image. It should be sharp as an overall honed edge.

Any cushiness, pixilation or shake and it is as vain to the Court and the Investigators as an Eagle with pinkeye. The entire case lays on Forensic Photography and any flaw at any rate sight, could cost a case to be lost.

Never anytime upset the wrongdoing area. The first round of photos should be taken preceding anything has been reached, wiped out or adjusted. It is the freeze packaging of the Crime Scene. The closest you will come to having been there during the bad behavior. So guarantee you plan the photo before you take it. A while later in case you should little changes, like the adding of an assessing device to show distance is admissible, anyway not during the first go over.

Guarantee you get a complete plan of shoots. Those should consolidate a close by, a mid reach and a wide point. The Angel is crucial as well. In case you use some unsatisfactory viewpoint you may conveniently fix the best shoot by mutilating the relationship of distance to the article, etc Keep at the top of the priority list, your photo needs to show accurately what is set out before you.

You need to record everything recorded as a printed copy. Engraving out unequivocal things, yet never mark on the photo it-self. For that it is canny to use an overlay that you can dispense with as is required. Straightforwardness paper is used therefore. Guarantee you lighting and transparency is set viably. There are a huge load of incredibly extraordinary composing available that can tell you the best way to set your receptiveness for which light, establishment and circumstance. This assistants take the best pictures required.

At last anyway not least. Photos can be botched successfully if your equipment isn't alive and well. Guarantee that your point of convergence is wonderful reliably of buildup. No smutches, etc I

understand it is apparently a point that should not should be referred to, yet as often as possible it is the seemingly insignificant details we disregard. After all the entire spot of criminological photography is to get those little clearly calm centers that are routinely ignored.

A suggest you make your-self a check once-over and spot even the most generally perceived sense things on your once-over. Batteries, Film, dust free stuff, mount, dispensing with the point of convergence cap. You can think about it, record it. You will be dumbfounded sometimes how viably even all that capable logical Photographer can submit a clear blunder that may have been thwarted by a check list. Recall the setback is relying upon you also.

Getting that Baby on Film

In the numerous sorts of photography you may need to do as a picture taker, child shots might be the most troublesome. Regardless of whether you are not an expert photographic artist but rather you are attempting to get an incredible looking picture of your own kid, getting them to participate is a significant endeavor.

The primary life affirming guideline with child photography is that, as an issue of face, they ARE the manager of this shoot. The whole cycle must be worked around that delicate mind-set of this kid. However, there several subtle strategies you can utilize, proficient or beginner to have the most obvious opportunity with regards to that sweet child.

Child's react well when they are taken care of and rested, with individuals they know and trust and when they stand out enough to be noticed. So first thing, you as mother and father can make sure that the shoot happens when prerequisite number one has been met. Presently, that isn't in every case simple. On the off chance that you have an arrangement to take the child to the get their picture made at the neighborhood photography studio, that disposition may not be the manner in which you need it to be.

That is the reason, assuming there is any chance of this happening we would debilitate making the efforts in a studio. On the off chance that you can set up a take shots at the child's home, where there is an open to setting and much that is recognizable around, you have a lot more freedoms to get that grin that will make a truly amazing picture there. Presently that requires a "house call" by the photographic artist however in the event that the person in question is a picture taker that

needs unquestionably the absolute best of the kid, they will work with what you need.

One more benefit of planning the take shots at home is that you know when the child generally is at their best so you can plan it when that season of day is perfect. Truth be told if the picture taker can appear during rest time, there is a lot of time to arrange the shot before the heavenly messenger stirs. What's more, by killing the vehicle ride to the studio, you remove a colossal danger of that delicate mind-set going south in transit.

A subsequent tip comes from the way that infants like individuals they know. So if the photographic artist has the opportunity to meet the kid, play with that person and kick an affinity off, then, at that point they will be more open to fun loving course to have the chance you need. You should be cunning how you present the camera as it can either be an object of dread or viewed as a toy and the child will need to play with it.

To the extent the camera goes, consider the sort of gear you will use to get that ideal child picture. You need it to be compact, so you can do those on the spot shots that work such a ton better. It ought to be little, both for compactness and to not alert the youngster. Advanced is best since you can shoot bunches of shots and never need to reload. However, ensure a decent quality piece of hardware will take shots at a high goal so when you have that regent chance, it will move to a representation printing pleasantly.

By setting up the room with the sort of sceneries that will make a decent representation, you would then be able to have the child start to play with her or her toys and cooperate with guardians, kin or the picture taker in a glad manner. In a little while that sound of the camera clicking and surprisingly the glimmer will get comfortable and the child will not pay it any brain.

The most ideal chances are of the child chuckling. Attempt to get on a similar level with the youngster as the individual in question plays. Mother and father know the notification or games that consistently get a snicker so abuse their inside data broadly. The child will appreciate becoming more acquainted with you and hearing those recognizable games coming from you ought to get along admirably at getting that sweet snicker or grin you need.

By learning the child's character and how to get in a state of harmony with the kid, you can cajole pictures from the shoot that may other astute be difficult to get. Furthermore, that is the thing that you need if a representation of a child that you need to endure forever.

Getting the Best Possible Audio from a Camcorder

At the point when you move from photography to videography as your methods for catching minutes either by and by or as a feature of your calling, you go into a lot greater world with more prominent difficulties also. For a certain something, you currently need to manage issues of development. The issues of lighting and surface clamor are similarly as large of an issue aside from now you have subjects that might be in a hurry and you need to go with them.

However, when utilizing a camcorder to catch the occasion under a microscope, regardless of whether it's anything but's, a discourse or show or some other critical occasion, the issue of having the best quality sound presents special difficulties. So its best to do some focused anticipating how you will oblige the sound requirements of the occasion to your gear since, in such a case that you have awesome pictures yet the words and hints of the occasion are sloppy or lost, then, at that point the nature of your end result is genuinely harmed.

Numerous an unsuitable video was taken with a camcorder on the grounds that the administrator depended too vigorously on the little mouthpiece that is incorporated into the packaging of the machine. The solitary circumstance where this receiver might be satisfactory would be in the event that you were leading a one on one meeting in a little room where you could situate the camcorder inside three feet of the subject. That being said, surface clamor from the encompassing structure could turn out to be important for the sound outside of the attention to the administrator at that point.

To guarantee that you have total familiarity with what is going onto your video recording of every occasion, the interest in a decent arrangement of shut back earphones to screen the sound is a remarkable move. You can plug it into the camcorder and you are powerfully mindful of what is going onto that tape consistently. On the off chance that something gets into the sound that isn't proper, you can utilize altering methods or even re-shoot the portion if that is conceivable with regards to the occasion.

For most of occasions, plan to utilize the assistant sound info attachment to join a portable mouthpiece unit as opposed to rely upon the locally available receiver in the camcorder packaging. This little stop alone opens up a huge scope of answers for the issue of helpless camcorder sound that is so regularly endemic of recordings made with this innovation.

In the event that you are working with an outer receiver, know about the limits of the wire on the off chance that you are not working with a radio recurrence mouthpiece unit. In a circumstance, for example, a speaker doing a show, you can lay the rope down between the recorder and the speaker's stand expecting you have adequate line length to arrive at the where the mouthpiece will mount on the stand. Be cautious with the abundance string, maybe protecting it with pipe tape so those paying attention to the show don't stumble on the line or pull it free which could cause injury and harm the hardware.

Much of the time, for example, one in which you intend to talk with individuals in a meandering design or to record a speaker who is progressing an extraordinary arrangement, a radio recurrence amplifier might be vital. These can be more costly yet without the interest in this innovation, your sound quality depending solely on the camcorder worked in mouthpiece will very likely be disillusioning.

Getting Your Groove Back.

―――

Innovative photography might be the most requesting of all. That is on the grounds that not at all like business photography, your manager is your innovative creative mind and the imaginative commercial center. Furthermore, who knows starting with multi week then onto the next what is considered creative and what isn't.

It's difficult graceful permit that we are utilizing when we talk about you following your innovative dream when you utilize your photography as an outflow of your specialty. You can take a gander at 100 settings and scenes and no one but you can know whether any have the crude materials for an extraordinary imaginative piece utilizing your camera. It's an immense channel on your enthusiastic framework and your innovative side however it is additionally quite possibly the most fulfilling things you can do. What's more, in the event that you can earn enough to pay the bills at it, that would be preferable.

In any case, one of the issues any craftsman has is the point at which that muse just will not converse with you for some time. Don't worry about it in the event that you have orders in or cutoff times that imply that you must be imaginative on a timetable. She just will not participate. So we need a few stunts to get around these little droughts and approaches to can cajole that dream back to work.

One stunt is to utilize the ordinary highs and lows of your innovative side. You realize that with regards to motivation, its either one extreme or another. Once in a while the innovativeness detonates like a fountain of liquid magma and you need to single out hands down the best stuff to deal with immediately. Well when that stream is detonating, take some time and get a portion of that motivation recorded. A motivation

diary either on paper or on tape can be utilized to catch it as quick as it emerges from that side of your spirit.

Presently this is the place where you are outmaneuvering that dream. At the point when the well evaporates, that motivation diary can bring you through. You can begin culling the thoughts out of there and creating them. Relax in the event that you don't "feel" innovative. You can ride the force of your imaginative high to keep your work pushing ahead.

The other extraordinary thing about utilizing your diary is regularly perusing your motivation from when things were flying in your creative mind, that will make preparations and get the new motivation moving once more.

Most importantly, don't freeze when you feel your innovative motors come to a standstill. Some of the time a day or so of rest will make something happen. Or on the other hand take a quick trip and see some creative work done by others at the neighborhood gallery. Seeing your kindred craftsmen best work can do marvels to begin the progression of thoughts coming your direction once more.

Imaginative funks are as much a piece of the cycle of inventiveness as the progression of thoughts are. So allow yourself to go through droughts and don't run yourself down about it. An outing into your files to survey your best work from the past is an extraordinary good promoter and it will assist you with recalling that, indeed, you are an imaginative individual and, indeed, you have accomplished great work previously thus, indeed, you will accomplish great work once more.

The last stunt is to allow yourself to make some poo. As such, don't smother the restarting of your imaginative brain by holding it to excessively high a norm of value in each thought you get. You know from past occasions of extraordinary inventive stream that the smart thoughts come out with the terrible. It doesn't assist with attempting to

alter them as they stream. So by advising yourself, I will go make some awful workmanship, that frees your inventive side to simply be allowed to communicate as it wills. It may be the case that such a stunt might be everything necessary to unstop the line and get the inventiveness moving once more.

In any case, it will stream again and you need to have the certainty that it will. What's more, when it does the inventive photography you begin creating will be as great or better than anything you have done previously.

Have You Seen The Latest Street Photography

———

Quite possibly the most real styles of photography is road photography. It comprises of sincere pictures taken of individuals in open circumstances. Road photography was done wherever in the city and now has moved to the shopping center, at clubs, roads, parks, and essentially anyplace. A road photographic artist never requests that anybody posture, and the person doesn't need anybody to go about as though the individual realizes what may occur straightaway. This detracts from the normal look required when utilizing the procedure of road photography.

Road photography originates from another sort of photo that called narrative photography. Narrative photography once said to be the most legit and consistent with life picture taking. There are proficient and novice brands of narrative photography, just as road photography. Road photography reflects society in its untainted state. This records for some photos we see on the web and TV that reflect what was occurring at that point.

Photos of this type utilize highly contrasting film. Road photography regularly shows incongruity in circumstances. Numerous road photographic artists utilize broad perspective focal point cameras to catch a more extensive region. The shots typically resemble a screen or a window seeing the human state at a specific second. The picture taker gets taken out from the scene. This sort of picture taking catches the most legitimate minutes throughout everyday life.

A few photographic artists who spend significant time in road photography take their cameras to public occasions like shows,

gatherings, and awful locales. Others essentially photo life around them. A popular road picture taker named Garry Winogrand was notable for catching New York regularly for quite a long time. He was keen on revealing insight into the contemporary social issues of his time. He got unmistakable after the 1960's. He shot around one hundred photos a day for around thirty years, and left more than 300,000 unedited openings.

Something intriguing about road photography is that occasionally a picture taker may catch things on film that they were not in any event, zeroing in on. Bizarre and amusing things may be going on behind the scenes or the forefront of a photo that they don't take note. At the point when the film is created, they frequently discover things inside the extent of their shots that are amusing, fascinating, or clever. Ordinarily, things are apparently random to the remainder of the shot, but since of this factor, one can say that road photography is one way that we use to catch the occasion.

The class of road photography began between the finish of the nineteenth century and the mid to late 1970s. One of the helping innovations of this kind of picture taking was 35-millimeter film. 35 millimeter film was presented towards the late nineteenth century. Photographic artists from both Europe and North America spread the notoriety of the class and fostered the craftsmanship behind it. Remembering for the early improvement were picture takers Henri Cartier-Bresson of France and Robert Frank of Switzerland.

You don't need to be an expert to take on road photography. You don't really need to utilize high contrast film by the same token. All you need is an approach to take pictures. You can make your own narrative film series. The photos you take can remark on society. Your photos can record individuals doing everyday exercises like eating or resting. Keep

in mind, notwithstanding, that you ought not distribute pictures of individuals without their assent.

Turning into a road picture taker can be an extraordinary diversion. You can give your photos to historical centers and sites, or you can begin your own site. There are likewise photograph documents that comprise of assortments of pictures that are accessible for public use. This is additionally a spot that you may have your photos shown. Road photography is one approach to catch the genuine snapshots of life. On account of innovation, film altering is simpler than at any other time. When you attempt road photography, you wind up got up to speed in reality. The photos mirror the regular day to day existence and times.

History Of Photography

Have you at any point pondered where present day photography started? While we are presently moving into the computerized age and away from film, the lighting procedures and other photography strategies started in the 1820's. Niepce and Daguerre were the principal innovators of present day photography. They utilized a substance segment from silver and chalk, which obscures when presented to light. This sort of innovation utilized a glass negative to solidify the image.

From the early cameras found in western movies we have continued forward to manual cameras with film. This film or negative caught the picture on a roll to be created in a dull space to forestall over openness. The manual cameras utilized a hypothesis of setting up shots. You needed to get opening, shade speed, white equilibrium, and metering to get the most ideal picture. This implied you invested a great deal of energy setting up the shot and must be an expert to get untamed life in their normal propensities.

Gap is estimated by F-stops, or the measure of light the focal point will allow in. Centering and profundity of field are additionally significant when setting the gap on your camera. You need to understand what numbers will permit all the more light to enter the focal point and the opposite to keep away from over openness and fogginess. Screen speed is the measure of time a focal point is open for the image. You may have found in an obscured room without streak your camera requires a long time to engrave the image on the negative. This is on the grounds that the light is faint and the screen should address for the absence of light. The absence of light

initiates a need to uncover the film longer to get the image where as more light will have the screen moving at a quicker speed.

From the manual cameras we moved into the programmed. The camera got lighter. The shade speed and opening was customized into the camera by the settings. ISO got significant. ISO is the film speed. Rather than requiring minutes to set up a shot you just needed to pick the right setting and hold the traditional to center. Numerous cameras came as programmed with manual alternatives for the individuals who actually preferred to regard photography as an imaginative business.

Advanced cameras are the new time in photography. Presently we can see the image we take without the utilization of film and negatives. We can send the photos to the entirety of our companions and utilize our home printers to make prints. Photography has moved from the centralization of making the ideal effort with an ability brought into the world to a couple to everybody taking pictures.

This isn't to say photography and picture takers won't remain. There is as yet the requirement for quality in taking proficient grade photos. Light affectability is as yet significant when managing a computerized camera and except if you spend a ton, you will discover nature of photos is as yet absent. Photo strategies lay inside the lighting gave whether normal or fake to the subject. You may consider how to make a photo in a dull room like a gallery to impart to your loved ones. Knowing the previous photography procedures will assist you in accomplishing that ideal photo with your computerized camera. Photography may have started with not many individuals, yet we can see the progressions their innovations have driven us to now.

How Hard Can it Be to Take Our Own Wedding Pictures?

Your wedding is quick drawing nearer and as the uneasiness fills in everybody related with the enormous day, two major concerns burden everyone's conscience. Those are...

(1) How would we be able to diminish the pressure of this large day?

(2) How would we be able to reduce the expenses?

These two inquiries are in struggle with one another too on the grounds that to lessen pressure, you need to build the work that somebody needs to do. At some point during the planning time span, the thought will come up, for what reason don't we let "John Jones" do our wedding pictures? John Jones might be somebody's sibling who is "great at photography" or simply a companion of the family. The allure is that they will save you a heap of cash and presumably do similarly as great a task as the costly picture takers.

While you unquestionably need to look out before you turn over this significant work, perhaps you or somebody in the wedding gathering can take the photographs just as an expert. All things considered, the number of wedding bad dreams have you found out about an expert picture taker who either harmed the heartfelt idea of the function by interrupting time after time, bothered the visitors by rubbing out their perspective on the wedding to have an activity chance or charged far too much just to convey low quality photographs.

In truth, it is altogether workable for an "novice" photographic artist to work really hard taking pictures at the wedding. Yet, there are a few rules you ought to follow if that work has tumbled to you. On the off chance that you are perusing this as the lady, groom or restless mother and you are thinking about utilizing a companion for these photographs, go through an hour going over these rules and not exclusively will you improve pictures, your nervousness level will go down as well.

1. Know your gear all around. Regardless of whether you are utilizing an average advanced camera or a costly set up that has taken you years to stir up, ensure everything is in first class working request and that you are completely acquainted with each subtlety of the machine. Recall Murphy's Law. On the off chance that anything can turn out badly, it will. So keep Murphy out of the wedding by checking and twofold checking your camera and related hardware.

2. Have extras of all that could be within reach. On the off chance that there are batteries engaged with the activity of the camera, have a few extra sets available and know where they are. In the event that the batteries go out as the lady and gathering are presented at the change, you don't need an hour postpone why you rush to the 7-11 to get more. The equivalent goes for streak bulbs and surprisingly the actual camera. Have extras of all that could be within reach so Murphy simply goes to the following wedding as it were to make his wreck.

3. The photograph is about more than the lady of the hour and lucky man. On the off chance that you are accustomed to "arranging" your photos, you may not stress that regularly with movement in the room. All things considered, if everyone is representing, the climate is controlled. This won't be the situation

during an activity shot like during the wedding or gathering. So keep a sharp familiarity with the room, the action around the subjects, the lighting and foundation props. You would prefer not to deliver the ideal shot of lady and man of the hour kissing just to have Cousin Ned choking on the cake behind the scenes.

4. Be mindful of glare from windows, lights and eyeglasses. These can sneak up on you.

When in doubt, somebody who is essential for the occasion can have extraordinary chances since they know individuals and can be blending as those awesome "little minutes" happen. So it's anything but an attempt on the off chance that you have a positive outlook on the abilities of your picture taker and they follow these little rules.

Instructions to Create A Professional Landscape Photograph

―――

Scene photography is generally well known. I'm certain in the event that you check out your home you will see somewhere around two scene prints that addressed you. Photography is a workmanship that has a message. As a picture taker you need to discover the message you need to depict. In the event that you have practical experience in scene photography you may think your errand is not difficult to finish. Similarly as with any photography you need to focus on the subtleties, the lighting, shadows, subject, and the gear.

High contrast scene photography is the hardest area to achieve genuine creativity since you are not depending on the shadings as much as the lights and shadows the picture will make. Structure is vital. Piece in photography intends to search for sharp edges, tones and surfaces. The premise of highly contrasting photography is getting the camera to perceive what your eye finds in shading; to carry the features and shadows forward with the point of the image. Ordinary subjects for high contrast photography are structures and water. Water gives the encompassing trees and shakes a difference while drawing the eye. Scene can include structures or scaffolds among different subjects. Structures loan to the points and difference you look for while going after for definition and feeling.

At the point when scene photography is your subject in shading you should have contrast between the tones. In the event that the sky is blue and you have blue water beneath chances are the image won't have the difference you are expecting. Like high contrast photography you need to have definition or organization in the

shot. You should require a couple of moments to set up the shot and maybe take a few casings prior to being fulfilled. Shading photography takes less expertise than high contrast photography so on the off chance that you have ace the last you will prevail at the first.

Lighting for scene photography is normal rather fake. This is significant when setting up your shot. You should have channels for the daylight in the event that it's anything but a splendid day, maybe a mount to set up the shot and an expert grade camera to make proficient prints. Contemplating your subject from all points is likewise significant. You need to ensure you are picking the best plot for the shot. Recollect the message is delivered by the ability of the picture taker.

You capacities ought to be sharpened and polished. Advanced photography makes scene photography simpler on the grounds that you can survey the photograph before you leave a site. Again the LCD screen won't show you each part of the print so you will need to make a couple of efforts of a similar site to guarantee an ideal picture.

In any event, being a beginner picture taker you can acquire proficient looking scene photography. The most ideal approach to acquire extraordinary photos is to rehearse with a subject. Returning to similar site during various seasons can help you sharpen your abilities and net you a shockingly better print the sometime in the future. All picture takers' beginning at a similar level, some may have natural abilities and an eye for the photograph, however practice will prompt the best print. Scene photography may not need the abilities of natural life photography with panning the subject or pictures where you need to breath life

into your subject; notwithstanding, it requires abilities and practice.

In Praise of Digital Photography

I n any control, you will have many's opinion about as "the idealists". Idealists are the individuals who respect the manner in which things have consistently been done and see new advancements in the field as upstarts and clearly of less fortunate quality than the proven techniques.

This is no place more obvious than photography. For quite a long time the film and substance preparing technique has gone through consistent refinement to accomplish increasingly elevated degrees of complexity and to discover more significant levels of value. Little marvel that when the computerized upheaval went along, "the idealists" were, most definitely, somewhat inflated about the possibility of expert photography moving toward this path.

Be that as it may, there are some veritable motivations to essentially consolidate advanced innovation into your expert photography approach. These reasons are convincing sufficient that increasingly more we are seeing the huge studios going all computerized. So in the event that you are maintaining an autonomous photography business or on the off chance that you are "only" a photography specialist (and express gratitude toward God for the specialists), you may need to thoroughly consider the benefit of moving to advanced handling yourself.

Convenience.

The measure of quarrel and sheer "stuff" of doing a shoot carefully is drastically less included than utilizing the more established innovations. Witness how the computerized transformation in photography has changed the individual camera world. Presently

63

individuals can take however many pictures as they need and have them to survey practically promptly.

Presumably the greatest jump forward in the utilization of computerized photography is that you can do re-shoots rapidly, effectively and for practically no expense. In the event that you lead a picture meeting with a client, you can have the "stills" of the meeting accessible nearly when the meeting is finished. On the off chance that a shot was acceptable however not great, you can address it and re-shoot quickly saving enormous measures of time and further developing the odds you will get the portfolio you need and that the client needs on the principal meeting.

Fast Customer Service.

The impression we get when an innovation conveys such a lot of significant worth to general society is that quality will go down. However, incredibly, this isn't the situation with computerized photography. Regardless, the nature of the photos is as great or better than any we could do with earlier advances. Furthermore, the expense both to you as the photographic artist and to your client drops off so drastically that the well established objection the client has had about proficient photos being too expensive can be dispensed with making the client need to utilize your administrations all the more regularly.

Advanced photography, being an offspring of the web and the computerized upset that has cleared our lives by means of PCs, can be conveyed in a horde of ways and at a speed that was unfathomable before the appearance of this innovation. We can convey the photographs by means of email, by presenting them on an online display or by copying them to a DVD or CD so the client can arrange parcels more shots for a similar cost and have them conveyed in a manner that simple to view and store.

Altering

Altering has likewise moved from the domain of the back room wizards to something any of us can do because of the modern PC programs, like Photoshop, that we can use to further develop the photos we take. Truly astounding the impacts can be forced on an image with this product. Yet, more significantly we can quite a lot more effectively right minor issues with a photo so what may have been a lost meeting can be improved to get adequate with some smart utilization of computerized altering.

In essentially every manner, computerized photography, conveyance and altering is better than the way "the perfectionists" would have us clutch. It makes our lives as picture takers simpler, quicker and more beneficial. However, most importantly, this is something our clients need us to utilize. They will make the most of their photos such a great deal quicker, at a more sensible expense and the photos can be messaged to companions and posted on their family sites which is a good time for everybody. So notwithstanding our longing to be "perfectionists", each reason we need is there to persuade us that advanced photography is the best approach.

Insider Tricks to Create a Great Wedding Video.

———

In the event that you have been recruited to make a video of somebody's wedding and gathering, it very well may be a truly fun work. Not exclusively is there a great deal of happiness, snickering and fun minutes during a wedding festivity yet it is truly satisfying to realize that the video you are making will be essential for family festivities of these individuals for quite a long time to come.

Normally, you need to work really hard. Be that as it may, regardless of whether you are simply beginning or have been shooting video for quite a long time, you realize things can sneak up on you and make your work more troublesome. So there are some "insider deceives" that you should remember particularly on the enormous day so the wedding goes off as expected and you get that incredible video without upsetting the delight and fun of the family.

The initial not many precautionary measures really happen well before you drive up to the congregation and that is an exhaustive gear check. Check and twofold check your hardware and afterward check it once more. It can't damage to be somewhat impulsive about this. Additionally, watch that the entirety of your provisions are new, fit as a fiddle and that you have back ups of batteries, bulbs, tapes or whatever recording media you are utilizing. In the event that you realize your hardware is fit as a fiddle, you can stroll in there like the expert you are.

Then, be wherever early and solid and steady. Indeed, it can't damage to investigate the congregation and meeting room the day preceding to check the lighting and do some anticipating where you may plan to get

your best video from. In the event that Martin Scorsese can preplan the entirety of his shoots, so can you.

Presently be certain everyone knows what your identity is. Meet the lady, groom, the wedding gathering and others near the arranging. On the off chance that there are security individuals, be certain they know what your identity is also. In the event that there is a requirement for passes or identifications of any sort, be certain you have one well in front of the big day.

Part of systems administration with the central members incorporates getting some publicity with other people who might be supporting the wedding. Numerous weddings have a wedding organizer who should know all that will occur. Be certain the person in question knows what your identity is and what you will do before you begin upsetting their area. It's anything but an extraordinary thought to meet different photographic artists and do a touch of primer movement so everyone can have their chances. Know that you truly don't have any desire to do such an incredible occupation of recording the wedding that you harm the experience of the wedding visitors. This all takes heaps of preparation.

On the off chance that they practice, you practice. The practice is one of the incredible botched freedoms that wedding photographic artists and videographers need to venture through the wedding with the gathering and plan where you will be. Presently secure consent to be there as you never need to amaze an apprehensive lady or her mom. Be that as it may, on the off chance that they realize you are filling in however hard as they may be to prepare, they will be excited and you may discover them offering you headings on chances they need remembered for the video and where they need (and don't need) you to be at vital minutes during the wedding. This data is gold on delivering a great video for your clients.

When everything is prepared, hop in there and appreciate the wedding directly alongside every other person. You realize you are prepared and you like what you do so you can commend this enormous day and produce a first class video that will be a loved memory for this lady of the hour and lucky man for a long time to come.

Is Photography Art?

⸻

The contention about whether photography is workmanship is one that has been seething in the craftsmanship world for quite a while and we are not prone to thoroughly address it here. In any case, it very well may be a significant choice you need to make on the off chance that you are thinking about a profession in photography fully intent on creating quality works of art. On the off chance that that is the place where you are, the possibility that somebody would say "That is not workmanship, you just snapped a photo" is quite upsetting. So it merits taking a gander at the inquiry from a few distinct points before we pick which side to say something regarding.

Obviously, workmanship is something emotional. Numerous individuals would take a gander at a Jackson Pollack "splatter" craftsmanship and decide undoubtedly that advanced workmanship isn't workmanship since it "doesn't appear as though anything." And on the off chance that you invest any energy in the cutting edge workmanship world, you will see something eventually en route consuming space in a totally decent craftsmanship historical center that, as far as you might be concerned, would never be viewed as workmanship.

So is it's anything but a question of assessment? Somewhat, yes. In any case, there is a workmanship world and an industry behind it that rely upon there being a few norms whereupon craftsmanship is judged. One such standard is the purpose of the craftsman. On the off chance that you produce a photo or a fine art got from a photo that is planned to be seen as craftsmanship, then, at that point the watcher is committed to attempt to see the creative legitimacy in it. If the watcher sees that

71

legitimacy may rely upon the watcher's capacities, how acceptable you are at making yourself clear or numerous different elements.

However, simply needing something to be craftsmanship doesn't make it workmanship isn't that right? As a layman in the workmanship world, I in some cases go with the "I don't know craftsmanship however I understand what I like" arrangement of assessing pieces I see. Workmanship, all things considered, tends to contact us in somewhere else that is far in excess of the picture. It's anything but a passionate spot, a position of reflection and comprehension. Perhaps we would say it contacts our "soul". For a work to be craftsmanship, there ought to be a message, a believing, an explanation the craftsman made the work since the individual needed to say something, regardless of whether how I decipher the assertion is not quite the same as what the craftsman implied.

So that may likewise be an assessment of a photo with regards to its imaginative legitimacy or not. Presently the essential issue with whether photography is craftsmanship some of the time is that a photo is frequently a practical portrayal of a second taken with a machine and some would say that "anyone can snap a photo." The ramifications is that a similar mechanical expertise it may take to illustrate shape a sculpture isn't required for photographic workmanship.

The facts confirm that the mechanical ability that the person at Wal-Mart may have to take child pictures might be equivalent to an incredible photographic craftsman may require. However, the protest doesn't hold up in light of the fact that a similar human language is utilized to make incredible verse as it takes shout out vulgarities at a ball game. So it's anything but the ability that makes it craftsmanship.

Great proof comes from the credit some incredible craftsmanship specialists have given to photographic displays in the fine exhibition halls on the planet. The very reality that photography is viewed as

craftsmanship by the individuals who know might be adequately proof. So the end should be that in light of the fact that the contentions against the creative worth of photos are powerless and individuals who know believe photography to be craftsmanship, then, at that point we are protected in survey what we do masterfully as well. Furthermore, that opens up that side of your spirit to put yourself out there through the medium you love the most – photography.

Keeping it Legal

———

Have you at any point been watching a video or a show that incorporates public shots and a portion of the faces appear to be obscured out? No, that isn't helpless creation esteems with respect to the video group. That is on the grounds that the makers who at last offered that video to be utilized monetarily didn't get discharges from those people. Furthermore, on the off chance that they utilized their pictures, they are exposing themselves for bunches of lawful issues.

So how can you say whether the work you are doing in your photography business requires such deliveries? All things considered, you would prefer to be protected than sorry and get discharges from everyone you use as a subject than deal with an issue as it were. In any case, there is a drawback to getting them in the event that you don't know. That is the impression you make in the brain of your client.

On the off chance that you basically do pictures, weddings or different occasions where the aim of your work is to offer the photos to individuals being shot, there is surely no requirement for discharges. Insofar as you have no goal of truly utilizing any of those photos in a deal that will benefit your business other than the first way, then, at that point you ought to be fine.

It is the point at which you venture over into that domain of photography wherein you might be working with models to give photos to publicizing, magazines, papers or some other reason in which you are selling the pictures you have captured for a benefit, that is the point at which a delivery is required. This space of expert photography is enormously productive in light of the fact that you are working at a higher level of polished skill than shooting general society

to furnish them with representation level pictures. Also, on the grounds that it's anything but a worthwhile field of expert photography, the opposition to make those deals is hardened certainly.

At the point when you are working with proficient models, getting their deliveries is essentially important for the program and never an issue. They are working for you and they realize the photos are available to be purchased so their representatives and attorneys do all the legwork so the deliveries are normal and perceived. Yet, according to your point of view, don't release this detail unattended to. Your clients, those magazines or advertisement organizations who seek you for proficient photography work, are expecting you have this covered and that they can depend on you to convey quality work as well as work that has been legitimately delivered to be utilized for advancement.

The difficulties come in the event that you do your shoots in a public spot like a recreation center, a shopping center or anyplace that there might be traffic that turns out to be important for the shot. On the off chance that you complete the shoot and find that the ideal shot that accommodates your clients needs perfectly ends up having incidental individuals from the general population behind the scenes, you must have discharges from them or you can't sell that photo.

You could think ahead and attempt to get those deliveries on the spot. In any case, if individuals you are attempting to persuade to sign such deliveries realize you will utilize their pictures for benefit, and you essentially need to advise them, you get into another entire degree of exchange. Be that as it may, you sure don't have any desire to need to obscure their countenances out on the shot. You could Photoshop them out yet that may lose the suddenness of the shot.

It's ideal to organize the shot beginning to end. On the off chance that you need traffic to happen around your model, acquire models who can do the work for you. Any great displaying organization to furnish you

with "normal looking" models to use for this reason. You should pay them yet essentially you realize that the shot is perfect. Additionally when you sell the shot, you will get inquiries concerning whether those models were paid and in the event that you have discharges on them as well.

You can track down a standard delivery structure on the web or your legal counselor can assist you with creating one that covers the legalities you need took care of yet additionally reflects how you need to deal with this issue. However, don't allow this issue to slide through the breaks. By securing yourself, you can do great business and beneficial business however most importantly, legitimate business in scrutinizing your expert photography profession.

Lighting Tips For Photography Artificial Light.

Photography is craftsmanship. People will go through hours in exhibition halls and displays examining an individual's photos for the significance. Like artistic creation photos have a message, at times it will inspire pity, bliss, a lighthearted disposition, and thought. There are numerous strategies a growing picture taker will figure out how to bring out the feelings they want. One such method is utilizing fake lighting. Counterfeit lighting isn't generally as fun and simple as possible daylight, yet you can utilize it to make some magnificent photos once you know how.

Indoor lighting is frequently fluorescent and tungsten bulbs. Tungsten bulbs are utilized by proficient picture takers, as "hot lights" due to the high temperature they produce. In photography comprehend the temperature scale corresponding to the shadings they will create. A hot light will deliver more red and lessen the blue. Firelight and candle light however not counterfeit can be utilized in ways to make shadows and profundity.

When utilizing indoor lights, explicitly fake light you should get openness. At the point when you have less light it will take more time to open the film to catch a photo. Some portion of openness is the point. Gives talk about taking pictures access an exhibition hall. For example I was in a historical center with minerals behind glass and a lady offered the expression in the event that she snapped the photo nothing would come from it. This isn't accurate. First in a more obscure room where you have direct light on the item you won't have any desire to utilize the blaze. The glimmer will bob the light back at the image. The subsequent stage is to get as near the glass as could really

be expected. The third thought is the point. Snapping the photo head on of the item will skip the light and shadows about. You should point the camera aside or up from the beginning achieve the photo. In the event that you don't have glass in the manner the point will in any case be significant, particularly when taking representations. Shooting any subject head on is probably going to make shadows and detract from the print. The best plot for shooting pictures is frequently up into the face.

When shooting faces or different articles you ordinarily need a three dimensional difference. You should look for the planes and shapes of the subject, particularly in picture photography. The planes and forms will assist you with deciding the point you will shoot the subject from. The shadows will regularly give the three dimensional differentiation in the event that you track down the right planes and point to shoot from. This assists with pictures that you need to independent.

Counterfeit lighting should be moveable. Simply turning on your home lights won't give you the ideal effect. Rather it can clean out the subject, place the light at some unacceptable point, or make a lot of shadow in one region. You need to have illuminates set on stands to change the point to suit your requirements. Rooms are little which is one explanation over head lights can either be excessively incredible or not immediate enough. Following lighting tips will build your photography abilities. Most beginner picture takers discover taking a class on lighting and having a couple of books regarding the matter will assist them with learning appropriate lighting strategies. The justification classes is to give input. You might be content with the shot, however ideas can help you make the shot wonderful later on.

Counterfeit lighting enjoys upper hands over outside or regular lighting, yet at times the image kills better with normal light. It very well may involve inclination or the craving of a customer or subject so

far as that is concerned. You never have fake lighting outside generally; you typically depend on your camera blaze to assist with the image quality. At the point when you pick your lighting, search for the best lighting circumstance to improve your subject and make your image as normal as could really be expected.

Lighting Tips For Photography

Photography several capacities to make your prints look capable. One piece of making a print capable is lighting. Lighting in photography takes a little orchestrating and perception two or three techniques. You best subject or thing most likely will not turn out that way if the proper light doesn't help with covering the locale. Coming up next a few hints on using light for photography.

First you ought to pick on the off chance that you will use fake or sunlight. In case you are using sunshine you will rely upon the Kelvin scale to choose the temperature of light and thusly the shade of light. The shade of light is basic to staying aware of the tones you see around you. For instance the more blazing the light the redder the light will be, thusly you may need to pick the time you will go out and shoot photographs. Outside lighting offers such incalculable different events to take pictures depending upon your need.

Next an image taker needs to grasp the sun's concealing scale. Pictures will overall lead the watcher towards explicit slants; regularly milder tones call really feeling. So understanding the suns influence on the shadings will help you sort out the right period of day. The sun rouses blue shades around the start of the day hours, while closer to early evening you will find more fair tones. The unprejudiced shadings can eliminate a bit of the definition you need in your print. Knowing how you need to shot the picture will similarly help you with choosing when you wish to put forth the attempt.

While using typical light you should work with the point and course of the sunlight. If the sunshine is extensive and diffused you will have milder shadows while the more dainty the light is locked in the more shadow you can make. Routinely around early evening when the sun is in mid bend you lose significance of the subject. The subject could look grainy. This is the explanation shadow is used; the shadows can give you more noteworthy quality to the print at whatever point used precisely. This adds to the greatness of your photographs.

You can in like manner change sunshine through explicit techniques. Changing light when taking portrayals outside requires the use of an establishment. You may need for a dazzling scene that will give more association to the photo. You may need to block the sun if it interferes with you or your subject's sight. You may in like manner gain a white surface to fill the shadows. Scene photography requires less work than commonly ordinary light for portrayals. Believe it or not using customary light for scene photography without changes can yield you an unrivaled photograph.

Scene photography uses nature to give the light and shadows. This is the explanation you need to fathom the light scale and temperature. Time is the fundamental piece of using light. To understand typical lighting you need to appreciate the impacts the sun will have at explicit occasions. For instance if you are in a thickly vegetative boondocks the sunlight will encounter issues spouting in aside from in the event that it is over head. You will have standard shadows in the boondocks and remember you can move around your subject to find the best point with the sun.

Photography is a workmanship that requires strategies and practice. Lighting is a huge piece of photography, especially when

you are using typical light. Sunshine can bring a great deal of shadows or eliminate them depending upon the hour of day. Understanding the best an optimal chance to snap an image depends upon the sun's point. Photography is a captivating redirection and calling when cleaned suitably will give you a ton of prints for your home and others.

Whether or not you are a specialist or a beginner photographic craftsman, you need to make some ideal pictures with the suitable lighting. Thinking about this, pick your lighting as shown by your necessities and the prerequisites of your subject or article. Your photographs will be magnificent with splendor when you use the best lighting condition.

More Than Pictures - Memories

At the point when you are employed to be the photographic artist for somebody's wedding, it's anything but an honor. For an expert picture taker, we can now and then consider it to be another "gig". However, it pays to take a gander at the occasion through the eyes of the wedding party, the guardians, the kin, the husband to be or more all the lady of the hour. For the lady of the hour particularly, there isn't anything routine about this day. Everything is close to home and getting the most ideal photographs of this significant day couldn't be more close to home and critical to her and her family and her husband to be too.

So in the event that you are venturing into or setting out on building your photography business to incorporate wedding photography, you should plan to move toward this undertaking much uniquely in contrast to some other type of photography. You are doing much more than taking a couple of depictions of an occasion. You are as much an indispensable piece of the function and the meaning of that day for this lady and this lucky man as the pastor or maybe even a considerable lot of the wedding visitors.

So how would you be able to deal with ensure the wedding collections you make catch the occasions of this day as well as the feelings and its profound significance too? The key is to know the hearts and psyches of individuals who are engaged with the occasion. That implies, get included early and be included frequently.

For most weddings, the arranging starts as ahead of schedule as a year prior to the service. In the event that you persuade recruited to

be the wedding picture taker, it's anything but too soon to meet the wedding gathering and family that early moreover. To be a gifted wedding picture taker, you ought to likewise have a touch of the insightful writer, the novice therapist and the mystic in you also.

Your photos will catch the pictures of the occasion as well as the soul of individuals who join in. So become more acquainted with every one of the vital participants independently. This absolutely incorporates the lady of the hour and husband to be nevertheless a comparable degree of commonality is fitting for the wedding party, the guardians of the lady and groom and their closest companions as well.

There are some inconspicuous ways you can become familiar with the hearts of these individuals so you can plan to get photos that will be ones the every individual will say, "I'm saving that one for eternity." Here are a few ideas...

. Get to know the shades of the wedding. Yet, more than that, discover how the lady of the hour and critical choices creators see tones. Watch how they dress and show them instances of wedding photos and pay attention to their responses. You can design the how to organize your photos appropriately.

. Every lady has that ideal heartfelt setting in their heart. On the off chance that you can find that secret fortune, you might have the option to outline an extraordinary wedding photograph just to fit that fantasy. Maybe she there is a public nurseries in the city that has a wellspring that she has adored since she was a kid. On the off chance that so you can make game plans to host the wedding gathering meet out there when the lighting is perfect in full dress and make some marry photographs that will be in her heart for eternity.

. Don't fail to remember the lucky man. Possibly he couldn't imagine anything better than to have a good time photograph showing him and the lady of the hour on his Harley. Or then again in the event that he is a major avid supporter, getting a photograph dressed out in group formal attire at later than the wedding can be a great expansion to the portfolio. What's more, it's anything but a great deal to him as well.

Knowing individuals, their characters and what is most important to them makes you a superior photographic artist. Try not to botch an opportunity to be with the wedding party at each phase of preparation. The central members won't just not despise your essence however they will see that you have a similar obligation to creating this day really extraordinary. What's more, they will cherish the result and you will stay as much a piece of this huge day as the blossoms and the actual church.

Photography Through the Ages

———

Right when you see chronicles of the early planners of photography, the present very entertaining especially thinking about photography. In those old movies, to get a picture, the camera was despite how huge as a PC might be today. The image taker expected to put his head under a sheet and hold up an epic mount which exploded with smoke and exhaust to make the flicker.

Today photography couldn't be more uncommon. In the films, we used to be confused when spies had cameras in their watches or the soles of their shoes. However, as of now it is totally expected for almost everyone to have a camera in their phone and to have the choice to pull it out and snap a photo basically wherever.

We should fill two or three openings. We can get back to the beginning stages of the language to find that "photography" began in the Greek events and it's anything but a genuine sense implies "drawing with light. Be that as it may, the authentic investigation of photography didn't really take off until the 1800's in this country when a person by the name of John Hershel applied the words "photography", "positives" and "negatives" to the task of making pictures. We had "negatives" of our photos starting there until the start of electronic photography over the a few years.

For most of us, in any case, the association Eastman Kodak is probable the one we accomplice most with the early headways of photography. Also, it was the early pioneer of photography, George Eastman that made the fundamental degrees of progress on the rough methodologies being used until his work in 1839. A little irregular information?

Eastman made the name "Kodak" up considering the way that he required his association name regardless a "K".

The upgrades began to appear wonderful routinely as photography created and end up being more current. Concealing photography was made in 1861 by a specialist named James Clark Maxwell. Up to that point all photographs were profoundly differentiating or monochrome. Concealing photography was a colossal leap forward yet it really didn't start to move into the public field until two kin named Lumière in 1907 fostered the concealing plate.

All through the quite a while to follow, photography pushed ahead reliably and moved out of the universe of science and a while later news-projecting and into all of our homes. Regardless, the distress that has changed photography into what we understand that it will for the most part be today occurred in 1981 when Sony created the essential camera that worked without film. The old age had shown up.

It was Kodak that again got the lead on the business place by getting the essential automated camera out accessible in 1990 when they encouraged the Kodak DCS 100. Similarly with all development, early progressed cameras were tremendous (by the current standards) and fundamentally more exorbitant than we are used to now.

Improvement in the field of photography has continued strolling almost as speedy as conceivable keep up. Exactly when exceptional cameras were offered that gave us a port to have the choice to download them to our PCs, the web impact of imagery was fueled.

Further improvement coming all things considered, every year since 1990 recalled the quick and brilliant augmentation of memory for modernized cameras close by the possibility of swappable accumulating drives. This changed the way where people took pictures since now the amount of pictures someone could take was essentially unlimited.

The expansion of memory in like manner empowered creators to add video catch to comparable contraptions as were used for photography so that basically anyone could transform into a cameraman with that tiny camera that could now fit in their shirt pocket. An enormous piece of the fun of web objections like YouTube can be credited to the limit of the typical occupant to take video wherever, at whatever point and to no detriment for them.

The photography and video industry has expected to do a lot of adapting to sort out some way to help this market that was changing at speeds incomprehensible by George Eastman a century earlier. The sensible availability of significant worth concealing printers that enabled people to print their photographs at home was a sanctuary to the beginner camera buff yet a hit to the photography business.

Nonetheless, shockingly, the business has kept up. However, we can be sure that the headways are basically getting in progress. Who can say without a doubt what new particular wizardry is ahead for the photography world. It makes sure to be a wonderful ride, paying little heed to what's available.

Arranging A Wedding And Still Looking For The Perfect Photographer

───

W edding photography is maybe the main field in light of the fact that these are the exceptional minutes in life we need to catch. Pictures are significant and frequently play a significant roll in wedding photography, yet there are more to the wedding and tracking down the ideal photographic artist. The following are a few hints to tracking down the right picture taker for you.

Gear is perhaps the main viewpoints. There are new photographic artists who will begin not having the option to manage the cost of a ton of camera gear, lights, mounts, etc. This doesn't make them a terrible photographic artist, however it can mean they will miss significant wedding minutes when they are reloading the film on one camera. In this day and age a wedding photographic artist ought to have somewhere around one advanced camera at the expert grade and two film cameras. A fruitful picture taker will have enough cameras to put suitable focal points on and have the option to switch memory cards in the computerized camera effortlessly. They ought to likewise have a camcorder run by someone else to catch the whole wedding.

Experience will decide the expense of the picture taker. Most photographic artists who have been on the circuit longer will charge somewhere in the range of $3000 and $10,000 for wedding photos. Everything relies upon the sort of bundle you will need and the number of collaborators they should cover the whole issue. Different picture takers normally charge between $300-$3000 relying on the bundle and their experience. A notable wedding picture taker will cost more, only for the name. These bundles frequently indicate their experience too as the gear they can utilize. A computerized camera doesn't cost film, yet

buying one can be costly so most new photographic artists may charge somewhat more to supplant the expense of the gear.

Cost of a wedding photographic artist ought to just be a moderate issue. The top significant part of an expert wedding picture taker lies in their photography abilities. They will quickly stroll into the spots your wedding and gathering will happen and have thoughts of the position of hardware and lighting. They can likewise show you an arrangement of past weddings. Wedding photography is about the minutes that pass between your family and yourselves. The second where you are taking a gander at your pledged with adoration composed all over when you think nobody else is looking will make the best photos. A wedding photographic artist needs to see these minutes and catch them just as get the representations.

Wedding photography is regularly seen around the home with the pictures. The representations of the lady of the hour holding her blossoms, the wedding party presenting, and the lucky man and lady together. The conventional wedding photography will incorporate the hands with the shinning wedding rings set on a cushion or folded over the lady of the hour's midsection. The course of action of the wedding couple is just about as significant as the photo. The wedding picture taker ought to have the option to present you while catching the light and foundation.

Photography is a multifaceted calling and when you have a significant day, for example, a wedding you will need the best. You may have thoughts of the photos you need and the wedding photo will be happy to assist with carrying those plans to fulfillment. Photography is tied in with lighting, getting those unguarded minutes, and making recollections that will keep going forever.

Representation Photography

D o you simply snap pictures of companions without an idea to how it my chance out? Representation photography makes you a stride up from individuals photography. It gives you components to notice, for example, the point you snap the picture, the lighting you will utilize, and the demeanor of feeling on a people face. While you might be a beginner picture taker choosing to take Christmas photographs without the cost you should have some essential information on procedures utilized by the experts.

First when snapping a picture of an individual you need to consider their face. The face is essential to the point you will shoot from. In spite of the fact that it's anything but a banality, it is genuine a few group have a superior side. This could be comparable to scarring or skin inflammation breakouts or much more straightforward. For example my left eye is bigger than my right by only a tad, and looking head on into the camera will cause an unpleasant picture, nonetheless if the photographic artist comes from the right side and points up somewhat the light and shadows will help even out the highlights while keeping the differentiations that make me who I am.

Representation photography is tied in with catching the substance of the subject, the character. The little subtleties of a face add character to the representation. You will need to relax up your subjects. In the event that you are turning into an expert representation photographic artist you will need to find out about your subject as you are taking pictures or maybe meet them before the meeting. In the event that they are only your family, you should realize what might get their character caught on film.

Lighting is the following significant advance to representation photography. A ton of photographic artists incline toward regular light to fake. Your subject will to some degree choose this for you. Recollect you will utilize the light you have. Normal light will regularly require setting the gap to make up for the cameras absence of definition. At the end of the day you need to make the differentiation with the light and shadows for the impact you need. Regularly counterfeit light is brutal and not coordinated as expected except if in a studio. Again you should utilize the manual settings on your camera to make the ideal picture.

The foundation is additionally significant when talking about light. In a studio a picture taker will pick a foundation that won't clean your highlights out or your attire. They need to have a qualification or differentiation among you and the foundation. This is additionally significant of home representation photography. You will need a foundation that offers tone to your subject instead of removing it. Tracking down a decent spot with a tree to sit on and mountains behind the scenes can be an incredible representation, yet you will need to ensure the foundation isn't too occupied to even think about diverting from the subject. Cause the subject to appear to be separated of the image instead of outside of it.

The sort of camera and film you use will likewise decide the nature of the photography. When you join procedures like lighting, points, and understanding your subject you will actually want to make a close to proficient if not proficient picture for your loved ones regardless of the event. Simply snapping an image is conceivable, yet it is extraordinary to have a superior picture?

Presenting by Not Posing

Hard everything being equal to acknowledge, portrayal photography is considered to apparently the hardest of the various specializations in the calling. That preview of arranging a subject before that plastic fake establishment to sit on an abnormal seat and make a smile they would never use in some other setting is legionary and not one that you expect. Additionally, you can tell the subjects, especially the men, are liking this presumably whatever amount of they like going to the dental trained professional.

So how to eliminate a segment of the teeth from the cycle. For specific portrayals, you can't move away from the formal "seating". However, that being said, there are ways to deal with release up the subject so the smile you get was one they really expected to give you.

The best picture is one that isn't a portrayal. If you can get the subject talking about their main subject, helping out someone they like or love and using their consciousness of what's really clever, that brilliance in their appearance and flash in their eye is incomparable portrayal gold to you the image taker.

By and by, you can't delude the subject. So if you explain that you will be here working on this troublesome camera, then carefully assistant the conversation, they will begin to get adjusted to hearing the screen to off and seeing the flicker anyway they may have the choice to not stress.

Presumably the a couple of portrayals I have gotten happened when I got the couple having a mindful talk or delicate conflict with some nudging and that ordinary coax came out. Exactly when you can

snap that second on time, you will have a photograph they will esteem for a lifetime.

Obviously, the way in to any photograph is to get the person and the "soul" of your subject. I was shooting a fledgling scout in his uniform for a fundamental photograph to the family considering the way that the child had achieved the Eagle rank, which is a high honor. Notwithstanding, I understood this youngster had lots of character so I required the "formal" shot at this point I required this current kid's heart in it too. So I uncovered to him I would two or three shots to test my screen and I made him talk about scouts and camping out. As I got him to instruct me concerning the most intriguing minutes he experienced camping out, that smile came out and impact, I had my shot. It hangs in my vestibule now as presumably the greatest second as a photographic craftsman.

If you can get the couple to do the portrayal at home, in a bistro or at some normal setting, you can get that kind of fondness going much more straightforward. This requires that you, the photographic craftsman ought to be a skilled expert with your camera just as somewhat an administrator, an investigator and an entrancing expert all confined in one. So tidy up some incredible "boggle" that you will use to back those person shots out of your subjects.

Likewise, good that interest for different characters. You may must be a coax the smile out of a little adolescent or persuade it's anything but's a child. You may need to get somewhere in the range of "one man to another" humor out of that burley improvement worker or make an off the cuff break about a legislator to get Mr. Cash supervisor to snicker. Also, for the newborn children, for sure, they will almost smile for their mom and probably smile for daddy so use them beyond what many would consider possible.

By merging your capacities as a photographic craftsman with a liberal fragment of people allure and excellence, you will make central portrayals that will be better than the abnormal, firm looks that so many recognize as okay. Your customers will be more upbeat and you will see the value in a pride in your work that you well legitimacy.

Sneaking Up on the Wedding

———

E ach wedding has an expert picture taker who has been doing this for quite a long time. What they will deliver is practically a known element before the wedding even begins. You realize he will hold the wedding party over after the service and do a lot of organized shots. You realize he will "stage" the taking care of the cake among lady of the hour and lucky man, the tossing of the bouquet, the dance of father and lady, all that standard stuff.

Be that as it may, you may have the task as a novice photographic artist to likewise take photos of the wedding. This isn't surprising. In the event that the lady's sibling is acceptable with a camera or the lucky man's uncle knows some things about photography, why not let them take pictures as well. So if that task has tumbled to you, there might be a couple of tips for you to remember as the large day draws near.

. You are the back up person. So let the expert do his stuff. Keep in mind, on the grounds that your sister or dearest companion has most extreme trust in how you can deal with make the wedding collection seriously fascinating and fun, those conventional shots are critical to the family and to the lady and man of the hour. They might be antiquated and somewhat exhausting however that paid picture taker was recruited to do a task. So don't impede the expert and on the off chance that you do collaborate with him, do so consciously. You don't need that person feeling awful. So give his space.

. Be prepared. You can wager that paid picture taker came here having looked at his hardware and he understands what he needs and he realizes everything works. So you be similarly as "proficient" as anyone else and accomplish your prep work the prior night. That way when

you venture up to have that chance you realize will make the wedding collection sizzle, your hardware works impeccably as well. This additionally incorporates showing up all set with reinforcement batteries, tape, lights and whatever else you will require for an entire day of shooting.

. Use what he does. That expert will arrange individuals to have those chances that are on his rundown of standard shots all wedding collections get. However, during when the wedding party is attempting to be acceptable yet overjoyed with apprehensive energy, there will be many little minutes that will make extraordinary photos. Possibly have that chance of sister fixing the bloom young ladies dress. Or then again that senseless stimulate meeting among lady and lucky man as they play with one another to get past the strain of the day. Use what that picture taker is providing for himself. However long you don't disrupt everything, you can get some extraordinary pictures that way.

. Those activity shots during the function. You have accompanied a more versatile hardware set than the expert has on the grounds that you will likely have the casual chances. So you have what you need essentially on your back. You can move around the corridor and get those little photos during the function of things going on up on that stage that every other person will miss. The wedding gathering will adore you for catching minutes that would have been lost to time in the event that you had not come prepared to deal with your feet and move those little expendable pictures that are worth gold in the wedding collection.

. The kids are "down there". Try not to ignore the youngsters during the wedding or the gathering. They add loads of fun and bliss. Yet, recall that, they are down there nearer to the ground than you are. To have their chances, you need to go down there with them.

Keep in mind, this occasion isn't about you. You are the notorious fly on the divider to have those chances that the professional doesn't have on his agenda. And yet, remember that you are imperative to this wedding to. So put down that camera now and again and have that glass of wine and do the out of control chicken during the gathering with every other person. Let another person get that image.

Start Your Own Photography Business

———

When you are a child and pondering the numerous ways you can cause a living when you to grow up, what is the counsel your elderly folks consistently gave you? It was, "Do what you love to do and you will consistently be cheerful." And that must be genuine since, in such a case that you can spend your work week doing what you love the most, it truly will not be function however much it will be play that individuals pay you to do.

So if your energy is photography, it's a good idea to begin your own photography business. Yet, how to go about it? You see so numerous little photography shops that appear to jump up from no place. What is the most ideal way for you to approach going into efficient this?

The main thing to consider when beginning a photography business is the way to do it's anything but an authentic way. You need a business that will endure forever so you need to begin it out right. So don't succumb to the "make easy money" web plans or books that guarantee they will spill the insider privileged insights of other fruitful photography business. There are no insider privileged insights to this business other than what you need to know to maintain any business. To succeed you need to...

? Pay your duty

? Get your schooling.

? Learn from the geniuses.

? Know your stuff.

? Network

? Value your clients.

You can achieve the initial five of these goals by going to class and working part or full time in another person's photography shop. You may surrender at the possibility of more school. Be that as it may, your photography business will be about something beyond cameras, photograph shoots and dim rooms. You have bookkeeping standards to grasp and execute, duties to be paid, an office to lease, representatives to pay, protection to stress over, agreements to sign and the entirety of that other "stuff" that goes with maintaining a business. So start early and get some fundamental business classes added to your repertoire like bookkeeping and financial matters. It will profit you many ways as you walk toward progress.

Numerous exchanges have a disciple framework where you coach under an expert of the specialty. Yet, it may be great for you to assume control over this matter. Plan to work for a photography shop sufficiently long to become familiar with the intricate details of maintaining a private venture and of maintaining a photography business. This allows you the opportunity to construct your insight and openness to gear, learn method and how to work with your subjects.

Indeed, it very well may be a smart thought to purposely disciple at various kinds of photography studios prior to jump starting out all alone. So you can get familiar with the intricate details of wedding photography, child photography, style photography and others from experts all before you go through your very own dime cash to begin your own venture. Thusly, you assemble abilities, you construct information, you fabricate insight and you can watch and take notes of the incredible things others do and the missteps to keep away from.

Your managers will be excited to impart their true information to you on the off chance that you are available to them that you need to gain from the bosses how to do this determined to turn into their

opposition later on. Most importantly, you can construct a customer base from the numerous clients you work with before you go into business. Purchase dealing with another person's clients, they can turn into your clients when you hang out your shingle. Furthermore, that is acceptable business.

Still Life Photography Techniques

There are numerous mediums to browse in photography. Regularly an individual will start with still life photography and work their direction towards pictures, untamed life, or scenes relying on their inclinations. Still life photography trains an individual to utilize light and shadows to discover the feeling of the item. Here I will examine a wide range of parts of still life pictures.

Still life communicates the photographic artists self while utilizing in enliven articles like earthenware, blossoms, candles, leaves, and organic product. The initial phase in still life photography is the lighting. You will need the item to have light from a solitary course, with the goal that you can give shadows a role as well as light on the article. This will give it a profundity of field, and measurement. You should pick whether you need a delicate or cruel light. The more unforgiving the light the more shadow you will have. Regularly in still life reflectors are utilized to restrain the light. The best kind of lighting for still life photography is side-lighting since you will accomplish more differentiation between the article.

With still life photography, you have shading control. You can pick the shades of the articles you use. While picking the shadings say with leaves and organic products you will need a difference in colors, however hold a characteristic look. Congruity is the best word to utilize when achieving shading control. The shading will draw in the watcher's eye, so on the off chance that it is disappointing to you the odds are your watchers will think that its comparably disappointing.

With still life, you can pick a theoretical theme. You may decide to assemble two items that don't bode well, however make a moving picture. You may have an intriguing cut on natural product, like a melon to uncover within center. The point of the cut and the importance of the image will require thought from the watcher. A few watchers see not quite the same as what another watcher may see. This occurs in the craftsmanship world every day. What one thinks addresses craftsmanship another finds unappealing. Never let these impact your fantasies and prevent you from getting far better in your work as a picture taker.

You can likewise have control of varieties. You can utilize a similar subject over and over with various foundations, courses of action, and different articles. The key is to stay away from mess while making contrast. The standard of thirds of piece is an extraordinary method to use still life objects. You can make an example dependent on the standard of thirds. Setting up the courses of action and attempting a few shots will lead you to discovering the amicability between the articles.

You may think still life photography comes up short on the profundity of different mediums; in any case, it tends to be utilized as a venturing stone to more prominent photography. Still life can incorporate a masterminded nursery to satisfy the eye or a characteristic look. You can utilize normal light to counterbalance the shadows and discover the differentiation. Still life inside or outside making the courses of action is only one approach to discover pictures you will wish to show or provide for companions. Recall lighting, shading, and minor departure from plans will give you will huge loads of subjects.

Applications for still life photography can incorporate taking photos for magazines. Regularly magazines have still life

photographs to show bloom game plans or enlivening thoughts for the home. With the numerous decisions in photography, still life takes a unique eye for orchestrating articles and understanding lighting strategies. With all of photography being craftsmanship you need to pick the subjects that will talk most to you and cause them to address others. These sorts of pictures go well when choosing to sell your photographs or show them for the general population. All photos if you figure it could be exactly what somebody needs to show and may offer to get it. This assists you with beginning a genuine goldmine of a business in the event that you feel certain with your work.

Making Great Efforts Of Your Baby

Your child is adorable, and nothing makes a parent prouder than sharing photos of their new youngster. Everyone loves taking a gander at pictures of children, as well. On the off chance that you have a little one in the house, prepare your camera and begin sharing those charming child pictures today. The more pictures you have a great time you will have showing your valuable pictures. Here are some extraordinary thoughts to help you make better efforts of your child.

Stay Ready

You can never know when your child will accomplish something engaging or work on something interestingly. Therefore, you generally need to have your camera close by and all set. That implies ensuring you have a lot of film in the event that you utilize a film camera and ensuring your have sufficient space on your memory stick or card on the off chance that you utilize advanced. You will likewise need to ensure that you have sufficient battery life in your camera consistently. Numerous guardians utilize more than one camera, as well. You can even place a dispensable camera in the vehicle or diaper pack for times that are simply too charming to even consider leaving behind.

Have Candid Chances

Probably the best pictures of children are open shots. You can take important photos of your child taking a jug, resting and grinning. Authentic shots look considerably more loose and normal than presented shots and you will just feel disappointed attempting to be presented shots in any case. Children are infamous for not

collaborating for presented pictures. Try not to burn through your time and make real to life efforts all things considered. Remember all to take photos of all aspects of your child, like those fat little fingers or those small toes. Those are in every case sweet tokens of this youthful age. On the off chance that you have a decent long range focal point, you can regularly make incredible authentic efforts of your child from a good ways. These are incredible in light of the fact that your child won't ever even realize you are there.

Take Pictures in Black and White

You can't get a lot of cute photos of your child taken clearly or in sepia tones. You can ensure that grandmother and grandpa will be spouting over those, as well. Most computerized cameras accompany high contrast and sepia settings, so exploit. What's more, when you take highly contrasting, you don't need to stress over the thing your child is wearing, since everything looks great. The more regular the photos the better time you will have taking a gander at them later on. Children found doing what they specialize in is consistently a work of art. They offer long stretches of pleasure and getting all the energy checks.

Make Many Efforts

You should make numerous efforts of your child doing likewise. You may take 25 of your infants creeping of the first run through, yet may just get a few that merit utilizing. The more pictures you take, you should need to browse as much as possible. It is in every case best to take more than insufficient. An expert just as armatures know, that not all photos end up, particularly in the event that you utilize a rapid camera. Simply continue to take pictures to guarantee you catch the occasion.

Accomplish Something with Those Pictures

The last tip is to ensure you really accomplish something with your photos after you take them. Such countless individuals leave lacking rolls of film lounging around for quite a long time or never print their advanced pictures. Children develop and change excessively quick. You should make it a highlight print and offer your photos consistently. Moreover, on the off chance that you utilize advanced pictures, you ought to consistently ensure you back up your photos onto a plate consistently. You unquestionably don't have any desire to lose these indispensable photographs. This has happen an excessive number of effective picture takers and causes a serious upheaval when you lose all your valuable minutes that you never again will see.

Strategies For Underwater Photography

Submerged photography carries the submerged world to the surface. Some miracle wheat swimming in the sea resembles, yet the don't wish to figure out how to jump. Submerged photographic artists have willingly volunteered to carry the submerged world to the individuals who don't wish to plunge or never got the opportunity. While all photography is a craftsmanship the submerged world necessities exceptional abilities to bring the greatest alive.

Dissimilar to untamed life photography the submerged world should be seen very close. In other words the marine life should be shot intently. This is a result of the water. The water refracts pictures regularly twisting them so the nearer you are to your subject the less water you have between you a the subject. Submerged photography requires a lot of persistence. You subject may swim rapidly by like the shark, whale or dolphin, or they may cover up with in the coral jumping out just when peril isn't felt. Water holds particles, most typically living life forms called tiny fish on the grounds that these particles regularly skim by while you are attempting to snap a photo you can free differentiation and sharpness of the picture.

Marine life utilizes the reason of concealing more than speed or natural selection. This implies you will regularly track down your subject covered instead of out in the open. You need to look for your subject sincerely, without frightening the subject. The submerged world requests regard. You would prefer not to contact the living organic entities and hence you should figure out how to move with the current while attempting to accomplish the ideal shot. A ton of marine life will kick the bucket in the event that

you contact it, particularly coral so having an interest of submerged photography expects you to keep the principles, a code of morals.

Submerged blaze or all the more commonly called a strobe can help you acquire the light you need to take an ideal photograph. It is fundamental to have a blaze with a submerged camera. It will assist you with bringing different tones instead of red and orange into the image. The strobe just should be medium estimated, any bigger and it can frustrate your photograph taking experience.

Sythesis is additionally vital. You will adhere to a similar principle you did in ordinary photography; nonetheless, you actually need to have a vertical point regarding the matter. This returns to the cover strategy of most marine species. They will in general liquefy into their safe-houses or now and again; their bodies are intended to cover up in the water when swimming like sharks. At the point when you are attempting to have an unmistakable chance when the subject mixes out of spotlight can be troublesome and makes a test.

When managing submerged photography as an interest you should sharpen your photography abilities ashore first. When you take incredible pictures ashore you can move into the harder variant of the submerged world, where a few guidelines you've utilized presently don't have any significant bearing and achieving the best picture accepts tolerance just as ability. Submerged photography carries the marine life to the surface reducing a portion of the obscure. On the off chance that you discover you are simply beginning to have an interest in submerged photography you will need to look for an expert submerged photography class to show you a portion of the significant strategies just as training.

The Basics of Photography

O n the off chance that you are an avid supporter, you understand what it's anything but a group goes into a "reconstructing year". It is exactly when the proprietors or mentors choose its opportunity to prepare new individuals and right unfortunate quirks in others. What's more, constantly, what group administration says when they go into such a period is that they are going "simple."

At times it's useful for us as picture takers to return to fundamentals. Also, obviously, on the off chance that you are simply beginning in the realm of photography and need to learn "the ropes", the essentials are a characteristic beginning. Be that as it may, you need the fundamentals of what the experts think about the specialty of photography.

Anyone can snap a photo. I went to a wedding gathering where the wedding party left a dispensable computerized camera on each table at the gathering for visitors to snap photographs. Before the evening was finished, it was the kids who were going around taking pictures of everything from the grimy dishes to their own clothing. These were not photographic artists and keeping in mind that those photos will almost certainly get a couple of laughs, these are not the sort of expert pictures individuals need for their drawn out recollections.

Clearly, the foundation of the rudiments of photography is the camera. At the point when you see a camera nerd strolling around with enough gear on his neck to dispatch a space transport, you get the feeling that cameras are remarkably intricate, beyond what

121

simple humans can get a handle on. In any case, take a gander at the experts and you see them working with compact, moderately simple to work cameras. That is on the grounds that the nuts and bolts of getting a camera come down to gap and screen speed.

Presently don't get anxious about extravagant terms. Gap is only a term for how wide your camera focal point is available to allow in light. What's more, shade speed is exactly what long you let the light come in to mean for the image. For having a chance of a quick occasion, you need a wide opening to allow in a great deal of light however a short screen speed so you catch the occasion rapidly and close the window so the image is gotten before more light damages the quality.

Photography is actually about light. You can and will get gain proficiency with a great deal about focal points and glimmer photography and alternate approaches to turn the authority over the lighting of a shot to you. So add to your center abilities of photography an eagerness to learn constantly. The better and more modern you get in your capacity to work with the hardware, the more you will learn and the more you will need to learn.

You can oversee these fundamental controls of the camera like opening and screen speed by figuring out how to change from programmed settings to manual settings. The programmed settings of any camera are only there for the overall population who are not keen on learning the fundamentals. So they give you some essential settings like scene, representation and sports settings. By changing to manual, you can realize what settings work best in various circumstances.

Furthermore, that takes us to the main essential about turning into an extraordinary photographic artist and that is practice. Take some time with your hardware and play with it. Take it to

circumstances and take photographs with various gap and shade speed settings, in open air and indoor settings and various directions to light. Try not to have disturbed whenever a few chances don't work. That is essential for the expectation to absorb information.

By learning by doing, you will fabricate your trust in your work and in the end become an incredible photographic artist. Be that as it may, don't get presumptuous, there is in every case more to learn. What's more, that would one say one is of the great things about photography, right?

The "Business" of Stock Photography

N ow and then we partner stock photography for certain adverse ideas, for example, the photographs you find in outlines that are marked down at a retail chain or the photograph that arrives in another wallet. Indeed, those pictures came from a stock photography library however there is a great deal more to stock photography than that.

You can place a ton of imaginative energy into building a strong stock photography library that will draw clients who need these pictures and like your inventive eye. Truly, things being what they are, stock photography is the same as doing a go for a client. It's simply that you are taking the photographs ahead of discovering the client and you can sell a similar stock photograph a large number of times. Also, that last part is the thing that makes running a stock photography administration a worthwhile business to work.

The interest for stock photography is continuous and expanding. In any case, in the monetary "model" of any commercial center, supply is just about as significant as interest. So to vie for business you need a decent, different stockpile. That implies your initial phase in building your stock photography business is to fabricate the "stock". In the present circumstance, amount checks.

At the point when you begin engaging clients, you need to have the option to show them a solid index of numerous kinds of stock photographs as well as of a decent assortment of photographs for every type. So if the purchaser is searching for botanical shots, you don't simply have three or four stock photographs in that class. You ought to have handfuls for them to pick from. By building an enormous

assortment, you limitlessly increment your shots at making a deal with every client you engage.

Try not to feel that taking stock photographs removes the innovativeness from the interaction. Truth be told, the inverse is valid. Truly extraordinary stock photography shouts character, regardless of whether it's anything but an arrangement of flower scenes you are taking. The purchaser is searching for a photograph that appears to have a story to it, that draws the eye and makes the watcher need to consider the significance of that photograph.

Sounds somewhat like craftsmanship photography, isn't that right? All things considered, as it were, it is. Since you are selling the photograph as a feature of your stock assortment, doesn't bring down the creative worth of what you are doing. Also, if your craft is going out the way to be utilized by a client, it is as yet being seen by individuals who will think about the thing you are attempting to say with that photograph. So to you, the picture taker, your creative calling is fulfilled and you have a pleasant throw of progress in your pocket for sure.

Alongside building a solid arrangement of value photos of every class, make your classifications as different as could really be expected. View other stock assortments and assemble thoughts for the class they have addressed and of the variety of shots and settings they have remembered for their assortment. You are not copying different photographic artists work in the event that you are allowing them to move you to accomplish your best work.

A decent order to fabricate your stock photography display is to require a day every week and go out and assemble one classification of stock photographs the entire day. So you may do botanical shots the entire the very beginning week, photographs of vehicles the following and pictures of understudies the following.

Presently remember to get your deliveries marked on the off chance that you utilize human subjects. Regardless of whether you simply hang out on a school grounds and convince understudies to model for stock photographs. Be certain you pay them something for their work and get a delivery. In that manner if their image winds up in some open setting due to how a client utilizes it, you are shielded from them returning with their palm up needing more.

At long last, pay attention to your gut feelings on what to remember for your exhibition. Your creative "eye" for what you like is presumably lovely dependable and will reflect what intrigues your clients. When the display is fabricated, then, at that point you can approach the "business" of assembling an actual inventory to sell from. Also, remember the choice of building an online display to sell from. You will require some specialized assistance to get your site up and figuring out how to sell from it and gather cash that way. In any case, this can be an incredible development of your fruitful and developing stock photography business.

The "It Girl" and the "It Photographer".

———

Style photography and turning into a model in this spectacular industry is the fantasy of numerous an excellent young lady and more than one incredible looking person also. But since the charm of making it to the high level in the demonstrating scene is so appealing, there is a ton of rivalry for those couple of top spaces that produce the world's "super models".

In the event that you are simply beginning, the test is the means by which to pick the ideal photographic artist who can do a first class portfolio for you. You need a portfolio that slices through the pack and gets your portfolio seen by those world class organizations who can land you the enormous positions demonstrating for design magazines and ads. So what are the capabilities for such a photographic artist?

Your first thought is area. In the event that you live in Dallas, Denver, Los Angeles, Chicago of one of the other significant metropolitan habitats, there are world class photographic artists who as of now have the contacts they need to get your portfolio to the key leaders in the business. In the event that you don't live in these urban communities, you have two different ways to determine the issue your "distant" area may cause.

The first is to get familiar with everything of the design business so you know who the central participants are. Then, at that point you can meet the photographic artists you do know to check whether they know about the systems administration they need to do to get your portfolio taken note. This can be a difficult task on the off chance that you don't have insider data however coordinating with models you may realize who have "made it" to at ;least some achievement is a decent beginning.

In the event that there are no picture takers in your space that comprehend the style business agreeable to you, you may need to venture out to a significant city to track down the right photographic artist. Be that as it may, most importantly, don't think twice about qualities on this. Simply being all around arranged isn't sufficient for a picture taker to be able to deal with your portfolio. There are some other basic tests for you to apply.

. The organization must be authentic. They don't request that you pay for the portfolio and they don't promote to get models. A decent office is making a lot of cash selling their work and they can discover great models without going as far as such measures.

. The photographic artist must be exceptional and know his gear. Meeting that person and talk about the impacts you need to see accomplished for your portfolio. They ought to have the option to talk about easily how they will accomplish that impact and show you instances of how they have done as such previously.

. The photographic artist ought to have a decent eye for shading, lighting, outlining and arranging your shots. Take a gander at different arrangement of theirs so you can see that they realize how to get what you need from a shoot. Additionally, get references from different models who have worked with them. You need to be certainty that once the shoot gets in progress, you are in first rate hands.

Most importantly, you need to "click" with your photographic artist. Having your image taken is an exceptionally close to home occasion. These photograph shoots may get long and troublesome. Flawlessness is difficult work. Pay attention to how the photographic artist discusses his work. The main thing to come from these shots is character. That is the thing that will break you through the pack and get you taken note. On the off chance that your photographic artist can get that from

you, they can take you far toward your objectives of achievement in the demonstrating scene.

The Photography Safari

———

Taking your adoration for photography out and about is one of the truly intriguing tasks a photographic artist can get. Regardless of whether you are going out into nature to photo an extraordinary dawn, a remarkable stream or to catch some other keep thinking about whether you are going to a metropolitan region to get photographs that recount the narrative of a group, the safari idea of the outing is something very similar.

Safari is a decent name for such an excursion since like that tracker going into the profound wilderness to pack major game, you are going to the obscure to get that ideal photo. Your arrangements must be master. Your control out and about should be engaged. Yet, most importantly, your assurance to get what you came for should be tireless as you chase the prize you need to sack, not with a weapon but rather with your camera.

One misstep to keep away from is over pressing for your experience. It's not difficult to do in light of the fact that you may have the desire to get everything your studio "for good measure". As a matter of first importance, in the event that you have each piece of photography gear you own with you, the probability that something will get broken or taken is very acceptable. So you need to realize how to strip down your movement stuff to exactly what you must have to take care of business.

In any case, how would you realize that if this experience is different to you? One way is to do a couple "trial runs". Similarly as you went out and rehearsed photos when you were learning your art, step through a couple of examination excursions to the following town. Do these without the pressing factor of a cutoff time or a deliverable that you

need to finish. An overnighter to take pictures at the zoo in the closest huge city will surface what is required and what isn't. Then, at that point rehash the activity to take photos out in the country where you may need to knapsack your gear in. You will discover pretty quick what "stuff" merits the additional weight and what requirements to remain at home.

Your photography safari is a work excursion to you and you have a mission. Be that as it may, your main goal is about something other than heading off to some place to get a preview. Similarly as each image has character and soul, the more you become part of the climate where you are voyaging, the better your "eye" will be to catch the ideal photograph.

Indeed, you should keep fixed on the reason for the excursion and stay on time. In any case, remember to appreciate the excursion. In the event that you will snap a photo of a characteristic marvel, similar to Mount Rushmore, for instance, investing energy chatting with others going to that sight or conversing with local people may surface a few areas and insider facts about the site that different photographic artists would not get in the event that they just came, snapped a photograph and left. Utilize the "down time" to enchant different voyagers and let them beguile you. Not exclusively will your image be multiple times better, you will have much more fun.

At long last, as you arrive at your objective, your arrangements need to pay off and you need to allow them to pay off. Here is the place where center and the eye around the prize is critical. It is so natural, particularly when voyaging, to get fixated on the gear, with the set up and with your settings.

Do the entirety of that before you leave, or in the lodging the prior night. On the spot, the meeting is about your subject, not your hardware. Your hardware is there to serve you. Try not to stress over

it. Confide in yourself that you worked effectively preparing. You have quality hardware and you have arranged the focal points, checked the batteries and done whatever might seem most appropriate. Everything will work when it needs to work.

Presently you watch out for the prize. Your master eyes are expected to pass judgment on the lighting, the point and each part of the shot to decide whether it recounts the story that you realize this photo needs to tell. Here is the place where the craftsman in you works perfectly with the photographic artist to deliver a photograph that you will truly be glad for. What's more, in the event that you submit to your controls and have that chance, it's anything but a photography safari that gets back home having "stowed the enormous one" to add to your prize space without a doubt.

The Power of Black and White Photography

I t's intriguing how now and again more established innovations or works of art take on a much more noteworthy worth when they are made old by the new and current. This is surely valid for highly contrasting photography. At the point when shading photography went ahead the scene, it appeared to be the times of highly contrasting in both video and photography were over for eternity.

However, that was absolutely not the situation. Throughout the long term we have seen highly contrasting interpretation of another imaginative worth in the two classes. Truth be told, it's anything but at all strange anything else to see an advanced film shot altogether clearly. It is likewise not unexpected to visit a compelling artwork exhibition hall and track down a photographic workmanship show that utilizations highly contrasting broadly. High contrast has some creative and enthusiastic characteristics that are simply impractical to accomplish in shading photography.

Most likely the most grounded quality that snatches the watcher with a highly contrasting photograph is its enthusiastic force. Regardless of whether the photograph is simply of an old horse shelter or a classical vehicle, there is a passionate allure that is hard to examine in words however widespread to us all as we take a gander at a high contrast shot. That is the reason high contrast photographs in a flash interpretation of an imaginative look. So in the event that you are developing your imaginative photography style and portfolio, incorporating some experimentation with highly contrasting will do a great deal to work on your work.

High contrast likewise zeros in the eye on the passionate focus of the piece. Most likely the best subject for highly contrasting photography is the human face. In even a serene demeanor, the watcher can see a particularly huge scope of appearance in the eyes, the slant of the head, the unobtrusive wrinkles or characteristics of the face and the focal point of the look.

Highly contrasting quite often welcomes the watcher to need to think about the story behind the image. In the event that it's a scene, "What occurred here?" is the issue that frequently springs to the psyche of the watcher and the more they look at the photograph, the more their creative mind fills in the subtleties. In the event that you are seeing the substance of a quiet or despairing young lady, it is practically incomprehensible not to consider what is the issue here or what of life's issues is burdening her conscience.

Alongside the passionate force and the manner in which highly contrasting propels the watcher to look for significance, highly contrasting conveys with it a colossal heartfelt force that contacts the heart in an amazing manner. That sentiment can undoubtedly make an interpretation of over to the sexy or even the sexual without getting obscene to accomplish that impact. Shots that are attempting to bring out the force of arousing quality and sentiment do well when they include dampness or a water scene like the sea shore. Notwithstanding the absence of shading, these tones appeal to the five faculties in manners that tone can never want to accomplish.

You can explore different avenues regarding high contrast and assemble the reactions of loved ones to figure out how to use the unobtrusive yet amazing creative subtleties that appear to accompany high contrast photography unknowingly. The computerized camera has introduced an entirely different period of highly contrasting photography. You see the structure utilized even in any case non creative settings like

wedding portfolios or commemoration pictures. That is a result of that passionate and heartfelt force that highly contrasting passes on.

In the event that you have not begun to try different things with highly contrasting shots, it merits an opportunity to figure out how to catch the incredible pictures this sort of photography can make conceivable. Alongside the innovative utilization of light and outlining, highly contrasting gives itself well to altering that you can do with Photoshop to draw out the enthusiastic focus of each shot. In a little while, you may really track down your self seeing high contrast shots in a shading world. Your consciousness of what will make an extraordinary second in this organization will get intense and you will be prepared to catch those minutes immediately, which is consistently the most ideal sort of photography.

The Underwater World Captured With Photography

———

Submerged photography is developing each year, the individuals who go plunging wish to bring the jumping scene noticeable to the individuals who don't plunge. We have consistently been captivated with the seas and narrows of the world as an obscure world. Bringing get-away pictures home to your companions or selling them as experts has been a respected practice and now we can bring the submerged world home using computerized photography.

There are numerous kinds of submerged cameras. You have the exceptionally costly expert cameras and the one time marginally viable variants. Knowing which camera will work for you is vital. Part of tracking down the right camera may lie with in the lodging you wish to buy. Submerged photography expects you to shield your camera from the destructive effects of water so you should buy lodging with seals to take out the water. The lodging you find may fit the camera you have. Truth be told, most organizations will sell the lodging for the cameras you have. On the off chance that you discover you, need a superior camera for the submerged world you should take a gander at bundles. These bundles will incorporate the lodging.

Allow us to take a gander at the 35mm cameras. The vast majority of these cameras are simply simple to use. In the event that they were intended for submerged possibilities are they have somewhere around a gentle channel to address for the absence of shading submerged. These cameras won't sift through the particles you discover coasting along in the water on a poor noticeable day.

Normally they are restricted to under 100 feet. I would not utilize this sort for anything under 80 feet. You would not have any desire to free pictures in light of the fact that the lodging fizzled under tension. While this isn't normal, it's anything but a worry for most picture takers.

The more expert cameras are bigger with a gigantic focal point to give light access just as have channels to assist with carrying clearness to any photo. Commonly, these cameras expect you to have a profound set diversion in submerged photography, as the cost is high. Advanced cameras are the most ideal approach to take submerged photos on the grounds that you can ensure you have the ideal effects prior to leaving the seen. Obviously, most submerged life won't stick around briefly shot, yet coral reefs and the creatures that occupy them may remain.

Most submerged cameras will likewise have a blaze. It is ideal to take a submerged photography course prior to digging to far in your pastime. Some of the time the glimmer will assist you with the photos, however different occasions it will clean the subject out and ruin the print. You can likewise utilize submerged cameras when you are swimming. A few glimmers are worked in to the camera while others are outer. The outside glimmers can be a stick with a little light on top.

While putting away your submerged camera and blaze you generally need to store them without the batteries as the batteries can bite the dust rapidly. This is generally for the cameras that utilization twofold AA batteries. Submerged photography is an incredible world to bring home with you particularly on the off chance that you are on a plunge get-away. Submerged photography requires a couple of a greater number of abilities than normal photography because of the lighting conditions, however once you

comprehend them you will get back incredible pictures without fail.

The Use Of Filters In Photography

———

C hannels have two unique implications relying upon how long you have had photography as a diversion. A large portion of us today think as channels as a choice with Photoshop. This isn't the situation. Before the innovation of PCs and things like Photoshop we had little glass circles to make the separated effect. There are numerous choices with channels you can obscure an image, hone the image, and even square out the UV beams. Channels are frequently used to address an issue or make an image look somewhat changed.

Lets talk about channels that obscure a photo. At the point when you are snapping a photo of a cascade at the base where the water ascends in a cloud you can add a channel to make the cloud in the image. Cameras don't generally see what the eye sees. Now and again it's anything but a high goal to portray the real water drops instead of the cloud, so adding a channel to your focal point can assist with making the impact your eye sees.

Different channels, for example, the UV defender guard against the cruel beams. Alongside the UV channel you ought to have a polarizer. The polarizer is utilized in photography when you are making an effort into direct daylight or other light. It will assist offset with excursion the photo so you don't get the cleaned out look. Different channels can give you the cleaned out impact on the off chance that you feel your photography would talk more. The channels in Photoshop are not as wide as possible really purchase for your camera, however they can have a portion of the very impacts that you are after.

Have you at any point needed to make a star impact when taking pictures of light separating through the trees? You can make a star impact with any photo by utilizing a star impact channel. This channel permits light to go through a progression of slender lines scratched into the channel letting the light streak outward in a star shape.

A few channels really assist you with making a profundity of field or point of convergence. The haze/fog channel is one of these. The haze/fog channel takes into account a shine or flare of light in the photo. Photography is loaded up with much expertise and gear. Having channels to assist with making the ideal expert photo will improve your fun with your side interest. Lets take a gander at a couple of more channels.

There are shading adjusting focal points. On the off chance that the sky is excessively blue for the photo you can pick a channel that will pack down the blue to a less brilliant state. On the off chance that you are into submerged photography you may have channels that consider the submerged shadings. The shading range doesn't have an extraordinary reach submerged. A great deal of things will look red despite the fact that they are not. It is not difficult to achieve the first shade of submerged life when you utilize extraordinary channels for shading amendment.

The utilization of channels in photography not just permits you to have embellishments in a photo to make something new and unique, however it can assist with improving the shot by adding shading or hosing the regular impacts of light. Photography has numerous sorts of gear that require ability and information making it a brilliant side interest or calling. On the off chance that you need a leisure activity, photography permits you to be inventive.

The Use Of Lenses In Photography

S imply having a camera won't get you the best pictures. The greater part of us who take photographs are novices in the workmanship world, yet with the right hardware our photography can be raised to another tallness. Focal points are significant particularly when you choose a medium you will prepare in. Most photographic artists pick one space of photography to represent considerable authority in. There are numerous sorts of focal points, the standard 35-80mm, fax, and all encompassing focal points.

Most cameras have a 35-80 mm focal point, even the simple to use type. Regularly when you buy a camera packaging they will sell you the standard focal point with it. All focal points are tradable. You do need to stay with similar brand of focal points as your camera and ensure the width is something similar. The breadth of most focal points is equivalent to long as you keep to a similar brand. The 35-80 mm focal point reveals to you the degree of reach. While you can take photos a few miles away with a standard focal point you won't have the qualification of highlights in the print that you need. The standard focal point is extraordinary for close up shots, like blossoms, cobwebs, individuals, and pets. To acquire characterized picture miles away you need a bigger focal point.

There are numerous zooming focal points in photography. One is the 75-300 mm focal point. While this isn't pretty much as monstrous as other zooming focal points you may see an expert strolling around with it's anything but an extraordinary advance up for mountain and natural life photography when your quarry is some distance away. At the point when you start to move from the 35mm into something bigger it is ideal to have a stabilizer with the

focal point. A stabilizer will help you hold the camera consistent for clear shots regardless of whether your hand moves a tad. At the point when you move into the universe of the zooming focal point you can by accomplices to assist with points and light.

Photography in the realm of display is another approach to take breathtaking scene photographs. The all encompassing focal point permits you to enlarge the photo, particularly with a computerized camera. On the off chance that there is a mountain reach or glacial mass that you wish to get the entire picture without gluing them together in Photoshop the all encompassing focal point is the most ideal approach. I'm certain you have seen scenes with an all encompassing perspective and wished you could have that alternative. Indeed, even with film cameras you could have an all encompassing focal point to broaden the photo.

Each of the three focal points are only the ice sheets on the utilization of focal points in photography. Regardless of whether you are a beginner photographic artist or a maturing proficient you will need to amplify your photograph taking abilities. The following hardware you might need to buy to assist you with the bigger focal points would be a stand to settle the camera considerably more. Stands are quite straightforward and lightweight bits of hardware and turn out extraordinary for picture photography. All mediums in photography expect moderate to first in class camera hardware to create a photo with quality. Photography additionally depends on the photographic artist's ability and eye. Focal points are only a little piece of the photography world when you begin to contemplate the workmanship. In the event that you have any inquiries on focal points the best places to discover answers are your neighborhood photography shop.

The World Of Underwater Photography

S ubmerged photography can be fun and intriguing. It's anything but ordinary that individuals will go submerged and take photos of the natural life that exists there. There are a wide range of kinds of untamed life submerged including the living and moving ones like fish and sharks, and the immobile ones like coral. Submerged photography has become an enormous game due to the various types of things that one finds to photo submerged.

Numerous advanced cameras today are submerged cameras. An ever increasing number of pictures are springing up everywhere on the web from submerged sources. This is a direct result of the accessibility of taking cameras submerged and taking pictures of everything there.

The solitary issue with these photographs is that individuals believe that they can take a camera, go submerged and begin taking pictures. The key is knowing how and where to take pictures. Numerous submerged photographs come out repulsive and it is difficult to see anything in light of the fact that the image quality was poor. The daylight works distinctively submerged and commonly photographs are only a white haze in light of the fact that taken straightforwardly into a sunray.

Pictures submerged can turn out lovely in the event that you take it the correct way. There is many stuff that accompanies submerged photography. Various types of cameras, camera holders, and lights should be bought to make some ideal submerged pictures.

Taking pictures in the sea is likely the initial step to taking extraordinary pictures submerged. Ordinarily, lakes and lakes can

be excessively cloudy with mud and soil and makes it unfit to see anything. In the sea, a few sections are so clear you can see up to five feet down, so the submerged picture comes out impeccably on the grounds that there is no contamination to upset the picture.

Some unique planned cameras work preferred submerged over others when jumping. These photos come out astonishing, on the grounds that they are normally a few hundred feet submerged where not a ton of pictures come from in any case. A portion of the photographs come out with odd things that one has never seen.

Other then the everyday routine structures that experience in water, it is likewise amusing to take pictures of individuals submerged. Submerged articulations can be very amusing if the right second is caught. Numerous individuals take photos of their youngsters and each other submerged while they are excursion. In Florida, numerous individuals take pictures of themselves with the manatees while they are swimming by. Taking genuine submerged pictures is an incredible remembrance for the whole family and extraordinary to impart to loved ones just as region photographic artists who have never gotten the opportunity to experience such favorable luck.

Water is erratic and that is the thing that makes submerged photography so incredible. The submerged impact that makes everything erratic makes pictures that were not anticipated. This makes the photos all the better on the grounds that it is amazingly difficult to set up a posture for a submerged photo. Submerged photography will keep on changing as the cameras in this day and age keep on getting further developed. Photographs would already be able to be taken submerged while the individual is as yet on a boat, making it a lot more secure than previously. We will keep on seeing increasingly more of these submerged undertakings with

astonishing pictures coming from far beneath the sea surface in the coming years and see unprecedented photographs from odd animals that nobody has at any point distinguished

Submerged photography will keep on turning into a thing that everyone needs to accomplish all the more particularly when you go on excursions and away to the sea. It's anything but a great game that anyone can take part in absent a lot of involvement however a pleasant game if individuals understand how they are doing their gear. At the point when you choose to show your photography abilities to everybody, they will perceive what they are missing and may choose to take up the leisure activity of submerged photography themselves.

Tips For Photographing Your Cat

———

E ach feline is pleased with their well disposed cat. Felines make ideal subjects in which to photo. You can get your feline and an assortment of intriguing and fun postures when you realize how to take photos of your feline. On the off chance that you are keen on shooting your feline, here are a few hints to assist you with having the best chances.

Discover your Cat Napping

Nothing looks very as unwinding as a feline sleeping. Felines do rest a great deal, so in the event that you snap a photo of your feline snoozing, you have a lot of chance. The best an ideal opportunity to snap a photo of your feline is to get it when it is sleeping. You can take close-ups of your feline either as it rests, or tenderly wake your feline up for a casual look. For a decent shot of your feline, attempt delicately scouring your feline's gut right when you need to snap an image. This will urge your feline to turn over on its back.

Regular Sunlight

When you think about a dozing feline, where do most felines appreciate resting? You can generally discover a feline resting in the sun. On the off chance that you have a window that gets full or sifted daylight during the day, then, at that point attempt to open the shades or blinds to support cap resting. When you see your feline protest the sun, attempt to take a couple of pictures. At the point when the daylight is acceptable, attempt a couple of shots without utilizing your glimmer. This will give your image a pleasant regular gleaming impact. Likewise, normal light frequently works best in any case since, in such a case that you utilize a brilliant

glimmer, your feline will generally close their eyes or the eyes could wind up looking red.

Disregard Posing and Planning

Felines are much for presenting. You can't actually ask that a feline remain and sit. At the point when you take photos of your feline, you ought to consistently have your camera available for real shots. Take a gander at your feline during the day and decide your feline's timetable and most loved spots. Work around your feline and you will improve pictures. Attempt to be unconstrained, or more all stay patient. It might take a few attempts to a few extraordinary chances, yet representing your feline seldom works.

I have attempted to get my three felines to posture and allow me to snap a photo, yet despite the fact that they rest together, play together, they can't stand or in this sit close to each without somebody beginning something. In the event that I had three individuals to help and hinder good and gone, it may work. As should be obvious, feline's necessities to do what felines do and take your photos that way.

Find support

Another great tip for taking photos of your feline is to find support. You can get extraordinary pictures of energetic felines and cats by having somebody help you squirm a string, the toss a ball or call the feline's name. It is hard to attempt to play with your feline and take pictures simultaneously. Your photos will turn out much better on the off chance that you get somebody to help you. Likewise, in the event that you are attempting to get an image of your feline gazing straight toward your camera, have somebody remain above you can call the feline's name, or make a commotion that will provoke the feline to gaze straight over your head.

In the event that you are a patient and willing, you can have some incredible chances of your feline. Felines are so enjoyable to take pictures of in light of the fact that no one can tell what they will do. Keep your camera convenient and all set when your feline gets a move on. Feline's typical action appears to make us grin and snicker, their shenanigans consistently may great pictures. Pictures of little cats playing from birth on likewise make for some incredible pictures. In the event that you have the camera, you won't ever miss the ideal picture.

Video Like Scorsese

At the point when your enthusiasm and maybe your business is the production of value recordings for individuals' occasions, you presumably have some saints. Martin Scorsese is fairly a symbol since he is known for his elaborate videography in his films. Presently, you don't required need as much style as a Scorsese gets in films that success him foundation grants. Be that as it may, such experts who are both exact and excellent at their work and imaginative by they way they have their chances are a motivation to most of us.

So how might you approach turning into your own form of "Scorsese" in arriving at better expectations of demonstrable skill in the video you get done for your clients or companions? All things considered, at times you simply need to return to essentials

At the point when you go on a shoot, consider yourself like you are going on a task into a disaster area. Obviously, ideally, no one will shoot weapons at you. Yet, similar to a fight, you must be completely pre-arranged going in. There is no calling "cut" on the off chance that you are shooting your child's first ball game. You will get it or not on the principal take so your hardware must be prepared and you must be prepared. So consider a portion of your pre-shoot arrangements for the enormous day.

Review, clean, fix and test your gear the prior night. Ensure you have any help materials like batteries, lights for your blaze or on the off chance that you utilize a light to emphasize indoor shots. Also, consider the different ways your gear may need to help you and how you can uphold it?

Consider the possibility that something needs power yet is excessively far from the power source. Bring electrical lines. Consider the possibility that you need greater power then, at that point plugs are helpful. Bring plug extensions. Imagine a scenario in which have electrical ropes where individuals will walk. Bring channel tape. Imagine a scenario in which you need to get that channel tape up quick. Bring a decent blade or cutting sharp edge. It pays to play these circumstances out to you and be ready as you wage war.

Outlining a shot so it glances great in the finished product takes some ability and expertise to get what you need where you need it to occur. On the off chance that the scene is exceptionally dynamic, similar to a game, you should have the option to move, set, shoot and separate and rehash it and again the entire day.

That implies your hardware must be light and independent yet you should be furnished to trade things out on your feet. A solid and steady supplies pack that you can get into, trade out a focal point, a battery or different requirements on the fly is fundamental to being that versatile. What's more, you need to realize your gear so well that you can in a real sense lock and burden in seconds so significant shots don't abandon you. Some training with your camera, stand, lights, supply sacks and whatever else you must have for such versatility will take care of big time during the shoot.

You may have recoiled when you saw the word stand however become accustomed to it. Try not to compromise on this "adornment". The mount ought to be as adaptable as possible drop it's anything but a ground shot and have it up and set rapidly each time you need to reposition. Yet, regardless of the "trouble" this may cause, the mount alone may make your shots 100% more expert.

Knowing your stuff and being arranged are the two top charges of creating top notch proficient video. It may not make you a "Scorsese", yet it will take you far toward that path in the improvement you will find in your work.

Videography Tips from the Pros

M aking recordings or "videography" is an alternate creature from photography. At the point when you are attempting to catch extraordinary pictures for a representation or an occasion, you think as far as still shots. To you the goal is "the thing that will make an incredible picture."

Video opens up entire scenes to be caught on film, for better and in negative ways. Be that as it may, it additionally opens up a great deal of chance for botches, startling outcomes or interferences and shocks. In addition to the fact that you have to keep on considering what makes an extraordinary shot, you presently have sound and development issues to factor in. So while videography is substantially more fun, it additionally can be much more work.

You are attempting to track down a center ground when you begin offering video as a component of your administrations. You realize that anyone can bring a camcorder and catch video transfers. Nowadays they can even do it with their telephone. In any case, you need to make a more expert shot than the secondary school kid with a camcorder. Of course, you are making an effort not to win a foundation grant here. So the degree of demonstrable skill must be superior to novice so you can legitimize charging for it yet it doesn't need to be incredible workmanship to be a decent video that the client will be content with.

To achieve this blend of compulsiveness and compromise, a couple of tips from the masters who have effectively set up a video business can help a ton. Here are what a large number of the old professionals advise us to zero in on particularly as we are getting our video business going...

The foundation guidance that the professionals give about making incredible video is prepare. The more you think about your shoot, the better prepared you are the point at which you appear. On the off chance that you are shooting a wedding, visit the sanctuary, maybe the banquet room and plan where you will set up to catch the best pictures. Plan your courses as you move around so you can make a smooth stream that works with the wedding parade as opposed to intrudes on it.

The equivalent is valid for any occasion. Indeed, even a game, however unconstrained as that may be, will offer some more unfamiliar regions where you can situate yourself to get the activity. In the event that the best area for catching video is above or a separation from the movement, then, at that point you realize you should utilize zoom and concentrate uniquely in contrast to in the event that you can be in the activity. This assists you with arranging how to set up your gear and your group who will be supporting the shoot.

Lighting is something that should be important for your preplanning so you have adequate light so the activity and facial responses are not difficult to choose on the video. Outside, keep the sun behind you assuming there is any chance of this happening. Inside, investigate how the current lighting will look on record during the hours that you will shoot. On the off chance that they are not adequate, you ought to get in there and set your lights set up well ahead of the occasion and work with the occasion coordinators so they realize your lights will be on during the occasion. Individuals who recruited you need an incredible video so they will work with you. In any case, you need to tell them what is happening.

A decent video is a blend of steadiness of the camera and consistent development. So utilize a mount to settle the shots when the video is in effect effectively shot. Yet, you must have the option to move the set up

rapidly to another area. So ensure that your hardware is very much kept up with and that cameras, mounts and that all provisions are rapidly open for field changes or fixes.

Quite possibly the most important insider tips is to shoot with the goal of altering. In that manner, you will shoot more film than you need, realizing you will alter it together later. You can return and catch interfacing video shots to streamline the activity and you don't need to get vexed on the off chance that you get some awful film. These and numerous different abilities you will foster will take you to that degree of polished skill you need to reach. Also, your clients will see it as well and returned for a greater amount of your capable videography.

Wedding Pictures with Style

———

Your wedding collection will be perhaps the most valuable recollections of this huge day that you will have. In any case, have you at any point seen in what manner or capacity large numbers of those "proficient" pictures are no different either way from wedding collection to wedding collection? Truth be told, one thing that leaps out about the wedding picture taker is that for a brief period on the big day, everything ends and everything's about him.

You know the drill. The function is energizing and fun and blissful, a few tears and a lot of significance as the lady of the hour and husband to be kiss and become one family. Then, at that point everything's finished and everyone records out to go to the gathering to move, have cake and commend this association. Be that as it may, stand by, the entire continuing needs to come to a standstill while the picture taker organizes the wedding party for up to an hour or more to "reproduce" the service and make those ideal wedding photographs. In the interim the gathering might be getting in progress and a considerable lot of the visitors that the lady of the hour or the lucky man or others in the family need to embrace and impart the delight to may need to go in light of the fact that they just can hardly wait out a fastidious picture taker.

By one way or another this total disturbance to the day has gotten acknowledged as a component of what is the issue here. Furthermore, the most noticeably terrible part about it is that the photos, while quite all around organized, seem as though a lot of life sized models being orchestrated a store window. The delight and fun of the service is finished. For quite a long time to come everyone will say they are lovely and significant however on the off chance that you look carefully the

wedding party looks anxious, awkward, exhausted and like they want to be elsewhere.

Well perhaps its chance to toss that custom out and put some inventiveness into how the wedding photographs and the wedding photographic artist works in your wedding. By discovering a photographic artist who will assemble some wedding pictures that have some style, some innovativeness and some feeling of imagination, you will have that wedding collection that truly is loaded with recollections worth recalling.

To get that sort of picture taker, you must beginning early. You need to track down that nonconformist photographic artist that "gets it" that the wedding is about individuals, not the outfits and the lobby and that his photos should whoop "this was a brilliant day and we commended this association."

You may need to look outside of the traditional "wedding photographic artists" posting in the telephone directory. An imaginative photographic artist might be more suitable. In any case, be patient and discover one that is similarly pretty much as expert as any photographic artist in that business repository however can bring some imagination and venture of becoming more acquainted with this wedding gathering to the work of taking your significant wedding pictures.

That wedding picture taker should become as much a piece of the wedding party as the groomsmen. All things considered, on the off chance that he will catch the character of this couple, he should become acquainted with you. Invest some casual energy with him and offer those great recollections of when you met, those extraordinary occasions while you dated and positively those exceptionally unique spots where significant minutes in your relationship occurred.

Equipped with that sort of innovative individual responsible for your wedding photos, you will look forward with incredible expectation to what he concocts. A considerable lot of the most ideal chances will be made before the wedding, at a portion of those exceptional spots and he can Photoshop them to mix them with wedding day minutes.

Over all that wedding photographic artist will comprehend that he is there to serve this wedding and catch those exceptional minutes as they happen. Certainly, you may "present" for an image every once in a while yet this entire business of carrying the big day to a pounding end to take unnatural pictures of exhausted wedding party individuals will go out with the garbage. The result will marry pictures with style, with life and a ton of adoration in them to mirror the affection that was traded in those promises and the affection for loved ones as they appreciated this otherworldly day with you.

What Do You Know About Stock Photography

———

Stock photography, gatherings of photos that individuals take, assembled and authorized for selling purposes. Rather than taking new pictures each time they need pictures, numerous individuals utilize the stock photography technique. Individuals that work for magazines, as visual craftsmen, and promoting organizations some of the time utilize public pictures as opposed to recruiting photographic artists for singular ventures.

Substitute names for stock photography is picture libraries, photograph chronicles or picture banks. Normally, to utilize these photos, albeit openly accessible, there is a little expense or a buying of utilization rights that accompanies a charge to utilize the photos. Now and then an enrollment buy permits you to approach a specific gathering of stock photography.

Setting aside time and cash, stock photography is an incredible method to upgrade pamphlets, websites, commercials, organization handouts and that's only the tip of the iceberg. It is clearly more affordable than putting a full time picture taker on staff and takes less time in the event that you need pictures of something explicit. Ordinarily, it is just about as simple as utilizing a web search tool or browsing an cmail.

Now and then full rights and utilization is accessible for procurement. Different occasions, full rights are restricted. In those cases, picture takers may be necessitating that they get a specific level of deals and additionally sovereignties of utilization. Organizations for the most part hold the pictures on records and

arrange charges. With the innovation and simple access that the web gives, exchanges are faster and simpler.

The expense of utilizing stock photographs relies upon how long the photos will be utilized, what area the pictures will be utilized, if the first photographic artist needs sovereignties and the number of individuals the photograph will be appropriated to or seen by. Costs for stock photography can be somewhere in the range of one dollar to 200 dollars.

There are a few distinctive valuing plans. Eminence free stock photography permits the purchaser to utilize photos on different occasions multiplely. At the point when you purchase sovereignty free pictures, there is just a one-time charge for limitless utilization. At the point when the pictures you buy have an eminence free area, the organization can exchange the picture to other people. On the off chance that a picture is rights overseen, there is an arranged cost for each time that it is utilized.

At times a purchaser of stock photography may want to have restrictive rights to the pictures. All things considered, nobody else will actually want to utilize the photos once selective rights have been bought. It might cost a large number of dollars to buy elite rights since organizations who handle the deals need to ensure that they are making a beneficial deal. On the off chance that a photo would get more cash-flow remaining available for use, they would miss out selling elite rights.

Stock picture takers some of the time work with organizations delivering pictures for them alone. Various subjects and classes may require different assortments of pictures. Once in a while givers work for various offices selling their photos for an expense. They work out game plans for eminences or they sell their shots for full

rights. This has end up being a major business for picture takers all throughout the planet.

Stock photography began in the mid 1920s. It particularly developed as its own claim to fame by the 1980s. Exhibitions hold hundreds, thousands and even great many pictures accessible for procurement. Stock houses jumped up in various spots. By 2000, online stock photography became microstock photography, which we call photograph documents on the web. Organizations like istock photograph and bigstock photograph offer you the chance to buy such countless pictures and when you go through them you can add more credits for another expense. Photographs that are appropriated online are normally more affordable than those that are sold printed copy.

Sites like www.shutterpoint.com and www.fotolibra.com permit stock picture takers to transfer and sell their pictures. It's anything but an extraordinary method to advertise pictures and bring in cash with photography. You can buy pictures at those sites also. With all the stock photography destinations accessible, one may discover pictures you never even knew about.

Where to Go to Learn From the Photography Masters

Regardless of whether you are searching for the correct way for your maturing understudy photographic artist in your family or looking on the most proficient method to kick off your own photography profession, the right school can have a significant effect. There is no doubt that photography is an exceptional vocation way with a wide range of headings that somebody gifted with a camera may go.

The variety of professions in photography is really stunning. From the base ability in photography and a strong comprehension of new and arising innovations, anything is possible for a gifted picture taker with strong schooling added to their repertoire. That is on the grounds that photography is both an artistic expression and a strong specialized ability. So a similar school may create an honor winning craftsman, a fruitful wedding photographic artist, a style photographic artist, a police agent taking pictures of crime locations, or a break paper photographic artist.

So the inquiry arises concerning what sort of photography school to pick for yourself or the understudy in your family that needs the most ideal training. How you pick any school is especially impacted by both how you approach training when all is said in done and what your goals are.

Some would advocate that you hope to get into the best creative photography schools in the country. Assuming you wish to go down that way, without a doubt the Brooks Institute of photography or one of the world class east coast schools of creative photography

is an honorable aspiration. Yet, there are three downsides to attempting to go to such schools. First is, obviously, the likely expense. Any first class school will charge tip top costs. Also, on the off chance that you resemble the majority of us, you need to get the most instruction for your cash. So doing some covering looking for a school is all together.

The subsequent downside is getting conceded. The vast majority of the first class schools have holding up records and extreme section prerequisites that may make that aspiration more requesting than is needed. In any case, the most significant downside is that these schools may not be the right decision for the vocation you or the photography understudy in your life may wish to seek after. So a decent broad arrangement of rules on the most proficient method to assess a wide assortment of photography schools is all together. The rules may incorporate...

. What sort of photography is appropriate for the understudy? A program intended for imaginative photography that will bring about pieces hanging in a cutting edge workmanship gallery will have a totally different methodology than a program to prepare legal picture takers. Your understudy may not realize immediately what field they need to go into. Assuming this is the case, beginning at a conventional school, for example, a photography accentuation at the nearby junior school might be the right decision until the vocation way becomes more clear.

. Is it a genuine school? You need to keep away from schools that are run from the web or that you read about on the rear of a matchbook. A genuine school will create a perceived degree that will be all around regarded in the business and will assist the understudy with landing positions.

. What is accessible locally? Why leave town or out of state on the off chance that you have great nearby schools? Many state colleges, junior universities and nearby trade school have discover programs.

. How different and exceptional is the program? Will your understudy get presented to the most current of innovation in the field of photography? Will they get prepared in how to support various kinds of photography tasks?

. How does the program's work arrangement rating look? Which level of graduates from this program land positions? How very much regarded is this school by organizations who utilize photographic artists?

These are strong assessment rules. What's more, in the event that you apply these norms a few dozen of the best schools both locally and broadly, in a little while a short rundown of good schools will arise. From that point, some site visits and meetings with educators and graduates will limit things down. Furthermore, you will be happy you "got your work done" to track down the sort of photography school that will take you or the understudy in your life to a higher degree of accomplishment in their affection for photography.

Untamed life Photography, Catching The Animals By Surprise

———

Photography has been around for over a century and our points won't ever stop. There is representation, scene, wedding, and untamed life photography just to give some examples. Perhaps the most remunerating styles of photography focuses on untamed life. It might take you a few hours prior to tracking down the ideal picture and catching it, yet the prize is more than worth the stand by.

Untamed life photography is maybe the most troublesome in the calling. You must have the time, tendency, and obviously the camera. Most natural life shots are caught utilizing a zooming focal point on the grounds that the creature won't stroll close to you. Sometimes you will actually want to catch the fox, elk, bear or other creature as it gets through the forested areas in your way, anyway more often than not they are yards away and tricky.

Natural life photography doesn't sit tight for you to happen a long and snap a photograph. You need to drench yourself in the site you pick your camera good to go, and set for the light of the day. Most programmed cameras work extraordinary on the preset for the individuals who are simply figuring out how to take natural life photos. Photography has consistently been about the second and all that photographic artists can get the second with a speed and spryness of the creature they are catching.

Start with little subjects when you start your introduction to untamed life photography. Practice on your pet. Allow them to wander normally and check whether you can catch the wild and

177

insane minutes on film without the photo winding up hazy. All extraordinary photographic artists have contemplated and polished. They additionally utilize more than a single shot. Ensuring your camera has a fast screen speed will help you make more than one effort as your move with the creature. At the point when you have the subject in your site you need to follow it while centering and afterward rapidly snap however many pictures as you can before they move out of site. This method is known as panning. Maybe than the subject coming to you, you follow the subject.

At the point when you have dominated your pets you can start to investigate the open air universe of natural life photography. A portion of your subjects will be stopping and this is another training procedure. Know about the lighting and situation while making an effort not to upset the creature. It is generally simple to get a squirrel when they are resolved to eating or rummaging for food. In the event that you remain quiet and walk cautiously you can regularly get very close.

On the off chance that you are picking a bigger subject, for example, a deer or bear you will need to remain far enough away to have the chance, and not cause to notice yourself. Bears are risky animals, however they can be shot in the event that you utilize presence of mind and don't step upon their region. Untamed life photography and in this way the photographic artists have a code of morals while achieving the ideal shots. You will need to follow these morals for your wellbeing and the creatures.

Untamed life photography is a cat-and-mouse game for the ideal picture to run across your viewfinder. It takes tolerance and a great deal of training, yet the prize of having a relative or companion go, " where did you get that photo? I must have one," will add to the arrangement.

Will Camera Phones Destroy Photography?

———

In any "photograph operation" second any more, it is difficult to miss the attack of the camera telephone. Where it used to be not difficult to tell when a camera was near and if individuals had them helpful, presently anybody with a telephone could be a surreptitious photographic artist. Indeed, even at events that used to be managed by the expert picture taker like weddings and so forth, we presently see those many hands going up snapping photographs with camera telephones that appear to overwhelm the scene.

Regular photography is a profoundly evolved work of art and calling. The accuracy of the hardware and the capacity of photographic artists to convey a top notch item to their clients is notable and the consequence of many years of advancement of the art. However, today it is feasible for anybody to turn into a beginner picture taker utilizing that small mobile phone in their pocket or satchel.

The inquiry needs genuine thought for three crowds. For the expert picture taker, is this the finish of your calling? Will advanced telephones clear out your client base and make you out of date? For the yearning picture taker, what might be said about your future? Would it be advisable for you to try and put resources into figuring out how to utilize the complex gear that makes proficient photography so predominant? What's the point if camera telephones will make it all out of date? Furthermore, for you the buyer, would you be able to get similar nature of photos with utilizing camera telephones as you can by recruiting a picture taker?

These are legitimate inquiries. It is normal when another innovation starts to make advances into a calling for the privileged few of that calling to feel undermined. It happened when TV went along and the media considered it the demise of radio. It happened when talkies and afterward shading was acquainted with films and TV and at each innovative improvement in the music world. Also, with each critical expectation of the destruction of an industry, the inverse occurred and that industry changed, developed, improved and flourished even more.

So there are valid justifications not to stress that camera telephones will annihilate photography as far as we might be concerned including...

? Camera telephones can't accomplish similar degrees of value. There is a valid justification that the expert photographic artist has put resources into the profoundly complex hardware that he has in his studio and that the person in question takes to a shoot. The numerous years and many years of exploration have surfaced the issues with quality that crude hardware couldn't manage. Current photography gear has exact instrumentation to deal with lighting issues to appropriately outline each photo and to create an expert quality result that individuals need from a wedding, a picture or any sort of expert photography. You can wager that criminological photography, style photography and photography for distribution can at any point acknowledge the low guidelines of value that are the result of camera telephone pictures.

? It's a novice game. At the point when you see kids holding up their camera telephones at a show to take an image, you realize that gadget won't bring about an expert quality shot. This is particularly obvious in a live setting like a show where there are bunches of issues like lighting, visual commotion and different issues that must be overwhelmed with refined instrumentation simply not accessible on a camera telephone.

Camera telephones are a novice photography gadget. Furthermore, they will consistently possess that specialty.

? Standards of the eventual outcome would be compromised. Furthermore, exclusive expectations of value are what make proficient photography a worth to it's clients.

This isn't to projected camera telephones in a negative light. They have their place and they are incredible fun. However, we in the expert photography world have nothing to fear from the development of this innovation.

About the Publisher

Accepting manuscripts in the most categories. We love to help people get their words available to the world.

Revival Waves of Glory focus is to provide more options to be published. We do traditional paperbacks, hardcovers, audio books and ebooks all over the world. A traditional royalty-based publisher that offers self-publishing options, Revival Waves provides a very author friendly and transparent publishing process, with President Bill Vincent involved in the full process of your book. Send us your manuscript and we will contact you as soon as possible.

Contact: Bill Vincent at rwgpublishing@yahoo.com www.rwgpublishing.com

SCREENWRITER'S COMPASS

SCREENWRITER'S COMPASS

CHARACTER AS TRUE NORTH

Guy Gallo

ELSEVIER

Amsterdam • Boston • Heidelberg • London
New York • Oxford • Paris • San Diego
San Francisco • Singapore • Sydney • Tokyo

Focal Press is an imprint of Elsevier

Focal
Press

Focal Press is an imprint of Elsevier
225 Wyman Street, Waltham, MA 02451, USA
The Boulevard, Langford Lane, Kidlington, Oxford, OX5 1GB, UK

Notices
Knowledge and best practice in this field are constantly changing. As new research
and experience broaden our understanding, changes in·research methods, professional
practices, or medical treatment may become necessary.

Practitioners and researchers must always rely on their own experience and knowledge
in evaluating and using any information, methods, compounds, or experiments
described herein. In using such information or methods they should be mindful of their
own safety and the safety of others, including parties for whom they have a professional
responsibility.

To the fullest extent of the law, neither the Publisher nor the authors, contributors, or
editors assume any liability for any injury and/or damage to persons or property as a
matter of product liability, negligence or otherwise, or from any use or operation of any
methods, products, instructions, or ideas contained in the material herein.

Library of Congress Cataloging-in-Publication Data
Gallo, Guy.
 Screenwriter's Compass : character as true North / Guy Gallo.
 p. cm.
 ISBN 978-0-240-81807-8
 1. Motion picture authorship. I. Title.
 PN1996.G32 2012
 808.2'3–dc23

 2011047375

British Library Cataloguing-in-Publication Data
A catalogue record for this book is available from the British Library

ISBN: 978-0-240-81807-8

For information on all Focal Press publications
visit our website at www.elsevierdirect.com

Printed in the United States of America

12 13 14 15 16 5 4 3 2 1

Working together to grow
libraries in developing countries

www.elsevier.com | www.bookaid.org | www.sabre.org

ELSEVIER BOOK AID
 International Sabre Foundation

To Jeannine, without whose love and collaboration this book would not have been written.

CONTENTS

PREFACE

I was twenty-seven and fresh out of graduate school. He was seventy-four and a film legend. I had just come in second in a student screenwriting competition. He had been nominated for an Oscar fourteen times and won twice. And there I was, sweating in Mexico, sitting at a cowhide-covered table, talking about my screenplay for *Under the Volcano*. I was full of myself. After all, there had been dozens of failed attempts by well-known writers to adapt this difficult novel into a film. And I had done it. It was *my* screenplay John Huston was preparing to shoot.

He was reading some pages I had just finished revising. A scene he thought wasn't right. Wasn't working. He stopped reading. Leaned back in his creaking basket of a chair, spindly arm arching over his head, like a bewildered and bearded Orangutan.

"It's fine, Guy," he intoned in a deep basso. "It's fine."

I started to puff up. Huston continued.

"But it's only writing."

I've spent much of the next two decades deepening my understanding of Huston's seemingly glib dismissal of an arrogant punk writer. After fourteen or so screenplays and twenty-odd years teaching film writing, I think I've got it figured. And then some.

What follows is not for the faint of heart. But since you're interested in writing a screenplay, you aren't. Or shouldn't be.

Screenwriter's Compass: Character as True North is addressed both to the motivated beginner and the seasoned professional. It can stand as an introduction to the craft of screenwriting. It can be read as a reminder—and deepening—of concepts you already know. Some of the ideas are, I think, new. Accepted ideas are challenged

or rephrased. Everything is presented with an eye to helping you approach and fill the blank page.

There are two organizing ideas: that composition is an act of exploration and discovery, and that our best guide through the imagination's terrain is character. Everything else harkens back to these two propositions.

ACKNOWLEDGMENTS

I am grateful to the many students who have passed through my seminars at Columbia University and Barnard College. They helped me learn what you are about to read. Thank you to Katharine Cluverius—agent, editor, and friend—for consistent and needed support. To Jerry Boak and Robert Brink for astute readings. To Nicholas Proferes for introducing me to Focal Press. To Annette Insdorf, whose kind graces were instrumental to my career, both as screenwriter and teacher. And to my beloved wife and in-house editor, Jeannine Dominy.

1

FIRST THINGS

SCREENWRITER'S COMPASS

There's a Steven Wright joke that goes like this:

> *I once tried to commit suicide by jumping off a building…*
> *I changed my mind at the last minute, so I just flipped over*
> *and landed on my feet. Two little kittens nearby saw what*
> *happened and one turned to the other and said, "See, that's*
> *how it's done."*

Many screenwriting guides are like that. They look at existing films and point: "See, that's how it's done." They provide an after-the-fact analysis of what worked in a specific case. Examples are drawn from released films, or (often) from a special form of screenplay called a continuity—a record of what was done during the making of the film. Strangely, these models for making screenplays aren't screenplays at all.

Looking at a finished film to learn about writing a screenplay is a little like touring a completed building to learn about architecture.

Even if examples are taken from actual screenplays, it must be remembered that models are of limited utility. They demonstrate only how a specific problem was solved by one writer in a given context.

Creation is not modeling. It is invention. Certainly we are influenced by those writers and directors we admire, or those who stand out as successful. However, our use of their models, our homage (or plagiarism) should be subtle and subconscious. Not studied.

Creation is not modeling. It is invention.

As interesting and edifying as it might be to read how other writers have solved various storytelling problems, it doesn't help fill your blank page. It doesn't give you the tools required to make a unique text, from your unique voice, anchored in your present.

Every story is unique. Telling a story, in any form, takes the writer into uncharted territory, with specific problems, specific virtues and pitfalls. Any analysis of a finished film, interesting as it may be, will be specific to *that* film. The idea embedded in the title of this book is that we approach the unknown landscape of each storytelling fresh, mystified by the ever-changing terrain. A screenwriting book can provide a set of tools to orient ourselves during the journey, to help chart both where we are headed and were we have been. That's the driving idea behind *Screenwriter's Compass*. The book's subtitle—*Character as True North*—does not mean to simply imply priority, or that what follows will examine solely how character functions in screenwriting. Rather, I want to emphasize that virtually every aspect of screenwriting requires that one eye be kept on the characters. You need to know where True North lies even when you are travelling in some other direction.

My emphasis will be entirely from the writer to the work. From the point of view of the blank page. *Screenwriter's Compass* focuses on the screenplay as a text that needs to seduce and interest. This is not a book on filmmaking. It is a book on writing, on how to tell your story in film terms that are easily read, easily comprehended.

I will not pepper you with explicated models to follow. I will not presume to tell you what kinds of stories to write. I will not tell you what structures to employ.

I do not believe in formulas. I do not believe any book can provide a set of rules to follow. Don't get me wrong. There are generally accepted guidelines regarding dramatic structure. There are many useful concepts to know and use when composing a screenplay. But the application of these ideas must be adjusted and adapted to the particular story being told. They must be treated as guidelines, not rigid rules. Applied too strictly, and too early, general formulas can get in the way at just that point when the writer needs the most flexibility. At the start.

There is no key, no secret. The best we can hope for is a compass. A tool to orient the writer in a chaos of possibility. A set of manageable challenges that—when applied with rigor and grace and humor, with a willingness to fail, to get lost and recover, to experiment and persevere—might actually point the writer's imagination to its own best self. Each idea, each writer, must be challenged in a unique way.

There is no key, no secret. The best we can hope for is a compass. A tool to orient the writer in a chaos of possibility.

No book, no teacher, no guru—no one—can teach you how to write. Ingesting theory, understanding past works, having an encyclopedic knowledge of film history won't make you a writer. Though perhaps you'd be really fun at a party. Or really annoying.

No one can teach you how to write. They can, however, teach you how to read. I will teach you how to read your own work. To challenge yourself toward completion, toward clarity. I will give you concepts and tools and (yes) tricks to help read your work as if it were not yours, so that you can see your creation as others see it. How else can you judge if you are accomplishing your goal?

Passion and creativity are insufficient to the task of composition.

The ability to read your own work objectively, critically, without bias or self-interest, generously but without either possessiveness or indifference—this kind of dispassionate reading is a necessary adjunct to genius and imagination. Passion and creativity are insufficient to the task of composition. You must also learn the craft of reading.

I like to think of the imagined film (the thing in your head that you're trying to get down onto paper in a legible manner) as a landscape. A chaotic and somewhat uncontrolled world. It has discoverable landmarks. It has a shape. But the shape, even as you think to put it down, is endlessly shifting and growing.

I like to think of a screenplay as the geography—both physical and emotional—of the imagined film.

A geography is more complex a concept than, say, a map. Or even a topography. A map implies delineated landmarks, accepted pathways. Direction and purpose.

A geography holds hidden and unexplored terrains. The dark places. A geography is about texture as much as detail. A map tells you. A geography needs to be explored and understood.

What follows might be thought of as a collection of tools to make you a better cartographer. To give you both a compass with which to find your bearings, and the technical means to convey your discoveries to the reader, who is, we must always remind ourselves, brand new to the terrain.

...character is not an element of dramaturgy, it is the thing itself.

I will lay out practical ideas and applicable concepts to help you discover the particular geography of your imagination, tools to help you navigate the unique problems posed by the struggle to articulate

vision, agenda, and story. I will help make some useful sense of the clichés and formulas tossed about by the myriad of how-to books. I will emphasize ways to create story and plot anchored in compelling behavior. I will tune your ear to voices, the voices that carry and create the dramatic action of your screenplay. You will learn that character is not an element of dramaturgy, it is the thing itself.

—— BIG DEAL—YOU'RE WRITING A SCREENPLAY ——

> *There is only one way to defeat the enemy, and that is to write as well as one can.*
>
> **—Saul Bellow**

Nobody wants to like your screenplay. Except your mother or your best friend or your lover. Everyone else will be looking for reasons *not* to like your screenplay.

That's not exactly true. It's not that your reader won't *want* to like your screenplay. When a reader first approaches a new script they are hoping it will be great and they will be the one to find it and shepherd it up the ladder toward production. But, it's also a fact that there are myriad pressures that will bias the industry reader against you.

Overworked and underpaid, the studio reader, the producer's assistant, the lowly intern will be anxious to find a reason to toss your manuscript onto the pile of rejects.

The reason for this is simple: it's safer for film professionals—readers, producers, executives—to say *No* than it is for them to say *Yes*. If they say *No*, well, that's an end to it. There are seldom any consequences for a negative report. However, if they say *Yes*, if they pass your work up the food chain, then that reader is at risk.

First of all, it means they have to write a more detailed and substantial coverage—the cheat sheet for the big bosses and agents who can't be bothered to read an entire screenplay. They have to be willing and able to defend a *Yes* to their superiors.

A friend of mine had a script given coverage by a major studio. The producer who had submitted the screenplay—as they often do—used connections to swipe a copy of the reader's report. It was glowing. It was gushing. Based on that one page, the film should have gone into production the next day. The producer's reaction was: "Wow. Must be a new reader. She's left herself no place to hide."

Things get even touchier if the film goes further along the preproduction line. Then the reader's *Yes* may actually cost money (one hopes some portion of which you have deposited into a money market). The stakes for the studio reader or production assistant get higher and higher. Until, in the best-case scenario, that simple *Yes*

turns into a production, into a film in the theater. And the reader's very job, at minimum their reputation, depends upon how well this screenplay—which they first met lounging by a pool along with forty other screenplays some distant weekend-read ago—is received by critics and fourteen-year-old boys.

The system is driven by fear. The intern is afraid they will not please the boss enough to get a paying gig or at least a good recommendation. The producer is afraid of wasted time, of rejection by the higher ups. The higher ups are afraid of the next major reorganization by the multinational corporation that owns the studio. Fear is not a good place to be when approaching new work.

Is it any wonder that their first instinct is to *Just Say No*? They want to put down your script and get on to the next, which might be the gem hidden amongst the dross. Back to the projects already in the pipeline. Back to the clients who are already employed.

The implication of liking a screenplay, of saying *Yes* and passing it up, can be measured in millions, tens of millions of dollars. Of somebody else's money.

Even if your target audience is the Independent Film producer, or if you are making the film yourself on a micro-budget supplied by Uncle Mort, you still need to present your idea for a film clearly and cleanly. You still have to get them to finish reading.

A reader's reason for tossing your screenplay may have nothing to do with the inherent worth of your story. It might have to do with formatting, or with trivial details like typos or page count or misplaced character names. Or not enough white space. It may sound silly, but it's true.

Your first task as a screenwriter is to make sure you have given your reader no easy out, no excuse to stop reading.

Your first task as a screenwriter is to make sure you have given your reader no easy out, no excuse to stop reading. You need to break down the inherent antipathy of your audience. You need to convince the reader to get past the first twenty pages. To actually *read* your work.

You cannot control the idiosyncratic tastes of your reader. You cannot control the many intangibles that might influence how they respond to your work. They might have just broken up with a girlfriend, or lost a fortune in Vegas, or had a bad burrito for dinner, or be suffering from a hangover. They might be biased against action adventures, or can't abide romantic comedies, or perhaps they simply do not like your main character's name.

You can't make them unafraid.

Since there are so many pressures for a reader to dislike your screenplay, since there are so many mysterious forces combining to influence their reading, why not control the few things you *can* control?

Your best weapon against the fear or inertia or bad mood or simple fatigue that may color a reader's reception of your genius is to continually ask two questions:

- Is it *logical*?
- Is it *legible*?

Every line of description, every line of dialogue, is vulnerable to these two challenges, and will be improved if you answer them honestly.

By logical I mean: Is every line of dialogue, every behavior, logically consistent to the characters as drawn? Do the plot twists and reversals follow from what has been written? Does your action description have a visual logic, effectively guiding the reader's eye through the scene's geography?

By legible I mean: Have you challenged every word, every sentence for clarity and precision? Have you controlled the mundane elements of screenwriting, such as format and proofreading, so that the reader can actually consume your story without pausing over the mechanics?

It is not enough to have a great idea. It is not sufficient to be passionate. A fabulous story must be visible. Your screenplay must be legible. Clear, precise, cleanly presented. And what is legible must be compelling, seductive, self-consistent. It must make sense, be logical.

No matter how great a prose stylist you are, no matter how good your ear for dialogue, no matter how fabulous your idea or inventive your visual imagination, if those talents are not presented in such a way that the reader can follow your intention, if your intention is not legible, then you have failed as a screenwriter.

Screenwriter's Compass will give you deeper insight into character and plot and their symbiotic relationship. That's the central idea driving us toward logic and completion. It will teach you how to most cleanly and precisely craft your screen storytelling. It will detail the peculiar conventions and devices of screenplay form. That's how we achieve legibility. The end result will be a more compelling read and a more legible presentation.

GEAR UP

Writing is easy; all you do is sit staring at a blank sheet of paper until the drops of blood form on your forehead.
—Gene Fowler

The proposition that your reader is almost always antagonistic might seem discouraging. But it's a reality. You need to gear up. Grow a thick skin. And persevere.

Writing is hard. Much harder than most people think. Screenwriting is particularly hard. It has a specific form. It has a limited size. It is constructed with a fairly set number of tools and devices. It requires a combination of visual, narrative, and dramatic genius. And all that is in addition to the need and ability to conceive and tell a story.

The first thing to remember is that you are the originator. It all begins with the writer. Without your craft and artistry there would be no story. No film. At this point, as you begin, the story is all yours. You are the one entering the uncharted territory of the imagination hoping to bring back something worth saying, worth writing, worth turning into a film.

Find pride and confidence in the fact that not everyone can do it. Lots of people think because they can compose an e-mail that they are writers. They aren't. You are.

Remember that you love telling stories, that you love putting words on paper.

When it works there's nothing quite like the pleasure of invention and composition. Here, at the outset, you must remind yourself that in the midst of all the grunt work—the brainstorming and outlining and the simple physical labor of getting it into the computer—there will be moments of profound delight.

Be patient. Be brave. Be flexible.

———— SCREENWRITING IS WRITING ————

There is a truism that goes: Writers are born, not made. You either have the sickness or you don't. If you are *able* to do something other than writing, you should. Or, as Andre Gide put it:

> *If a young writer can refrain from writing, he shouldn't hesitate to do so.*

Those who persist in the excruciating life of a writer are those who cannot do otherwise. Writing is their way of being in the world.

Even if your ultimate goal is to be a writer–director, or you hope to produce and direct your screenplay on a micro-budget, at this point you must engage that part of your talent that is the writer. Otherwise your screenplay will remain a private document, for your eyes only, and you will not fully finish your story.

Seems, sometimes, that everyone is writing a screenplay. And everyone thinks they know how. Everyone knows what a film looks like. How difficult can it be to write down the movie in my head? This is the first fallacy of the neophyte screenwriter. They think that describing a possible film is the same as writing a screenplay. It isn't.

A screenplay is a literary text. It is written.

No matter how much you love film, if you don't love writing, putting words down and rearranging them, and rearranging them again, then screenwriting is not for you.

Some consider screenwriting an orphan child. Not really film. Not really literature. As a result many fail to appreciate or understand the craft.

The commonplace goes something like: A screenplay is an intermediate form, a blueprint, not a thing itself. This presumption considers a screenplay an abstract description of some future film. It implies that the screenplay need only provide the general shape of a film story and the heavy lifting will be done by a coterie of other professionals. I say, nonsense.

I believe that this attitude diminishes the importance of the writer and abrogates precisely that part of writing that only an individual can control and create.

This metaphor—that a screenplay is like a blueprint—approaches truth only if you realize that the writer stands in the place of the designing architect, not the draftsman. The screenplay communicates the ruling aesthetic of the film as well as the plumbing.

Of course there are accidents of production and differences of interpretation that cause a film to diverge from its screenplay. Nothing can be done about accident. But the screenwriter can work to make his script as impervious to reinterpretation as possible. The best way—the only way—to do so is writing well.

I had a mentor, William Alfred. I once asked him why he wrote his plays in verse. He responded, "To make them actor-proof." I like to think that the precision I strive to inspire in my students, and reach for in my own writing, is akin to writing in verse. I want to give the text its best possible chance for success in an antagonistic world.

At its best, a screenplay presents a meticulously wrought literary form, designed for a very narrow audience, which, using a very specific set of conventions and stylistic devices, manages to enact a dramatic story, to give the reader a consistent, complete, and legible imagined film. Ideally, a screenplay gets under the skin of the writer's collaborators. It creates a world so self-consistent that it cannot be radically reconceived.

The goal is to so control the text, and so direct the creativity of the reader, that the imagined world will be broadened and deepened in its translation to celluloid, that the contributions of the many who work to make a script into a film will remain consistent with the original aim of the writer.

This book presumes the importance of the literary quality of screenwriting. The composition of a film script requires the same precision and control as does any other literary form. To think of a screenplay

as merely a blueprint for a future film leads to writerly laziness. It relegates all authority to some subsequent professional. The writer is no longer responsible for the deep orchestration of their material (since someone else is going to be making those decisions later). It leads to the mistaken idea that a screenplay is a description of a possible film, rather than a crafted dramatic/cinematic literary form. It also ignores that a screenplay does, in fact, have a literary audience. That is, a screenplay depends for its success on a *reader*. The people who give money to make films, actors and directors and agents who say *yes*, are all *reading* the screenplay. They are your audience. And like any reader they are manipulated and seduced by the writer.

Writing a screenplay is a craft. And that craft is not simply coming up with a striking idea or a great plot filled with suspense and conflict and surprise. It is being able to write that narrative in a way that is legible, in a way that will induce a similar imagining in the mind of the reader.

A screenplay is not a written description of a film. That's an important idea. It must be internalized. *A screenplay is not a written description of a film.* Even if you fancy yourself a filmmaker and hope to eventually direct the screenplay you are writing, you must dispense with the idea that this collection of pages you are putting together is simply a blueprint for the making (it isn't) or a description of what the film will look like (it never could be).

A screenplay is not a written description of a film.

Think about it. At 24 frames per second, a ninety-minute film comes to about 129,600 individual images. Even given the overlap of the long take, or the gradually changing composition, that still leaves tens of thousands of unique images. However meticulously arranged by a production designer or computer animator and framed by the director, each image also includes serendipity and accident. Tricks of light and weather that cannot be predicted, that appear only when the cameras are rolling or even, sometimes, when the film is developed.

There's no way a written sentence, paragraph, or scene can fully describe the detail that will appear once the image is rendered onto film. There is no way for the writer to anticipate the complex contribution to the final product of actor, design, and accident.

There are two options available once you accept that the screenplay is not a description of the film, that it can never fully duplicate or mimic either the image in your head or the image as it will one day appear on the screen. One response is to write as little as possible in setting the scene and letting the director hang—I mean—do all the work.

This type of screenplay strikes me as resignation. It presumes that creating the shape of the story, the characters who populate it, and the

incidents that move the plot are all there is to screenwriting. It misses a crucial point.

Just as a sentence cannot possibly capture the visual complexity of the eventual film image, the image does not spring fully grown from the head of the director or cinematographer, like Athena from the head of Zeus. The written text of the screenplay can, at its best, possess a literary complexity and depth that the eventual film can only approximate.

What I mean is this: Though a screenplay is not and should not strive to be a description of the movie, it does provide the raw material—I should say the refined material—the deeper understanding of story and character, from which the rest of the film professionals will craft a movie. Looked at this way, a screenplay is a teaching document. It teaches the reader how to imagine the film. How to attempt to control the accidents and vagaries of film production.

Your second option: to develop a narrative prose style specific to the task of approximating a film. There are ways to manipulate your scene descriptions so that the reader's mind is guided through the scene, not with a one-to-one correspondence to what the film should or will be, but with sufficient fluidity and economy, with precision and craft so that the film in your head will be imagined legibly in the reader's.

───── **CRAFTSMANSHIP** ─────

The great literary critic Northrop Frye often told the following story. It has resonated with me for thirty years.

When John Milton was at Oxford he was considered the second best poet of his class. The best was a student named Edward King. They were not friends. They were acknowledged rivals. During a break between terms, King drowned in the Irish Sea. When classes resumed, King's friends set about putting together a book of memorial verse in his honor. They asked Milton if he wished to contribute. For this man he didn't particularly like (let alone love), for a rival who had not been even particularly pleasant, Milton wrote the greatest elegy in the English language: *Lycidas*.

Frye took a long pause and then intoned: "The only truth in art is craftsmanship."

His point was this: though Milton may not have loved King, he most definitely loved elegy. What mattered most in the making of that poem was his feeling for, and devotion to, the language, the terms of poetry, and the specific requirements of the elegiac form.

I tell this story not to diminish the value of deep feeling or authentic emotion in your work. Rather to draw attention to the obvious—and

neglected—fact that a writer loves the drawing of his subject as much as he loves the subject itself. That we have feelings for the method of our making as much as we have feelings for the themes, the ideas, the literal *truth* of our story.

Narrative is story articulated into plot. And the key to that articulation is craftsmanship. I can feel some of you turning resistant. The word *craftsmanship* conjures for you dry and humorless labor. It makes you think of that third grade English teacher who drilled you on the parts of speech. It's heartless and mechanical and the opposite of creativity.

Wrong.

Craftsmanship in writing lies in the mastery of the tricks and manipulations, the methods at our disposal, that render intention and passion visible to others. It's at the heart of why a writer writes. If you don't get off on how moving a word from here to there alters meaning, how this word is better than that word, how punctuation can lead the mind's voice to understanding, then you shouldn't be here. Writing is too hard, the life of the writer too peculiar, to pursue if you don't love the craft, the game, of moving words around on the page. If you don't love composition.

GROUNDWORK

———— **READING THEORY** ————

Writers read with a difference. When they read other writers, they constantly ask "How'd he do that?" or "How can I use that in my work?" Writers are cannibals. They eat other writers. Ingest them. Similarly, when a writer reads critical theory they are more interested in appropriating theory as a tool to make new work than in using theory as a way of interpreting existing work.

This is distinct from the pure literary theorist (or academic) in that the critic uses theory to parse, to deconstruct, the meaning of a work that is complete. Theory provides a guide to understanding and appreciation of literature in general, the given work in specific, and constructs a way of thinking about literature that has a beauty separate from the works considered. Literary theory, like philosophy, can devolve (or evolve depending upon your bias) from a discourse about a literary work to a discourse about itself. It becomes the purview of the specialists, and the language becomes private—a way of thinking relevant only to those already thinking in that language.

In this chapter I hope to transform several theoretical concepts into useful tools. Theory is usually applied to finished texts. I believe it can be used by a writer prior to the text, that it can help us think about composition and the blank page.

Bear with me. Suffer what may at times seem both too simple and too abstruse. We will end well.

I believe the ideas unearthed in the following theoretical discussions are foundational. They lie at the root of what we do when we compose story. And besides, the contrarian view espoused—that plot is not primary to character—will give you ammunition when next you are in a

story conference, or seminar, and someone starts quoting Aristotle as if they knew what he was on about. Chances are they have it wrong.

I promise, after rendering theory useful, we will turn to a series of chapters devoted to practical discussions of how to make a character, a scene, a plot, a screenplay.

If you are only interested in the "how-to" aspects of this book, then skip to the next chapter. But I think that's a mistake. The concepts I'll cover (and uncover) provide a great base for thinking about action, character, story, and plot.

Character Up, Not Plot Down

Pick up any random book on screenwriting at your local bookstore and there's a good chance that it will speak most about plot and structure, relegating character to a secondary role in the making of drama. Most writers on dramatic form emphasize structure and plot to the detriment of character. This comes, I believe, from a basic misreading of Aristotle.

This misreading has led to screenplays that feel contrived. All emphasis is on event. Characters are reduced to vehicles for the plot's needs or the author's agenda.

We are not seduced by plots. We are seduced by characters.

This plot-oriented methodology misses a crucial point: story is not carried by plot or theme. These aspects of narrative emanate from behavior. From a particular character's need or decision or success or failure. It is often the case that a clever and compelling plot fails because the characters have been pushed and pummeled to fit a preordered outline of events. The result can be disastrous: characters whose motivations are strained, whose dialogue sounds all the same (and all like the author). Such characters are, at base, inauthentic. And therefore, no matter how exciting the plot, the reader simply doesn't care. Doesn't buy it.

We are not seduced by plots. We are seduced by characters.

I do not mean to diminish the importance of the well-wrought plot or the need for a compelling (and surprising) structure. And perhaps the entire enterprise of ranking the elements of dramatic composition seems foolish and of limited utility. But given that so much has been spouted about how once the structure of a story has been achieved the other elements can be fixed, or about the locus of empathy being the nature of a story rather than its particular execution, I find myself needing to suggest a corrective to such single-mindedness, and propose that the first element in dramatic construction is not the plot, not the structure, not even the story, but the characters who enact the story.

Screenplays Are Structure

Hollywood loves the one-liner. And it loves to take complex ideas and reduce them to their simplest form. There's truth in the joke: "In New York they read the book, in L.A. they wait for the T-shirt."

One of the catchiest pronouncements concerning screenwriting comes from William Goldman, in *Adventures in the Screen Trade*. Eminently quotable, from a master craftsman, presented within a book full of humor and insight, it seems, at first blush, profoundly and obviously true. *Screenplays Are Structure*. The authority of this Goldman Axiom #2 is bolstered by the fact that Goldman Axiom #1—*Nobody Knows Anything*—really *is* profoundly and obviously true. But I believe his statement on structure has been corrupted and trivialized by overuse and simplification.

It's a seductive notion: If you get the shape correct and compelling, the spaces in more or less the right order, the plot points properly plotted and the momentum cleverly rhythmed, then the rest can be subsequently filled in, fixed, perhaps even improvised. It implies that if we can find a way to speak of structure and plot well, we can then develop easily taught and remembered formulae for making a successful screenplay. And every worker-bee in Hollywood loves to think the Holy Grail of a knowable formula can be found.

It's perhaps easier for the non-writer to think of story from the plot down. It gives the illusion of control, of analytical precision.

The result is that story departments and producers and readers and executives have become enamored with step outlines, beat sheets, and other methods of describing the structure of a story. Pitch meetings devolve into mini-seminars on Aristotle and the Well-Made Play. Phrases like *inciting incident* and *rising action* and *reversal* and *character arc* are tossed about like confetti.

The problem is, the whole thing is based upon a misreading. A misreading, first, of the granddaddy of the Structure Is All theory of dramaturgy: Aristotle. I'll tackle the Big-A in the next chapter. It is also a misreading of Goldman.

Let me quote two further passages from Goldman to put his oft-quoted Axiom #2 in context:

> Yes, nifty dialog helps one hell of a lot; sure it's nice if you
> can bring your characters to life. But you can have vivid
> characters spouting just swell talk to each other, and if the
> structure is unsound, forget it.[1]

[1] William Goldman, *Adventures in the Screen Trade*, p. 195

True. But it certainly isn't the entire story. Just take Goldman's own screenplays for example. What made those films work? What do we remember years after seeing them? Not the structure. We remember Butch. We remember The Dread Pirate Roberts. And we remember dialogue. Goldman's work stands out because his structures are married to (and motivated by) deftly drawn and uniquely imagined characters.

Seems to me it's a big leap from "the structure must be sound" to "screenplays are structure," but hold that thought.

Goldman goes on to say:

> *The essential opening labor a screenwriter must execute is, of course, deciding what the proper structure should be for the particular screenplay you are writing. And to do that you have to know what is absolutely crucial in the telling of your story—what is its spine?*[2]

That's the crux of the matter. Not that Structure Is All or Primary or must be the first focus. Rather, that the spine of your story, the thing that drives both shape and incident, must be *specific* to your story.

And how do we locate spine?

For the remainder of the chapter, what does Goldman talk about as the means of discovering spine? He talks about character. Not formulaic dramatic shapes. He talks about genre and character and motivation.

Although having a sense of the story's shape and its purpose must certainly be a high priority as you begin, as you conceive your story, it can be limiting to the writer to consider structure the most important thing *while composing*. Which is how his axiom has been corrupted, and how it has influenced screenwriting teachers and books and seminars.

Structure cannot be divorced from what Goldman calls spine, and spine cannot be divorced from character and motivation.

But Goldman's larger point, the more complex proposition that structure is spine and spine is character and character is theme and motivation—well that's not very quotable. Doesn't make a good one-liner. So we're left with *Screenplays are Structure*. That's what people remember from Goldman's book. And it's wrong. At least, it's not the whole story.

The phrase *Screenplays are Structure* may well help us to *read* a completed screenplay. It is certainly useful to the other artisans who must

[2] Ibid., p. 196

take the screenplay apart and put it back together as a film. But how does it help us to *write* a screenplay? How does it help us confront the blank page?

It doesn't.

You can't get there from here.

───────── **UPSETTING ARISTOTLE** ─────────

The Poetics

To understand how deeply rooted is the proposition of plot primacy, we have to reach back to antiquity and look at Aristotle's *Poetics*. A book that virtually no two people read to mean the same thing, Aristotle's *Poetics* has had an astonishing, some might say inordinate, influence on dramaturgy.

What follows may seem a tad academic. Perhaps even a little bit abstruse. But I urge you to bear with me. It's really pretty simple and will leave us with a couple of basic ideas that will prove useful as you imagine your stories, as you consider your characters.

Since its rediscovery in the Middle Ages, commentators have been arguing about virtually every word of Aristotle's *Poetics*. There are a multitude of textual problems—inconsistent usage, scribal errors, missing passages—and as a result, every translation of the *Poetics* reflects the bias (and limitations) of the editor. Aristotle's words are always presented through an interpretive filter, and that filter is always defined by the preoccupations of the time of its creation.[3]

The Classics professor would point out that Aristotle was writing only about Tragedy, and only about Tragedy that concerned a "good man who suffers bad fortune through an error in judgment." That his notion of imitation (*mimesis*) was a direct response to Plato's distrust of all art/mimesis as a corruption of Reality and a potential corruption of individuals and the State. That the stories available to Greek drama were received fables. The characters within those stories were, likewise, known entities. That plot—the arrangement of incidents—involved the selection and presentation of a subset of pretty much known and predetermined events. And that the incidents of these received fables concerned established choices and behaviors. Not

[3] The most glaring misconception about the *Poetics* is that it is a work of aesthetics. In fact, Aristotle meant it as a work of science, on the model of *On Animalia*, that would provide an objective description of what constituted Golden Age tragedy. It would provide a taxonomy. It would strive to name the parts and their interrelationships. It was not meant as a how-to book.

much room for free will in Greek drama. No such thing as personality as we know it.

In Aristotle's time the individual was defined in his relation to the Polis, the city-state. Just as in previous cultures the individual was defined in relation to the Tribe.

The concept of an individual personality… capable of altering his own fate… Aristotle would not be able to comprehend.

Our modern notion of the individual—with exceptions made for the exceptional writers (Willy the Shake, Rabelais, Cervantes)—did not appear as a culturally embraced idea until the eighteenth century, with the Enlightenment's Natural Man and Romanticism's Anguished Ego. But even these characters are defined primarily by their relation to class and wealth.

The concept of an individual personality, valued for being individual—irrespective of nationality or class or wealth, composed of privately engineered ambitions and desires, plagued by unique demons and neuroses, capable of altering his own fate—is a very modern development. One that Aristotle would not be able to comprehend. It would be as opaque to him as MTV. He, quite literally, would not be able to see it.

Much of what Aristotle believed, we no longer believe. Much of what confined him, limited his purview, no longer obtains.

For the modern dramatist, there are several parts of the *Poetics* that no longer apply. For instance, we no longer feel a need to obey the unities of time and place. We do not concern ourselves only with the high-born or the gods or demigods. We do not have a commenting chorus that breaks into song from time to time. And we do not share his dismissive attitude toward women and slaves.

Plot and Character

What remains?

The influence of the *Poetics* on modern dramaturgy centers around his comments on plot and character. Even if we ignore the larger contextual issues, and pretend that we and Aristotle are speaking the same language, there are objections we can make on the linguistic level that put the Plot Primary premise in doubt.

Many writers on dramatic technique—especially as it applies to film—present a kind of Cliff Notes guide to the *Poetics*, hitting the high notes, pulling out the eminently quotable passages. They have left the textual problems to the experts, have glossed over the difficulties that arise when the historical context of Greek Drama is

juxtaposed to modern dramaturgy, and have ignored the fundamental cosmological differences between Aristotle's time and our own. They have drawn from among the sometimes sketchy, sometimes circular arguments and the references to works that have vanished into oblivion, a handful of forceful pronouncements on the nature of plot and character. And taken together (and I would say out of context) they provide a very insistent view of the plot/character question:

> The most important of these is the arrangement of the incidents, for tragedy is not a representation of men but of a piece of action.
> **—Fyfe [1450a20][4]**

> Hence the incidents and the plot are the end of a tragedy; and the end is the chief thing of all. Again, without action there cannot be a tragedy; there may be without character.
> **—Butcher [1450a22]**

> The plot, then, is the first principle, and, as it were, the soul of a tragedy; character comes second.
> **—Fyfe [1450a35]**

From this handful of lines, modern film writing gurus and teachers have deduced the simple truism that plot is more important in the composition of a screenplay than character.

Let's look at the two words central to the argument. Plot and character.

Aristotle's word for plot is *mythos* (from which we get myth). But this word does not mean simply plot. It is much broader. In other writings by Aristotle, and in other places in the *Poetics*, this word can mean story. It can mean Fable. It can be the broad outline of the story content of the drama.

Aristotle's word for character is similarly rich in connotation. *Ethos* (from which we get ethics) In some places it means a character's moral and ethical qualities. In others it refers to a person's physical attributes and distinguishing peculiarities.

[4]Quotations from the *Poetics* are taken (for the most part) from *Aristotle in 23 Volumes*, Vol. 23, translated by W.H. Fyfe. Cambridge, MA, Harvard University Press; London, William Heinemann Ltd. 1932. This edition is available in an online version at http://www.perseus.tufts.edu/. For purposes of comparing translations—and the impact that sometimes has—I also quote from the readily available edition edited by S.H. Butcher.

Aristotle defines *character* in this way:

> *Character is that which reveals choice,*[5] *shows what sort of thing a man chooses or avoids in circumstances where the choice is not obvious…*
>
> **—Fyfe [1450b]**

Curiously, in the same section, Aristotle seems to place the drawing of character in tragedy on a par with realism in painting:

> *Polygnotus delineates character well; the style of Zeuxis is devoid of ethical [character] quality.*
>
> **—Fyfe [1450b]**

Zeuxis was known for creating "ideal" portraits. So we can deduce from this comparison that Aristotle is equating the creation of character in a drama with the depiction of realistic individuating aspects in painting.[6]

It's not clear to me how Aristotle can, in the same section, go from describing character as a moral quality—that which reveals choice—to relegating it to a function of portraiture. But there it is. He does. And the fact that he does is significant. It allows us to draw a useful distinction for the writer looking at the blank computer screen:

- Character as Agency. This is the idea of a character who, through behavior and active decisions, engenders action, causes something to happen. The exercise of will.
- Character as Aspect. What we would call characterization or character study. Individuating attributes.

There are two ways to make sense of Aristotle's contention—in the context of Greek Dramaturgy and Cosmology—that character is secondary to plot, indeed is not needed for the making of a drama.

The first is to point out that for the purposes of telling the story of an idealized hero, what we might call characterization, or character study, is not necessary. It is not important that Oedipus have the markings of

[5] The Greek here translated as *choice* is *proairesis*, and as Fyfe comments, it "is a technical term in Aristotle's *Ethics*, corresponding to our use of the term 'Will,' the deliberate adoption of any course of conduct or line of action… If character is to be revealed in drama, a man must be shown in the exercise of his will, choosing between one line of conduct and another…"

[6] Don't give up on me. We're getting to the punch line. It'll be worth it.

personality and individuation. It's important that he be Oedipus, who, in fact, is defined not by his attributes but by his actions.

That's the point about why this is a misreading (or at least a misuse) of Aristotle. The use of character idiosyncrasies—what I'm calling Aspect—as an element of dramaturgy is a particularly modern methodology.

The second is to look at the more substantial notion of Character as Agency, and examine it in its relation to the Greek idea of story.

Let us look again at the most damning—for character—of Aristotle's assertions:

> ...*without action [arranged in a plot] there cannot be a tragedy; there may be without character.*
> **—Butcher [1450a–22]**[7]

On the face of it, this statement seems nonsensical. Obviously, Aristotle did not mean to suggest that you could have a plot without *dramatis personae*, without characters enacting the action of the drama.

Just as obviously he could not mean there can be a plot that exists free of agents and agency. The only way there could be a plot "without character"—without the author having to determine and draw those moral and intellectual qualities of personhood that relate to choice, to will and desire—would be if those elements of character *were all predetermined by the given plot*. That is to say, only if the selected *mythos*—fable, story, plot—revolves around a character that needs no characterization because the story has *within it* the choices that must be enacted.

This idea of a plot that already contains the character as moral agent (and therefore the dramatist must focus primary energy on the arrangement of event) is possible only in a dramaturgy, like that of the Greeks, where the fable is a given, where the heroes exist, fully formed, outside of any given articulation of the story. The modern equivalent would be if all films concerned actions by a set number of primary characters. Say, Santa Claus or Jesus or Napoleon. We have received notions of their characters. Both their aspect and their agency are givens. And so we would, in some peculiar light, be correct to focus primary attention to the plotting of the events being dramatized.

In such a dramaturgy, it makes sense to suggest that the arrangement of incidents is more important than drawing character, since the major choices in the creation of character have already been made by the received fable.

[7] It should be noted that Aristotle gives no example of a tragedy that is devoid of character, that is action only. The reason is simple: it cannot be.

Aristotle ends the section on plot and character with the following bizarre statement:

> And furthermore, two of the most important elements in the emotional effect of tragedy, "reversals" and "discoveries," are parts of the plot.
>
> **—Fyfe [1450a–32]**

This goes to the heart of Aristotle's error. His blindness. He seems to be suggesting, with all seriousness, that one can have a reversal without a being to whom that reversal of fortune happens, a reversal that is not caused by that character's choices and actions. Similarly, it suggests that recognition (the achievement of insight) exists as part of the plot, and not within the character enacting or effected by the plot.

It is perhaps understandable in a world that defined man only in his relation to the city–state, that had a dim and mechanistic notion of personality, to believe that a man's actions might be separated from his character. The Greeks attributed to Fate or Destiny what we would attribute to the individual. Heraclitus posited the most pithy summary of this point of view: "*Ethos anthropos daimon.*"[8] This is usually translated as *A man's character is his fate*. But *daimon*, for the Greeks, was not simply predestination. It also referred to an inner drive or voice that determined an individual's behavior. What we might call conscience.

Aristotle seems quite divided on the point. In some sections character seems reduced to portraiture, to character study; in other sections it is clear that he is crediting character with the power of agency, with as much free will as might be allowed within the Greek cosmology.

It's as if the Greeks came close to understanding what they had unleashed, but had to back away given the myopia of a culture that could not conceive of individual free will, free will divorced from the structuring and determining forces of Fate and Destiny.

It's as if everything Aristotle says about character hints at its organizing power, but given the overwhelming presumption that plot was paramount, that stories were given and familiar, he could not make the leap to realize that new stories were possible, and were possible only if his analysis of character were extended. If he could accept a notion of the individual capable of altering his own fate.

What we would consider character behavior, Aristotle considered predetermined actions inextricably linked to and contained by the plot. What we would consider will in action—choice—Aristotle would have considered fate.

[8] *On The Universe.* We get the word *demon* from *daimon.* Isn't that great? A man's character is his demon.

The closest Aristotle could come to our notion of the individual was the concept of *Harmatia*—usually translated Tragic Flaw—that error in judgment by a character, the "missing of the mark" that leads to the action of the drama. Oedipus believes he can avoid the fate decreed by the Delphic oracle. Antigone believes family law can override civic tyranny.

But note that these essential character attributes are not inventions by the dramatist. They too, as much as the incidents that tell the story, are givens within the fable being dramatized.

It is in this light that we must read the statement, "The most important [element of drama] is the arrangement of the incidents." If the story is given by the fable being dramatized, if the character's primary flaw or blindness is also predetermined by the fable, then all that is left for the dramatist is the arrangement of the (given) incidents into a dramatic shape. No wonder plot is primary for Aristotle. It's all there is left to invent.

Action

Ancient Greek had two words for action: *prattein* (πράττειν) and *dran* (δρᾶν).[9] *Prattein* was the more common term and possessed a wider range of connotations, finding its way into more and more varied usages than *dran*. *Prattein* could refer to what we might call activity—running a race, for instance. It could refer to a rote action—such as making wine or sharpening a sword. It could refer to a public stance—a speech or an act of trade. It could refer to what we might call event or incident.

Dran, on the other hand, is found much less frequently in the surviving texts. It would seem to refer, in the main, to "consequential action," such as socially or politically relevant decisions and accomplishments. It contains a connotation of individual will. The emphasis lies in the doing, not the thing done.

Our word *practice* is directly descended from Aristotle's *prattein*. And our usage emphasizes the repetitious or rote nature of the action. Practice. To perfect or improve by repetition. By contrast, we get our word *drama* from the more obscure Greek word *dran*. A drama implies conflict. Implies individuals at odds and choices taken. Drama portrays a contest, the outcome of which is in question and accessible to human intervention.

There. Right in the root of the word drama: the imitation of an action (or series of actions), a tapestry of behaviors resulting from human will, from choices made, decisions taken.

From character.

[9] How precisely these two words were viewed by speakers and writers of Aristotle's time, we can never know for certain. It has been suggested that there were regional preferences (Athens leaning toward *prattein*, some of the provinces toward *dran*).

In the *Poetics*, Aristotle uses the term *dran*, or variants, only a handful of times.[10] To better understand the distinction between the two words, let's look at this passage in which Aristotle uses both. He is noting the similarity between tragic and comic writers:

> ...*they [Sophocles and Aristophanes] both represent men in action and [men] doing things.*
>
> **—Fyfe [1448a–25]**

For "men in action" Aristotle uses a form of *prattein*: *prattôntas*. For men "doing things" he uses a form of *dran*: *drôntas*.

This is not just a repetition of the same concept. I believe Aristotle is making a significant distinction.

I suggest that this passage and its use of both forms for the concept of "action" goes to the heart of how we need to think of drama, to the heart of how we read or misread the *Poetics*. And it teaches us a crucial lesson about character and its relation to incident (*pragmata*) and plotted story (*praxis*).

Seems like a lot to put on a very slim semantic distinction.

Here goes. Here's what I propose.

> *Prattôntas*—men in action—can refer to actions, like wars, or political discourse or commerce that are (1) not individual and (2) do not require a specific and consequential choice or decision by the agent of the action. Things happening.
>
> *Drôntas*—men doing things—has a connotation of direct agency and causation. Men making something happen. They are not simply bystanders to or even embroiled by the events or incidents or action. They are instrumental in bringing those events into being.

The passage continues:

> ...*and that to some is the reason why they are called 'dramas' because they present people doing things*...
>
> **—Fyfe [1448a–25]**

People doing things. The emphasis in this connotation is not on action or on incident, or on event that occurs to a person, or that which a person experiences. Rather the emphasis is on agency. On doing.

We might translate these two concepts as *participants* (*prattôntas*) and *agents* (*drôntas*). Those who are swept along by the tide of events

[10] The first usage is a rather curt discussion of the origin of tragedy and drama in which he notes the Dorians claim to the invention of drama based upon the fact that their word for action is *dran* rather than *prattein*.

and those who have a direct impact upon the course of those events. Think *Hamlet*. Claudius, Gertrude, and Hamlet do things. Rosencrantz and Guildenstern (and the rest) are carried along by their actions. Take any drama, or film, and you can divide the characters along this line: those that effect and those that simply experience. The agents and the participants.

Our engagement with drama concerns those who do, who effect. Concerns the agents whose decisions form the plot, whose decisions we approve or anticipate.

Perhaps the most quoted phrase in the *Poetics* is Aristotle's definition of tragedy:

> *Tragedy, then, is an imitation of an action [mimêsis praxeôs]...*

I would argue that this use of the Greek term for action should not be translated as action at all. Aristotle was creating a new term of art, appropriating a common word to describe a new concept, which is more accurately translated into English by the word *story*. *Praxeôs* in this phrase signifies an aesthetically unified action, one that can be enacted through drama. The definition continues:

> *...that is serious, complete, and of a certain magnitude...*

The most important of these qualifiers—and the most relevant to modern dramaturgy—is the notion of *completeness*, of the action presented being a *whole*.

Aristotle defines a *whole* this way:

> *A whole is what has a beginning and middle and end. A beginning is that which is not a necessary consequent of anything else but after which something else exists or happens as a natural result. An end on the contrary is that which is inevitably or, as a rule, the natural result of something else but from which nothing else follows; a middle follows something else and something follows from it.*
>
> **—Fyfe [1450b]**

The point of this seemingly convoluted passage is that *praxis* is a special case of action. It is an action shaped by motive and consequence into a whole—a beginning, middle, and end linked by cause and effect.

We have lamely translated *praxis*, literally, as *action*, clouding (or ignoring) the distinction between action as incident and action as a matrix of events telling a complete story.

Aristotle's definition of tragedy concludes:

> *...that is serious, in the form of action, not of narrative*
> *[drôntôn kai ou di' apangelias]...*
> **—Butcher [1449b24]**

Here there is a second instance of the word *action*. But notice that Aristotle uses a compound derived from *dran*. Here the emphasis is not on completion—on action as story—but on the individual events carried and caused by character.

One could translate this definition of tragedy so:

> *Tragedy, then, is an imitation of a story that is serious, con-*
> *taining motive and consequence, of a certain magnitude, in*
> *the form of enactment, not of telling.*

The fact that *praxis* is always translated simply as *action* gives a subtle confirmation to the idea that action—and the plot that organizes it—is primary. It misses the point that (1) action, in this usage, is synonymous with story, an action imbued with motive and consequence, and (2) that the second use of action (*drôntôn*) carries with it the implicit notion of a character *in* action, distinct from action divorced from agent.

Praxis refers to the overall shape and organization of the drama, the unified action portrayed; it implies a beginning, middle, and end; it implies a matrix of motive and consequence, it implies decision and acts of will. In short, it truly describes what we would consider a story.

——— PUTTING ARISTOTLE TO WORK ———

What then, can we take away from my rereading of Aristotle's comments on plot and character? How does this analysis of Aristotle help when confronting the blank page?

In the course of explicating Aristotle's statements regarding plot and character, some useful concepts have become clear.

Character as Aspect

For Aristotle, the notion of a character's individuating attributes implied portraiture, more specifically, realistic portraiture as opposed to idealization.

For Aristotle, portraiture—character aspect—was indeed secondary to action and plot. For good reason. It encompassed a notion of character drawing, or character study, that was unimportant to the telling

of the fable. I believe that's what he meant when he said you could have a tragedy without character (without aspect), but you could not have a tragedy without action. He meant without portraiture. Agency, for Aristotle, was a given, part of the fable being dramatized.

In modern parlance, this idea of aspect encompasses our notions of personality and psychology as well as physical attributes. When drawing a character, we think of aspect as those unique markers—from background, education, bias—that go into making a character's specific identity. Habits, speech, ticks, and quirks. Physical traits. All fall under the heading of *aspect*.

Aspect is how we come to identify and know a character. These are communicable attributes and behaviors that, taken together, define the personhood of a character.

Character as Agency

Agency goes beyond the individuating traits of a character. Agency can be considered a character's relationship to the events that comprise the plot.

That relation can be active (*drôntas*: men doing things), where a character's decisions and choices create or alter the course of events.

Or it can be more passive (*prattôntas*: men in action), where the events of the plot are external (a war, for instance). In this case, the agency may only be that of witness or even victim.

Clearly, it is more dramatic if we are following a character whose choices, motivated by need or desire, impact directly upon the course of events.

Even when the story contains an external event, what turns that event into something we follow with interest are the responses and decisions of the main character.

Drama lies in a character's response to event, not in event itself.

For instance, if there is a war, does the hero sign up or make for Canada? If there is a hurricane, does the hero stay and help the stranded? From this angle, *pruttôntas* (men in action or things happening) is not interesting, not dramatic, until there is a *drôntas* (a man doing things, making a choice). If the large external events of the story remain separate from the choices and actions of the individual characters, then they are only spectacle. Drama lies in a character's response to event, not in event itself.

Agency is not secondary to action. On the contrary, it is integral to action. It motivates and causes action. For Aristotle, character as agency was entwined with action; it was part of the given of the fable. I believe Aristotle so took for granted the idea that agency was, in fact,

action that when he speaks of plot as the soul of tragedy he means to include *within* plot the idea of character as agency.

Drama as Choice

The center of the action, the heart of dramatic conflict, lies in the individual act of will. Action as decision, as choice, as event motivated by human agency, leads directly to a more profound and useful understanding of the relation between plot and character.

A dramatic character is both an accumulation of traits and habits and predispositions—a personality—and a collection of actions. Actions that are the direct consequence of acts of will.

Decision drives plot.

Once you view dramatic action as fundamentally driven by the characters' choices, character becomes True North, the fixed point to which the writer can continually refer in judging the logic, the authenticity, and the appropriateness of behavior, of event, of overall structure.

Character becomes True North, the fixed point to which the writer can continually refer...

It is in this context, this definition of drama as the presentation of a thoughtful and motivated character choosing a course of action, that we should place the questions that every beginning screenwriter has heard flogged about: *What does your character want? What is the character arc? What is at stake? Whose scene is it?*

These questions come into focus—and can be addressed and answered in practical fashion—once you think of dramatic action as decision.

Character Completes Plot

Character necessity gives coherence and meaning to plot.

The difference between a B-movie—which may be great fun to watch—and a film that survives the conversation on the way home is character.

Sidney Lumet put it this way (paraphrasing): In melodrama, plot forms character; in drama, character forms plot.

Whatever your idea, whatever the genre; no matter how ingenious the incidents or cinematic the vision—if you do not ground your story in character you will end up with simple spectacle.

Character helps you create and solidify plot.

No matter how wildly inventive your images are, no matter how original the events you concoct, if they are not tethered to your characters, if you have not evaluated their consistency to character's True

North, they will seem false, forced. They will be insufficient. They will not add up to story.

We do not identify with incident. We do not empathize with event. We consume story through character. That's our way in.

We do not identify with incident. We do not empathize with event. We consume story through character. That's our way in.

What's the difference between a good movie and a bad movie?

It's simple. In a good movie, you feel a stake in the characters' choices. This goes beyond empathy, or antipathy, and drills down to the heart of drama.

There are only a few things that make an audience member lean forward. There is fear. There is sex. And there is thinking.

And it's particularly interesting to watch a character make a choice. The right choice, wrong choice, the choice we fear, the choice we ourselves would make.

In a bad movie, effects may be spectacular, action riveting, and the starlet beautiful, but if I don't believe the choices they make are important, and genuine, and meaningful, then I will not care.

If there isn't an individuated personality whose desire we can recognize and understand, if there is no choice with which we can agree or abhor, then all that remains is the titillation of spectacle. Which, one could argue, is the definition of pornography.

—— CHARACTER-DRIVEN VERSUS PLOT-DRIVEN ——

Okay. I admit. That's asking a lot of a reader. It's pretty heady stuff. You came here to learn how to write a screenplay and here I am holding forth on Aristotle. But, trust me. By the time you finish this book you'll want to return to the last chapter and you'll see it anew. And it will help. I know it will.

Let's take a breath and put it all in more familiar and colloquial terms.

You will often hear films described as either *character-driven* or *plot-driven*. I think this is a false dichotomy. All films are character-driven. All films have plot. These labels tell something, it's true, about emphasis. And, for the most part, it's become something of a commonplace that smaller, independent films are more character-driven, and larger "tent pole" films are more plot-driven.

But it seems to me that these terms are best seen as describing a spectrum. At the far end of the character-driven end you might find personal dramas or portraits, films like *Sideways* or *Woman Under the Influence*. At the far end of the plot-driven you might place most horror films, Kung Fu movies, disaster movies, and plot-heavy thrillers

like *Inception*. In the former we are drawn into the story by character agency, by how what the character chooses generates story; in the latter character is seen primarily in reaction to events beyond their personal control.

What interests me about this distinction is (1) how the vast majority of movies, at least the vast majority of good movies, fall into the middle and (2) how we can turn it to task in the making of new characters and new plots.

From the point of view of the writer confronting a blank page, plotting sometimes feels like an exercise in mechanics: how to get the pieces to fit together, how to concoct action and event that rivets and interests and is logically probable and consistent. But if you accept that all but the most extreme spectacle films are also character-driven, you have a tool with which to create and challenge event toward plot. Imagined events, when viewed through character behavior and motivation and ambition, become necessary; not simply interesting, but compelling. The reader is drawn, via empathy and understanding, into the plot.

It would be easy to make this point about character's relation to plot in the quieter, more personal movies of the independent film universe. More interesting is to demonstrate that this idea of character impacting and refining plot can be found in relatively plot-heavy popcorn movies. Many of the examples I will use in what follows are taken from such movies. The intent is not to suggest that *Die Hard* and *Lethal Weapon* are the kind of films you should be writing; or that they are paradigms of film art. Rather it is to make the point that what makes these movies transcend their plot-driven genre, what has made them memorable and successful, is an astute entwining of plot and character. Take the *Bourne Identity* franchise. There you have popular, heavily plotted thrillers driven by the main character's search for identity. Deftly drawn and consistent characters are what separates successful films from their B-movie siblings.

The concepts examined here are equally applicable to Hollywood blockbusters, independent film, micro-budget, and television.

Realize that this distinction between character-driven and plot-driven is usually applied to completed films, to characters and plots that have already been created and composed. We are concerned with making a plot, not with appreciating one. We are concerned, not with *plot*, but with *plotting*:

> ...that which makes a plot "move forward," and makes us read forward, seeking in the unfolding of the narrative a line of intention and a portent of design that hold the promise of progress toward meaning.[11]

[11] Peter Brooks, *Reading for Plot*, p. xiii

What a great definition of our goal as dramatists: to seduce a reader toward meaning with a combination of intention and design. That's an idea of plotting one can sink one's teeth into. But it's not as quotable as *Screenplays Are Structure*. Reread it. I think you'll come to like it.

In order to think about character and plot from the point of view of *plotting*, of making a plot rather than analyzing one, we must turn again to theory to get some terms straight, to lay out a vocabulary.

FABLE AND CONSTRUCT

What do you have when you sit down to write a screenplay? What now? Where to start?

Let's look at what you bring to that first night of composition.

How do we approach the blank page? Usually with nothing but an ambition or urge to tell a story.

Sometimes you don't even have that. Sometimes you just have a desire to sit down and do fun things with language. The hope for a story becomes an excuse for feeling the pleasure of composition.

We might not even know what story we hope to tell when we first create that blank document or crack the newly purchased composition book.

Where do we find our stories? History. Personal experience. An old folk tale or an obscure novel. Yesterday's headlines. A single image. A thematic idea.

No matter the source, all of these—urge to tell, high concept, political point, personal history, contemporary event—have one thing in common. They are ambitions to story, not story itself.

What's the joke in *Annie Hall*?

> *Right now it's only a notion. But I think I can get money to turn it into a concept, and later turn it into an idea.*

At this point you are swimming about in a inchoate morass of possible story ideas and directions.

How do we start typing? How do we move from the unformed notion to screenplay? First, we need to understand what we mean when we think about story.

Story

Surely, I hear you say, *story* needs no definition. *I know a story. I heard this story. It's a great story. What's your story?*

But what do we really mean when we use *story* to refer to a screenplay? Or more specifically, in the context of setting out to write a screenplay?

A friend asks what your screenplay is about. You try and tell them some graspable aspect of the story. But really, if you haven't finished the screenplay, you're just flailing about to find the more interesting bits of what you are working on, trying to find a way to link them together in a way that makes sense. But deep down you know this attempt to tell what isn't finished just won't do. It isn't doing justice to your idea, to your ambition.

This kind of precomposition storytelling has been codified in the film industry as *The Pitch*. You work out the barest outline of a story, using as much glitz and glamour and as many formulaic catchphrases as you can, and you act it out for a studio executive. If you're good enough at the performance aspect of *The Pitch* you may walk away with a deal. But you haven't actually written a story. You have described—just as you did in answer to your friend's casual question—what you *hope* to write, what you *plan* to write. You have described an ambition to a story, not a story. You have described a story before it has been composed.

Now ask the question from the point of view of the writer before he has set pen to paper (finger to keyboard). What is the story, the chaotic field of infinite possibility, the thing that struck the author one evening in the shower, that now swims in his head, keeping him up at night? That story is amorphous. It is flexible. It changes as the writer imagines alternative turns, thinks through character and location, adds event, discards, winnows.

Story, in this sense—as the idea with which we begin, the material from which an author will craft a narrative—is not a thing, not an artifact. It cannot be told. It is a range of decisions yet to be taken.

Story, in this sense—as the idea with which we begin, the material from which an author will craft a narrative—is not a thing, not an artifact. It cannot be told. It is a range of decisions yet to be taken. It is expansive, formless, without center. Story prior to its telling in a specific form remains an abstraction. An idea for a story.

This impulse toward a story must not be thought of as a whole, as a thing that only need be transcribed into screenplay form.

Story, as this field of possibilities, provides the raw material for the making of the screenplay. But it is not the story *of* the screenplay. That story can be grasped and shared, and is only tellable after the screenplay is complete.

If we turn to literary theory, specifically to Russian Formalism, we find a set of terms that can be turned to our advantage. If we shift the point

of view on those terms from after-the-fact explication to before-the-fact contemplation, they provide useful tools for thinking about story.

The Formalists, in their analysis of folktales, delineated two aspects of a literary text:

- The *Fabula*—the ur–story, the story as it might exist in real time, the story unmediated by an author (and hence ungraspable by an audience).
- The *Sjuzet*—the story as arranged and organized by an author, how the story is apprehended by an audience, the tellable story.

In most Lit Crit books these terms are approximated in English as *story* and *plot*. I find that confusing. And not terribly useful when we change the point of view from critic to writer, from after-the-fact exegesis to before-the-fact imagination.

Story is too colloquial. It refers to the casual recounting of events as much as it refers to the source material of a narrative. It refers to the thumbnail sketch and the water-cooler anecdote. So I propose retaining the literal translation of *fabula*—*fable*—when referring to the untold story, the story before articulation into a graspable shape.

Sjuzet is more problematic. *Plot* is too specific. It refers to one element of the completed work: the arrangement of incidents in a temporal relation. *Sjuzet* is more than the shape of a story. It includes the author's agenda. It includes the many stylistic choices and narrative devices that comprise the composition. It is as much *how* something is said as it is *what* is said. I prefer to use the word *construct* when referring to *sjuzet*, to the articulated story.

Think of it this way. *Fable* exists prior to and outside of composition. *Story* is what you are making up (out of the fable) during composition, and *construct* is what results when the composition is structured, by an author with an agenda and a style, into an organized matrix of incidents and behavior.

The distinction I'm making is between the *imagined story* (fable) and the *articulated story* (construct). Fable does not come into being fully formed. It appears—to the author or to the culture at large—as a collection of narrative possibilities, an imagined field of narrative elements without form, without structure. Only after it is articulated into a form through selection and artifice—when it is constructed—is the story tellable. Consumable.

Let's think again about story. I mean, *fable.* The fable is the story as it would exist in reality, an infinity of event, unmediated by artifice or artist. The *sjuzet*, or *construct*, is how an audience is made aware of the events of the fable; it is the selection and arrangement by the organizing hand of the artist.

It's quite appropriate, really. The word *fable* implies an ill- or undefined speaker. A fable floats above language, above any specific telling, and resides in the culture, in the imagination. It has no location, no locus.

Construct fits our need to describe the told story, the tellable story, after composition, as it implies a singular authoritative maker. A specific teller.

A constructed narrative possesses an author, a maker. A fable does not.

What I refer to above as the amorphous idea of story, the nagging low-grade fever, corresponds to the fable. The working out, from the scene level, of the details of telling, corresponds to that aspect of *construct*—the arrangement of event—that we call plot.

We can have an idea of a fable's import, of its overall shape. We can have a passion for the theme hidden within the chaos of a fable. But we cannot have a construct—something tellable—without actually putting words on paper.

Event

Which brings us back to the blank page.

You've imagined a main character. Given him a name. And a location. A time. You have begun to populate an inchoate geography with a cast of characters. Perhaps they are only types and generalities at this point. Defined by their role: the good guy, the love interest, the bad guy. Most importantly, you have a secret intent. A theme to explore. That glimmer of meaning swirls around your head all the while you are locating the story and discovering your actors.

These vague choices begin to shape the chaos of the *fable* into a *construct*. Some things are now possible. Others are excluded simply by a choice of location in space and time.

How do you start typing on that first blank page? What do you actually put on paper?

It is at this point in the genesis of a screenplay that many will write an outline, listing the events that you know will happen (Boy Meets Girl, Boy Loses Girl), trying to make those events specific to the location and time you have chosen. And then filling in the intervening spaces.

This can be dangerous. It is easy to abuse an outline, turning it into a simple list of events disconnected from story and character. I'll speak more of outlines later, but for the moment, let's accept that starting with some sort of outline is a reasonable thing to do.

So, struck by a story idea, we begin the process of winnowing fable into story toward construct by imagining and selecting the events from the infinite possibilities to hand. What events are most striking, most necessary? Most cinematic? We make a list of events that begins to look like an outline of the story.

There are two very different kinds of actions to list in your outline, two very different approaches to the first step in turning an abstract ur–story into something tellable.

- What happens? An outline of the incidents that structure the story.
- What do they do? What does your main character do to achieve what he needs or wants? This will lead to what happens.

It must be stressed that there is no such thing as an event within a plot (or there shouldn't be) that has no relation to character. The question of what happens should always be asked through the eyes of your main characters.

How is incident tethered to character? In two directions. Backwards to motive. Why did this happen? forward to consequence. What will this cause to happen next?

Event disconnected from the twin engines of motive and consequence presents mere spectacle.

Event disconnected from the twin engines of motive and consequence presents mere spectacle.

Let's walk through an example that should clarify the terminology of event, motive, and consequence.

A murder. What's that? Not a story. Not a plot. Not even an action. Just a disconnected event.

Add a location. *A murder occurred in Manhattan.* Still just an event. Located. But an event.

A man murdered his wife in Manhattan. Now we're getting somewhere. There's an agent. So I think we're qualifying for an action. There's an actor.

Frank murdered his wife after finding her in the arms of another man. The action now has a motive. But it's still not a plot. It's a discreet event. Has only a beginning and middle. Incomplete action.

Frank murdered his wife after finding her in the arms of another man and then killed himself. Motive, action, and consequence. Beginning, middle and end. This is what Aristotle would call a *praxis.*

Where does that leave us in our quest to figure a useful approach to the recriminating blank page, the aggressively blinking cursor? Well, I would suggest that it gives you a very specific task. It gives you a tool to dig deeper into your abstract story than would be possible simply by meditating on plot and outline and event.

With every idea you have to thicken your story with incident, challenge yourself as you jot that event down, to ask *why* and *what.*

- Why does it happen? Why does it happen now? Why did it happen to my character or why did my character cause this to happen?
- And what. What does this event cause? Is there only one consequence? Have I imagined all possible versions of consequence?

By asking such character-based questions of your plot outline (even as you are just barely beginning to form a shape), you will thicken your story. You will generate links and relations that will be useful as you compose the story into a narrative.

Events are fundamental elements of story, but do not create story in and of themselves. Stringing them together does not make a plot, no matter how interesting the events.

Often, at the beginning of composition, events occur to us separate from character, in the abstract. Such events have no motive, no connection. No causal relation. They are simply events. However interesting, they are not a story. They become construct when arranged into a plot.

An imagined event, for a writer starting a screenplay, can be an ungrounded happening. For instance, if I hope to write a Romance, it follows that somewhere in the first act the two lovers will meet. The event, at this point in the composition, remains untethered, except perhaps by chronology, to the other imagined events of the fable that crowd the writer's brain. The fable remains a morass of possible happenings. Meeting, first dinner, love scene, home to the parents, the other girl shows up, etc. etc.

As a fable event creeps toward a narrative plot point, two aspects must manifest, must be located and crafted: motive and consequence.

Why this event? And why now? What brought it about? And most significantly, what ambition or fear or desire in one of the fable's characters— or the collision of such motives held by multiple characters—engenders the event?

What results from this motivated event? What reversal of fortune or complication ensues? What motive for the next event has been created?

There is *what* happens, there is *why* it happens, and there is *what follows* from it happening.

Taken together, motive and consequence constitute a Janus-faced causality, looking back from the event to the motive that constructed the happening and forward to the logical next event.

Plot

David Lodge gives a pithy summary of the relation between fable and construct:

> *The sjuzet [construct] is always a motivated deformation of the fabula. That is to say, its selections, exclusions,*

rearrangements, and repetitions of the raw material of the fabula are what determine its meaning or import.[12]

There are two crucial points contained in this quotation. First, any time one sets to plotting a story, to making an object out of the raw material of fable, that fable is *deformed*. The act of selection and arrangement, by its very nature, alters the base material. Second, the deformation takes on the specific character of the author. That is, it is *motivated* by the writer's agenda. Agenda here is a neutral term meant simply to denote the unavoidable biases, politics, and autobiography of the writer doing the deforming. If you are a card-carrying bird watcher then you cannot help but bring that passion to your fiction.

Plot is the working out of how to tell the fable. It is the ligature upon which a fable is strung like clothing upon a slumping line. We only discover the shape—the nature of the slump—by hanging the clothes, by writing the scenes, by populating them with characters, by hearing voices and following them wherever they lead.

Plot is … the ligature upon which a fable is strung like clothing upon a slumping line.

In my view of this relation between *fable* (what is possible) and *construct* (what is said), the former has no being without the latter. Going further down this line of thinking: construct is not simply what is said, but how it is said. The how, the details of composition, creates the form of the fable being told.

Using these same terms from the point of view of the writer requires some adjustment. Most importantly, the *fable* must remain malleable and accessible to constant adjustment. The story changes in its telling, is changed by the act of telling. The making of a construct must alter the fable being told.

At this point in composition, we have a *premonition of plot*, a sense of how the story will be carried forward, how it will be structured. It is only in the act of writing that this premonition will become tellable plot. It is only as decisions are taken and the consequences of those decisions followed that our sense of the story's structure will, in fact, be rendered into construct.

In this view of narrative there is a constant discourse between story and plot: the story pointing to specific needs; the working out of those needs in the details of composition shedding new light upon the story. It's a cycle of knowledge and discovery; knowing a story enough to start writing, discovering story by writing, knowing the new story, writing to further discovery. And on and on.

[12] David Lodge, *The Practice of Writing*, p. 208

It is a fallacy that a plot can be worked out prior to composition. It is impossible to know a plot without making one.

TURNING THEORY TO TASK

Taking the vantage of the screenwriter confronting the blank computer screen, there are several ways in which the theoretical framework sketched previously will prove useful.

The notion of a fable provides a way to approach and hold a story before it is composed into a plot.

The notion of a fable provides a way to approach and hold a story before it is composed into a plot. It can give the author a greater sense of confidence and comfort. That is, thinking of the yet-to-be-written story—the fable—as a field of possible choices can lead to discovery and risk. It provides a counter-pressure to the idea that the story and plot should spring whole from the writer's head, needing only to be typed up. Thinking of the unfinished story as a *fable* provides a way of conceptualizing the act of imagination.

There have been many instances where students of mine have complained of being blocked. "My story is stuck," they say. I suggest they feel stymied because their initial choices have led them to think of their "story" as the first draft of the outline. They have become captive to their idea of plot. Reminding them that the fable is larger than any particular decision, any given plot point, has often opened up new ways of thinking about their story.

If you are stuck, go back to fable, go back to the originating image, the initial decisions. Swim about in the sea of possibilities and make some new decisions. See where that leads you. Invariably, such an exercise will break the block and get you writing again.

Thinking of event as an element of plot, and not plot itself, should likewise engender a sense of freedom and choice.

You are struck by a fable that needs telling. This could come from an image (a bomb goes off in lower Manhattan, a shark devours a skinny-dipper) or a thematic idea (the redemptive power of love, the fruitlessness of revenge); your fable could be a fact from history or personal experience. It could be a single character, or a single line of dialogue. Any of these originating ideas might prompt a desire for further exploration, mulling, research, deep thinking... until the nebulous and unwieldy fable begins to take form into a tellable construct.

Among the first things to help nail the amorphous fable into the writer's imagination is event. There are certain things that we know

will happen. Boy will meet girl. Villain will be defeated. Cops will chase robbers. The father will die.

These events stand as landmarks in the murky swamp of the untold/unformed fable. They help us through the myriad choices and decisions we must make on the journey toward narrative. Event stands, with the originating image or impulse, as the *what* of your story.

But *what*, in and of itself is not interesting. Certainly is not dramatic. What transforms an event into a dramatic event is *why*. Motive. And how do we achieve motive in drama? Through character.

By articulating a character's behavior and instilling in them need and motive and ambition—fear and loathing and love—we can begin to build on our nebulous intention (our theme or image or idea) and transform it from abstraction to legible enactment. It is character that transforms fable into plot. Event motivated by character leads to plot. Idea embodied by behavior leads to plot.

That is to say—given an originating impulse or image, given a selection of possible events—it is the way we approach the actors of the drama, their choices and decisions, their peculiar and idiosyncratic habits and desires, that provide the guidelines, the compass, that will help the writer choose and motivate event, that will carve from the unwieldy fable a tellable construct.

Judging event by the qualities of motivation and consequence prevents the writer from thinking of plot as distinct from character.

Judging event by the qualities of motivation and consequence prevents the writer from thinking of plot as distinct from character.

The plot of a narrative is not simply the chronological outline of the events that comprise it. The events must have a logic. They must have a relation to one another that creates the sensation of propriety. Of compelling necessity.

A well-constructed plot generates a satisfied feeling of appropriateness. Of inevitability. That it could not be any other way.

Plots are not believable. Characters are believable. Plots are compelling. The effective plot surprises and satisfies as it unfolds. But it is important to realize that surprise alone is insufficient virtue. What makes a dramatic turn in a plot most satisfying—no matter how surprising—is if, once the twist has occurred, the audience cannot imagine the plot otherwise. If it seems—after the fact—inevitable. Right. The right thing. In any plot, there is always a balance between expectation (predictability) and surprise.

Understand, I am not saying that answers to these questions are in any way absolute. Given two writers, two different sets of answers

will arise from the same set of questions. The writer's own preoccupations and predilections—their agenda—will determine which questions are most interesting (to them) and therefore which answers will help carve story from fable.

Your intent will guide you to character, your characters will guide you to event and plot. Trust your purpose. And trust that your characters will teach you how to tell.

Character provides the bridge between fable and construct. That's the punch line. That's how the nature of the deformation is determined. That is to say, confronted with the unwieldy chaos of fable, and looking to shape it into a tellable construct, one should first ask questions about the major actors in the story—what are their needs and ambitions, where do they collide, what suspense and interest can be generated by manipulating their conflict, with whom will the reader identify and why? Answering these and related questions of character action and decision will automatically determine which parts of the fable are relevant to the making of the construct.

A story is comprised of a series of events. How events are linked, how they lead from this to that, how a character rides them like a surfer—that is plot.

It bears repeating: if event is not motivated by compelling character you are left with spectacle.

Not that spectacle can't be entertaining. Much of modern moviemaking is simply spectacle. But the films that stick, the ones that persist, the ones that become classics, the ones, usually, that make money, are the ones driven—no matter the genre—by believable characters generating compelling plots.

Character mediates the transformation from fable through event to plotted construct.

Character mediates the transformation from fable through event to plotted construct.

From this vantage plot is not primary to character. Nor is character separate from plot. The most useful way for the writer confronted by the blank page to think of character and plot is symbiosis. They need one another. They feed one another. They have an intricate and insistent relation. Each changes and informs the other toward the unity that is the composed narrative. The construct.

GETTING READY

———— MASTER SHOT SCREENPLAY ————

Screenplays come in three distinct flavors: master shot, shooting script, and continuity.[1] Before we settle into discussing how to go about making one, let's be clear about which of the three flavors we are trying to master.

Most of the screenplays available for purchase in a bookstore, and many that you can find on the Internet, are more accurately called *continuities*. That is, they are a record of what was actually shot when a film was made. They contain all the accidents that occurred on set, and the improvisations (or mistakes) made by the actors; they leave out descriptions or scenes from the original that were not shot, or add scenes that were never in the screenplay. In most cases these post-production documents are put together by the production department based upon the writer's work, but edited and added to according to what happened during the filming.

A continuity is a screenplay *after the fact* of the film. It has no bearing on our task. And so I warn you—if you are looking to published continuities for models, you are looking at a distinct and separate form. Despite being an accurate text depiction of the film as shot, it likely no longer conveys precisely those things that caused someone to say *yes*. It may have lost some of the seductive power of the original screenplay.

The second flavor of screenplay is the *shooting script*. This version of the screenplay is a production tool put together by the director and

[1] There's a fourth form of pseudo-screenplay available on the Internet called a *transcription*. Beware. These are created by fans and are simply transcribed dialogue from the released film. They aren't screenplays at all.

Screenwriter's Compass.
© 2012 Guy Gallo. Published by Elsevier Inc. All rights reserved.

his various departments—sometimes with the original writer, some-times not—as a working tool for the day-to-day shooting of the film. At its most extreme, a shooting script will delineate—and number—each of the hundreds of individual camera setups, with camera angles, movement, and distance specified. This intermediate step between the screenplay and the film is used less now than it was in the heyday of the Hollywood System, but often enough to note and to understand. What you download from the Internet as a screenplay for a block-buster film might be a shooting script whose intended audience was the elite coterie of technicians who made the film.

A shooting script is a screenplay *during* the filming. And like the continuity, its purpose is not to seduce and convince and cajole some-one into giving you money. It comes into existence only after someone has agreed to make the film.

That leaves the last (or first) flavor of screenplay. The only one that is relevant to our endeavor. The screenplay written by a single author (or collaborating partners), with a single vision. Its audience is the agent, producer, director, actor whose approbation might lead to a contract, a second draft, a shooting script, a film.

This is referred to as a *master shot screenplay*. Let's use an extreme example to explain "master shot." Say you are filming a scene in a bar. At some point you will place a camera in a position that captures the totality of the place. And the actors will play the entire scene. Then the camera will be moved for closer shots of the two main actors. There will be close–ups. There will be over the shoulder shots of the conver-sation. Inserts of the pool table or the bartender or the empty beer bot-tle. The editor then puts together the scene as it will appear on screen by selecting and arranging all these various angles and distances. The master shot establishes the basic geography of the space (e.g., a bar; on the right: the exit; in the background: a pool table). And as the editor puts the scene together, she always has the "master shot" to go back to in order to give it shape.

Unlike a shooting script, the master shot screenplay does not break the script down into individual shots, but rather composes with the scene as the smallest unit. Each master shot constitutes a scene, and within that scene it is left to paragraphing to suggest the individual shots or camera angles or movement.

A master shot screenplay is the screenplay *before* the film. The task isn't to specify each camera angle and setup. Rather it is to tell the story sneakily, with cinematic inferences rather than instructions. With angles and movement and cinematic tricks implied rather than speci-fied. The highest virtue of a screenplay, seen from this vantage, is not to describe a possible film, but to be easily read, to be compelling, to indicate the film without ever causing your reader to pause. It has to be both a good read—a good bit of prose combined with a good bit of

theatre—and at the same time it has to be attentive to the peculiar syntax and conventions of film.

It's a lot harder than it seems to most people.

The task of the master shot screenplay is very specific: to seduce a series of professionals into doing what you want them to do. You want the agent to represent you. You want the actor to play the hero. You want the producer to write you a check. You want the studio executive to green light production. You want the director (even if you *are* the director[2]) to realize, as much as possible, the film you originally imagined.

At the same time, the screenplay has to be easy to read, has to tell a compelling story, has to weave together all the threads of your theme, story, plot. And make it look easy and effortless.

The master shot screenplay is both a teaching document and an act of seduction.

The master shot screenplay is both a teaching document and an act of seduction.

That's a lot to ask of 120 pages. But there it is.

——— READING SCREENPLAYS ———

It can be extremely useful to read screenplays. Especially for films you particularly admire or that are similar to the one you are writing yourself. But when you read a screenplay don't ask, *How'd they make this into a film?* Ask, *Why did they say yes?*

Questions about what was changed, what deleted, what improvised, about what the director did with the screenplay, where his vision complemented or contradicted the writer's—these are questions for an academic paper. They do not help us to understand why this screenplay succeeded, how it began the long journey toward a film production. It does not help us to write a screenplay.

The finished film does not tell us why it got made. It tells us what happened *after* it went into production. What's useful for a

[2] I once worked as dramaturg to Athol Fugard. He was directing one of his own plays. He said my job was to mediate between the writer and director. Which puzzled me for a moment, as he was both. "When I write, I am only the writer," he said. "When I direct, I am only the director." Even if you are directing your own script, you need to finish it *as writer* before you can take it apart and put it back together *as director*.

screenwriter to learn from a screenplay (which is why continuities are of little utility) is how the writer seduced and compelled the reader.

When reading a screenplay look for those moments, inventions, and originalities that caused a reader to lean forward, caused them to continue reading, and ultimately led them to say *yes*. What made the producer write a check and the studio to green-light a production? Look for those things that jump off the page, the unique or startling; look for how the writer generated surprise, how they delineated character. What makes you say you wish you'd written it? Those are the things the reader likely appreciated. Those are the things to understand and emulate.

─────── COMPOSITION CREATES STORY ───────

Prior to actually doing the dirty work of composing a scene we have an amorphous idea of story. We hold in our heads an amalgam of images and thematic urgencies and story elements. As we sit down to actually put the characters in motion, enacting needs and desires, describing the behavior of the scene's actors, we often, too often, do so with the story needs dictating the limits and shape of the scene. This is what I would call writing from the top down, writing from the story and plot down to the character and behavior and gesture. Too often, when this approach is taken (and it is by far the easier or more obvious method) the scene feels stilted or, worse, forced.

Composition creates story. If you trust your vision, if you trust your characters—then you can write the scene first and foremost with an eye to the needs of the scene. And the story will find expression. It may even find new or different expression than the one you expected. But it will be true to the characters. It will tell, in every given instant of your screenplay, what *needs* to be told. Not what you thought needed to be told. There is a difference.

The details of character gesture and speech, the minutia of behavior and background action, are not simply texture and color, they are not simply illustrations of character and story. Discovering truly authentic and compelling details actually generates story, reveals character. When we discover the correct word, the correct gesture or movement, location or weather, we are not filling in the blanks of some pre-existing idea of plot and story. We are, in fact, creating the story in its articulation.

What follows will give you ways of thinking about scene construction and character development that will help you move from story to event to plot—creating the arena, the landscape, in which dramatic action can occur. And ways to begin the colloquy between author and character.

The key is to always be willing to adjust. To view both character and plot as malleable. To continually frame the debate, to ask the proper and challenging questions: of yourself, of your cast of characters, of your plot, of your story.

This process of constantly arguing with your story—and risking the wasted time of the blind alley and false lead—will maximize the chances that you will, eventually, after the hard work of composition and recomposition, create a uniquely voiced and logically self-consistent fictional universe.

It will maximize the chances of what I call *the happy accident of writing*. Of true writing that includes discovery and risk, and the surprising reward of writing what you did not plan on writing. Of truly channeling the truth of your story and your characters.

If you write what you set out to write, you are not writing.

If you write what you set out to write, you are not writing. You need to put yourself in a place where you are open to discovery, to risk and failure. You need to let the act of composition teach you something you didn't know. It's a mark of things going well when you reread your work the next day and don't recall writing a sentence. When you surprise yourself.

It is only by creating the circumstance amenable to composition, opening yourself to learning as you write, that you can hope to find your own voice and the voice of the characters carrying your story. It is only then, as you pry open your presumptions about your plot, that you make room for the specific genius of your story to enter. And only then can you hope to create a screenplay that it is impossible for your reader to put down.

——— ON OUTLINES ———

The general (and misguided) emphasis on plot and structure has led to an abuse of outlining. Many believe (are taught or have read) that they must have a complete outline of their story before they can begin writing scenes.

I believe this view of the outline is more than wrong, it can be destructive.

A meticulous outline can give the false impression of completion; it can induce you to write *to* the outline rather than *from* it. This can result in a scene or character that has been manipulated and strained in order the fit the shape dictated by the outline.

Some proponents of the outline go to extremes. They recommend what has come to be known as "step outlines" or "beat sheets." The

former strives to list not simply the plot points and twists that the story will take, but the steps to reach each. The beat sheet strives for even more detail. The writer is expected to know and put down each minute dramatic moment.

If you expend that much imagination and energy on the outline, why not write the screenplay? Why not struggle through the decisions and discovery in the dramatic form—with characters in a space, speaking in voices, with desires and ambitions enacted?

Getting too detailed in your step outline may have the undesirable effect of making your story static. And, more dangerously, it may limit your imagination. If you write to fill an outline, the field of possible choices, however unconsciously, are narrowed. The presumption becomes that moving from A to B—two points on the outline—constitutes success.

There is, in this attitude, no room for discovery.

In my experience, screenplays written from the top down, from meticulously detailed outlines, have a sameness, a suddenness, all plot or all concept, all flash and no depth. They have no center.

Here are my thoughts on outlines:

- An outline stands as an ordered record of what you know about your story at any given instant.
- It should change and deepen during composition. It must remain malleable.
- The outline is a list of what needs to happen. It should be, in the broadest and most flexible way, a tool to enable dialogue between the fable and the construct, between author's intention and audience's expectation.

By emphasizing the flexibility of an outline rather than its comforting structure, by always remembering the symbiotic relation between outline and composition, between character and plot, you will be freed from constraint, will have a tool to battle writer's block, will become more open to discovery. You will be in a better position to write a complete and consistent screenplay rather than a description of an imagined movie.

The outline should never get in the way of your access to the rich chaos of fable.

Treating the outline as a malleable and fluid tool will help to remind you that the story you are molding from the source material grows out of your writing, it does not determine your writing. It will give you access—when you are blocked or confused—to that earlier step: the original impulse or idea, the fable that first sparked your imagination and begged for articulation. The outline should never get in the way

of your access to the rich chaos of fable. By continually reaching back to your original impulse, to the untellable fable, you will find fresh and unexpected solutions to the problems that arise while forging story into plot, fable into construct.

I am not saying do not outline. I am suggesting that in the early stages of composition your goal is to get just enough of a sense of the story's shape, to hear just enough of the characters' voices, to begin writing scenes.

So, yes, start an outline. Don't be surprised if the events and chronology of Act I and II are a whole lot thicker than Act III. Don't fret. Just jot down what you know as you learn it.

An outline should reflect what you know about your story at any given moment. It should contain the landmarks that you know will be in the finished screenplay. It should get filled in as you learn more. You should think of it as a tool. It is not for public consumption (any more than your notes and research are for others to read).

...an outline reflects the current state of your understanding of story.

Rather than think of the outline as a shorthand description of your story, think of it as a list of current decisions taken in the transformation from fable to construct. Doing so will open up the creative space. It is important to emphasize that an outline reflects the current state of your understanding of story.

It is also important to constantly remember that the fable is larger than the series of decisions taken in order to render it tellable. That is to say, when you are stuck and staring at your outline, and trying to break through a particularly difficult block—it is important to recall that the outline is just one possible solution, that you can return to the fable and make a different decision—that the story is not stuck, the plot is. If the outline gets in the way, change it.

ON CHARACTER HISTORIES

Create a dedicated file for your character notes. Or even better, use a notebook. It's easier to brainstorm on paper, where it doesn't look so carved in stone as it does on a computer screen. In this notebook, try out various names and combinations of names. Start building histories for your characters.

Start out small with details that are immediately pertinent and visible in the character's introduction. Age, class, ethnicity. Things that will be manifest in the first image. Jot down ideas for background: birthplace, education, family configuration.

Write lines of dialogue (disconnected from a particular scene or particular information) in an effort to get a hint of voice. That's the biggest hurdle. To find that first bit of speech that you know only this character could utter. I have found that nothing sets the imagination off like a line of dialogue that surprises me, that seems to show up out of the ether. As if I were being spoken to by my character rather than transcribing and adapting my own words to fit.

Don't just think in terms of the past. Take notes about current behavioral quirks. Is there a limp? A phobia? Hung over? Needs a haircut? Anything you can think of that will give aspect to your characters, that will thicken the texture of their presence on the page. Character notes are a tool for finding your characters' unique voices, their particular gestures and habits. And like the outline, this character notebook should grow and change as you compose.

Some take this idea of a character notebook to a greater extreme, writing cogent narratives, little mini-biographies. What they have for breakfast. Favorite books and movies. Whatever gets you writing, and organizing your thoughts and your scribbles, is a good thing. If a character history that reads like a short story appeals to you, I say go for it. But bear in mind that, like the overly articulated outline, the extensive character narrative has its dangers.

For one thing, it takes a lot of energy, energy that could be poured into writing scenes. There is the danger that you will become overly invested in something that took so much time (and looks so pretty and finished when printed).

Keep reminding yourself that a character history—like an outline—is a working tool. Do whatever helps you to think about and deepen your understanding of your character, whether disjointed notes on paper napkins or a cleanly narrated history.

You learn most about your characters not by thinking about them, but by putting them in a room with other characters and having them behave.

But at a certain point you have to stop thinking and start making. You learn most about your characters not by thinking about them, but by putting them in a room with other characters and having them behave. You discover character from the act of making the character, not by thinking about it.

We don't just build characters from their history. We build them from the present tense. There are three distinct things to consider: what they do, how they react to others or events, and how others react to them. You can tell a lot about a character by how the other actors in the scene treat them. So, as you take notes on your character, or as

you stand them up in scenes, remember to think of the entire arena, the entire scene. How does your character respond to the space, to the geography, including the objects? How does your character interact with the other actors in the scene, and how do they react to your main character?

ON TREATMENTS

A treatment is a narrative presentation of your story idea. It is a description of your intention, a legible rendering of your story ambition.

But, as I assume you can gather by now, I do not believe a treatment can ever truly represent the screenplay you will ultimately write, because writing the screenplay will inevitably change and enhance your story. I hate treatments. I'd rather spend that energy writing the script.

A treatment is a legible rendering of your story ambition.

Be that as it may, treatments are a reality of the industry. You may be asked to write one. You may even get paid to write one.

It's also possible to render a treatment useful, to make it a tool, like an outline. But you must approach the treatment cautiously, aware of its limitations.

There are two ways to think of a film treatment:

- Articulating your story—what you know of your story before actually finishing it—to yourself.
- Pitching the story's potential to someone else.

The first is a working document. The second is a sales document.

A story is bound to change, to thicken and deepen, perhaps change radically, in the process of writing the screenplay. So a treatment (or an outline, for that matter) is a snapshot of what you know about your story and its shape at any given time.

Some writers spend a great deal of time on their treatments before setting to the work of writing the screenplay. I wonder if they aren't expending energy better spent on writing scenes.

Some writers do no treatment or outline at all and simply jump in. That can be exhilarating and terrifying.

If you think of a treatment as a private document, a working document, then its utility—for the writing—is manifest. It becomes an organizing tool for all the random and disparate notes you have taken on the project.

But it is very different if you are talking to the world rather than talking to yourself.

If you persist in writing screenplays, likely you will be asked to compose a treatment of your story. Sometimes a treatment will be the first paid step in a work-for-hire contract. Though more often it is a less formal (and unpaid) document done as part of a pitch to a producer or a studio in order to interest them in writing you a check to write the screenplay.

It's important to realize that any treatment you write for public consumption that describes the story prior to the actual writing of the screenplay is a marketing document, not a working document.

Remember that the sales document treatment needs to accomplish two things: convey your passion for the subject and inspire the reader to appreciate the potential of the imagined film. It needs to interest a reader who knows nothing about your story.

Remember that the working document treatment needs to help you through the work of composing the screenplay. It needs to phrase the unknown well, to pose questions, to leave space for discovery. It needs to interest (and challenge) you.

Bear this dichotomy in mind. And realize that rarely does a treatment accomplish both tasks—selling and working document. Think why you are writing a treatment, consider the purpose and the audience.

And never forget that a treatment—of either variety—is not a screenplay. The problem with a treatment is that it forces you to tell. Not enact. It can never have the same impact as characters in motion.

——— ON ADAPTATION ———

Bearing in mind the ideas of narrative structure outlined above, you could say that all screenwriting is an act of adaptation. Even with an original idea, you are adapting the raw material of the fable into the construct of a screenplay. But what of adaptation of an existing work? Of someone else's fable? How are these ideas useful?

The majority of screenplays written are original to the author. But the majority of films *made* these days are based upon novels, comic books, older films, or newspaper articles. Why are so many films adaptations? The answer returns us to one of the points made at the outset. Hollywood is driven by fear. And one way to minimize the risk associated with putting a film into production is to be able to point to a track record. The novel was a success. The comic book has a following. The earlier version of the film was a classic. An adaptation comes with a pedigree.

Certainly there are a great many original films being made in long–form television, as independent features, and by individuals on a micro–budget. But even if your hoped for market is one of these

alternative outlets, the chances are, if you succeed in finding any place in the film industry, or if you are already in the industry, you will be asked to adapt someone else's story. It therefore behooves us to think a bit about adaptation.

What's the difference between an original screenplay and an adaptation? The most obvious answer has to do with personal stake, with passion. That is, the original is seen as an order higher than the adaptation because the fable comes from some mysterious, deep place within the author's imagination. It strikes us as having greater authenticity since it originates with the writer.

And it is true, the original story requires an initial leap into the void to imagine the fable.

But, I would argue, even when the work is an adaptation "work–for–hire," the screenwriter appropriates the source material, and the fable acquires just as great a level of importance and passion as the fully original idea. If it didn't, you wouldn't be able to write it.

The real difference between a wholly original screenplay and one adapted from existing material lies in the author's proprietary, not creative, relation to the fable being adapted into a screenplay construct. It's still a fable. And the tasks of inhabiting that fable and articulating a story from it are the same.

As a result, all that is said in this book about the making of a screenplay obtains both for fully original and for adapted works. The things you need to consider, the questions you need to ask, the procedures to prepare, and most importantly, the ways in which character and plot interact are all the same.

That said, there are a few ideas specific to adaptation that we should consider.

Types of Adaptation

Adaptations come in several flavors:

- The Prestige Adaptation. A classic or popular book is adapted with a fair degree of fidelity. Think *Out of Africa*, *The Color Purple*, and *Under the Volcano*. *Harry Potter* and *Lord of the Rings* would be examples of this type that are both prestigious and popular.
- The Straight Up Adaptation. The book is relatively unknown, or is an obscure genre piece, or a work of nonfiction. The film is more important than the source. Think *Social Network*, *Slumdog Millionaire*, or *Die Hard* (yes, that was an adaptation).
- Adaptation as Reimagining. The writer takes the source material as the starting point for what is essentially an original vision. Think *Prospero's Books* and *Apocalypse Now*.

These three general types map to a spectrum of fidelity. The first (and to a degree, the second) would be what I call a *transposition*—where the goal is to adapt the source material in such a way that the most salient features are still there, still visible. It is recognizably an adaptation. It's still *Amadeus*. The third is what I would term a *transformation.* Here the source material is, to one degree or another, left behind. Sometimes, the source material vanishes. You'd have to be told that the filmmaker was adapting an existing story. For instance, *My Own Private Idaho* is in part an updated version of Shakespeare's Henry plays.

So, the first question to ask is why are you adapting a book? Are you trying to represent the book in film? Are you constrained by the material's provenance, with a mandate to remain as faithful as possible? Or are you using the source material as an excuse for original work?

Fidelity

Fidelity is not a virtue when adapting a novel into a screenplay. That is to say, if you strive for a one-to-one correspondence between the source material and what is in the screenplay you are doomed to failure.

The forms are just too different. Every adaptation takes liberties. You will always have to modify (and invent) dialogue, condense the plot, perhaps combine characters. You will always have to invent new action, new scenes. You will undoubtedly have to leave things out.

In adapting *Under the Volcano* I combined two characters. Actually, in the final script, you could say I killed off a fairly major character. It was a big change. And it was the reason John Huston liked my first draft and asked me to work on a revision.

I was asked many times how I could dare to take a cult classic like *Under the Volcano* and make so many changes. My response was to quote Malcolm Lowry—the author of *Under the Volcano*—who wrote a screenplay based on *Tender Is the Night*. When he handed his draft to a producer he said, "We've left out enough for a Puccini opera, but here it is." Lowry himself understood that adapting a novel requires major changes and omissions.

The reasons a novel cannot be simply transcribed into screenplay format are many and various. A book is full of things that cannot be accurately adapted to screen. Style, use of time, perhaps even tone. The fact of a narrating voice. The use of point of view. The simple fact that films are apprehended—immediate—whereas novels are comprehended over time. You can puzzle over a passage in a novel, pause, reread, go back, read again. A film moves relentlessly forward.

Your task is to burrow through the thing in your hand—the construct that is the published book—and try to recreate the fable, that larger-than-fiction realm of possible story elements from which the author crafted this particular construct. You are not adapting the aesthetic

whole of the construct. You are adapting the fable of the construct, using select elements of the existing articulation, inventing others.

The goal of the "faithful" adaptation is not to be literally true to every aspect of the novel. It is to locate and transpose to film that portion of the complex work without which it would no longer be recognizable as the work.

The first task of adaptation is an act of literary criticism. You have to figure out—to your own satisfaction—the thematic and story center of the object that you are adapting. What makes it what it is?

I would argue that what is most essential in an adaptation is trying to be true to the author's intent, not his writing. His writing is specific to the novel.

Transformation

When using a supplied work as a jumping off point for a radical transformation, the source material is almost incidental. It should be seen as the engine and excuse for what is essentially an original work. For example: *Ran* (*King Lear*), *Apocalypse Now* (*Heart of Darkness*), *Clueless* (*Emma*), and *West Side Story* (*Romeo and Juliet*).

These types of adaptations do the same thing as a transposition. They return to the fable of the original novel. The difference is that they have only a glancing relation to the novel as construct. They may take only one or two elements from the underlying story, or they may dispense with the novel except as a loose outline for event and plot.

The same questions apply when doing a transformative adaptation. The difference is in emphasis. Rather than looking for the ways in which the source material will be rendered visible and useful, you are looking for ways to diverge from the original construct, perhaps even from the originating fable.

A transformation may actually contravene the author's original intent. Compare Disney's *The Little Mermaid* to Anderson's original. Or it may be that the theme is the only recognizable thing that remains. Take for example *Apocalypse Now/Heart of Darkness* or (even more tangentially) *O Brother, Where Art Thou/The Odyssey*.

Narrative Time versus Story Time

One of the most significant differences between a novel and a film lies in the manipulation of time. In a novel, each sentence of a paragraph can refer to a different time. Take, for instance, the following:

```
Cecelia arrived in New York, filled with
expectation, shortly after the failure of
her second marriage. Now she is homeless and
alone.
```

This paragraph refers to three different times. But it does not do so in chronological order. That is, the first time is when she arrived, the second is her second marriage's failure, and only the third is present tense. It refers to past, distant past, and present, in that order.

There is a collision, in this paragraph, between what literary critics would call *narrative time*—the order in which it is told—and *story time*—the order in which it actually happened (in the fable).

Novels allow great flexibility in moving from one time to another. It is a very trivial thing to manipulate story time. With a single sentence the narrative time may jump backward (or forward) by decades. One chapter can be in the present tense of the narrative voice, the next chapter generations before, the third leaping into the future. In a novel there is almost always a considered collision between story time and narrative time.

In film, narrative time and story time are usually the same. Exceptions made for extremely nonlinear films, or for films whose entire premise is the manipulation of time (such as *Memento*).

Even when a film is built on flashbacks, it is usually the case that there are only two times between which the film alternates. And, I would argue, each time seems to be, when we are in it, the present tense of the film. A great example would be *Godfather II*, which alternates between two distinct stories, one set in the 1920s of Vito Corleone's early life up to his revenge killing of the man who killed his father and brother, and the other set in the 1950s, following Michael Corleone's unraveling the mystery of a failed assassination attempt (among other things). The two stories are linked only in theme, not narratively, or even cinematically. And when we move between them we move—fully—into that story's present tense.

Film is always present tense, moving forward in an imagined now.

Film is always present tense, moving forward in an imagined now.

Therefore, one of the major tasks of adaption is to hammer out the portion of the story that takes place within a single time frame. And what to do with all the references to other time periods to which the novel so casually refers? Are they useful? Necessary? Only part of the character backstory?

Film Storytelling

How best to gather from the field of possible story elements those that are most amenable to film storytelling?

The most important thing to remember is that film shows enacted behavior, whereas a novel tells the reader the meaning of described behavior. A novel has an authorial voice that we believe. A film depicts behavior that we find compelling.

In adaptation you must find the active gesture and conflict that will embody the "told story" of the novel.

And of course, you need to avail yourself of the many visual tools and techniques of film. You need to let images help you tell the story. Image and physical geography, close-up and camera movement, variation of scene length and light quality. These are techniques that can help to render a purely literary story into a film story.

A novel always has a narrating position or point of view. Whether first person or third, authoritative or unreliable, there is a narrating voice. Film cannot present an authorial voice. It is an objective medium. There are exceptions—using voice-over to give a sense of point of view, or experiments in subjective point of view—but in the main film has no discernible narrator or narrating point of view.

I can hear objections that the point of view in film is supplied by the main protagonist—who, in some films, occupies a position in every scene. That is certainly true. But we are not seeing the story exclusively through the limitations of their vision as we are in a novel.

In a novel we are told the inner thoughts, we are given the meaning of a character's behavior as well as the behavior itself. In a film, we are limited to what can be enacted. And the meaning manifests from the physical action. The inner states are implied by the dialogue and behavior.

A screenplay does not have the luxury of the authorial teller. We can only show. Show in a way that will most effectively induce the reader to fill in the proper blanks.

You may resort to voice-over to attempt to capture the novel's voice if that voice is part of the reason you are adapting the book—for instance my adaptation of *Adventures of Huckleberry Finn*. Another instance where the use of narrative voice-over is totally justified would be *Sunset Boulevard*, where the whole trick of the film lies in the fact that it's being narrated by a dead man.

But you should avoid reaching for voice-over narration as a first solution when adapting a novel. It is too easy to use this device to fill in story blanks with telling.

Similarly, writers reach too easily for the flashback in order to replicate the temporal flexibility of fiction.

First try to adapt the fable of the novel, transposing it into the new form of film. And then, after you have a workable draft, decide if the devices of voice-over or flashback are truly warranted by the needs of the storytelling.

Tasks of Adaptation

Here is a breakdown of what I believe are the questions to ask when starting an adaptation:

- What is the originating impulse? What drew you to the story? What idea, character, image caused in you the shiver of recognition and need?
- What is the author's intent? What theme is the book trying to carry? What is the heart of the book, without which it is not the book?
- What is the object? A critical look at how the novel/play/true story works. How it does what it does, how it accomplishes the shiver. How does it articulate the theme, the author's intent? Taking it apart down to its essential story, down to the thing without which it is no longer the story that you want to tell.
- What can be transposed to film? Some elements will jump out as inappropriate to film. Some will just seem not worth the bother. What elements of the story will supply the building blocks for the new form?
- What must be transposed to effect minimal fidelity? Of the elements that can be transposed (or adapted), which are required? That is, which elements have most significance, without which it's a different story?
- What should be transposed to complete the adaptation? From among the other elements you have a wide range of choices. The choices we make during the process of rebuilding the fable into a new "motivated deformation" should reflect back upon—or rather draw direction and purpose from—the originating impulse.
- What must be created? In virtually every adaptation there will be things that cannot be translated, holes no one notices in the narrative form that are glaring in film, omissions or coincidences to be healed. To a greater or lesser degree every adaptation will require invention. The caveat is this: Even things created from whole cloth should take guidance from the necessities of the originating impulse.

How these questions apply when looking at a novel or play or memoir being transposed into a screenplay is pretty obvious. But, in fact, they are also applicable to your original fable. You still have to always keep in mind your originating impulse, hold fast to your intent, choose from a range of possibilities those which are most filmic, be true to the elements without which it is no longer the story you want to tell, and be flexible enough to discover new and unexpected solutions.

 4

FIRST DRAFT

——— **THE BLANK PAGE** ———

Planning to write is not writing. Outlining...is not writing. Researching is not writing. Talking to people about what you're doing, none of that is writing. Writing is writing.

—E. L. Doctorow

Jump In

It is never too early to start writing the first scene. The sooner you get your characters up on their feet, walking about in an imagined geography, and talking to one another, the sooner you will be able to learn more about your fable and about the direction to take to turn it into a constructed narrative.

It's true that you have to have some idea of shape and character in your head before you start writing scenes. But I'm trying to dispel the notion that there is a correct order of composition. That the outline must come first. Then the character history. Then a treatment. And finally, the opening scene.

That isn't how the creative mind works. We do all these things at once. We pick up the outline to avoid doing scene work. We do character study when the outline turns obstinate.

If you think of the outline, history, and treatment as working tools—as private methods of organizing imagination—then it should be obvious that they can be used simultaneously and throughout the composition of the screenplay.

Show Up

Some thoughts on how to face the daunting recriminations of the blank page. The first order of business is to show up. Writing is difficult—in part because it is so easy to avoid. Especially if you write on a computer. There are so many readily available distractions. You know you've done it. Sat down to write and ended up doing e-mail or shopping on Amazon or surfing through the headlines.

I like to think of the writer's discipline this way: "Optimizing the possibility for the happy accident of writing to occur." You've got to be there when insight or inspiration happens.

Discipline is horrifically difficult to maintain.

One suggestion—and it has worked for me—is to carve out from your daily schedule a time that can be devoted to writing. Even if it is only an hour. Even if it means setting the alarm an hour early.

For that one hour (or two, or more if you can manage the stamina) you cannot check e-mail, you cannot surf the Web. You must write. Something. Anything.

If you stick to this for a week, you'll find it gets easier. Like going to the gym. It will become a habit. And your hour may turn into two. Two into three.

But you have to show up. You have to be there writing junk in order for the not-junk to appear. You have to be available to the muse. She's not going to go out of her way to find you.

- Think of the task as writing one good sentence rather than one good scene. One sentence at a time.
- Get a composition book—an old fashioned notebook, the cheaper the better—to scribble notes in. Don't use a fancy leather journal. Use something you won't mind wasting, making mistakes, risking foolishness. Don't think of it as a record of anything, but as a writer's Etch-a-Sketch.
- Don't bring the entire weight of your story and theme and political agenda to the blank page. Write the scene, not the importance of the scene. Let your agenda manifest.
- Most importantly, be willing to fail. Try stuff. Nothing is wasted, nothing is precious.

Genre

Spend some time thinking about genre. Are you setting out to write a Western, a Romantic Comedy, a Film Noir, a Thriller? Is your idea for a film a deliberate mix of genres? Is it a slice-of-life bit of realism or a fantastical journey?

Asking this question is important, as notions of verisimilitude, psychological authenticity, pacing, time flexibility, and even visual geography are slightly different with each genre.

Watch a lot of films in your chosen genre. Bear in mind that each genre has its own conventions. Internalize them.

Movies are made of other movies. Like literature, movies cannibalize all other movies. You aren't writing in a vacuum. There's a tradition of the Western or the Film Noir that you are either joining or commenting upon or violating. You cannot decide and articulate your position in regard to earlier examples if you haven't thought about genre.

I am not suggesting that you be slavish, that genre rules creativity. But it is part of the field of play. It is part of what you are using to form the construct of this particular fable.

The question becomes how can you make genre useful. And I would say you do so by first understanding the form as it has been practiced in the past; deciding your take on the genre; realizing the liberties or restrictions the genre implies. And then writing.

Experience versus Imagination

Writers don't write from experience, though many are resistant to admit that they don't… Writers write from empathy.
—Nikki Giovanni

The question comes up a lot. Should you limit yourself to what you know from personal experience?

There's an oft-quoted phrase: *Write what you know.* It's a fallacy. Wouldn't it make most of literature impossible? Most of film? If the writer were constrained to tell only those stories that had an intimate relation to his own (necessarily) limited experience?

The extreme form of this perspective is a kind of imaginative provincialism. It contains an element of political correctness. It insinuates that a rich man cannot write convincingly about the poor, or a man about a woman. It presumes that we all must stay within our class and gender and race when making stories, in order to be acceptably authentic.

I say nonsense.

You should write what you need to write no matter where it comes from, no matter how distant from your biography.

Writing is not simply a matter of transcribing (or tapping into) experience. It is an act of imaginative empathy.

You don't have to be a bank robber to write a heist movie. Or a sociopath to write about a serial killer.

Writers *imagine* characters. Through research and a hyperactive sense of empathy, we create characters other than ourselves.

Write what you can't not write.

And that must be true when crossing gender or racial boundaries as well.

Worrying about affronting others because you are writing about their "turf" is a sure recipe for block.

The better phrasing might be: *Write what you know in your bones, what you care about, what keeps you up at night.*

Write what you can't not write.

Nothing is off base, nothing disallowed. As long as you have passion and empathy, as long as you are committed in your composition, I say go for it. Whether it is a purely imagined universe, or from your direct experience, or a combination of both. Go for it.

Don't Be Precious

A frequent cause of being blocked on a scene (or sequence, or screenplay) is thinking it too important. That is, being precious about your agenda. You think it's got to be right, got to be perfect, got to get you a job, got to make you famous. No scene, sequence, screenplay can handle that kind of pressure.

So. The first thing to do is remember you like writing. That writing is fun. That rearranging words on the page, when it works, is a true and profound pleasure. If you've never experienced that pleasure then you aren't a writer and should stop now.

The second thing to do is remember that this screenplay you are writing is not your only screenplay. It is only one screenplay. Perhaps your first screenplay. But it isn't your last or your only. It's just one.

Posterity

Nothing kills creativity faster and more thoroughly than writing for posterity. It's just too much pressure. Write for now. For the fellow sitting next to you on the subway.

If you are trying to write a screenplay to become famous, or to solve world hunger, or to leave a legacy of brilliance to the generations to come, you are doomed.

During one of the many blocked times I have experienced, a friend offered this: "Your problem is you want to be a writer more than you want to write." It was a harsh condemnation. And, sadly, there was truth in it. I have to continually remind myself—difficult to do—that I love writing more than I love being a writer.

Remember that. You are a writer only if you are writing. You're only as good as the last sentence you managed to put down on paper.

Topicality

Just as daunting as looking into the future is looking too closely at the present. That is, worrying if your idea will be *topical*. Will it be hip enough? Will it catch the next wave?

First of all, no one knows what the next wave will be. We only see the wave when it breaks. Second, you are of your time. You cannot help it. So anything you write will also be of your time. It can't be otherwise.

Everything that you know, that you've experienced, that is going on around you—everything—feeds into the script you are writing.

Concentrate on what you want to write, what moves you. And, perhaps, with some deal of unpredictable serendipity, it may prove to be ever so slightly ahead of the next wave.

But if you focus on trying to guess what's next, to mold your work to some idea of topicality, you will surely miss.

Revising As You Go

There are two types of screenwriters. Those who write forward relentlessly, and those who revise as they write.

There are virtues to each method. And pitfalls.

I call the relentlessly forward method *brain-dumping*. You have your story more or less in hand, perhaps you've done an outline. And now, once you start writing scenes, you write quickly and forward, without looking back. Chances are this method will result in a bloody mess, full of missing beats and overwritten scenes. Likely it will be too long when you finish. That's the bad news. But the good news is that this rush of words is sometimes the only way to get it down.

Brain-dumping is a way to avoid getting sidetracked by all the doubts and fears that naturally plague a writer. That is, writing forward without looking back is a way to plough through, intuitively, with as little self-consciousness and self-censorship as possible.

The other method—and the one I tend to use myself—is to carefully revise each scene. Start the day's work by looking back at yesterday's. If you're stuck, start reading at page one and revising.

The good news is that what you write will have much more polish when it arrives at first draft. The bad news is that sometimes we use this method to avoid writing. We spend too much time reading and revising and never get around to the new stuff.

As I said earlier, the act of composition—carefully rearranging words—leads to changes and discoveries in character and plot. It can actually change your story. It's my bias that considered composition should be happening even in the first draft. I believe the more you write, the more the two methods—intuitive dumping and analytical composition—blend together. The ideal is have both parts of the brain working as you write.

That said, whatever gets words down on the page is a good thing. There's no one method that's right for every writer. You need to find your own variation.

Slow Down

Don't write the end of the film in the beginning. Don't try and cover everything. Slow down. Let the first scene be that. The first scene.

I've seen it happen over and over. The writer tries to get it all in at once. The result is a rush of information, a thick conglomeration of backstory and foreshadowing—and a scene that doesn't play organically.

For each scene look for the organizing shape, the ruling point. If the scene feels overly complicated, if it seems to be trying to accomplish too much, then consider if it isn't actually two scenes. Save something for later.

You have to remember that you know more than your characters. You know—more or less—where the story is headed, where the turning points will be. You need to write each scene, particularly at the beginning, without letting that knowledge intrude. You need to limit what happens to what would happen, what the characters say to what they would say given what they know, not what you know.

Like so much else in screenwriting, it's a balancing act. The opening pages must be efficient. They have to get you to that first conflict, to the inciting incident that moves the story in a new direction. But they also have to establish the world. Give the reader some time to learn the rules of the universe and acquaint themselves with the characters. Don't rush toward a known event. Take your time. You can always go back and trim and cut. But in the first pass, let yourself enjoy the task of introducing the world.

Don't let the fact that you know where things are headed bias your writing of any given scene. Look first to what's happening in the instant—its needs, its limitations—and trust that if you are true to the scene it will lead you to the next necessity. Don't force information. Don't push the scene where it doesn't want to go. First, write the scene. Then follow its consequences and expectations to the next scene, and the next. I guarantee that your larger purpose will manifest, you will find your way toward the necessary plot point or reversal. And you will do so more organically the more you trust the scene at hand.

Innocent Reader

Earlier I proposed that your readers are often adversarial. We must now add that they are also innocent. They are new to your story, ignorant of your intention, literally an innocent in this new world you are creating. They do not have your comprehensive view of the story and theme. They are entering the world afresh. And the only tools they have to orient themselves within your fictional world are the ones that you supply.

It is your job to give your readers landmarks that anchor them into your imagined geography. Much of what I talk about is geared toward how to orient yourself, how to chart new territory, how to navigate the fictional landscape. But it is also important to realize that a great deal of the work of screenwriting concerns the meticulous creation of a world in which your naïve reader will be comfortable.

Part of this comfort is created by simple technical things like grammar and format and proper spelling—things that will not set the reader on guard. But it is also a deeper matter of emotional, visceral comfort. The reader must be given sufficient cause for empathy, moments of connection that involve them in the progress of the story. They must never feel lost or confused. Or if they are lost or confused they are so intentionally, for good reason, and still anchored by empathy or suspense.

SCENE AND ACTION DESCRIPTION

Setting

Prose description in a screenplay has two basic functions: to draw a picture of the location in which the scene takes place; to present the actions and behavior that take place within that arena.

In setting the scene you should focus on those aspects of the location that are obvious, and those that are salient. If there is a pink elephant in the room, it should appear in the first sentence. If the hero jumps off a balcony at the end of the scene, I should know it's there are the beginning. You should immediately describe those features that are prominent and those features that function in the scene.

This is especially important for the first time you introduce your reader to a location. The first paragraph should be a considered introduction to the geography. How that first paragraph is structured will determine how the reader enters the scene.

Do I see a character first? Or the details of the location? Is it a broad establishing shot? Or a close-up of one element of the location that then broadens out?

You control the reader's entrance into the scene through adept and thoughtful sentence and paragraph structure. Scene setting it not just what you describe, but the order in which you describe it.

Details

Before considering the various tactics you might use to cajole your reader into imagining the image in your head, you need to decide what to include. You can't say everything. How do you winnow down

the things you *could* describe to a manageable and effective handful of things you *should* describe?

Readers like lots of white space. If they flip through your script and find lots of dense description it will bias them against the read.

More importantly, over describing a scene slows things down. It can confuse the reader by inundating them with detail. The task is to select those specifics that help, that mean enough to tell, that generate interest or suspense.

The object of scene description in a screenplay is not to tell the reader everything they would see were they were watching the filmed scene. That's impossible. For one thing, what ends up on screen is a result of so many accidents and variables, so many other artisans' input—from prop master to production designer. There is no way to fully imagine a scene before it is shot.

A paragraph of scene description in a screenplay guides the reader's mind through your imagined landscape, highlighting the important landmarks, the things that cannot be hidden, the things that will have consequence in the scene. The things that are most important to the characters. The objects that interact with the people using them.

How do you decide what to leave out? How do you decide which details to describe? How detailed to get in your description?

- **Geography.** What is obvious and unavoidable in the scene? What is the minimum layout to specify that will make your reader comfortable in the space?
- **Behavior.** Does the object do something? Does the object interact with the characters in the scene? Describe what is necessary to the action. Give vivid and clear representation to those parts of the world that the characters use.
- **Teaching.** Does the description teach the reader something they need to know? Does it give something to the designer, the director, to guide them in the realization of the scene?

Everything else is, literally, window dressing.

Remember, you are not simply guiding the eye of your reader through a physical landscape—though that is certainly part of the task—you are also guiding them through an emotional landscape. You are plunking them down next to your characters—hoping to elicit empathy or antipathy, generating familiarity and comfort. Your choice of physical detail, the manner in which you describe the image in your head, must *always* service the presentation of character and behavior. It should always help present the enacted behavior of the scene.

Set description creates an arena in which the drama takes place.

Think of it this way: Set description creates an arena in which the drama takes place. Too much description and the arena overwhelms the actions that occur within it. Too little description and the drama has no locus, no unique geography.

The decisions as to what to include—in a master shot screenplay—are yours. For this draft you are writer, director, and production designer. Use that power wisely.

I have this quotation pasted above my computer:

> *To do the necessary in the fewest possible steps, that is grace.*
>
> —**Anton Chekov**

I like the emphasis on the *necessary* as well as on *economy*. There are things that must be done. The trick is to determine that necessity and then find the most economical way to articulate it. This pertains to all facets of composition.

First and foremost, decide if the detail swimming in your head is necessary. Then run your sentence through a series of tests: Does it impact the behavior within the scene? Does it help clarify the physical geography? Does it teach the reader something about the tone, time, space of the story? And last, does it help or hinder the enacted drama that occurs within the scene?

Don't write so much detail that the reader no longer engages in creating the image. Leave some room for the reader to enter and complete the scene.

Be specific, not detailed.

Details versus Specificity

You can be too detailed in your action description. You cannot be too specific. It is worth looking at the difference in connotation carried by these two words. *Detail* implies that you are scouring your imagination for the minutia of setting or character behavior, trying to describe everything, and describe it down to its smallest components. *Specific* implies that you are making rigorous choices as to which details to include and being precise in their presentation.

A detail becomes specific when it has a function.

A detail becomes specific when it has a function. When it isn't random. When it is inextricably linked to the action of the scene or the emotion of the character.

When you have decided upon a gesture or action to punctuate the movement of a scene, be sure to think through from the general to the specific.

For instance, you might find yourself writing something like:

```
Frank and Gladys arm-wrestle.  A loud noise.
```

Surely when you imagined this scene you had an inkling as to what caused the loud noise. What quality it has. Tell me.
Similarly, something like:

```
Frank makes a face.
```

What kind? A pout? A grimace? Tell me. If you don't tell me, I'm going to make it up.

The audience will make up story when story is insufficiently supplied.

That's an important point. It's the nature of how we read, how we consume story, that if the author does not specify gesture and action, the reader will fill in the blanks. The audience will make up story when story is insufficiently supplied.

Sentence and Paragraph Structure

Now that I've got you thinking about how to decide what to include, here's a monkey wrench into the works: *the what of an image is not the image itself.* That is to say, the content of the image alone is not the image. The image is also, if not primarily, how the content is conveyed. The image is as much *how* as it is *what*.

The written equivalent of an image is the sentence. That's what you use to compose the image. That's your frame.

Think tactically. What word you choose to place at the beginning of a paragraph has a large impact on the presentation. Sentence structure and order determines the meaning of a paragraph as much, if not more, than the simple facts—the what—of a paragraph.

Here's a *what*: a classroom, a seminar table, a lecturer, a group of students.

Here are four variations on the *how*:

```
Seven bored undergraduates sprawl at an oak
table, listlessly listening to a droning
lecturer.

A charismatic forty-year-old man, bearded,
blue-eyed, recites poetry to seven bored
students.
```

```
A hand slams down on a table, startling seven
dozing undergrads.  A blue-eyed professor
recites a sonnet.
```

```
A Hello Kitty pen scribbles on lined
paper.  The hand holding the pen -- manicured,
petite -- belongs to Gladys.  A voice recites
a Shake-speare sonnet as she doodles.
```

Each of these four paragraphs tells a slightly different version of the what. By rearranging what comes first in the sentence, I have actually altered how the facts are received by the reader. I have *chosen* how I want my reader to enter the scene.

It isn't random. Don't let the facts sit there on the page as you thought of them. As they occurred to you while waiting for another *vente latte*. After you've dumped them onto the page, step back and consider. Compose. Think about how those simple facts should be presented. And—here's the kicker—make a choice.

By forcing yourself, as you write, to see each sentence arrangement as a choice—*is this the way I want to guide the eye?*—you will inevitably produce more precise writing. And more importantly, you will, I guarantee, discover things about your scene, about your intention, about the image you are describing. You will learn things you weren't looking for.

I would argue that describing an image with an eye to this kind of specific word arrangement has two benefits: it leads the mind's eye in a considered way. You have *chosen* how to lead the reader into the image. And it prepares the ground for the possible happy accident of discovery. That's when true writing happens. In the accidental discovery. When you compose a phrase or sentence that you weren't expecting. I believe the odds of such a surprise sentence increase when you refuse to accept, without challenge, your first draft, your first thoughts; when you compose and recompose your words.

That said, I am not suggesting that your first impulse is automatically suspect or wrong. I'm saying you need to make sure you decide to keep the first impulse. Trust it, but not to the extent that it is privileged. Always challenge your decisions.

Geography

A major part of your task in deciding what to include, and how to include it, is to create a legible geography for the scene. You are literally building an arena in which the enacted drama takes place.

You need to make sure that the reader is comfortable in the space. That they have the landmarks necessary to orient themselves. That in addition to hearing the dialogue and imagining the faces, they are able to place those actors in a space.

To do that you must, at the outset, describe the salient features of the geography, the portions of the landscape that will be used in the scene to follow.

I think if you give serious thought—and composition—to the geography of your scenes, you will inevitably find things to use, ways to thicken the scene.

Take for instance a very common type of scene: two lovers sitting across a table in a restaurant. It's a very foreground-heavy idea—that is, the serious dialogue about their relationship may be the most important part of the scene (deciding to marry, breaking up, talking about sex). But the scene doesn't take place in a vacuum. The way you imagine the geography of the space—the type of restaurant, is it crowded, is someone eavesdropping, small space or large—completely changes the possible external forces that might come into conflict or tension with the intimate dialogue scene. You can't decide what to include in the scene if you haven't imagined a range of possibilities.

Your job is to create a useable arena in which the action can happen.

Your job is to create a useable arena in which the action can happen. It is not to specify each movement of every character. That is, you should not be blocking the actors. You should not over specify when they stand or sit or cross the room; when they light the smoke or sip the drink. Too many such blocking directions make a scene unreadable.

You should, however, imagine the scene fully and confirm for yourself that it is *blockable*. That is, the scene is amenable to actually being shot as you imagine it.

And never forget, as with so much else, your decision about the space and how it is used depends upon the needs and desires and habits and emotions of the characters who inhabit the space. Character as True North. Use them to help navigate the geography of the scene.

Mimetic Description

Effective action description in a screenplay balances scene setting and mimesis. The prosaic presentation of image and detail. And the presentation of enactment.

Mimesis is a fancy word for imitation. But it is sometimes used to speak of imitation where the term (the thing being imitated or mimicked) and the vehicle (the thing doing the imitation) can never have a one-to-one correspondence. Such is the case with writing and film.

The ways in which words on a page *imitate* an image on screen can only be approximate; conveying a sense of similarity, but not a representation that is complete. Colloquially it works. We get mimic from

mimesis. And here I'd argue that prose can mimic a moving image, it cannot really fully imitate it.

...prose adapts to the task at hand.

Mimetic description. Where the pacing and the word choice mimic the action or the emotion being portrayed or enacted. The prose adapts to the task at hand.

If you are writing an action scene then short sentences, incomplete sentences and one-word sentences will mimic the rhythm of the scene being described.

If you are writing what you imagine to be a languid shot establishing the interior of Gladys's bedroom your sentences might take their time, linger a bit on detail. Might even be a bit purple, this prose, as you are, after all, preparing for a love scene.

Your prose can mimic the speed and perhaps even the content of your image. Lyrical for a pastoral outdoor scene. Full of harsh diction for an inner city crime scene. Perhaps as transparent as possible—get the prose out of the way—during a thick and emotional dialogue scene. Opaque and a bit intrusive for a slapstick bit of comedy.

I suggest this kind of mimetic writing to my students and they look at me dumbfounded. No one has ever told them to write other than clearly. And the result is a monotonic prose style that puts me to sleep. It has never occurred to them that they have such responsibility, or such power.

You control how your sentences wind upon in the world. And how they come into the world has a profound effect on how they are received and understood.

Don't ignore this powerful tool of manipulation.

Camera Gestures and Paragraphing

Let's take this idea of *imitative prose* a step further. If a sentence is standing as the analog to a single image onscreen, then the paragraph might be seen as the analog to the collection of related images or frames that constitute a shot.

Novels are written across the page. Screenplays, like poetry, are written *down* the page. Do not think of these passages of description as you would think of paragraphs in a novel.

A paragraph in a screenplay does not obey the rules you learned in third grade. It doesn't have the three-part shape Sister Ann Francis taught you: topic sentence, development, conclusion.

As we often allow incomplete sentences when the tempo of the prose requires it, so with paragraphs. They can be short. They can be abrupt.

The paragraph in a screenplay stands for the camera.

You should start a new paragraph whenever a new shot would be required or when you want to feature an action.

In a master-shot screenplay—which is what we are discussing—that's what you give to a producer—you should not be using an abundance of camera direction. Camera cues such as CLOSE ON, CLOSE UP, TWO SHOT, DOLLY SHOT, etc., etc. get in the way of a fluid read.

Instead, use paragraphing.

Here are three ways of describing the same thing. One using no paragraph breaks, one using camera cues, one using paragraphing:

```
Frank's living room.  An unholy mess of books
and magazines.  Dirty dishes and cartons
of left-over Chinese litter the coffee
table.  The wide-screen television loops the
start menu for a DVD of Citizen Kane.  The
door knob rattles.  Frank enters, pulls off
his rain coat, dropping it at the door.  He
collapses onto the sofa and searches for the
remote under the throw pillows.  Finds it.
Presses play.
```

Any time you see a paragraph of action description that is more than three sentences long, you should think about dividing it up into smaller chunks. Nothing puts off a reader as quickly as turning the page and finding two or three dense paragraphs of description.

Here's the same action divided with camera cues:

```
Frank's living room.

PAN ACROSS:  an unholy mess of books and
magazines. Dirty dishes and cartons of left-
over Chinese litter the coffee table.

ANGLE ON:

The wide-screen television loops the start
menu for a DVD of Citizen Kane.

CLOSE UP:  The door knob rattles.

Frank enters.  FOLLOW:  as he pulls off his
rain coat, dropping it at the door, and
collapses onto the sofa.

Frank searches for the remote under the throw
pillows.  Finds it.  Presses play.
```

Certainly this is easier to read—and has more of a visual shape than the thick chunk of prose. But are the camera cues adding anything that can't be achieved by careful paragraphing?

```
Frank's living room.

An unholy mess of books and magazines.  Dirty
dishes and cartons of left-over Chinese litter
the coffee table.

The wide-screen television loops the start
menu for a DVD of Citizen Kane.

The door knob rattles.

Frank enters, pulls off his rain coat,
dropping it at the door.

He collapses onto the sofa, searches for the
remote under the throw pillows.  Presses play.
```

By using paragraphing—the precise use of new paragraphs to describe discrete elements of a scene—your prose will guide the reader's eye every bit as effectively—and less intrusively—as would camera cues. Paragraphing gives emphasis. It mimics camera angle and depth. It goes a long way to seducing your reader into imagining the film.

By using paragraphing—the precise use of new paragraphs to describe discrete elements of a scene—your prose will guide the reader's eye...

Camera direction should be eliminated, or at least kept to the barest minimum. It should be reserved for those few moments in a screenplay where the intrusion into the read is warranted.

I say the same impact is possible with simple paragraphing, but if you must show off your knowledge of cinematic terminology, save your ANGLE ON, or CLOSE ON, or PAN ACROSS for truly important moments. By being parsimonious with the use of such markings, you will increase the impact of each. If you use them all the time (1) the effect of each is diminished and (2) they become annoying.

The Camera versus We See versus Paragraphing

A stylistic convention you often see—even in many classic screenplays (including those of Preston Sturges)—splits the difference between

camera cues and simple paragraphing. Frequent references to the camera as the all-seeing eye, with some reference to its movement, are embedded in the prose:

```
The camera pans to reveal Frank at his desk.

The camera holds on Gladys.

The camera follows as Frank heads into the kitchen.
```

These are conventions born of the shooting script. And they have bled into the over directed master-shot screenplay.

I don't want to be reminded of the camera. I want to get on to the next sentence and image. Rewriting the above sentences to include a gesture is more important than to place the camera.

```
Frank thrums his fingers on his desk.

Gladys stares longingly out the window.

Frank heads into the kitchen.
```

There's also a frequently used convention that replaces "the camera" with the Royal We, intending to mark the audience's point of view:

```
We see Frank enter in the background.

We follow as Gladys heads into the bedroom.
```

I don't see the advantage. It doesn't really add anything to the image over:

```
Frank enters in the background.

Gladys heads into the bedroom.
```

All these phrases manage to do is break the frame. They are padding. They remind me that I'm reading a screenplay. The fluid presentation of image jolts to a halt and I'm tossed out of my easy chair and onto a movie set.

I don't want to be reminded of the camera.

I would also argue that not allowing yourself to use camera cues, or "the camera," or "we see" will force you to make the image and gesture more vivid. It will force you to finish the sentence.

Editorial Description

Storytelling reveals meaning without committing the error of defining it.

—Hannah Arendt

Film is composed of images. Images have objective reality. We build the drama of our film story through enacted behavior, visible gestures, and actions. Often a writer—out of stylistic bravura or out of laziness—will resort to the baldest form of telling to convey what should be acted out.

Here is a snippet from the opening scene of Quentin Tarantino's *Kill Bill Vol. 1*:

```
A hand belonging to the off-screen Man's Voice
ENTERS FRAME holding a white handkerchief with
the name "BILL" sewn in the corner, and begins
tenderly wiping away the blood from the young
woman's face.  Little by little as the Male
Voice speaks, the beautiful face underneath is
revealed to the audience.

But what can't be wiped away, is the white hot
hate that shines in both eyes at the man who
stands over her, the "BILL" of the title.

In another age men who shook the world for
their own purposes were called conquerors.  In
our age, the men who shake the planet
for their own power and greed are called
corrupters.  And of the world's corrupters
Bill stands alone.  For while he corrupts the
world, inside himself he is pure.
```

Look at the difference between the first paragraph and what follows. The first gives specific images: hand, monogram, blood, beauty. That's film writing.

The second paragraph presents a single image: a man standing over a glowering woman. The rest tells me information: it's intense hatred, the man is Bill (just in case you missed the monogram). This paragraph tells the meaning of the image in addition to presenting it. This is novel writing.

The third paragraph dispenses with image altogether. It could have been lifted from an essay on the nature of evil. It shows me nothing. It tells me how I am to feel about Bill. It's very pushy. And no matter how nicely written or how clever the idea, this kind of narrative

description stops the movement of the film in its tracks. This is pure editorializing. It's the author's voice intruding on the screenplay, and telling the reader what to think.

Tarantino gets away with such extreme editorial comment, well, because he's Tarantino. And was one of the first and most prolific practitioners of this style. And his films make money.

But for an unknown writer such excursions into novelistic prose will land you on the reject pile. I am certain of it.

Telling the reader a character's emotional state, or their attitude toward another character, what they are feeling or thinking, all are editorializing and should be avoided, should be replaced with something active.

Editorializing usually happens out of laziness. You are dumping the scene onto the page. You have an intent, something to accomplish, and have done so and moved on. But you simply haven't finished thinking through from your intent to the interesting gesture that might carry it.

Another example. What's more engaging:

```
The waitress drops the plate of overcooked
cabbage in front of Frank.  He can't stand the
smell.
```

or:

```
The waitress drops the plate of overcooked
cabbage in front of Frank.  He covers the
plate with his napkin, pushes it across the
table.  Grimaces.
```

Attitude should not be described (nor should state of mind or feeling). It must be enacted.

I do not want to be told the impact of a gesture, I want to be shown *the gesture.*

I do not want to be told the impact of a gesture, I want to be *shown* the gesture. Then I, the reader, can engage in the scene. There is room for me to enter. I get to complete the gesture by understanding its meaning rather than passively sitting there and being told its meaning.

Another kind of editorializing—where the writer's voice and the writer's knowledge is used as a sledge hammer to guide my thinking as a reader—comes in the form of information that can't possibly

be known or presented on screen. This can happen in character introductions—

```
Jess, Sophie's brother and a child
psychologist...
```

Hunh? Says who? The guy just entered a deli.

Such information should come out in the course of the scene, not simply be plunked down. I am extreme, a purist, on this point. It seems to me that part of the seductive quality of a screenplay, what often makes them compelling to read, lies in mystery. Limiting yourself to what can be and will be visible on screen generates a suspense in your reader. It allows them to participate in the completion of the image. They are constantly filling in blanks and wondering what a bit of behavior means. The result is a greater sense of engagement by the reader. They have a higher stake in the screenplay, because, literally, they are engaged in active understanding rather than passive reception.

Find the characterologically consistent gesture to contain the attitude or information you wish to convey.

This preference for enactment over description applies at all levels of film action. The previous examples are simple character gestures meant to convey state of mind or attitude. But it is equally true when describing a spectacular action sequence.

Description:

```
The explosion is catastrophic.
```

Enactment:

```
Boom.  A girder tumbles toward Gladys,
narrowly missing her shock of red hair.
```

Put it this way. Nobody likes to be bullied. And writing that simply tells you information feels bossy. Whereas writing that presents behavior pulls the reader into the scene. I'd much rather be pulled in than pushed forward.

Colloquial Narration

It has become fairly common in contemporary screenwriting for the author's voice to appear undisguised, as a kind of playful, witty commentary on the screenplay and its writing.

Many screenwriters, some very well-known and successful, take a tactic of familiarity in their writing. They pepper their screenplays with jokes, or references to other films.

Screenplays styled this way are addressed directly to the reader. The overall effect of this tactic is to generate a casual, colloquial tone, almost conspiratorial. *Me and you, dear reader, are on this journey...*

The problem with this style of screenplay is that unless you are well known, and already have a deal, unless the reader is already predisposed to like your work (which is rare), it can come off as too cute. It can be distancing. It can feel like the writer's voice is too present. It can get in the way of the storytelling.

It's one thing to get the reader to like you, another to get them to like your story.

A particularly heinous form of the colloquial style references other films. For instance, introducing a character by naming a specific actor:

```
Gladys, looking like Veronica Lake in
Sullivan's Travels...
```

Or more generally:

```
A bleak cityscape, a cross between Batman's
Gotham and Blade Runner's Los Angeles...
```

The problem here is that you're taking the reader out of *your* story. Even worse, you're plunking them down into great films. You're setting up a comparison you can't win. Don't stop your reader. Certainly don't make them compare your work to some classic. It's not going to make them think that you're the next Preston Sturges or Ridley Scott. It's going to make them think about how much they loved (or loathed) the film you reference.

Anything that takes me out of the story is bad. Whether it is a typo or an editorial comment, or tags like *we see*—they all have the effect of making the reader pause. The typo makes them think about spelling. The editorial comment makes them wonder *How can we know this? How is that shown on screen?* The tags are just padding that slows down the read.

The goal of a screenplay, especially by a newcomer, is transparency. To get the text out of the way of the storytelling.

> *Good style, to me, is unseen style. It is style that is felt.*
> **—Sidney Lumet**

Be direct, be specific, and keep it all in the urgent present tense. Keep it clean. Say what you need to and no more.

Tone of Narration Fit to Tone of Piece

I've said that the best prose style for a screenplay is the one that is most transparent, that gets out of the way of the reading. I've insisted

that you should avoid editorial flourishes that tell the audience what to think or the meaning of a gesture. I've warned against being too familiar in the narration; that it can seem cute and become annoying.

All that said, there is some leeway.

You should strive to have the narration mimic the desired tone of the film. It should help create in the mind of the reader what the film would create through visual style. If the film is a parody, your prose might be more flippant, more self-referential. Might even bear more colloquial intrusions. If the tone of your piece is serious, a personal drama, then it's best to keep the prose out of the way.

I can't think of a genre where editorializing is useful.

The tone of your narration is generated by a combination of sentence length, paragraph complexity, and diction.

Clipped sentences equate to quick cutting; thick paragraphs feel like long shots. Always be aware how the sentence structure and length and variation will imply a visual analogue.

The words you use should match the tone you are trying to create. If you are writing a police thriller, chances are your language is more street and more raw than it would be were you writing an adaptation of Jane Austen. If you are writing a comedy, your word choice will slant to the humorous and self-referential.

Nothing is random in a screenplay. Every word has a purpose, everything, in this tightly woven tapestry.

Nothing is random in a screenplay. Every word has a purpose in this tightly woven tapestry. Be sure that you are in control to the best of your ability. That you have chosen what is on the page.

Show, Don't Tell

Anyone who has taken a screenwriting class or read a screenwriting How-To book has heard the phrase *Show, Don't Tell*. That is the Prime Directive for the neophyte screenwriter.

It's so clever. Nice parallel construction. But has anyone bothered to unpack this phrase? To really look at what it signifies? The obvious meaning—that film is a visual, not a literary medium—is often just left to hang there, as a rather arrogant admonition. Smug in its simplicity.

But truly there is a deeper meaning, and one that is not quite so obvious. One that can shed some useful light on specific screenwriting tasks.

Film—no matter the genre, no matter how visual or "cinematic"—is at base an enacted form. For the most part it involves characters the

audience cares about (loves or hates) engaged in behavior in a compelling space. The drama—the event motivated by choice and will—is revealed, delivered to the audience, through action.

So I would modify this dictum. Instead of *Show, Don't Tell,* a more useful version might be *Enact, Don't Describe.*

Let's get down to cases.

Instead of:

```
Gladys enters.  She is nervous.
```

how about:

```
Gladys fumbles through the door.
```

or:

```
Gladys enters, fumbling her keys, drops them.
```

or even:

```
Gladys enters, biting her fingernails.
```

The first example describes Gladys' state of mind. It tells the reader what Gladys is feeling. The other examples—and I'm sure you could come up with a half-dozen as good or better—give Gladys a gesture, an action. It is left to the reader to surmise from the behavior what she is feeling or fearing. There is room, in the enactment, for the audience to engage.

Not only is the action/enactment more "cinematic," more vivid, more three-dimensional—and something an actor can build on—but it's also more interesting to read. The reader leans forward. They aren't being pushed into a fact, they are being seduced by a gesture.

Push versus Pull

In a novel there is an authorial voice—an authority—telling us what happened, how to think about it, the significance and consequence. By the very nature of the medium, we are pushed around. Directed.

In film we witness. We garner meaning and significance by watching enacted behavior. We are drawn into the story. We are seduced.

There is a very big difference between being directed, pushed and being seduced, pulled.

Meditate upon that.

It is much more important for the reader to feel the emotional direction of a scene than it is to know facts and information.

A silly example:

```
The room shakes fiercely.  Computers
explode.  Smoke  seeps through growing cracks
in the wall.

                    FRANK
        The core reactor is gonna blow!

Frank dashes for the door as the ceiling falls.
```

The dialogue here is pure information. It's true. It's a fact. But it adds nothing to the visceral and emotional impact of the narrative description.

This example is a pretty obvious one. But the same thing obtains in the most subtle dramatic scene or love scene or argument scene. Let the emotion of the exchange or gesture be true to itself—not to information you think needs to come across. Let the characters speak to one another only as they would. Let the audience figure it out.

Truly enacted drama does not tell or teach. It performs.

Truly enacted drama does not tell or teach. It performs. And from that behavior a reader or viewer learns.

There is a big difference between learning something and being told something.

The former implies an attitude of attentiveness, leaning into the scene.

That's the goal. To make your reader lean forward. Even if they are confused. You want them to figure it out, to deduce from what's on the page what's been left out. You want them to want more.

I like to think of a story pulling the audience forward, dragging them into an embrace. Bad writing feels like the audience is being pushed—to a conclusion, to a punch line, to a neat image. Pushed around.

Nobody likes to be pushed around. Well. Almost nobody.

And as in life, so with literature. We are always more engaged in a story when we feel *pulled* along rather than *pushed* forward. Drawn into the flow of event and language rather than lectured and bullied.

Isn't that the deeper meaning of the film writing cliché *Show, Don't Tell*? Don't push your reader around. Pull them into the image. Let them do some work.

Be on guard for the pushed scene or speech:

- Action described rather than presented as enacted.
- The meaning of a gesture rather than the gesture itself.
- Information conveyed by the writer through a character rather than a character limited to what he would actually say at a given moment.

- A necessary bit of plot information or backstory that needs to be conveyed and the writer bends the scene until the character can find a place to utter it.
- The more important a bit of information or plot device, the more seamlessly it must be integrated into the story, the more its appearance must seem inevitable. The less motivated by a character, the more it feels like a device.
- A nifty idea or image that the writer really wants to fit in.
- A punch line the writer needs to find a way to have someone say.

What's common to all these possible problem spots is that they can be avoided—turned from pushing to pulling—by making sure they are properly and deeply motivated by the characters in the scene. By looking to True North. By making sure that character action and speech and motivation obey the character logic laid out in previous scenes.

Are your characters dragging you forward, teaching you something? Or are you, the writer, pushing the characters around, forcing them to do your bidding no matter what their natures require?

Don't push your characters around. We all know when we're doing it: writing a line of dialogue or a bit of action or interaction that is there only to achieve an end. Where character behavior is placed in the service of the clever retort or a bit of information. Try to create room in your scene for the characters to pull *you* around, teach *you* something about their immediate needs and urgency.

Don't push your story around to fit a preconceived plot. Discover event and incident as you do voice: by being flexible. Let the story pull you in directions you hadn't expected. Follow the accidental to see if it leads to new insight or blind alley. You're bound to discover something along the way.

Another way of looking at push vs. pull: Is the scene *closed* or *open*? A closed scene is all neat and tidy, with all the facts laid out (no matter how awkwardly). There's no room for the reader to enter the scene and finish an image or supply meaning. There's no room for them to learn they are so busy being taught.

I think a reader has more at stake in the reading—is leaning forward more—when they can actually do some of the work of completing the scene.

Write only the necessary, the probable, that which is truly consistent with character—and let the audience engage and figure out the deeper meaning. Don't spoon-feed or bludgeon. Allow the reader to partner with the text, not simply sit back and receive.

No Apologies

Perhaps the cardinal sin a writer can commit is to mitigate his intention for fear of offending. I always say: if it's worth doing, it's worth doing extremely.

Drama doesn't like sort of.

The most benign form of this error is timidity. I have often seen descriptions of characters that pull punches. Make a decision. If your character is greedy, make him very greedy; if arrogant, very arrogant. Drama doesn't like *sort of*. There is no such thing as sort of miserly. Or kind of cruel. Own up to your character's flaws. Let them be extreme.

The more pernicious version of the error is fear of giving offense. If you are writing a story that includes a racist or a sexist, should you tone down their speech or behavior in order to mollify your reader?

I say, emphatically, not.

You either convince me that the sexism is warranted, the racism justified, in the context of your story, or change your story.

The surest way to fail at convincing a reader that an extreme political position or a repulsive behavior is justified in your story is if you apologize for it in the writing. If you mitigate your vision and intention.

We all have a little censor-demon sitting on our shoulder as we write. He often sits there just making you feel like writing is a waste of time and you should go to law school. But every once in a while you will hear the demon say, "You'll never get away with that," or "You'll get crucified if you write that." When you hear that voice, it's time to press harder. That's precisely the scene that stands a chance at originality.

If it's worth doing, it's worth doing extremely.

I mean it. If it's worth doing, it's worth doing extremely. Never apologize for your words. Own them. And make sure you have earned them.

——— BEING GOD ———

It begins with a character, usually, and once he stands up on his feet and begins to move, all I do is trot along behind him with a paper and pencil trying to keep up long enough to put down what he says and does.

—William Faulkner

In *The Stunt Man* a film director explains to the new and naïve stunt man the power of film so: "Did you not know that King Kong the First was just three-foot, six-inches tall? He only came up to Fay Wray's belly button. If God could do the tricks we can he'd be a happy man."

During the composition of your screenplay, you are God. You get to make the choices. You get to create life. You draw the characters.

During the composition of your screenplay, you are God. You get to make the choices.

There was a party during the filming of *Under the Volcano*, thrown by a local real-estate agent who procured plants for the set department. Her husband asked what I had done on the production.

"I wrote the screenplay," I answered. He looked at me blankly. Silence.

"And what is that?" he asked.

"I wrote the screenplay," I repeated. "I wrote the scenes, the dialogue." His face fell from quizzical to confused. I stopped. It was no use. He truly thought the actors got on set and just made it up.

It's certainly true that ultimately an actor will be taking your character and standing him up, giving her specific actions and gestures and lilt and accent. At some point, you can hope, the actors will know and understand your characters better than you do.

But now, during the composition of your screenplay you are all your characters have. You are the writer and the actor. You are the one deciding what will bring the character to life on the page. And in so doing you are giving the actor a vivid starting point for bringing the character to life on the screen. But more importantly, you are giving the reader a way into your story through character.

So. Don't be shy. Don't worry that you are stepping on the creative toes of the famous actress who will play Gladys. The good actor will take your decisions and make them better. The one thing you cannot do is make no decisions at all. That reads as incomplete if not incomprehensible.

Making Character

What do we mean when we speak of a *character*? It's another of those words we think needs no definition, no discussion.

Let's examine the concept of character, take it apart, put it back together.

In English we use the word *character* to accomplish a multitude of tasks:

- **Colloquial:** What a character. Referring to someone who has a peculiarity, a quirk, usually amusing or comedic.
- **Moral:** A person's spiritual backbone, their ethical position in the world.
- **Psychological:** an arithmetic of attributes and attitudes indicating a personality. Timid, narcissistic, extroverted. Character reduced to clinically accessible labels.
- **Melodramatic:** a role or type, divorced from plot or motive: the villain, the ingénue, the father.
- **Dramatic:** a named actor in a dramatic presentation; *dramatis personae*.

A person's character stands as the public face of their identity. Identity being how I see myself; character being how others see me. The stew of traits and personality aspects that define my being in the world. It's usually hard to pin down. And often reduced to one dominant feature. He's honest. She's brave.

Character—in our day-to-day lives—is synonymous with *personality*. The big difference is that *personality* is morally neutral. Whereas *character* presumes a position on a spectrum of socially accepted moral behavior. [1]

Where does that leave us in the creation of a fictional person? First off, all the connotations listed above combine in the delineation of a dramatic character. They are named. They are types. They possess quirks. They have a moral position in the fictional universe. They possess attributes and attitudes akin to a personality.

Personality is to character what fable is to construct.

But. We mustn't confuse a character in fiction with personality in a living being. Personality is to character what fable is to construct. It is a chaos of possible traits and whims and mores and habits and history too big to fit on the screen. Real people are too complex, too random, too contradictory to make for dramatic characters. As with fable and construct, we must choose from the virtually infinite possible personality traits in an imagined person those that are useful and legible. We approximate personhood in the creation of a fictional character by emphasizing the salient aspects of their imagined personality. We look for readily legible markers and behaviors in order to give the audience, the reader, a way in, something to hold onto. A way to empathize and identify with the character. A way to understand the character. Or, even more important than explicit understanding, to give the reader a *desire to understand*. An interest. A vested interest in learning more.

There's a wonderful *New Yorker* cartoon. Two cavemen stand in front of a wall drawing of a hunt. One holds a bit of charcoal. The other says: "Maybe you could make the hunter more likeable."

A successfully drawn character is not simply likeable. Our relation to a fictional person is much more complicated than simple approval or comfort. We can despise a character and still be fascinated by his contests. We can be bewildered by a character and still be anxious to follow her journey.

[1] The word has become a weapon in political discourse. Lack of character, the character question — which is the ultimate perversion of a complex concept into a simplistic code. Politicians challenge their opponent's character as a way of ostracizing. A way of turning them into The Other.

Set aside simple notions of like and dislike, sympathy and antipathy. An audience's reaction to a fully drawn character goes much deeper, is more complicated. And is more satisfying.

How does a reader relate to a character on the page? We can break down the possible engagements into categories of emotion:

- Comfort and familiarity. Where a character possesses passions and desires easily shared by an audience.
- Wishful identification. Where a character resides within our comfort zone of familiarity, but also possesses something we do not. A greater competence, for instance. Or greater wealth. We admire them, want to be them for the time of the telling.
- Intrigue or titillation. A character is less familiar—at least in some respects—but in ways we find seductive. Empathy feels a little like a guilty pleasure. We aren't supposed to like them, but we do. Wouldn't want to be them, but are glad they exist.
- Fear and loathing. Usually reserved for the bad guy. It's a mark of a successful villain that even as we cringe at his passions, his threat to the hero, we are ever so slightly admiring or understanding.

Of course, our relation to a character is almost always a mix of these emotions. Yet usually there is a predominant emotion, one that marks the distance we maintain from a character. Are we entwined? Are we kept at a distance by peculiarity? Are we appalled and judgmental?

You need to understand the predominant emotion inspired by your character in order to draw them well and consistently. Once you have considered the impact of your character upon the innocent reader you can more easily find and focus upon those traits and behaviors that will either strengthen or violate that relation.

How do we draw character? How do we put them on paper?

As discussed earlier, you can think of a character as having two primary qualities: aspect and agency. Who they are, and what they do. Aspect entails the delineation of identifying traits—both physical and spiritual. Agency—discovering how the character responds to and generates the action of the story—is the application of aspect to circumstance.

We can think of aspect as having two parts: extrinsic and intrinsic. The external attributes of a character are perhaps the most immediately obvious, and the first drawn. You imagine their *physique*. Tall or short? Comely or plain?

Atop this general notion of a character's looks you layer other visible manifestations of their place in society. The first among these would be their *costume*. What is their customary dress? Is there an item of clothing—like Indiana Jones' fedora—that marks their job

or their attitude? Their self-image or their ambition? Dressing your character is not random.

Certain internal qualities have external consequences.

What *habits* can help define your character? We meet Martin Riggs smoking in bed; then he has a beer for breakfast (and mouthwash). That tells me a great deal about him and how he lives.

What *conditions* impinge upon your character? Are they claustrophobic? Afraid of snakes? Fear flying?

What part of their *history* continues into the present tense? Recently lost a loved one? Grew up an orphan? Suffered severe heartbreak?

These qualities—physique, costume, habit, condition, and history—reside outside of any particular story, any particular circumstance. They are, after a fashion, part of the fable or your construct. From these details we build a being in space, a physical manifestation of the imagined personality.

It is when we place a character within a specific context that we move from aspect to agency. Then we must ask deeper questions about the internal make-up of the character. We must fill the manifestation with motive and desire, with intent and direction.

What is their *daimon*? What drives them and defines how they will react to external forces?

At the outset of the story, what are they trying to achieve? What do they *want*? Is that want the same at the end?

What are they willing to do to achieve that want? What won't they do? What are their *boundaries*?

In drawing a character you must focus on both their aspect—who they are as individuals and on how that individuality manifests in the fictional universe—and on their agency—what they do in reaction to the events of the plot.

Both sides of your character must be imagined simultaneously, in a continual interaction of decision and discovery, of exploration and extrapolation.

In real life what we do is often at odds with our own best intentions. With who we think we are. In the messy world of reality, it is the rare person who's aspect is completely in synch with their agency.

But in dramatic fiction, for the most part, there is a more strict linkage and intimacy between who the character is and what they do. This makes sense when you consider that what we choose to feature in a character are precisely those traits and behaviors that will help us to enact their inner motives and desires. To make their choices legible and sympathetic to an audience.

Every character in your script—from hero to henchman—must be given unique aspect. It could be argued that they all also have agency *within their individual stories*. But usually only the main characters

have agency that has a direct bearing on the story being told. The best secondary and tertiary characters are those conceived with an eye to the fact that they, too, have a story. And even better, when their story impacts directly upon that of the protagonist.

Take for example the bad guy henchman, Karl, in *Die Hard*. He has his own drama playing out within the movie. John McClane kills his brother. For the rest of the film that is Karl's motive. He is the hero of a revenge subplot. And the fact that he is intent on avenging his brother's murder impacts the trajectory of McClane.

When imagining the aspect of your characters remember that no detail is too small, no gesture is insignificant. As you choose physique and costume and habit and condition you are making decisions that may have enormous impact as you compose the screenplay. You are creating a palette of colors from which you will draw throughout the writing. What may seem only a bit of character color, an interesting quirk, may be useful as the story develops. Nothing is random in a fictional character. It is designed. And the elements of that design will prove useful. They become tools in the telling of the story.

In addition to providing your reader a way into your character and so into the story, I contend that by thinking clearly about various character gestures and quirks, habits, and mannerisms, you will also learn more about your character. You will deepen your hold on the story. You will discover unexpected actions and interactions, perhaps leading you to new events, and perhaps even altering your plot.

Fully imagining your characters, giving them compelling flaws and believable desires, inevitably impacts story. Screenwriting does not happen just from the plot down to the details, but also from the details up. There must be an ongoing colloquy between your characters and your plot. Character is central to both the how and the what of your storytelling.

Backstory

Backstory is that part of your understanding of a character's past that actually shows up in the present tense of the screenplay.

Having written a narrative of your character's past means nothing if it doesn't manifest in the relationships and motives in the present tense.

It's possible that you have written (or just imagined) an extensive character history. If so, likely it's more than could ever fit into a feature film. So, think of backstory as that subset—perhaps only one or two things—of your character history that has a specifiable impact on the action of the story.

In *Aliens*, Ripley has had a bad experience with androids and so enters the story with a deep distrust of Kane.

In *Lethal Weapon*, Martin Riggs' wife was killed, he thinks, because he was busy being a cop. Now he's indifferent to the job's dangers. Casually suicidal.

Here's a subtle example of how a character's history impinges on the present tense of the story, carried by a very minor gesture. In *Three Days of the Condor*, after all of his colleagues at a CIA research facility have been assassinated, the main character reaches into a drawer and takes out an automatic pistol. But he grips it wrong. He grabs it upside down, holds it awkwardly, as if it were a stinky sock. He clearly is not comfortable with the weapon. He knows he should take it, but he's not holding it in a useful or threatening way. He's thinking the gun is a good idea, but he's not ready to use it. That small gesture speaks volumes. It is consistent with his history: he's an intellectual, not a field agent. The gesture is completely consistent with who this character is, and who he will become in the course of the film.

There has been a tendency in Hollywood story departments to confuse backstory with character history. What I sometimes refer to as The Backstory Police will often ask "What in the backstory makes the hero who they are?" The only answer is "everything." What they are really asking for when asking for more backstory is a better handle on their understanding of the character in the present tense. Write the active character better and perhaps the Backstory Police will leave you in peace.

Be careful not to overburden your present tense story with baggage from the past. Be delicate and specific in the use of backstory. Taken to the logical extreme, your character's history is as messy and chaotic and infinite as any real life—you can't possibly use it all (or even understand it all).

What does your backstory do? How does it impinge on behavior on the page?

Phrase it this way: What does your backstory do? How does it impinge on behavior on the page? Knowing a nice character history is one thing. Using it is another.

Backstory must never appear as blatant explanation or justification. Remember, it is motive in the present tense that engages the audience.

Make sure the piece of character history you let wander into the present is a bit that can be acted upon, that can be rendered legible and dramatic. General backstory—he had a traumatic childhood—can be hard to render useful. Also, make sure the backstory isn't more interesting than the present tense. If it is, that's the film you should be writing.

Introducing a Character

How much detail to give in your character introductions? You cannot avoid the obvious. Age, for instance, is pretty much a given. And

gender. Race is a more complicated issue. There are characters where race is not relevant. But in other instances the specific character's racial background would be crucial—and not to be avoided through an extreme of political correctness. If you imagine the bad guy as German, make him German. If he's an albino, tell me he's an albino. Telling me a character's race can, of course, border on the stereotypical—the Latino gang member, the African American gangsta rapper. Yes, it's possible that reaching for these types might be seen as too easy and, in extreme cases, as racist.

That's why you have to make certain that you have justified the use of such types. That the scene requires it. That you aren't simply using shorthand. That the racial collisions in the scene are integral, not gratuitous.

Back to the more difficult decisions regarding character description. Once you've dispensed with age and gender and race, the next most obvious clue to a character's place in the imagined universe is clothing. Be detailed enough to escape the generic, but not so detailed as to derail my interest in the character's entrance.

After the physical and cultural details are in hand and you've decided the minimum to describe to make your point, you still have a deeper decision.

It is always more vivid to introduce your character with a gesture.

Is there a way to describe your character's emotional state, their attitude toward the universe they are entering? Can you give them a behavior, a gesture, that will distinguish them from all the other actors in the scene?

It is always more vivid to introduce your character with a gesture.

As with scene description and detail, you should paint your characters in action. Find a gesture that tells me something about them. Try to find something that teaches and intrigues me. Think of your favorite movies and how the main characters enter. Usually in the midst of an action that interests. Jack Sparrow clinging to the top mast of a sinking ship. John McClane white-knuckling the arm of his airplane seat.

I had a student once who began her screenplay in a typical family room. One after another, she introduced the members of the clan. The youngest boy played an electronic game; the teenage daughter yattered on the phone; the mother entered from the kitchen carrying a tray of iced tea; and the father sat in an easy chair picking lint off of his jacket sleeve. Each character had a specific behavior. I particularly liked the father and his lint-picking. It told me all I needed to know about him.

As with scene description, character introductions have a dual purpose. To describe the character and to teach the reader something

useful, something that will help them understand why they are following this person.

Individuating the Waitress

There's a diner scene at the beginning of *The Stunt Man*. A waitress clutches a yappy dog under her left arm while she pours coffee. A customer reaches for her chest. The dog snaps at him.

With this very brief image, we get a very strong sense of this minor, nonspeaking character. We even get a sense of her relationship to her customers. It's a little bit of brilliant color that thickens the scene simply by giving a waitress a bit of business that's arresting.

The scene of the waitress and her dog is not in the screenplay—but it should have been. What I mean by that is: you should be thinking of *every* character in your scene and giving them details of behavior and voice.

It's hard to write an interesting walk-on. But you have to try. As Akers says in *Your Screenplay Sucks*, somebody has to agree to play the bit parts as well as the principals. And it's always a good idea to write arresting dialogue and behavior, even for the most minor of roles. Screenplay as actor bait.

But beyond that, fully imagining all the players in a scene will inevitably lead to a thicker scene. It can lead to an exchange you hadn't planned. It can lead to discovery.

Fully imagining all the players in a scene will inevitably lead to a thicker scene.

If the minor roles have no individuated presence, how can they interact interestingly with the principals? If they have no personality, how can they add to the texture of the scene? Fully imagining character—even the most minor—helps to drive the scene, to teach us something we didn't know.

Character Logic

In character-drawing, just as much as in the arrangement of the incidents, one should always seek what is inevitable or probable, so as to make it inevitable or probable that such and such a person should say or do such and such; and inevitable or probable that one thing should follow another.
—Aristotle [Fyfe 1454a]

There is an arithmetic that must be performed at each turn in the story, in each scene, for each dialogue exchange. The writer needs to do a summing up, a calculation to ensure that the character is

behaving according to his nature. Is he growing (or not) according to the laws implied by previous behavior?

Perhaps the word "logic" strikes you as too rigid, too academic.

It's really simple. All I'm asking for is consistency. That you continually ask: is the character behaving now consistently with how she behaved previously? At every fight, every turning point, every reversal—with each action—you must challenge the behavior you invent (or the character teaches you) for consistency.

It sounds so obvious. But it's very easy to either forget or ignore the precedent you yourself have established when a great bit of action occurs to you and you can't wait to get it in because it will be so funny… only your character would never do it.

Yes, characters do change over the course of a film. But the change must be consistent with who they are (as you created them). Otherwise, it will strain credibility.

Behavior is not random. And should never seem so.

The tool to ensure that behavior is not random is right there: what you've already written. Just keep studying your own words. And be responsible to them.

Believability

Some writers confuse believability in fiction with truthfulness or authenticity. With factness.

This is clearly not the case.

How many times have you heard the phrase "stranger than fiction" to refer to something that actually did happen? How many times, in our own life, did you say "if you put that in a novel no one would believe it?"

In narrative, having actually happened does not, in and of itself, lend credibility to an event.

Don't confuse yourself with the truth.

Don't confuse yourself with the truth. Just because it happened doesn't mean it's believable in a film. Just because it's true isn't a reason to include it in the dramatic artifice you are creating.

Real life can be excruciatingly illogical. It is often improbable.

Drama requires much more logic and probability than does our everyday life.

This can lead to great anguish if what you are writing is based on your own life. If it comes from heart-felt history. Your impulse will be to include things because they happened, to be true to the people you actually knew. But you must realize that what really happened may not be dramatic in its form; the real people may not be amenable to

portrayal as characters in fiction. You still, even when writing from personal history, have to make it up. You still have to compose the fable (in this case a real one) into a fictional landscape.

Samuel Taylor Coleridge, writing on the composition of nonrealistic (highly Romantic, slightly fantastical) poetry, suggested that:

> ...*a human interest and a semblance of truth [is] sufficient to procure for these shadows of imagination that willing suspension of disbelief for the moment, which constitutes poetic faith.*

I find that a good description of the writer's task. To earn the reader's poetic faith. Their trust and confidence. And that comes by compelling them, by seducing them, not by presenting them with "what really happened."

In film, because of the naturalism inherent in photography, the audience is halfway there at the outset. Ready to be compelled. Inclined to believe.

Your task is to seduce—through empathetic character and compelling incident. To earn the reader's poetic faith, we need only a semblance of truth and—more importantly—human interest.

The adjective "human" is crucial to my point. It's not sufficient to simply be interesting. It must elicit *human* interest, by which I take Coleridge to mean it must concern actions and events accessible to empathy and emotion. It must concern, fundamentally, character.

——— HEARING VOICES ———

Who's Talking?

The most important question to ask when composing dialogue is quite simple: Is this my character speaking? Or is it me, the author?

We enter every scene with an agenda. With an idea of what (we think) needs to happen. And often that agenda overwhelms the natural flow of the interaction between the characters in the scene.

We all see it, we've all done it. Tried to shoehorn in a bit of information. About the current scene or about the back story.

Is what you *have* the character say actually what the character *would* say? What they would say to this person, at this time, in this place?

Stop thinking about dialogue as information disguised as speech.

That's worth repeating. Every line of dialogue should be challenged with the following questions:

- Would *this* character say it?
- Would they say it *here?*
- Would they say it *now?*
- Would they say it to *this person?*

Stop thinking about dialogue as information disguised as speech.

Differentiating Voices

A common criticism of student screenwriting is that all the characters sound the same. A frequent defense of this criticism is that these students are writing about very specific groups of people—for instance, college kids, or musicians—and so they should all sound the same. Nonsense. Even within a relatively homogenous group, the individuals all have different habits of speech.

The most obvious would be accent or dialect. Think of your own experience. As soon as someone opens their mouth you make a judgment about them based upon their accent. Southern, Boston, Long Island. And that geographical placing carries with it a presumption about class or education. Perhaps even politics.

Just as we make presumptions about people in our day-to-day lives based upon their linguistic habits, their accents, and their mannerisms, so should you do the reverse, and give your characters some idiosyncratic habits of speech consistent with the attitude you want your reader to have about them.

You can't have all of your characters sounding the same, and you certainly can't have them all sounding like you.

You must make a decision about the character's speech as it relates to their backstory. And if there should be an accent, then try and give them a discernible lilt. Not by writing in diacritically parsed language, but by shifting the syntax to match the dialect.

```
It's okay.  No problem.  Ain't no
nevermind.  No bother.  Forget about it.  No
biggee.  No worries. Don't give it a thought.
```

All of the above are colloquial idioms—specific to a geography or a group—meaning the same thing. They are not interchangeable.

For each speaker in your screenplay, there must be a correct, telling, and appropriate voice. The first task in learning to listen for the unique voice of every character in your screenplay is to accept that you need to tailor their language, to try out various kinds of speech, to

give them license to be harsh or poetic or stupid or eloquent. To find the right music.

Once you tag that specific language, once you hear that first line of dialogue that seems right, the character will thicken, their voice will get stronger and stronger, and you will then be led to their unique way of speaking.

Beyond accent or dialect, you should also ask if a character has a speech habit. A slang tick that peppers their dialogue. For instance, in our current culture some use the word "like" the way another generation used "um"—filling every pause for thought, standing in for commas, sentences thickened with "like" to the point where they threaten failure as language.

Such an extreme dialogue tick can be justified—if the character warrants it. Take Crush in *Finding Nemo*:

```
                    CRUSH
      Ah.  Saw the whole thing, dude.  First
      you were all like whoa.  And then we were
      all like whoa!  Then you were like whoa...
```

Funny. And completely consistent with the surfer dude sea turtle.

The more detail and particularity you can bring to the way a character speaks, the greater the differentiation between one character and another, and between any given character and the author.

Voice is character made manifest. It is the outward display of identity.

But speech habits and quirks and accent are only the surface manifestation of a deeper idea of a character's individuated dialogue. Voice, the idea of a character's unique verbal presence, is built on such details, but truly originates with your understanding of that character's inner life, your imagining of their history and their desires. Voice is character made manifest. It is the outward display of identity.

Speech into Voice

Speech is what is said, *voice* is how what is said is said. Voice transcends the facts of the speech, moves beyond the words toward gesture and behavior.

We find voice by fully imagining the character. By running every line of dialogue through the filter of their limitations, their education, their ambitions, their demons. Every utterance needs to feel as if no one else on the planet could say it, or could say it this way.

We articulate voice on the page—as opposed to in performance, where an actor will take over and give voice to your words—through a range of technical devices. Word choice. Sentence length and lilt. Syntax. Stammer and ellipsis. Use of contractions. Omitting articles. Punctuation. All must be turned to the task of tuning speech into voice.

Write dialogue, without regard for a given scene or exchange, without an eye to plot movement or information. Just let them talk. And listen closely. Whether you do this by simply hearing the voice in your head, or by doing notes and scenes on paper—doesn't much matter. As long as you are listening and letting the voice have free rein.

If you persist, if you focus on what makes the character unique, as well as the various tools to specify their speech, then eventually, perhaps when you least expect it, you will hear their voice. It's a great moment of epiphany, when a character speaks, unbidden and with deep identity.

Once you have discovered your character's voice—truly heard the music of their idiosyncratic language—embrace it. Relish in it. And never let the needs of story or plot corrupt or compromise it. As you compose scenes that do require plot momentum or necessary information—if you truly listen to that voice—you will write scenes that feel organic and true. Nothing seduces and surprises a reader more than a distinct—and consistent—voice.

Speech Is an Action

Speech is a form of action. It is behavior. Every word spoken has behind it an intention. We speak what we speak and how we speak it in order to get something, to accomplish an end. To fool or seduce or deceive or comfort. Or even, simply, to present ourselves.

There is no such thing as neutral speech.

We speak to achieve an end. And we adjust our speech—sometimes radically—to fit the circumstance and to fit the listener.

We speak to achieve an end.

Long, long ago, I worked in a 7-Eleven convenience store. My College Prep language habits were inappropriate to the job at hand—making change and ringing up smokes, making small talk with little old ladies and the local gas station attendant. I found myself talking in a brand new patois. This point was brought home one late night when a regular wino came stumbling in muttering to himself and brandishing what seemed a gargantuan Smith & Wesson revolver. It was me and the drunk and the gun. And language. I had to find the right words and put them together in an order the wino would hear. I heard myself assume a role. "Whatcha doin' Mitch man? Y'okay? Whatsat? You gonna shoot me? You ain't gonna shoot me. What you want, Mitch? Tell me. I'll get it. Tell me." I had to stumble and mutter and cajole using

language and lilt appropriate to the task of calming him and getting him to pocket the gun and be content with a half-pint of Jack Daniels.

You've all been in some version of this situation. Talking tough when fearing a confrontation coming; coy or seductive to gain an advantage; talking down to comfort or trying to talk up to impress. The point is simply this: we know what it is in real life to match our language and our speech to the needs of a given moment.

Why would it be any different when creating a character on the page? It isn't. You need to consider the moment-by-moment circumstance, and adjust your character's speech accordingly.

Remember that dialogue is not simply alternating speeches. It is almost always some sort of contest. One character wants something from the other, wants to convince them, seduce them, dominate them; wants to be forgiven, wants to be loved or feared or followed. It is rarely information disguised as speech (and when it is, it is usually deadly dull).

The facts of a dialogue exchange are never as interesting as the emotional content of the contest.

So always run your dialogue through this wringer: Who is trying to get what?

Exposition

The primary goal of a line of dialogue is to get something. To further the speaker's immediate need or long-term want. As a side effect of this, dialogue can tell us something about the past, or even hint at something to come.

Theorists of the form of theater from which contemporary screenplays are lineal descendants (The Well-Made Play) went so far as to suggest that every line of dialogue should tell (1) something about the past, (2) something about the present, and (3) something about the future. Exposition, character, and foreshadowing. But in the Well-Made Play most of the action of the story has already happened before the play begins, and the play consists of revealing what has already happened. That's why it was so exposition heavy.

In contemporary film dramaturgy, exposition is not your friend. Film is an insistently present-tense medium. Any time there is a reference to the past, that insistent flow forward is slowed or stopped.

How many times have you heard a character in a film start a speech with the phrase "Remember when we…" and immediately thought to yourself "Uh-oh, here comes exposition…" And, admit it, that's when you leaned back into your chair and reached for more popcorn. You became disengaged.

Because it's not active.

Exposition is only palatable in film if it feels absolutely and completely organic to the moment. If it falls out of a speech gesture that has immediacy.

Here's a bit of exposition that lands with a thud in an otherwise sparklingly written script. *Lethal Weapon*. The police psychologist is fighting with the captain about Rigg's mental state:

```
                 PSYCHOLOGIST
        May I remind you his wife of eleven years
        was recently killed in a car accident.
```

Anytime you find yourself thinking "May I remind you" or "Remember when" chances are you don't want to write the next sentence. In this case, we already know he's in mourning. We don't need to know precisely how many years they were married. And it just feels forced. For the audience, not from the character.

Another phrase to avoid, and which usually marks a bit of forced information or exposition, is "Speaking of." It's often used as an awkward segue when the author needs to get in a new thought or change direction and hasn't bothered to make the exchange organic.

A constant balance must be struck between narrative clarity and enacted authenticity.

A constant balance must be struck between narrative clarity and enacted authenticity. There is often a tension between what the author wants to have a character say—about the past, about information—and what the character would say in a given context.

I contend that if ever there is a choice to be made between character authenticity and information, authenticity should win. The emotional clarity of the moment is more important than the factual clarity. Your audience will catch up—if they are compelled by the character's behavior. They will abandon you if the dialogue rings false.

Same with foreshadowing. How many times have you heard a bit of burdened dialogue and thought "that's going to be important later."

Foreshadowing is most effective if it goes by unnoticed until it is fulfilled.

It's difficult to remember, but you must: You know more than your characters about where they are going. In every exchange, your character must be limited in what they say by what they know at the moment. Don't let your knowledge creep into the character's speech. Don't write the end of the story in the opening scenes.

Long Speeches

Most of the time, for most characters, dialogue is clipped, short, and to the point. Most of the time, people interrupt one another.

If you find yourself writing long speeches for every character, if they speak in consistently complete sentences, or even worse, complete paragraphs, you need to go through and find the heart of the exchange and cut down the dialogue. You need to challenge each line and ask is it the character speaking or is it you, the author? Is the line of dialogue for the actors in the scene? Or is it for the audience?

A page full of dialogue paragraphs should ring warning bells in your head.

It is rare, very rare, that a character speaks in full paragraphs. For one thing, why do the other actors in the scene allow it?

Of course, there are times when a character has a for true *speech*. A long diatribe or lecture or meditation. I call such character revelatory speeches *arias*. The character really belts it out, holds forth. It's an opportunity for a rush of language and emotion.

Just make sure that it isn't constant, that such arias are rare. And that the long speech is justified by the context of the scene.

For example, the confession of true love, or the villain's arrogant revelation of his evil plan, or a bit of storytelling bravura, or an existential rant. But such *monologuing* must be rare and warranted. Justified instances of the long speech: any of the rants in *Network*, or the eloquent disquisitions in *A Man for All Seasons*. Or the tall tales in *Big Fish*.

In order for such an aria to have effect, it must be the exception. It must be surround by normal, active conversation. If everyone speaks in arias then none of them are special. And the idea of speech as action is lost.

Voice-Over Narration

Voice-over is a special kind of speech in film. A narrating voice—either belonging to a principal character or to a storyteller, who addresses the audience directly.

Many neophyte screenwriters reach for voice-over as a device to start their films. And sometimes it seems they do so out of laziness, or in imitation of a favorite film, without really determining if the device is warranted.

What reasons can there be for using voice-over?

On the face of it, using voice-over is a very novelistic device. And perhaps the most old-fashioned use occurs in films based on novels where the voice-over is used to frame the film, to supply necessary information at the start or between acts.

Sometimes, as when I adapted Mark Twain's *Adventures of Huckleberry Finn*, voice-over has the added virtue of including some of the prose of the classic source material. It seemed part of the purpose of my adaptation to include the unique voice that Twain gave to Huck.

There are cases, such as *Badlands,* where the narrating voice, in addition to being unique and interesting to listen to, in addition to telling

facts that help move the plot forward, also serves a dramatic and character purpose: what we hear in voice-over often contradicts what I see on the screen, thereby generating its own tension.

In order to justify the use of voice-over narration you should make sure that:

- It isn't simply standing in for scenes that could be part of the film.
- It isn't simply filling in information, or explaining, or justifying.
- The voice is interesting to listen to.
- The voice-over doesn't simply repeat what I see on screen, but rather comments upon or contradicts the image.
- The device is appropriate to the tone and genre of your film.

Give some thought to where the narrator stands in relation to the present tense of the film. Usually, the narrating voice comes from some unspecified future. For instance, the grown-up voice of Scout in *To Kill a Mockingbird*. Often it acts only as a framing device—at the beginning of the film…

```
                FRANK (V.O.)
     I'd lived in New York all my life.  And
     in all those years I never made it to
     the Hamptons.  Until now.
```

and then at the end:

```
                FRANK (V.O.)
     ...and that's how I spent my summer
     vacation.
```

Voice-over can be extremely effective. In the opening of *The Opposite of Sex*, the smart-alecky narrator breaks the frame, acknowledging that we are watching a film; it prepares me for the style of what follows. There could be no *Stranger Than Fiction* without voice-over. The entire film is predicated on the main character hearing his life narrated. But that's an exception.

Perhaps the best test of good voice-over narration is this: Can you do without it? In my opinion, narration should be a grace applied over a film. It should not be necessary to understand the story. It can add tone, it can present character, it can comment upon or compliment or contradict the image. But it should never be necessary to follow the narrative.

Take, for instance, *Apocalypse Now*. If you could turn off the narration, the film would still make sense. I'm inclined to say it might even be a better film. But that's beside the point. It's well written, well

delivered. It adds greatly to the tone. And it helps the viewer through a difficult film. But it is not integral to following the story.

Take, as a counterexample, the perversely brilliant *Barry Lyndon*. If you removed the narration, the film would still be gorgeous, and perhaps compelling in each scene, but the story would vanish.

Kubrick somehow got away with illustrating a novel rather than adapting it. But for the rest of us, it's a pretty good rule of thumb that the voice-over narration should not be necessary for the story to be legible.

Voice-over needs to be motivated. Why is the narrator given voice? What is the narrative position in relation to the present tense of the film? I understand the nostalgic voice of Scout; I am seduced by the naïve voice of Holly in *Badlands*; I'm curious and willing to follow the hard-boiled voice in *Sunset Boulevard.*

Filling in blanks in the narrative is not a good reason to use narration. Make sure the voice is worth listening to, that the narrator has a point of view that adds something to the story. Make sure the device is warranted, and not simply a device.

——— EMPATHY ———

Character Is What We Remember

My wife doesn't follow sports. She has no interest in celebrities, especially sports celebrities. She has a minimal grasp of the rules of baseball, and virtually no understanding of football. Yet, if I tell her a player moved his family to New Orleans just after Katrina, or was ousted from his position after an injury and then traded to a rotten team; if I tell her a player was a garbage man two months before showing up at training camp and then got the job… then she will pay attention, then she will follow the team or the player. And even watch.

So what has happened? She has become interested in the characters involved in the drama that is professional sports. She empathizes with the man passed over or the "up from the streets" drama. It gives the contest a hero.

The analogy might be an action film. The plot is full of pyrotechnics. But what gets people to lean into the story, to pay attention, and to remember the film after it's done, is character. Not the spectacle.

Take, for example, a great popcorn movie. Very popular, very profitable. It's a buddy movie. It's an action film. *Lethal Weapon.*

Here's a description of the main characters and their conflict. A suicidal cop, in anguish over his wife's death, partners with an older cop who is nearing retirement. Though he doesn't care much for his own survival, he comes to value the life and family of his new partner.

Every decision made in this film is filtered through this conflict. Every event is deepened and given context and meaning by the relationship between these two men.

What do we remember about this film? We remember Riggs doing a Three Stooges routine, badgering a suicide to jump off a roof (and to safety) by jumping with him.

We remember the character gestures that build relationship and enact conflict.

I dare you to tell me the underlying plot. You probably can't. It was about ex-special forces soldiers smuggling heroin.

If you look at films that transcend their genre, that last, in virtually every case you will find a remarkable character. And chances are we recall much more about the small character actions than we do of the plot.

Identification

The other night my four-year-old turned to my nine-year-old—as *Wall-E* was starting up on the DVD player—and asked:

"Who are you in this movie?"

He didn't ask *Who do you want to be?* Or *Who are you going to pretend to be?* He asked *Who are you?* I found that striking. I found that a wonderfully primitive expression of how narrative is consumed, about how we enter into a story. In some peculiar way, we become the actors in the tale. We have an instinct to identify, to fully immerse, through the characters, into the narrative.

I listened as the conversation continued.

"I'm Wall-E," said the four-year-old boy.

"I'm Eva," said the nine-year-old girl.

"The one I love," answered the boy.

I wondered, was the identification based upon gender? He's a boy, Wall-E is a boy. That simple. Was it the power difference between him and his older sister? Was it the emotion of love?

Since then I have noticed that with virtually every movie, every TV program, my kids enter the story first by deciding who they *are* in the narrative.

And they are giddy as they do so. They are really tickled to become Peter Pan or Lightening McQueen or Violet or Indiana Jones.

And it made me think about empathy. We speak of characters in a film as being empathetic, having accessible virtues and vices, problems that we can understand.

Certainly that is a large part of how drama works on the viewer: presenting problems that resonate, creating characters that are familiar, with whom we can feel sympathy; pleasure at their victories and sadness at their defeats; anxiety at their troubles, suspense during their journey.

But perhaps it's deeper than that. Perhaps we must recognize that there is a primordial emotion prior to empathy. Identification. And

that this urge *to be* a character in the narrative does not depend upon familiarity. The tale can be completely fantastical, or filled with characters from outer space; they might all be criminals, or all obscenely rich; they may be kings and queens or homeless; action heroes or super spies. And still we find ourselves identifying, wanting—as did my son with a robot—to be them for the time of the storytelling.

How does this insight help us? By throwing into stark relief the major mechanism inherent in our consuming of story. It isn't, as Aristotle seems to suggest, by our appreciation of the plot's conveyance of organized event. It is through the actors of the story, the characters who enact plot and push story forward. For the time of the telling we *are* the actors of the story. Yes, yes, as adults we no longer phrase it *Who are you in this movie?* We have layered empathy over identification. We speak more distantly of stake and sympathy, of outrage and anger as the emotions that bind us to character. But still, at base, I wonder, aren't we engaging in an act of body-shifting? Entering into the story through the characters?

Character Want

A question that is often posed to the screenwriter starting out on a new screenplay, or pitching his story idea to a workshop or a producer, is: "What's the main character's want?" Another formulaic question you will eventually hear: "What is the character arc?" I propose taking these two ideas apart and seeing if they can be rendered more specific and useful.

What does your character want? This is too general. This is, like theme, an abstraction. They want love requited. They want revenge. They want money. A want is not dramatic. At best it can be a motive toward action. It is the action taken to achieve the abstract want that engages the audience. So, answer the question of "what does your character want" in your notebook. But in the screenplay you must leave it buried. Such overarching wants must be revealed by behavior, by choices. The character want, like theme, should manifest from the details of characters in action, not be pointed to. Nothing is more pedantic than an underlined theme. Nothing is duller than an overly articulated want.

We need to distinguish between character want as it refers to the arc of ambition and yearning that spans the entirety of the piece and character need in the immediate scene level.[2]

[2] This distinction between general and specific character ambition is spoken of by various writers using varying terms. Some prefer to think of the *character need* as the overarching, defining drive; and use *scene want* or *character want* to describe the immediate behavior performed to accomplish that need. To my mind the word *want* implies longing, perhaps unspecifiable longing, and so is more appropriate to the more general and overarching drive; *need* implies an urgency and so is more appropriate to the immediate, scene-level behavior.

Take, for instance, Don Draper in *Mad Men*. He wants to keep the fact that he stole another man's identity a secret. In virtually every episode this want collides with challenges that require immediate, necessary attention.

Want is internal. It's desire and ambition and obsession. It's the *daimon* that drives. Need is more reactive to the current circumstance. It's how a character will behave in a given context in order to achieve their want.

Story want. Scene need.

For a character driven by revenge, the *want* is to avenge the death of a loved one. But in Scene X his *need* is to get a weapon. Obviously, in this example, the immediate need and the larger driving want are related. In the revenge drama, most immediate needs are linked intimately to the want—and that makes sense, as the want is so urgent and specific. I'd suggest this is the case with most genre films: Westerns, Sci-Fi, Slasher, Thriller, Mystery.

In mixed genre, or in slice-of-life realism the driving want may seem more vague. It may be unconscious or even denied—Frank wants love and acceptance—or it may be multifarious—Frank wants financial success, but what he really wants is to be important, to matter. In such films, the deeper emotional want is less specifiable—though no less important—and its relation to the immediate scene need may be more tangential.

It is useful to think of the immediate need when constructing a scene than it is to focus upon the thematic story want. The urgent requirement of the present context helps to shape how a character behaves. If you break down the large and abstract *character want* into the small actions and decisions that the character must take to achieve it—then you have something that can be useful. That can guide the composition of individual sentences, gestures, scenes.

Character Need

Every character, in every scene, has an immediate ambition. It might not even be related to the larger, more thematically important *want*. Might be a one-off, a specific need of this scene, this moment.

I find it useful to think of each character's urgency. What are they after *right now*? What is their current and immediate agenda?

There are two levels of action. Those actions identifiably related to the larger ambition, the want and arc. And those actions that are simply urgent necessities.

In building a character and composing a scene, you first pay attention to those immediate actions required to get what they want now, here. What is unique about this circumstance, this place, this time? What gestures, movements, stillnesses, language, deceptions will get the character what they need at this instant?

There is a difference between a want—which implies yearning and desire, which can be deeply internalized and hidden even from the self—and need. What a character must do at each instant to achieve their want, or what habit requires, or their reaction to circumstance and accident.

In every moment of every scene there is a logical need.

And there is such a need for each character in the scene. Including those in the background.

Immediate need constructs character. We garner it, gather it, by watching behavior. Behavior determined, modified, colored by motivation.

Looking at such microscopic questions—for each character—will give you tools to construct and then thicken your scenes.

The immediate need impacts and articulates behavior. It may have nothing to do with the larger, overarching want. Yet it can alter the enactment at the scene level, and ultimately may alter or refine the story and the plot.

Here's a simple example of immediate need impacting story. From *Die Hard*. McClane doesn't like flying. His seat companion suggests that a good cure for fear-of-flying jitters is to take off your shoes, go barefoot and make fists in the carpet. He does so as soon as he's alone. It's a small character need/whim. And the fact that he's barefoot becomes an important element of the action.

Want and Empathy

The concept of character want needs further unpacking.

First of all, the *want* cannot be separated from our empathy with and interest in the character. That is, without a compelling voice, without distinct and consistent behavior and gesture, it doesn't matter what the character wants.

If I don't care if you get what you want then it doesn't much matter what it is that you want.

If I don't care if you get what you want then it doesn't much matter what it is that you want.

A character's driving desire must be embodied by a compelling soul, by a voice and by behavior that has seduced me. That has made me root for their success.

Or root for their failure. Even a villain must be compelling as a character. I must take the threat of evil seriously. I must feel fear and antipathy. And that is only possible if your bad guy is a credible character, posing a threat consistent with the rules of the imagined universe. It isn't enough that he wants to do evil. I must believe he is capable of it and that his motives are consistent.

Second, *want* is seldom singular. Don't think of your character—certainly not when you are composing—as monolithically one thing, one want. The *want*—in this larger, thematically relevant sense—manifests as a matrix of temporally distinct things.

- The want abstractly spanning the entirety of the story. Being, in some sense, the story itself.
- And the distinct moments—where that want leads to crisis—resolved well or badly.
- And the moment of learning.

Seen in this light, the "character want" should be thought of as a trio of ideas: every character has a want, a conflict, and a lesson. The trajectory of the character's journey is determined by all three.

Put another way: There is the abstract character want or yearning. When this want is tested by circumstances, or by the world of the film, or a specific antagonist, we have the central conflict of the film. That's what the Greeks would have called the *agon*. The contest between the hero and the universe of the work.

The *agon* articulates the theme of the story.

What I've termed the lesson—what Aristotle called *Anagnorisis*—lies in the moment where the want is resolved, for good or ill, well or badly, leaving the hero with insight, a new state of being; with a recognition of how their initial want has been rendered by action into understanding. This recognition can be prompted by success or failure. It enacts the culmination of story, the embodiment of the theme. It is the character's journey's end.

Arc versus Trajectory

Another way of looking at character want is to trace its success or failure, its changes, over the course of the film. And to think of the resulting shape—the up and down generated by success or failure—of this journey. That's what is referred to as *character arc*.

The idea of a character arc comes from dramatic criticism; specifically from Stanislavsky. It was originally intended as an actor's tool, a way to map the movement of a dramatic character *in an already existing construct*.

Character arc might be a useful concept when doing an analysis of a completed film or screenplay. But how does it help me to compose, to fill the blank page? It doesn't. It's too abstract, too general to be of much use in the moment by moment of composition. Thinking of character arc as a *determinative* thing can be just as dangerous to creativity, just as limiting, as constantly thinking of your outline. It can lead you to think narrowly. Simplistically. As if such yearning were singular, knowable. Can be rendered in a sentence. It seldom can.

Such desire is lifelong and chaotic. Ever-shifting. Moving from failure to failure. Adjusting expectations. Modifying means.

Think of it this way. An arc is a completed geometric shape. You can only see it when it is finished. A better phrase, for the writer confronting the blank page—when you are still discovering story and plot and character—might be *trajectory*. This word implies movement and direction, but it leaves open the possibility of change. It contains within it the idea of change in reaction to outside forces. It requires extrapolation—imagination—to visualize completion.

The writer starting out certainly has a sense of the character want, of what drives them. But the actual shape of the journey—the arc—is not visible until the screenplay is complete.

Raising Stakes

In many a story conference you will, I guarantee, hear the phrase "can we raise the stakes?" or "what's the stake?" or "we need more at stake." What's that mean?

The easy answer—since there is a longstanding Hollywood formula that goes something like: put them together, put them in jeopardy, get them out—is to make the situation more dangerous. To make the consequences of failure more grave. To increase the dollar amount of the theft or make the bad guy's sadism more intense.

But these are all external, almost incidental, ideas of risk and danger.

The reader doesn't care—truly—about risk for its own sake. They might be titillated by the viscerality or spectacle of a really dangerous situation. But what makes them care about the danger isn't the danger, but *who* is at risk.

That is, we hold our breath because a particular character that we have come to care about is in peril, not because there is peril.

So, I would argue, the idea of "raising the stakes" should not be seen in a mechanical way. It is not about increasing the cleverness of the villain or the intensity of the danger or the severity of the illness or the cruelty of the betrayal.

Raising the stakes, at heart, means: make me care more about the character in jeopardy. It's back to character. Do I understand what they want, why they are in danger? Do I sense, in each instant, their best case/worst case?

These are the variables that combine to make me care, that make me want the heroine to best the bad guy. Or to get over the illness. Or have the last word in the love affair. Because I have come to identify with her ambition. Her want.

When that producer tells you that you need more at stake, don't automatically reach for the external. Don't presume he's asking for greater danger or deeper consequences.

It may be—it likely is—that you simply haven't done enough in drawing the character, in making the character's decision one that the reader understands and wants to succeed.

When someone asks you to raise the stakes, what they are really betraying, it seems to me, is a confusion of empathy. They aren't sure what they want to happen.

Or, put another way, what, in the scene, are they hoping will happen?

That's another phrase you'll no doubt hear. "What am I rooting for?"

If you have defined a character I care for, and given them a decision that I want answered and fulfilled, then you have determined my rooting interest. If the character's decisions and desires are amorphous, then I have nothing to hope for. I have no interest in the outcome. I, as the audience, have no stake.

That's the punch line. You need to raise the stakes *for me*, the reader, not for the character.

You need to raise the stakes for me, the reader, not for the character.

Viewed through the lens of character, the questions *What is at stake? How do I raise the stakes?* are no longer abstract. They become a specific relation between audience and character. What decision is she about to make? Do I believe it is a good or bad decision? What do I think the decision, if taken, will lead to…? From this vantage the stake becomes legible. The audience is rooting for the character to make the right decision (or if it's the villain, to make the choice that will lead to his downfall).

Watching a character make a decision is inherently dramatic. It generates anticipation. Will the decision pay off? Will it backfire? The audience has become vested in the character's choice. They are leaning forward.

——— THINKING OF STRUCTURE ———

The Pieces

Let's think about how films are constructed, and about the analogues on the page.

Image

The smallest unit of film composition is the image. Due to the nature of film, the image is dynamic. That is, the visual information within it changes as either the camera or the actors and objects move.

At its basic level, the image conveys any (or all) of three types of information: aesthetic, meaning, emotion. We consume imagery by apprehending at a purely visual level, by comprehending whatever information, and by feeling viscerally.

An image is created on the page with every sentence that you type. And the shape of that sentence determines how the image blossoms in the reader's imagination.

Shot

The dynamic nature of the image is approximated on the page by the accumulation of sentences, by the paragraph.

So if a sentence is the analogue to a single image, the paragraph stands as the analog for the composed shot.

Again, how the paragraph is composed, its rhythm and tempo and tone, will generate in the reader's mind a sense of the visuals, the movement, the space, even the silence.

Scene

There are two types of film scenes: those composed purely of visuals and those where the visuals constitute the arena for dramatic exchange. One of the powerful tools available to the screenwriter—and not to the playwright or novelist—is the ability to move story forward silently, via image and spectacle. Remember as you are composing a list of the dramatic scenes in your head—the scenes where characters confront and discuss and argue—that not every scene must, nor should, have the same shape. The rhythm of your screenplay is created by deliberate alternation between dramatic scenes and visuals, scenes with dialogue, and scenes with very little or none.

The rhythm of your screenplay is created by deliberate alternation between dramatic scenes and visuals...

Some scenes—those that move quickly, that are mostly dialogue free—can be simple. That is, have a single point, make it, move on. Usually, a series of such small scenes occur sequentially and add up to a shape, a movement forward.

But a dramatic scene recapitulates the shape of the screenplay as a whole. It has (usually) a narrative structure: introduction, complication, resolution. It may have more than one thing going on—and more than one conflict. But, for the most part, a dramatic scene has a single and overriding direction, a momentum to a point. That primary shape is what generates expectation, what prepares us for the next scene.

Sequence

A sequence is a series of related scenes, all concerned with a single portion of the story. There is no set number of scenes within a sequence. Could be three, could be seven. Usually it breaks down to ten to fifteen pages per sequence.

A sequence is to a screenplay as a chapter is to a novel.

It's useful to think in terms of sequences. It helps divide your story into manageable chunks. It gives you something to hold onto, something to shape and manipulate.

As with the individual scenes, a sequence of scenes builds to a dramatic conclusion.

If you look at some of the screenplays of Preston Sturges, *The Lady Eve*, for example, he marked the end of each sequence in the finished screenplay. It's interesting to see the sequences so clearly delineated. However, I'm not suggesting your submission draft should have the sections marked. It may, however, be useful to do so in your working document.

Think of it in terms of outline. If the top level, heading 1, represents the Act breaks:

1. Boy Meets Girl
2. Boy Loses Girl
3. Boy Gets Girl

Then the sequence would be heading level 2 (the discrete sequences are the lettered headings):

1. Boy Meets Girl
 A. Meet Boy
 B. Meet Girl
 C. First Date
 D. Running Away
 E. Trip to the Parents

It is at this level of the sequence that outlining can be useful. But I do not mean you need to know all the sequences before you start writing. I actually add these section headings during the course of writing, or after a draft is finished. It's a useful tool for analysis that allows you to easily hold the movement of the script in your head.

This is a case where the point might be helped by taking a well-known film and breaking it down into sequences. Here's an act/sequence breakdown of *Amadeus*:

1. Act One
 A. Meeting Salieri. Attempted suicide. The priest. Meeting Mozart and Costanza. Desire to stay in Vienna.
 B. *Abduction from the Seraglio*. Katarina. Engagement to Stanzi.
2. Act Two
 A. Father to Vienna. Marriage. Seeking help from Salieri. "I will block you," Salieri says to God.
 B. The maid hired to spy. *Marriage of Figaro*. Fight over the ballet. Emperor yawns.

C. Salieri's opera. Father's death. *Don Giovanni.* Salieri's plan.

D. Vaudeville *Don Giovanni.* Salieri commissions the *Grand Mass.* Mozart working himself sick.

3. Act Three

A. Stanzi leaves. *The Magic Flute.* Mozart collapses.

B. Salieri takes dictation of the *Grand Mass.* Stanzi returns. Mozart dies.

C. Salieri's final condemnation of God.

Bear in mind, this is a breakdown after the fact, and so looks a bit smarter and more finished than a working outline of sequences likely ever would. But it is meant simply to illustrate that we can break the three-act structure into smaller units. And that each of those smaller units also has a dramatic shape.

Take your favorite film and look at it again with an eye to sequence. See what you come up with.

Note: Do not confuse this idea of sequences with the chapters into which a movie is divided on the released DVD. There may be some correspondence, but likely not.

The Well-Made Play

Many of the principals of construction espoused by screenwriting How-To books are lineal descendants from a nineteenth-century play-wrighting formula called The Well-Made Play. Practiced by Frenchmen Scribe and Sardou, adapted by Ibsen, Strindberg, O'Neill, codified by William Archer and George Pierce Baker, the structural components of this form are themselves based on Aristotle and his commentators.

The fundamental aspect of The Well-Made Play that has survived in its transmogrification into film is the division of the action into three basic movements: setup, complication, and resolution.

The Well-Made Play was typically in five acts (the first and fifth being more prologue and epilogue than full acts). The first and second acts contain the Rising Action—introductions, interest, minor complications; the third act presents a major complication or collision; the fourth and fifth reach a climax of the elements presented in acts two and three, and then follows a *dénouement*—an untying (of the plot's knottiness?)—and the falling action of the resolution.

The standard three-act structure of mainstream filmmaking simply combines the first and second and fourth and fifth acts of the Well-Made Play. So we, in general, and with some variation, follow this dramatic shape:

- Act One: Introduction of the world and inhabitants; establish the problem.
- Act Two: A series of complications, false victories, setbacks.

- Act Three: The problem comes to a final crisis, the hero solves the problem (preferably in an unexpected way) and/or achieves insight. Resolution—either closed or open-ended.

The opening of a screenplay presents the status quo of the world of the film—and the hero. It then posits the problem. This is variously called the first complication or the inciting incident. From the status quo, there is a change in direction. The journey begins.

Some examples: Riggs is assigned a new partner (*Lethal Weapon*); the journalist is sent to find the meaning of Rosebud (*Citizen Kane*); the alien life form is discovered (*Alien*); Hans Gruber and gang crash the party (*Die Hard*); a narcissistic corporate yes-man is tasked with purchasing an entire Scottish village for an oil company (*Local Hero*).

In its simplest form, the inciting incident is some external event that crosses the hero or some internal desire that prompts the hero to take action. How it looks and when it happens is dependent upon genre. Action adventure and thrillers often open with the problem already underway. Character driven "slice-of-life" dramas may meander a bit before settling into a journey.

In the second act, the consequences of the first complication lead to a series of trials—ups and downs, victories and reversals. It is the body of the film.

The second act is usually the longest of the three. A rule of thumb: Act two comprises half the length of the screenplay; acts one and three, a quarter each. But don't get caught up in page count. Especially for a first draft. It takes as long as it takes to tell the story. You can always cut after the rough draft is complete.

The third act presents the final confrontation and conflict between the hero and his antagonist (or the world, or himself). It leaves the protagonist either triumphant (Hollywood), or defeated (French), or chastened ambiguously (Art House). Snideness aside, no matter the victory or defeat, the end of the film leaves the hero with an altered understanding of his place in the world. And the audience with him. It leaves the audience with a sense that something—good, bad, or ambiguous—has been achieved.

The lesson must be consistent with what we have been led to expect in the setup of the problem. Or, perhaps I should say, consistent with character logic, but perhaps different and *better* than what we have been led to expect. That's the best resolution. One that satisfies in ways that were not predicted.

Back to Aristotle

Aristotle speaks of three important parts of dramatic enactment: *Harmatia*, *Peripeteia*, and *Anagnorisis*. Although he speaks of them

as components of the plot, it is important to note that all three are inextricably linked to the main character. They can be mapped to modern concepts of plot construction and character delineation.

Harmatia

This is often translated as "tragic flaw" or "tragic error." Its root meaning is "missing the mark." Aristotle uses the term to refer to that aspect of the main character without which the plot would not proceed; the character trait that is most vulnerable to the inciting incident, that predisposes the hero for the journey ahead. It's a character blindness stemming from single-mindedness. I like to think of *harmatia* in the light of *daimon*, the Greek concept that meant both conscience and embraced fate. It is the hero's driving passion and his demon.

Think pride (Oedipus, Lear), an overdeveloped sense of ambivalence (Hamlet), ambition (Macbeth), greed (Scrooge), conviction (Antigone, Creon). It is the mistake—in moral judgment, in personal ambition—that is corrected or amplified in the course of the story, leading to redemption or failure in the final act.

Many films have as their initiating engine just such a character blindness, an overwhelming—yet somehow mistaken—desire or purpose. Other films take their archetypal shape from the quest journey (which for Aristotle was the purview of epic rather than drama). In the quest story the hero is given, or assumes, a task to achieve. In this case, the driving character trait is hope or belief. They believe that the successful completion of the quest will result in the overriding desire's fulfillment. For example: *Apocalypse Now* or *Into the West*. In both, the result of the quest is other than what was expected at the outset. Willard, rather than cleansing the world of Kurtz, takes his place. The boys discover their father rather than their mother.

The character blindness, or the object of hope represented by the quest, sets up an expectation for what would constitute success or failure in the course of the story.

Peripeteia

Aristotle defines it thus:

> *...a change by which the action veers round to its opposite, subject always to our rule of probability or necessity.*

In colloquial terms it's simply a reversal. In modern dramaturgy there may be many small reversals leading up to the culminating *peripeteia* at the end of the film.

It's a fundamental of dramatic construction that reversal plays on expectation. The best reversal is the one that disappoints expectation. And then, in the disappointing, satisfies in a manner more fulfilling

than what was originally desired. The expectation is met in a way that was unexpected.

The audience gets something they didn't know they wanted and their perception of the story takes a major shift.

Anagnorisis

An enlightening discovery or recognition. In its simplest form: mistaken identity is unmasked, the hero discovers the truth of his birth. That is, literal recognition.

More frequently, and more interestingly, the discovery is within the hero. Self-awareness. In such a case it is most effective if the recognition is directly related to the *harmatia*. Scrooge comes to realize that Christmas isn't so bad; Hamlet that action is required; Willard that he is capable of the same extremity as Kurtz.

Journey

Now let's map this Aristotelian terminology to modern dramaturgy. The term *character arc* or *character journey* is simply another way of naming the movement from *Harmatia* to *Anagnorisis*.

In story conferences and seminars you will often hear the question "What does the hero learn?" or "How has the main character changed by the end of the film?" Aren't these questions really: What is your hero's initial blindness and what does he come to recognize in the end? What is the *harmatia* and *anagnorisis*?

I would say most times there is too much focus on the lesson—what has he learned, how has she changed—and not enough on the initial character aspect of *harmatia*, the defining blindness or passion that determines behavior. Look first to your hero's driving demon.

If you can get that right, deep and interesting enough, the lesson will follow.

The important point to realize, to internalize, is that all three concepts—*harmatia*, *peripeteia*, and *anagnorisis*—which Aristotle described as aspects of plot, are impossible to conceive without fully understanding your character. It is precisely the True North of character that allows you to determine the passions, reversals, and recognitions that generate story and determine plot. It is nonsensical to think of them apart from character.

——— BREAKING A BLOCK ———

The pages are still blank, but there is a miraculous feeling of the words being there, written in invisible ink and clamoring to become visible.

—Vladimir Nabokov

Ever tried. Ever failed. No matter. Try Again. Fail again. Fail better.

—Samuel Beckett

Imagine we're in the middle of composing the first draft. Whether with an outline or following characters where they lead, it is sometimes the case that we get lost. That a scene or sequence just won't come out, or won't come out right.

It happens. Not really *writer's block,* at least not the kind for which you'd seek therapy. But a block. A lull in the composition. It just isn't working.

That's the time to step back.

Revisit the Fable

Time to go back to your very first notes, to recall that first image or line of dialogue or theme that started you on this journey. Write it down. Tack it above your computer.

Time to revisit the fable and swim about a bit in all the choices you didn't *make.*

Go through all your notebooks and research in an effort to recapture the feeling you had when you began. Time to revisit the fable and swim about a bit in all the choices you *didn't* make. And think again about the ones you did.

This is the time when the theory of fable and construct can be made useful. Remember that nothing is a given, that things can change, that you can alter the story and make different decisions, choose different elements of the fable to help mold your construct. It's all still malleable.

The fable has no substance. You can't be possessive about something that has no form.

It bears repeating: nothing is given. It's time to recall that your outline is not carved in stone, that it only represents what you know at any given instant. And that now, having written pages, having made a start, you can go back to the outline, and through it to the fable, and think again about what you know.

Reread What You've Written

What you need to write next is embedded in what you have already written. Scene two is implied by scene one.

What I mean to suggest is that every time you write a scene, you are generating expectation as to what should come next. A scene may have three or four possible "next things," and your job is to consider

which path out of the scene and to the next is most appropriate to your intention, most interesting dramaturgically, and most consistent with the characters.

Every scene generates an expectation or desire on the part of the audience for what they want to happen next.

When you are blocked, when the outline no longer guides, print out what you have so far. Read from page one. Read with an eye to discovery. What does what you've written teach you about the sticking point, about what needs to happen next? Look at what's down already and follow each implication to its logical conclusion. Are there scenes you haven't tried, turns you haven't taken?

Try to see it fresh and think about what a new reader expects or wants to happen next. Compare that expectation to what you believe is dramaturgically what should come next. Do they complement? Contradict? Are you fulfilling expectation or subverting it?

By looking again, with a fresh and critical eye, at what you've got down, you will likely find a way out of the scene and into the next. At least one version of the next. You'll have something to work with and revise, discard, or enlarge.

Change the Tools

This is going to sound a bit like magical thinking. Change something about your writing habit. Go to a café. Sit on the sofa instead of at your desk. If you always compose on the computer, try longhand. If you write with a pen, try a pencil.[3] Get a fresh pad. Create a new document just for the scene that's got you stuck. You might even try dictating into a recorder.

The object is to isolate the scene that's holding you up—to think of what you are doing as doodling—so that you can try new things, brain-dump, just write anything. And it won't feel like you're putting these random and disjointed attempts into the same document that holds all the stuff you think is working well.

New Location

If a scene proves recalcitrant, if despite having a good idea of what it's supposed to do you simply can't get it to work, move the scene. Change the location. The more radically the better.

If you have a love scene in a bedroom, move it to a subway.

[3] I'll go out on a limb here. When you move to longhand, if you haven't tried it, get a fountain pen. I know that sounds archaic, but I find this tool, even more than a pencil, has a wonderfully tactile feel that you don't get with ballpoint or rollerball. The sensation of scratching words onto the page gives a vivid sense of being connected to the composition.

Changing the location forces you to think of the scene in relation to a new geography. It might help you focus on what is essential in the scene.

I'm not suggesting you'll end up keeping the subway sex scene, but you sure as hell will learn something about your intention, about the scene, about the characters, and perhaps about what was blocking you.

Do the Opposite

This is a variation on the "new location" exercise.

Given what you know about the scene, what you had intended for it to be and to accomplish, ask the question: what would the absolute opposite look like? Not only changing the location, or night into day, or interior to exterior—but fundamentally the opposite. If Gladys gets good news, what if it's bad? If Matthias finally gets Maggie to stay the night, what if he runs away when she walks out of the bathroom naked?

Again, the point of the exercise is not to alter your intention, but to solidify it through challenge. Opening your imagination to other possible solutions.

You'll either learn that a new path is better. Or you'll learn that your original solution is correct. And you can return to the scene with whatever new insights the exercise gave you.

Write What You Remember

For use in extreme instances of writer's block. Use with caution.

Turn off the computer. Put away the printed drafts of your false start that are lying scattered about your desk. Hide them.

Now. Start writing. In longhand. Start writing your screenplay (or the recalcitrant scene) on a legal pad. You will write what you remember. What was important enough to remember. What was important.

Then you can compare what you wrote from memory with the drafts of the scene that did not work. You may find a fresh way to finish and fill out the scene. You may then be able to see the things you had written that were unnecessary.

The Sister Ann Francis Solution

Back in the olden days—perhaps you've seen it on TV or in some antique coming-of-age movie—one of the favored punishments for a grammar school smart aleck was to be kept after school and forced to write some inane phrase like *I will not be disrespectful* on the black board a few hundred times. A variation on this index-finger-cramping punishment might be to transcribe onto paper a chapter from a civics text book or the Gallic Wars.

Well, as strange as it may sound, you can apply this to screenwriting.

Say you have twenty pages of your terrific screenplay. But you just can't get past a particular scene. Try sitting down with your screenplay and transcribing it onto a legal pad. See if the physical act of copying your own words onto paper doesn't spark interest, teach something. It gives you, so to speak, a running start at the block. I have known this exercise—in my own writing and my students'—mysteriously, to work.

As Sister Ann Francis used to say, "Apply yourself."

Every time you transcribe your work—whether from longhand to computer, or from typescript to longhand and back—you will find yourself editing, refining. You can't help it. The physical act of writing will lead to composition.

Do Nothing

Sometimes you just have to sit back and wait. That's part of the process as well. Sometimes you just have to do nothing. Or work on some other project. Write letters. Write a journal. Take lots of walks or cold showers. Back away from the computer.

I once had a mentor who said to me, during a blocked time, "You'll write when it hurts too much not to." It's true. Believe it. You will get over the block.

But there are times when you have to give yourself permission to procrastinate, to let the problem simmer. To let the solutions appear when and how they will, without pushing, without overthinking.

Even as you step back, as you tell yourself there's no rush and no reason to panic and you can take some time off thinking so hard about the stuck parts, they will be there. Ever-present. Nagging like an itch, a low-grade fever. Let them. Sit back and do nothing.

Return to the problem a bit more distant, a bit more objective. Listen closely for the whisper of a solution. Or the echo of that first blush of enthusiasm. Recall your originating insight or image. And then try again.

<center>——— 5 ———</center>

REVISION

<center>——— **FIRST READER** ———</center>

After struggling with the blank page and accreting notes and scribbling an outline and hearing the first faint whisper of a voice and gathering pages like rooting truffles and building idea to event to story to plot and finally hammering out a few scenes and a few more until you can almost see a shape, almost sense the first whiff of possibly finishing; after junking it and starting over and junking it again and persevering and wondering why you didn't go to law school; after writing anyway and being surprised when all of a sudden you've finished. You've got the first draft. Now what?

Evil thoughts inevitably crash through the elation. *So what? Who cares? Is this nearly as good as I thought it was last night? Did I get away with it? And if so, will anyone else see the film I see in my head?*

And then the practical. *Is it ready for the outside world?*

No. Best to take that first draft and step back. Don't send it out anywhere yet. Too fresh. You're too close. You really have no idea, having just heaved the heavy sigh of relief that comes with finishing, if it works or not. You need to find a sympathetic reader. But not too sympathetic. Still needs to be honest. Maybe even diplomatically brutal. Willing to piss you off.

Such a reader is very hard to find.

The person most readily available and likely most willing has seen you naked. And their objectivity is questionable. I mean, really, they're so tickled you might now stop being such a bear to be around, they're so vested in your mood. Chances are they won't be able to tell you what you need to hear. And even if they are great readers and have

amazing insights, likely you'll discount their opinion, dismiss it as tainted by love.

No, you need someone to help. Not someone that'll coddle. Not someone that'll cudgel you with ideas that are more about them than about your intention. Someone who won't get in the way.

Your first reader, the person you should trust to tell you if the screenplay works, should be you.

You need to back off, take a breath, take a breather, have a beer, go away for a weekend and then do what may be even harder than writing the first draft: you need to read your screenplay as if you were not the writer. You need to engage the critic part of your brain. You need to start on page one and read every word, every syllable, with a rigidly critical eye. As if you were coming to the story ignorant and innocent.

Here are some tricks that might help you accomplish this gargantuan feat of critical objectivity.

- Don't be precious. Really difficult, but you have to approach this read of your first draft believing it isn't important. That anything can be cut, that everything is expendable.
- Perhaps it will help to think this: writing is never wasted. If you cut it here, it will show up somewhere else.
- This thought also should help: it isn't your only screenplay. It's just one. Just this one. If you are putting all your writerly ambition on one story, one screenplay—it is doomed. Can't bear the pressure. I have a button—don't recall where I picked it up. "It's only a movie." Think that. It's only a movie. Keep it in perspective.
- Remember Faulkner's advice: "Kill your darlings." The more your instinct is to say, "I want it that way," the harder you should look at the scene and prove to yourself that it must be that way. That your desire isn't trumping the needs of the scene, the needs of the character. The more an image or exchange or event makes you smile and chuckle, the more rigorous you should be when you look at it. Don't look away. Don't be lulled.
- And finally, and perhaps most importantly, please, please don't read your screenplay on the computer. Print it out. Print it out single-sided. There's a good reason for single-sided (more on that later).

As you reread your first draft, challenge each word, challenge each sentence. *Is it the right word? Is the sentence shaped correctly to achieve the impact, the movement, that I want?*

If you don't relish revising, then you aren't a writer.

Revising should be the fun part of writing a screenplay. You've got a shape, a draft. Your story is down on paper. Now you can play with the language, move words about, and move them again (which is, after all, the fundamental definition of a writer…). You get to experience the elation of cutting out the unnecessary and refining the parts that work so that they work even better. If you're lucky you might get to kill a character. Nothing feels better. You might discover your first scene is actually on page twenty.

If you don't relish revising, then you aren't a writer.

Enjoy it.

And while you're revising, while you're reading your draft as if you didn't write it, bear in mind the following questions and challenges.

——— LOOKING AGAIN FOR LOGIC ———

At the outset I suggested that a useful idea when approaching composition is the notion of logic: does every moment, every gesture, every action, every image, fit consistently with what comes before?

This idea of logical consistency must now be brought to bear as you read and revise. It is the cornerstone of what I mean when I suggest that you need to learn to read your work as if you hadn't written it. It's what I mean when I say you must be brutally objective in your revisions.

It may seem obvious, but it bears repeating. Here, then, are the three aspects of screenwriting that are accessible to challenge on the grounds of logic.

Character Logic

Challenge every line of dialogue, every minor gesture, every interaction for logical consistency with the character you have imagined and the character you have drawn on the page. Would they say what they say, do what they do? Is what they do consistent with their overarching want? Is every action motivated and linked to an immediate need?

The most egregious error of character logic appears when you allow the manipulation of the plot to corrupt the characters. Where you have a character do something fundamentally out of character in order to allow for a plot twist.

Plot Logic

Do the events of your story follow one from the other? Is the cause and effect of your plot reasonable and probable? When an event surprises, when it deviates from the expected—violating the logic established—does it do so satisfyingly, in a manner that transforms my expectation and generates a new insight into the story?

At base, the question we ask of a plot is this: given the rules of the fictional universe, is it probable? Do even the reversals and surprises, once achieved, seem possible, acceptable, linked to what came before?

Visual Logic

Does your action description paint a coherent and navigable image for the reader? Have you thought through what you wish to feature, to jump off the page, to be revealed? And has your prose been composed and designed to accomplish the movement from one image to another? Description in a screenplay is not simply scene setting. It isn't general. You need to think what must be described because it is obvious, what can be foregrounded by word or sentence placement.

——— QUESTIONS ———

Active and Accurate Verb?

Eliminating the use of a single word will instantly improve your screenplay by a factor of ten. That word? *Is.*

In day-to-day colloquial speech, we indicate an event that is happening as we speak and is likely to continue happening into the near future by using a combination of "to-be" and the -ing form of the verb.

For instance, "Gladys is standing near the exit." "Mark is waiting." "Felix is cleaning up."

Grammatically, there is nothing wrong with this construction. In fact, as the intent is to describe an ongoing action, an action that presumably began before the utterance, continues through the utterance, and likely will continue after the utterance, this is the correct tense. It even has a name. Present Progressive. Or Present Continuous.

But in a screenplay, which must be insistently present tense, where the presumption is that the actors do and continue to do what they are shown doing—this formulation feels passive, stilted.

Such constructions describe the action rather than presenting it. They *tell* what is happening rather than *showing* it happen. Or to use my preferred vocabulary: they *describe* what is happening rather than *enacting* it.

It is not, technically, the passive voice (in that it doesn't promote the object of a sentence to the subject position: The ball is thrown by Jack. Passive. Jack throws the ball. Active.). But it *feels* passive.

In a screenplay, where we are trying to craft prose that exists in the present tense, where we are not describing a past action, but attempting to mimic the immediacy of film, the Present Progressive draws attention to duration rather than focusing on the immediate action.

I guarantee that if you go through any random five pages of any screenplay you have written and circle every use of "is," you will find fifteen or more Present Progressive constructions. It is so deeply imbedded in the idiom of English that we reach for it without thought. It presents itself as the natural construction for describing present action.

I contend that it's too easy. And the very commonness of its currency leads the writer to lazy choices. Find those constructions. And now ask yourself if you've truly chosen the verb that follows the "is."

Ask yourself if there is a more vivid, character-revealing active verb.

Ask yourself if there is a more vivid, character-revealing active verb.

Take a trivial example. "Gladys is standing at the bar." A perfectly grammatical construction. It is truthful. That's what you imagine. A woman standing at a bar.

But what does this tell you beyond the fact of a standing woman? Nothing. It tells you nothing about her state of mind. Switch the emphasis from "is" to the verb, from the state of standing to the character of the standing. Even better than simply removing the *is*, why not look for a better, more telling verb? Instead of "Gladys stands at the bar." Why not *leans* or *slouches* or *hovers*? Any of these action verbs tells me more about Gladys than "is standing."

Finding an active, simple, present tense verb can lead you into corners of your scene that you did not know existed. It can reveal character gesture or character attitude. The very act of challenging your presumption regarding the descriptive verb—begun by the simple act of refusing the Present Progressive construction—can open up the event of the scene. Can teach you something you didn't know you knew about Gladys.

Take our example. What if I choose:

```
Gladys slouches against the bar.
```

Perhaps I then ask, why? Fatigue? Depression?
What if I choose:

```
Gladys hovers at the bar.
```

Is she anxious? Is the bartender ignoring her?

By forcing myself to make a decision about a single word in a single sentence, I have opened up possibilities in the scene that I hadn't considered when the description was simply "Gladys is standing at the bar." They come into being as I make decisions about the right verb,

as I ask implied questions, as I choose which of those questions are relevant and then answer them.

```
Gladys slouches at the bar. The bartender eyes
her, concerned. He shoots soda water into a
hi-ball glass and places it in front of her.
She looks up, smiles.
```

A *standing* Gladys didn't need soda water. A *slouching* one did. From a simple decision a mini-scene has appeared. Who knows, perhaps that bartender will come back later in the film now. He's had a moment. Perhaps I'll use him again.

Is It Varied?

Every writer has a predisposition to a certain kind of sentence. We likely settled on our favorite sentence shape long ago when we were in middle school. Some favor short sentences. Some long. Some with multiple clauses. Some with lots of modifiers.

Our favored sentence structure is a habit. And you have to read through your work and figure out yours.

As you read, do you hear a particular lilt in every sentence? Are they all about the same length and complexity? If they are, you must edit. You must vary the music.

Variation is good. And an effective tool.

There are some passages in your description that will need long and complex sentences. Others will ask for short and pithy. From the reader's point of view, variation is a virtue. It gives the read more interest.

If every description has the same lilt, it becomes droning. Use the fact that variation can help to imitate on the page what is being imagined visually.

Is It Immediate?

Susanne Langer, in one of the earliest philosophical essays on the nature of film, provides three key insights that every screenwriter should memorize.

The first has to do with film's inherent "factness." No matter the genre, no matter how stylized or how surreal, no matter the special effects, film has an inherent "realness." Langer makes the point so:

> *...photographs, no matter how posed, cut, or touched up, must seem factual, [...] "authentic."*[1]

[1] Susanne K. Langer, *Feeling and Form,* p. 411. Subsequent quotations in this section are all from the "Appendix on Film."

Langer's *Feeling and Form* is a meditation on how narrative fiction creates what she calls a "primary illusion." She proposes that narrative fiction in novels creates the primary illusion by creating a virtual past. Once upon a time. Even the act of picking up a book implies that it was created some time in the past. She contends that drama, with its insistence on "what's going to happen next," creates a virtual future. The audience lives in anticipation of the next event.

In the appendix, almost as an afterthought, she writes of film—then a new art—that it creates the primary illusion through an altogether new mode:

> *This is, essentially, the dream mode. I do not mean that [film] copies dream, or puts one into a daydream. Not at all...Cinema is "like" dream in the mode of its presentation: it creates a virtual present, an order of direct apparition. That is the mode of dream.*

The interesting aspect of this notion of film as a dealer in dream mode, and the second insight, lies in the implication that we consume the film experience *as if* it were happening in a continual present. She continues:

> *The most noteworthy formal characteristic of dream is that the dreamer is always at the center of it...the dreamer is always "here," his relation is, so to speak, equidistant from all events.*

Here she is creeping up on the rather profound conclusion, the thing that unites the idea of *authenticity*, of *factness*, in film with its use of dream mode as its methodology:

> *The basic abstraction whereby virtual history is created in the dream mode is immediacy of experience, "givenness," or [...] "authenticity."*

That's the third insight: that factness combined with insistent present tense presents story with an immediacy of experience.

...the combination of insistent factness and relentless immediacy works upon the viewer viscerally.

Narrative fiction is comprehended. Film is apprehended. Comprehension implies the ability to think through, to pause, to reread, to mull, to compare—to draw meaning. To learn. Apprehension implies

an immediacy of experience. Meaning is delivered without recourse to leisurely analysis.

Film moves forward. It does not stop for the audience to ponder and fiddle meaning. The point is gotten or missed. (The fact that there are special cases of film, such as *Last Year at Marienbad*, that are read as one reads a book, should be taken as exceptions that prove the rule.)

Here then is a summary of Langer's analysis of the phenomenology of film—of how we consume the film experience—and her useful set of connected insights:

- Film possesses an inherent realness, authenticity, factness. No matter how stylized or fantastical, no matter how grittily realistic, no matter how unfamiliar the universe presented, it manifests as compelling reality. Not as true, but *as if it were true.*
- Film is a continuous present tense, no matter how many time periods it collides or collapses, no matter how time is bent or reversed or manipulated. The image is always in the present tense *and from the point of view of the audience.* Anything that hinders the rush of immediate image and action is contrary to fundamental film syntax.
- The combination of insistent factness and relentless immediacy works upon the viewer viscerally. At a noncognitive level.

Is It Visceral?

When John Huston would intone, "It's fine, Guy. Fine. But it's only writing," I would slowly extract the dagger from my heart and turn back to work.

For many months I did not know what he meant.

Then he told me the following story by way of illustration. He was shooting *The Night of the Iguana.* The scene for the next day was one in which Richard Burton's character is being tempted by an under-aged girl. Tennessee Williams happened to be on the set that day, and John gave him the scene and said, "Something's missing." (I am quite certain he did not follow this with, "It's fine, Tennessee. Fine. But it's only writing.") Williams took the scene away and showed up on the set the next morning and said, "The scene's fine. But what if, right at the beginning, Burton knocks over a bottle of booze. And the entire scene is then played with him walking on broken glass."

That's how Huston revised the scene.[2] That's what he meant by taking a fine scene and pushing it from writing to drama. He wanted some element that might increase the immediacy, the viscerality; might grab the viewer by the throat and not let go.

[2] One could argue that Huston overbaked the idea. That he liked the image of the glass so much, it became the central, rather than commenting, action. The scene has five dialogue references to "broken glass."

This story has proven extremely useful to me in years since when trying to pin down what distinguishes a perfectly well-written scene from one that transcends good writing and becomes good dramatic writing.

This story gives context to Langer's theoretical meditation. We want the scene to always perform as a present tense action. We want that action to have an immediacy of meaning. And, at its best, to have a viscerality that pulls the viewer into the scene.

In prose literature, and in stage drama, we think of there being a text and subtext. In film, we should think of an event such as the broken glass as an "underaction." An image or behavior that resides alongside the main action, commenting on it, or contradicting it, or amplifying it.

The genius of Tennessee Williams' suggestion is that he found the underaction by looking directly at the character involved—the alcoholic ex-priest. He didn't change the surface of the scene. He didn't alter the intention of the scene. He simply added a texture to the scene's geography, a texture that gave the scene a heightened reality. And he found that texture by looking True North, to character.

So, the point of this anecdote is that when we approach a scene we have a presumed task—the scene contains this conflict or that complication, conveys a plot twist or bit of information. But that is only the part of the scene we entered the composition thinking we knew. The underaction, the texture of the scene, is something we discover during composition. If we are open. If we are asking the right questions.

First Time or Ritual?

One of the simplest questions—and most obvious—is one that many writers forget when approaching a scene. Is the event of the scene new to the people in it, or is it something they have done before?

Take for instance, a scene you are writing between two lovers. It takes place, you have decided, in a diner on Broadway. You know what they have to say, more or less what the scene needs to accomplish (you know where it fits in your outline). And you dump onto the page a perfectly nice exchange that contains the dramatic movement you intended to write. But what happens when instead of focusing on the top of the scene—the intended point of the scene—you ask if your characters have been to this particular diner dozens of times before? Or is this the first time? Doesn't the answer radically alter the geography of the scene? In one case the waitress knows them by name. In the other she might be indifferent and surly. How does that change the underaction, the background noise, the tone and feel of the scene?

For virtually every scene, asking if it is new or ritual will teach you something, lead you to possible discoveries.

And all it takes is a minute's consideration.

Take the example of Gladys slouching at the bar. Doesn't the scene change radically if everyone knows her? "Oh no," the background noise seems to say, "Not Gladys taking the air out of the room again." And if it's the first time she's been in this bar, "Who's the new girl looking sad? She okay?"

Considered the Space?

Another obvious question we often forget to ask: Have you fully considered the space? Every scene takes place in a specific location, with unique geography.

But have you truly explored all the nooks and crannies of your location? Have you made it specific? Or have you treated it as a generality—a diner, the docks, an office, a bar—and focused only on those spaces within the location that are inhabited by the primary actors?

Fully imaging the geography of a location will thicken your scene. Imagine foreground and background, exits, closed doors, furniture. A film location is not like a stage set. It is not static. There are tools you can use to enliven your scene in the simplest of locations. If you look for them. If you write the scene without reference to the space, without thinking through the props and the furniture, then you are not finishing the scene, you are not completing it in your imagination.

Let's play a thought experiment. Imagine a date scene between two lovers. You might even write a few lines of dialogue. It's going to take place in a bar.

Now ask a few questions:

- The light in the bar: fluttering candles or buzzing neon beer signs?
- Bartender: loves his job? Can't wait to get home?
- At the bar? At a table? Booth?
- Waitress: flirtatious or surly?

And the list goes on. The point is: Every answer has the potential not only to impact the background noise or tone of the scene, but also to change the scene itself.

Go through the various options. Answer the questions both ways. Now look at your dialogue. Does it need adjusting? Did something occur to you that you hadn't thought of when you were writing the talking heads in a generic bar?

Every scene, no matter what the location, is accessible to a list of similar questions. Don't consider the scene finished until you've at least asked them. And answering them will, I am certain, thicken your hold on the scene. You will, I believe, discover something you didn't

know and perhaps even write a sentence that surprises, that wasn't what you sat down to write.

Seen from All Sides?

A question that you might have hurled at you by a teacher or a reader goes something like this: "Whose scene is it?"

The intention of the question is to make sure that you have considered and are controlling whose ambition and desire drives the action or conflict of the scene. But I fear this might also lead to a single-mindedness that can blind you to dramatic textures.

Certainly, you need to imagine the scene from the point of view of the primary mover. But if you limit yourself to the purview of the main actor, you risk writing a scene with no depth, no complexity.

I urge you to try to inhabit the scene from the point of view of each character. To realize that everyone in every scene has a best case and a worst case. Everyone wants something.

If you can fully imagine the complex relations among all the actors in a scene—even the most peripheral—I believe you will thicken the universe, find actions and dialogue you were not expecting, and ultimately make a better scene for the character who does, in fact, own it.

—— CHALLENGES AND PITFALLS ——

Creativity is allowing yourself to make mistakes. Art is knowing which ones to keep.
—Scott Adams

Nothing Is Sacred

Liking an image is not enough. No one cares what you want, what you like. They care if the story is pulling them forward, interesting them, confusing them in interesting ways.

In my years of teaching screenwriting, the most frequent response given by a student to the question "Why did you do this or that?" has started with the phrase "I wanted…" or "I like…."

The fact that you like something is not a reason to keep it. It's not a determinative reason to cut it either. But those things we are most fond of are those that must be challenged the most for necessity.

If you build a scene around what you like, or what you want, around a favorite image or action, the scene will be doomed to failure. It will feel contrived and forced.

This is not to say you must abandon your beloved image or action. It means you must lock them into the scene, you must make them

seem inevitable. It must seem like there is no other image, no other action that would feel correct.

And how is that done? By motivating the image or action through character.

Let's say you think it would be really cool if, during a heated argument over the nature of love and life and things that make the heart go, one of the characters knocks over a goldfish bowl. It shatters. The poor fish is flopping about. What you want is the image of them fighting over the dying fish. How do you make it necessary and believable, so that it can't be cut from the final film? That's the challenge of screenwriting.

Accident. She throws a pillow. It hits the goldfish bowl. He backs up awkwardly, knocks it over. Image accomplished. But not really nailed into the scene. Because it's her fish, that would stop the argument, as she frantically tries to save Goldie.

Deliberate. He picks it up and throws it down. "I hate this fish," he says. Same problem. Argument over.

He *threatens* to drop the bowl. "I swear, if you don't cut it with the blather about commitment, I'll do the fish." And she calls his bluff. "Go ahead. Asshole." He doesn't. In a reversal, she knocks it out of his hand and continues berating him for his cowardice. In another reversal, he's the one frantically trying to save Goldie. She continues on in her tirade.

Seems to me the last version goes farthest in making the flopping goldfish integral to the scene. So. If you want something, if you *like* an image, your best chance of getting it into the film is if you spend some time thinking how best to make it necessary to the scene. Not bending the scene to the thing you like. But bending the thing you like to the scene.

Padding

If a thing can be done adequately by means of one, it is superfluous to do it by means of several.

—Thomas Aquinas

A frequent bad habit found in screenplays I call "cushioned description." It comes in many forms. And for various reasons. But such sentences all have the same shape: padded with temporal or spatial modifiers.

Here are some examples of what I mean:

```
As Gladys enters the bar, she spies Frank.

While Frank plays pool, the music fades.

When Toby reaches for the gun, it isn't there.
```

These instances use the preparatory adverbial clause. As this that, while this that. It might be seen as a reasonable grammatical construction for a screenplay, as it draws attention to the simultaneity of two actions.

But to use such phrases is completely unnecessary. For a simple reason. It is assumed that everything described in a screenplay is happening now. Present tense. Two sentences, butted up against one another, imply simultaneity.

Padding your action description with time markers such as *while, as, meanwhile,* or *when*—has the opposite of the intended effect. It slows down the presentation of the image. It makes the collision of action description more muted, more convoluted. And, I would say, less legible. More difficult to read.

Compare the preceding with:

```
Gladys enters the bar in a huff. She spies
Frank. Marches over.

Frank shoots pool. The music fades.

Toby reaches. No gun.
```

By giving each action its own active verb, its own sentence, you actually make each moment of the description stand out. You draw the reader's attention.

There is also a compositional advantage to simple, unencumbered active sentences: you have room to deepen or thicken the image and the action.

A special category of padding has to do with narrative point of view. Things like *we see, we follow, the camera reveals*:

```
A kettle can be heard whistling from another
room.

We see Gladys sneaking another shot of Rye.

As the camera pulls back, it is revealed that
Frank has fallen asleep in his chair.
```

I contend there is nothing added, nothing gained by these constructions over the more direct and simple:

```
A kettle whistles.

Gladys sneaks another shot of Rye.

Frank sleeps in his chair.
```

Of course we hear the kettle. We can't know which room. It's not in the image. Of course we see her sneak the Rye. The revelation of Frank asleep is embedded in the new paragraph, new sentence. It doesn't need the preface about the camera and revelation.

What's more sudden?

```
Suddenly, there is a loud bang.

A loud bang.

Bang!
```

Ironically, the use of suddenly—the time marker intended to point out how suddenly the bang happens—pushes the bang back, makes it less sudden on the page.

Surely, there are times when time markers may help you make the point. There are times when you want to slow down the read. And there may be times when a camera direction really is required to make sure the reader isn't lost in the image.

But these constructions are so frequent, it rarely seems to me that they are *chosen*. Rather it seems that such padded prose comes too easily. As if the writer were simply transcribing the imagined image rather than writing the best sentence to do the necessary.

Just be sure you are composing the sentence. Not simply dumping down the temporal padding because that's how it occurred to you.

Read through what you've written, bearing in mind the Rule of Parsimony, or what is sometimes called Ockham's Razor: "entities should not be multiplied needlessly." The interpretation of Ockham's proposition (put forth to prove the existence of God, by the way) comes down to: All things being equal, among two theories, the simpler one is preferable. For example, "If you hear hoof-beats, don't think zebras." Unless you're in Kenya, I suppose.

Apply the Razor to your text. If you can do without something, cut it. Go with the simpler sentence over the complex, be parsimonious in your use of modifiers.

That is not to say that everything in the screenplay must move the plot forward or engender action. There is a place for pure color, for gesture descriptive of character that may seem like a digression. I'm not saying you should cut out all lyricism, all texture. I'm saying you must decide which digressions add to your story, which do something necessary. Sometimes, as Holden Caulfield says, digressions are the most interesting part. But you should cut the things you would not miss if they were gone, and trim to the elegant, graceful necessary, the things that remain.

Question and Answer

There's a particular kind of dialogue that always reads as false, that always sounds as if the writer ran out of steam. Or was just dumping stuff down to get through the scene. It's sometimes called *Asked and Answered*. Or *Question and Answer*.

> FRANK
> Where to?
>
> GLADYS
> Anywhere but here.
>
> FRANK
> You sure?
>
> GLADYS
> Never so sure about anything.

It just lies there on the page. Moribund.

> GLADYS
> Isn't it a gorgeous day?
>
> FRANK
> Very nice.
>
> GLADYS
> Shall we walk?
>
> FRANK
> Sure.

The fact that people in real life sometimes speak this way is no excuse for including such an exchange in a scene. Unless you are deliberately trying to slow things down to a snail's pace. Or enacting boredom.

Most of the time the point of such a series of questions can be accomplished more efficiently and more actively.

A variation of *Question and Answer* is what I call *Eliciting Dialogue*.

It's a line of dialogue, not necessarily a question, whose sole purpose is to elicit a particular response from the other character. The point of the exchange is not the exchange, but the response. It's a mark of laziness, or over-attachment to a comic line, or devotion to an agenda at the expense of character logic and verisimilitude.

Most of the time the writer has conceived line B before writing line A. They need to get in a bit of information or reach a punchline.

In such an exchange Character A is a tool (literally) to get to Character B's line. Classic example:

> HAT CHECK GIRL
> Goodness, what beautiful diamonds!

> MAE WEST
> Goodness had nothing to do with it, dearie.

In this case we accept the artifice, partly because the film is a farcical sex comedy. Partly because both lines seem in keeping with the character speaking. Partly because it's Mae West delivering the nonsequitur.

But for us mortals, we should be very aware when line A and line B are connected by the repetition of a word. When it works it seems like repartee. When it fails it seems like forced dialogue.

This kind of forced eliciting dialogue is sometimes a way to just get it down, a way to break a block. Often it's how a scene gets from here to there, to transition from one beat of a scene to another.

For instance, I was surfing through the cable stations and came upon a film called *The River Why*. The info said it was about a fisherman from the big city. I like fishing. I paused long enough to catch the following snippet:

> Titus lights his pipe, turns to the bookcase.

> TITUS
> Well. Gus. Ready to go fishing?

> GUS
> For what?

> TITUS
> For your soul.

> GUS
> And where do you find that?

> Titus holds up some books.

> TITUS
> Here.

This exchange rings false. For one thing, Gus, a fisherman, would not ask "For what?" He'd ask "When?" The point of the dialogue is to transition into a conversation about soul. And fishing—both for Titus and for Gus—is nothing but an excuse to get there.

We've all done it. I've done it. In *Under the Volcano* there is the following dialogue:

```
                    HUGH
    ...the next war will be fought for our very
    souls.

                    CONSUL
    Ah. Our souls. We still have them do we?
    But no. I mustn't judge others as I judge
    myself.

                    YVONNE
    You have a soul, Geoffrey. You have a great
    soul.
```

It pains me to type that. Huston was adamant that he wanted the line, "You have a soul, Geoffrey. You have a great soul." And I was tasked to fit it into the scene. I wrote backwards—literally—to Hugh's portentous pronouncement about the coming war. True as it might be, it was not what Hugh would have said at this time, in this place, in this way. It's there so that the Consul can be snide, and Yvonne can be sentimental. In the finished film the exchange fails. The actors aren't sure why they are saying the lines. They almost seem, to me, to be winking at one another.

You must always be on the lookout for such forced exchanges and they must be the first thing cut or fixed in a revision.

Eye Drama

As you go through your first draft (or even better, as you are composing your first) make note of every time you use a phrase such as:

```
Gladys looks at Frank.

Gladys and Frank exchange a look.

Frank stares off, blankly.
```

I call this *eye drama*, where stolen or sullen or glaring glances are meant to indicate an emotion. Such minute notations of how a character is looking, who they are looking at, how long they are looking

silently—are almost always placeholders for a more complex gesture or missing dialogue. They almost always stand for something the writer was too lazy to write, or was avoiding.

Certainly there are times when the only correct and appropriate thing to say is "Gladys looks at Frank." But if that's the case, at least make the "look" mean something: "Gladys looks daggers at Frank."

But most importantly, do this sparingly. If every page is peppered with ocular direction, the reader quickly comes to dismiss them all. The more you use it, the more you dilute the power of each instance. Save such eye drama for the moments when, truly, it's the only way to finish a gesture or make a point. When you really think that's what has to be.

Emotional Geography

Just as a scene has a physical shape, a landscape through which the agents move and interact, so the emotions—the wants and fears—of the actors form a terrain. In every scene there are competing agendas, hierarchies, subtle conflicts of want and necessity. Every scene depicts a terrain of alliance, deception, vulnerability.

Just as you would build an image by thinking through the most prominent features—the landmarks and architecture, the quality of light, the dimensions, the empty space—so in constructing a useful and dramatic emotional landscape you would begin by determining the most active and urgent emotions.

Start by asking, of every character in the scene, from hero to bus boy, from villain to sidekick: what is their best-case scenario? If the scene could result in their fondest hope, how would it end? What does everybody in the scene want?

Leave out no one.

Then ask which of those urgent necessities are most visible? Which are coded into subtext? Which hidden entirely?

Then ask how these necessarily disparate needs are in conflict? Or mutual and supportive? Or at cross-purposes? How deep goes the conflict?

Fill Time or Ignore It

You must account for every second in a scene. You can't say something like:

```
Frank puts the kettle on the fire. He sets the
table, carefully arranging the silverware. The
kettle boils.
```

The kettle would not boil in the time it takes to set the table. You have to think through how much screen time each action will take.

An equally egregious error is the casual mention of time passing, without specifying what happens during the ellipsis.

```
Gladys sits at her computer. She types
furiously. After a while, she throws up her
hands and screams.
```

What actually happened during that "while?" Don't be cavalier with time.

Even more jarring would be to note the precise time that has passed.

```
Gladys sits at her computer. She types
furiously. After a couple of minutes, she
throws up her hands and screams.
```

It would never happen. A "couple of minutes" is an eternity in screen time. Fill it with action. Or don't mention it.

In general, unless there is a bomb attached to a countdown timer, you should not specify how much time is passing. Or exactly what time it is. If we are carried along by the rush of event and incident, leaning into the enactment, then the last thing we are thinking about is the clock. We only think about time when you draw our attention to its passing.

Enter Late, Leave Early

Here's a formula that, if abused, can be very destructive. *Enter late, leave early.* Start the scene as late as possible and get out of the scene as soon as you can. Clear enough. Obeys the Rule of Parsimony. I like that.

But the problem is that it sometimes leads a writer to value curtness over completion.

Don't forget the implied and elided "as possible" and "as soon as you can."

We begin writing a scene with some sense of what it should accomplish, what revelation or conflict or reversal it should contain; with an image of its shape and purpose. We know it needs to move the plot forward from here to there, or reveal some bit of information, or result in some crisis or revelation.

This idea of entering late and leaving early might encourage you to stop writing the scene once these general notions of what the scene was supposed to be—notions conceived before the writing began—are accomplished. That is, to consider a scene finished when it does what you want it to do rather than what *it* wants to do.

Writing a scene should teach you more than you knew before you began. The scene has its own logical ending—not just the one you

thought would suffice. Be sure you aren't leaving early for the sake of leaving early.

Let the Scene Play

A mistake often made by young screenwriters, especially those who plan on directing the screenplay themselves, is over specifying action.

Here's a bad example:

 GLADYS
 I need you to listen.

Frank turns away.

 FRANK
 Not a chance.

Gladys is near tears.

 GLADYS
 Please. I need. I do.

Frank stands and walks away.

Only one of the three action descriptions is needed. The last one. The other two are gestures embedded in the dialogue.

The problem arises when the writer (1) over blocks the movement in the scene ("Frank turns away") and (2) doesn't trust the scene to carry the emotion ("Gladys is near tears") and so feels a need to hammer it home.

One problem with over specifying action is that the scene becomes harder to read. The insertion of action after each line of dialogue breaks the flow of the exchange. The intent is to be clear, to make sure the reader sees what you want them to see. The intent is to direct the actors on the page. But the result is to distance the reader from the scene by micro-managing gesture.

The other problem with over directing the scene is that it stymies discovery. If you don't let the dialogue exchange play, if you are only concerned with supplying minute details of blocking, you diminish the chances of writing the unexpected line of dialogue. The line that might radically change the direction of the scene.

Let the characters have their say.

I am not saying that your scenes should have no action interruptions or be a nonstop flow of dialogue. That would mean you aren't using the space, aren't creating image. If you see a page of unbroken dialogue, there's a problem.

However, make sure you aren't inserting action or editorial comment on the emotion of the scene just for the sake of breaking up the dialogue. Or because you don't trust the character and dialogue to convey the deeper meaning of the moment. Make sure it means something, adds something to the scene. And make sure it isn't getting in the way of the flow of the exchange.

Blocking is not gesture.

Detailing movement and mannerisms—when a character sits or stands or sips a drink—is not the same as specifying an action. Blocking is not gesture.

Write the Love Scene

It has always struck me as odd that screenwriters can go into great and gory detail when a character is being murdered, or for a fight scene, or a car crash, but when it comes to writing a love scene most get coy and leave it to the reader to imagine.

It's as if the writers assume that it's all going to be improvised anyway, and the director will figure out how to make it interesting and not too explicit. And so they leave it at "They make love," or "He leans in to kiss her and they embrace passionately." CUT TO next scene.

I believe you should actually write the love scene with as much focus and creativity as any other scene. You have to ask the same dramatic questions you would of any other scene. And as with any other scene, your job in the first draft is to make it interesting to read and revelatory of character.

Don't simply leave it to the reader's imagination. Make a decision.

So. Think it through. Both emotionally and visually.

Is it tender? Rushed? Angry? Vulnerable? Are the principals hesitant? Scared? Laughing?

Visually, a love scene is a challenge because, for the mainstream cinema, it cannot be too explicit, yet it needs to be interesting to watch.

Think of the more successful love scenes in movies you like. In the original *Thomas Crown Affair* the sex is intercut with the chess game that preceded it. In *Three Days of the Condor* the love scene is very abstract, with quick images of hands, knees, shoulders intercut with her somber photographs. In *Don't Look Now* a passionate love scene is underscored by contrastingly gentle music, and intercut with flash-forwards of the couple getting dressed for dinner.

If you simply refer to the fact that there will be a love scene without thinking through what kind of love scene, you have no chance of making the scene work—both on a character level and on a structural

level. A love scene can tell me something about the principals. And it can add texture or suspense to the shape of the film.

Don't just throw it away.

Needs of the Scene versus Needs of the Story

We know more about our story than is useful in the telling. In approaching the composition of any given scene we must be careful to focus on the needs and logic of *that* scene rather than the needs of the story. As we write, we constantly have the various plot points and story lines, ideas and themes, wafting through our heads. It is often more temptation than one can bear. We sneak in a little plot even when it doesn't fit. Or bend and warp a scene to hold a bit of story that doesn't belong there. Or plunk down some foreshadowing, some character backstory. All the little tricks of storytelling. *I'll just sneak a little bit of that here.*

I am not suggesting that we don't have plot and story line and back-story in virtually every scene. Of course we do. But these elements must grow out of the needs of the scene organically. Each scene has its own necessities. First, be true to the scene. Story will manifest. A logically consistent scene is rarely achieved if you approach it as a vehicle for story.

How many times have you thought: *I need to make this point* and then very cleverly, oh so cleverly, modified the scene or dialogue to fit it in? Does it ever really pass muster? Don't you know, deep down, that you've cheated? *The plot twist should happen here, the foreshadowing is long overdue, the character needs to pass out.* Approaching the blank page holding fast to an agenda, a preconceived notion of what needs to happen, is a surefire recipe for a stilted and failed scene.

——— ON EXPECTATION ———

Expectation and Reversal

Everything you write, every word, every sentence, inclines the reader to form an expectation. The reader is constantly taking cues from the text and extrapolating, filling in blanks, making up a story... expecting something.

> *Everything you write, every word, every sentence, inclines the reader to form an expectation.*

It's a natural instinct. It's how we consume story. The reader is insistently anticipating, trying to get ahead of the story. And it's

important to realize this as the storyteller. Only by realizing this dynamic can you control it.

It's a talent that needs to be developed: you must read the scene as if you didn't write it and imagine what a new reader would expect—line by line, scene by scene. Which is a great deal more difficult than it sounds. You should think how it would impact a reader who doesn't—as you do—know where the story is headed.

What expectation does the scene set up? When the scene ends, what does the new reader want to happen next? Or what are they afraid will happen next? Or what do they assume will happen next?

The next scene (as you imagine it, or have written it, or have in your outline) may not fulfill, or even be related to, any of those expectations. Your instinct may be to jump ahead or sideways. And that may be just what is needed. But you cannot truly know that until you have *decided* that it is the correct next scene—that the jump or transition works. And you can't make that decision without considering what expectation you have set up in the reader.

Dramatic reversal consists of setting up an expectation and then disappointing it in an interesting and satisfying way.

It is important to note here that I am not suggesting every expectation generated in your reader should be fulfilled. Quite the contrary. Dramatic reversal consists of setting up an expectation and then disappointing it in an interesting and satisfying way. But you cannot even disappoint an expectation unless you know what it is.

You have three options when expectation is created:

- Let it go unresolved, unanswered; let it have an impact and then fade away, replaced by another expectation.
- Fulfill the expectation.
- Disappoint it.

At minimum you should think what each scene promises, what, at the conclusion of a scene, is the audience expecting to happen next? Compare that to what you imagine happening next. That is, compare what you would guess a new reader would want and what you want. Are they at odds? In a good way? Are they the same? Is there a way to fulfill the reader's expectation in a more unique and original way? Can you do the opposite, and disappoint the expectation? Surprise them?

It's a common dramatic structure (at both the scene level and the story level) to set up an expectation, to then disappoint it, yet in the disappointing supply an even more satisfying conclusion. That is, give the audience something they didn't see they wanted, and once they have it, it's better than what they thought they wanted.

Here's an example of manipulated and disappointed expectation from *Lethal Weapon 2*. Riggs is in hand-to-hand combat with Adolph, the guy who murdered both his wife and his recent lover. A knife in his thigh, he's getting beaten badly (boo). Riggs gets the upper hand, and starts beating Adolphe senseless (yay). Adolphe grabs the knife sticking out of Rigg's thigh (boo). They struggle. Riggs is stronger. Manages to stab Adolph (yay!). He's on top of Adolph. We think he's going to slit his throat (yay!!). He doesn't (boo). We're disappointed. Riggs walks away, and for an instant our bloodlust battles with higher justice as we think Riggs has transcended vengeance by refusing to murder the bad guy. Adolph struggles up and pulls a gun (boo!!!). He takes aim. Riggs presses a button and a shipping container falls and crushes the bad guy (yay!!!).

So. Our expectation that Riggs will prevail and slit the guy's throat is momentarily disappointed. And just when we think it's good news—that he's above murder—he drops the container on him. Brilliant. And a very satisfying end for this particular bad guy.

You must have a sense of what anticipation you are generating—whether you consciously intended to do so or not—in every scene. Readers want to know what's happening and where a sequence of scenes is leading. They are constantly making up stories as they go. If you leave a scene without a considered purpose, your audience will make one up. And that will lead to confusion, not suspense.

Nothing is arbitrary. Every decision you make—from scene detail, character dress, sentence structure, word choice, dialect—generates interest and expectation. Whether you like it or not, whether you intend it or not. So, best to attempt to control what expectations are aroused.

That's why it is so important to take nothing for granted, to leave as little as possible to chance, to play God during this first draft—the only time you will have such unfettered power—and consider closely, and repeatedly, the impact of every choice you make. And also consider the lost dramatic possibilities of every choice you leave hanging for another to make for you.

The first draft is the only draft that belongs solely to the writer. Take advantage of that license. The only way to fully exploit the freedom of the first draft is to accept—completely—the responsibility of composition.

Make the decisions. They are only yours.

The Axis of Good and Bad

Here's a tool to apply to your first draft that will help you to visualize the shape of your story, the alternation between good news and bad.

The basic shape of a dramatic story consists—in the main—of rising action and falling action. The tension and anticipation leading toward

a culminating conflict followed by the resolution and consequences of that high point. From a macroscopic point of view, the movement is all up to the *dénouement* and then down.

On the way to the culminating conflict there are several smaller peaks and valleys. It isn't a straight line up and then down. The arc itself has a dramatic shape consisting of alternating highs and lows.

Put it another way: every sequence has a direction—up or down— toward good news or bad news. You should be able to map this zig-zag of emotion through the course of your story. Go through the major events and incidents of your plot and mark whether you think the audience will view it as good news or bad, make them smile or make them anxious.

Fred Schepisi, in a *New Yorker* profile, described this aspect of film construction and provided a tool to see it on paper.[3]

You can create a visual representation of this alternation between good news and bad using a Cartesian x–y axis. X (vertical) represents emotion and y (horizontal) lists the landmarks of your plot, or individual scenes. Give each scene a value—marriage/love/victory being the highest above the y-axis; illness/death/defeat being the lowest below the y-axis. What you come up with should look something like this:

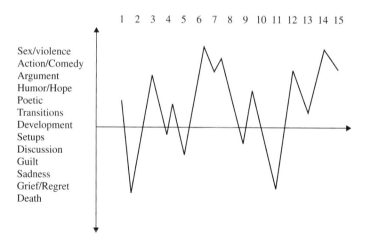

This should allow you to see at a glance if there are too many scenes of the same basic shape and emotion in a row. Is there insufficient variation? It gives you a snapshot of your plot with an eye to emotional momentum and expectation.

This exercise looks like it is concerned mostly with matters of structure. But beneath the shape being mapped is actually the rhythm of

[3] *The New Yorker*, December 20, 1993

emotion portrayed by the action. Once again, even as we are looking at the rise and fall of event and action, we are actually talking about the emotions and behavior within those events, behavior that will be received empathetically by an audience. We are still looking at—and to—character.

Nudity and Violence

Roger Corman, mentor to many of the great seventies directors such as Coppola and Scorsese, and producer of such B-movie classics as *The Pit and the Pendulum* and *Death Race 2000*, once said (allegedly) that to make a good screenplay all you need to do is have violence or nudity every fifteen pages.[4]

Funny line. Until you think about it. Or at least until you think about it from the point of view of character.

Sure, violence and sex, in and of themselves, abstracted from purpose or emotion, devoid of character, in a spectacular sort of way, are visceral. They are engaging.

But if you look deeper. If you consider. Acts of violence and acts of sexuality have, at their core, fundamentally dramatic structures. There is a stake. Victory or defeat. Acceptance or rejection. They require an act of will on the part of the actors. To engage the fight. To walk away. To risk vulnerability.

What distinguishes dramatic action from simple event and spectacle is decision.

What distinguishes the erotic (or romantic) from the pornographic is a stew of human emotions: fear, longing, surrender. What makes a fight more than just a bloodbath is our empathy for the combatants.

Corman is asking for a peak of viscerality every fifteen pages (the approximate length of a sequence). And if those peaks are motivated, if they reflect decision, if they result in believable emotion, then you are no longer writing a B-movie.

What renders Corman's glib formula applicable to all drama is character.

Endings

Endings are hard.

Many writers will tell you that they never begin writing without a fair notion of the ending. Some go so far as to say that they write the ending first.

That has always puzzled me.

[4] I say "allegedly" because, try as I might, I cannot find the reference. I know I read it. I've been saying it to students for a decade. If he didn't say it, he should have.

Doesn't that take the pleasure out of writing? If you know precisely where you are going?

Robbe-Grillet, avant-garde French novelist, once said, "I write to find out what I am writing about." An extreme statement. But don't we all discover the deeper meaning of our work, and the true direction of our intent, during composition?

One of the reasons writers get stuck as they approach the third act of their screenplay is that they are holding onto an idea for an ending that no longer fits with the first two acts as written. Having composed sixty or so pages of actual behavior and discovered motivation and deepened their understanding of character, they are now, at the end, trying to fit a preconceived notion of the third act to what they have already written.

The third act is often the most problematic part of a film. Just doesn't land as we expect or want. And the reason, it seems to me, is pretty obvious: too tight a hold on abstract event and not enough focus on character.

Take your time. Go back and reread the first two acts. Make sure your idea of an ending still fits with the world you have created up to that point. Think about what a new reader wants and expects from the first sixty pages.

Challenge your ending. Does it follow from the expectation generated in the first two acts? Does it truly follow from the characters you have created? Does it embody a satisfying ending to the journey we have witnessed? It may have seemed awfully clever when you first thought of it, when you jotted it down in your outline. But does it work now, does it really finish your story? Surely, as you approach the composition of those last thirty pages, you know more now than you did at the outset. Surely, your characters have grown and changed. And their wants and ambitions have incrementally shifted. Does the culminating conflict, or the reversal, or the recognition that you always assumed you were headed for, does it still fit the story as it has manifested on the page?

6

FINISHING

———— WRIGHTING A SCREENPLAY ————

Wrighting versus Writing

Ever notice how a writer for the theatre is called a *playwright*, yet the writer for film is called a *screenwriter*? *Playwright* is modeled upon archaic compound nouns such as *wheelwright* and *barrelwright* and *ploughwright*.

Here's a definition of *wright* from the Oxford English Dictionary:

Noun:
 1. An artificer or handicraftsman; esp. a constructive workman.
 b. Applied to the Deity, = CREATOR
 2. One who does or performs something; a doer or worker.

Verb:
 1. trans. To build, construct. Obs. rare.
 2. To repair (a ship); to renovate, mend.

Buried deep within the word/suffix *wright* lies the idea of artifice and creation. The word also contains the implication of manual labor that requires meticulous craft. It means maker, creator, joiner. The guy who makes the barrel tight, the angle square, the wheel true.

Screenwriting came into the language late, into a world without wheelwrights and barrelwrights (at least not so's you'd notice).

I believe this idea of a craftsman who builds up, makes true and just, who makes something sturdy and useful—these are good concepts to apply to the making of a screenplay. The word itself contains

some of the truth of composition: hammering words and sentences into a proper, functional, unbreakable shape.

So, you are not a screenwriter. You are a scriptwright. Here follows a description of some of your tools.

Control What You Can

As I stated at the outset, your reader is usually antagonistic and looking for any reason—any excuse—to put your script down. The foregoing sections focused on how to render your story logically, how to use character to solidify plot. Now assume you have at least a draft of your story. More likely, you've already revised at least once. Now it is time to send your brainchild out into the world. It's time to present your work to the enemy.

This section will examine some of the more technical aspects of screenplay form. It will focus on the presentation of your screenplay.

By my count there are only two things that are absolutely and completely within the writer's control. Two things that do not require genius or inspiration. Two things that require only application and patience:

- Proper screenplay format.
- Meticulously proofread prose.

This section will focus on the minutia of properly preparing your work for your adversarial reader. It will be, at times, dry. Some of its dictates will seem silly or juvenile or irrational. Some of its more arcane propositions may appear, at first blush, patronizing, may seem foolish secretarial stuff that can only get in the way of the wild genius you have whirring in your heart. It may seem that these issues of formatting and organization are at odds with the great rush of inspiration that constitutes creative writing.

I suggest this is not the case. I suggest that once you study and understand the reasons behind the rather complex physical form of a screenplay, you will thereafter be liberated to create, you will find tools for expression that you did not previously know lay to hand.

——— SCREENPLAY FORMAT ———

Rules Have Purpose

What follows is a discussion of the formatting guidelines for a master shot screenplay. I have not included every possible cinematic device and notation, many of which are appropriate only to a shooting script and should be avoided in a reading script.

To the beginning screenwriter (scriptwright), it may seem that the formatting rules are overly complex, picky, limiting. *Why can't I just write it however I want and let the director sort it out later?*

Three answers:

- Because the industry reader expects a certain format and if you don't use it they will likely not read your script.
- Because for this draft you *are* the director (just don't tell anyone).
- Because these "rules" will actually help you tell the story.

Instead of thinking of the formatting rules as strictures, as dictates on how it must appear to the reader, try and think of them as tools in your bag of tricks, as ammunition in the arsenal. As colors in your narrative palette. If you understand the intricacies of screenplay format—and the reasons behind the rules—you will broaden what you are able to conceive in your screenplay.

Screenplay Processors

Chances are, if you are reading this book, you already have a computer program or style sheet for writing screenplays. If you don't, get one. It makes entering the complex format of a screenplay infinitely easier than manually entering margins and tabs and spacing.

If you type "screenplay program" or "screenplay template" into a search engine, you'll find many alternatives. Which one is right for you is a completely personal choice. Try them out. See which one fits your own particular habits.

However, screenplay processors do have one drawback: they make everything look so pretty. It's hard to remember that what you are dumping into the computer is only a draft. Don't forget that. It's just a draft. No matter how finished it looks.

One Page/One Minute

A feature screenplay, properly formatted, should page out at 110 to 120 pages. As soon as that is said— I can imagine a few scoffs—someone will pipe up with the counterexamples, and there are many. But for the purposes of this study, the examples of the brilliant ninety-page wonder that won an Oscar or the 150-page costume drama that won a Golden Globe are the exceptions that prove the rule.

The reason for this rather specific idea of a screenplay's length comes from the more or less true fact that, in general, and on average, one page of screenplay text results in one minute of screen time. Take several pages of talking heads, mix with a few fight scenes and a car chase or two—each of which takes a very different shape on the

page—shake well and shoot, and basically, it turns out, the ancient adage of one page/one minute holds true.

More important than the fact that it turns out to be true is the fact that the formula is useful. Thinking of scene shape and tempo, of visual variation molded within the confines of a specific page count, forces the writer to become acutely aware of economy. You have a limited amount of script real estate. You need to populate it carefully. It forces you to consider how paragraphs fill the page, how sentences shape the paragraph and words the sentence.

A screenplay's strict limit on length produces a field of play. And I stress the word play. Embrace that. Think of it as a ready-made vessel you need to fill.

Aim low. Try and write a ninety-page script and be happy with 110. I urge underwriting, for two reasons. First, parsimony. Remember the Chekov quotation? *To do the necessary in the fewest number of steps. That is grace.* Second, you are reserving space for later additions—after you get comments from readers and producers. It is easier to add than it is to cut out what you may have come to love. Leave room to add.

You could also think of page count from the practical point of view. Each page of a screenplay represents a dollar amount to the producer. Chances are they'll be tickled if you come in under the expected 120 pages.

Font

The font used for feature screenplays (indeed, still used for all manuscripts) dates from the precomputer age, from the ancient days of the typewriter: Courier 10 pitch, 12 point. It is monospaced, meaning that every letter takes up the same amount of horizontal space. With a 12-point font, this measures out to 10 characters per inch.

This font is known by various names depending upon your computer system: Courier, Courier New, Courier Final Draft, or Dark Courier. Two other typewriter-style fonts that are acceptable are Pica and Prestige Elite (but you still have to make them 12 point).

The primary reason to stick with a monospaced font for your screenplay is simple: that's what's expected.

Other good reasons to stick with a typewriter style font:

- It makes reading easier.
- It gives plenty of room for emendations and edits (or notes from your reader).
- It spaces out more or less accurately to the one page/one minute rule.

Using proportionally spaced fonts or decreasing the pitch size from 12 to 10 will definitely fit more words on the page. But nobody is

fooled by such fudging. The people who make a living reading screenplays can tell in an instant if the writer is trying to make a long screenplay look shorter.

Bold and Italic

I've seen screenplays in which every slugline was formatted as bold. I wouldn't suggest it.

And if you need to emphasize a line or word in your screenplay, use underline, not bold. Again, that's what's expected in a manuscript that is mimicking a typewriter.

I've seen italics used as well. I would avoid it. With the possible exception of foreign language dialogue. The purist would mark even that with underlining.

Typewriter versus Typeset

Everything about a manuscript screenplay is designed, for reasons of convention, tradition, visual layout, and timing, to mimic a typewritten document. This extends to spaces and punctuation marks.

Two Spaces

Two spaces after every sentence. And after a colon. One space after a semicolon.

It's one of those rules it's better to accept than to quarrel with. There's a reason. But it's arcane.

Since Courier is a typewriter font, the space "character" is the same as every other letter. With proportionally spaced fonts, the space is actually larger than most of the other letters. The result is that sentences have some "air" between them. This air has to be manually added when using a monospaced font. And that is accomplished by adding an extra space between sentences.

It does make the text, especially extended paragraphs of action description, easier to read.

Don't question it too closely. Just get in the habit of doing it.

Dash

A dash is made by entering two hyphens. If it is used to indicate interrupted dialogue, there is no space between word and dash. If it is used to indicate a modifying thought, the dash is preceded and followed by a single space.

```
                    FRANK
          I need to tell you--

                    GLADYS
          Don't.
```

```
                    FRANK
          --I'm leaving.

    Gladys -- hand shaking -- opens the door.
```

If your word processor automatically changes hyphens to dashes, the preceding would look like:

```
                    FRANK
      I need to tell you—

                    GLADYS
      —Don't.

                    FRANK
          I'm leaving.

    Gladys — hand shaking — opens the door.
```

The mix of typewriter and typeset characters looks strange to me.

Smart Quotes

Turn them off. Like dashes being two hyphens and the need for two spaces after a sentence, the style of your quotation marks should match the style of the font. For monospaced fonts you use straight quotes. For typeset, proportionally spaced fonts you use curved or smart quotes.

Look at the difference:

Typewriter font, typewriter quotation marks:

```
    Frank's a stickler for proper
    typography.  "It's important."
```

Typewriter font, typeset quotation marks:

```
    Frank's a stickler for proper typography.
    "It's important."
```

Ellipsis

The same thing applies to the use of ellipsis. With a typewriter font, an ellipsis is marked by three periods. If smart quotes are turned on in your processor, these are automatically changed to the typeset ellipsis character:

```
                    GLADYS
      I'm... I'm just not... sure.
```

becomes:

```
                GLADYS
     I'm… I'm just not… sure.
```

These last four sections may seem extremely picky, almost trivial. They concern a truly fine point of typography. And not all computer programs make it easy to change the defaults for these characters.

For my taste, it's worth the bother. I prefer the way the manuscript looks when both the letters and the punctuation use the same style of typography.

Line Spacing

Any screenwriting program or template will handle the spacing between paragraphs automatically. But I'll list the conventions here.

- Between scenes. After the end of a scene, whether marked by a transition break (e.g., CUT TO:) or a scene that ends with action description or (one hopes rarely) dialogue, there should be two blank lines before the next slugline.
- Between paragraphs of action description. There should be one blank line.
- Between action and character name or dialogue and character name. One blank line.
- Between character name and dialogue. No blank line.
- Between character name and parenthetical and between parenthetical and dialogue. No blank line.

Capitalization

There is some disagreement regarding what to capitalize in a screenplay. It is generally agreed that:

- The character name before dialogue is always capitalized.
- The slugline and headlines are always capitalized.

There are those who also suggest that character names appearing in the narrative description are always in caps. That's definitely overkill. And it makes the screenplay very hard to read fluidly. You are constantly jolted, ever so slightly, with each emphatic word.

Others will tell you to capitalize important sound effects. Some will even capitalize props. That's more appropriate to a shooting script, where you want to make sure the sound designer and the prop guy see what they have to do. I think it's unnecessary in a master shot screenplay.

I am a minimalist. I suggest that you capitalize the character name when that character is first introduced. And that's it.

Sluglines: Scene Headings

A *slugline*, or what is sometimes called a *scene heading*, tells the reader where they are, what is the quality of light, or what is the time relative to the preceding scene.

To be a bit more specific, a slugline conveys, in this order, the following information:

- Type of location—interior or exterior.
- General location.
- Specific location within the general.
- Time of day or time relative to the preceding scene.

A slugline takes the following format:

```
INT.  GENERAL.  SPECIFIC - TIME
```

Some guides propose a slightly different format:

```
INT.  GENERAL - SPECIFIC  TIME
```

or

```
INT.  GENERAL, SPECIFIC - TIME
```

I prefer the use of periods after the elements of the slugline. It's as if each element is an abbreviation for a complete sentence. So, for instance, a slugline that reads:

```
INT.  GLADYS'S HOUSE.  KITCHEN - DUSK
```

would be parsed as follows: It's an interior. We're at Gladys's house. We are in the kitchen. It is dusk. That sense of a complete thought for each element does not occur if you use hyphens or commas between the location elements.

It is important that your sluglines are consistent. That you choose how your refer to a location and then stick to it throughout the

screenplay. For instance, if you have a scene that takes place in Molly's Pub, it should always be Molly's Pub:

```
INT. MOLLY'S PUB. POOL ROOM - NIGHT

INT. MOLLY'S PUB. BAR - SAME
```

not:

```
INT. MOLLY'S PUB. POOL ROOM - NIGHT

INT. PUB. BAR - SAME
```

It makes it much easier for the reader to orient themselves—to know where they are—if the sluglines are consistent.

The format of the slugline was designed to help production workers. The person who scheduled the shooting of the film could group all the interior shots of Gladys's house to be shot at the same time.

For our purposes, in a master shot screenplay—which, remember, is not being read by the production manager, but by an intern or an agent or a producer—a slugline should be designed to convey the greatest amount of geographical and temporal information in the fewest possible words. It should do so consistently—referring to the same location with the same words throughout the screenplay.

Its purpose is to locate the reader as thoroughly and quickly as possible.

Quality of Light

The time marker at the end of a slugline most commonly notes the general time of day: Dawn, Morning, Day, Dusk, Night. In addition to orienting the reader in terms of the clock, these notations also imply a quality of light. Dawn is very different from day. Dusk different from night.

Note: Don't overuse *dawn* and *dusk*. They are difficult to shoot because the window of light is so limited.

Relative Time

Within a sequence of related scenes, the time marker can be any of the following:

- SAME. Denotes that the general time of day is the same as the previous scene; this might be used even if the two scenes are in different locations (more or less simultaneous scenes between which we are intercutting); it allows for the elision of unspecified, but minor, amounts of time. That is, the time doesn't have to be *precisely* the same to be SAME.

154 Screenwriter's Compass

- CONTINUOUS. Often confused with SAME. With continuous there is no elision of time at all. The action of scene A continues without interruption, usually following a specific character, into scene B. For example:

```
INT.  MOLLY'S PUB.  POOL ROOM - NIGHT

Frank and Gladys at the pool table.  Gladys
sinks the eight ball.

Frank slides his cue onto the table and heads
toward --

INT.  MOLLY'S PUB.  BAR - CONTINUOUS

--the crowded bar.

                FRANK
     Another round, Maggie.
```

We have walked with Frank from the pool table to the bar. There is no elision of time.

- LATER or MOMENTS LATER. Used when the location does not change and you want to draw attention to the elision of time. This would be appropriate if there were a series of scenes in the same location that are meant to show the passage of time. For example:

```
INT.  HOSPITAL.  WAITING ROOM - NIGHT

Frank flips through a magazine.

INT.  HOSPITAL.  WAITING ROOM - LATER

Frank paces nervously.

INT.  HOSPITAL.  WAITING ROOM - LATER

Frank sound asleep in a chair.
```

Headlines

A *headline* is, like a *slugline*, formatted as all caps, with a space before and after. It is used within a scene to indicate a shift of focus that might be missed with simple paragraphing, or a camera cue (to be used sparingly).

I find it most useful, and most necessary, when the scene geography has several distinct areas. For instance, you might have a party scene that takes place in a large loft-like space. There might be distinct

areas where different characters are engaged in conversation. So, after the slugline setting the scene, headlines are used to specify changes within the same location:

```
INT.  FRANK'S LOFT - EVENING

A party in full swing.  Blah, blah, blah
general description.

AT THE KITCHEN

Gladys arranges candles on a birthday cake.

AT THE DOOR

Frank greets latecomers.

                FRANK
     Just in time for cake.

SOFA

                GERALD
     He looks good for an old fart.
```

If used sparingly, you can also set off camera cues with a headline.

```
ANGLE ON

Frank and Gladys whispering in the corner.
```

Continued versus Continuing

A distinction has been lost with the rise in popularity of screenwriting software. Many treat the abbreviation (CONT'D) and the character cue (continuing) as equivalent. They aren't.

(CONT'D) is an abbreviation for "continued"—and should, technically, only be placed next to a character name when a speech is broken across a page. That is, a speech begins at the bottom of page X and is *continued* at the top of page X + 1. The speech is continued across the page break; it isn't a note that the character is *continuing* to speak after an interruption:

```
                SNOOPY
     It was a dark and stormy night and I was
     alone with my dog bone.
                (-more-)

-------page break
```

```
                SNOOPY (CONT'D)
     I wondered where my friends were hiding.
```

When a character's speech is interrupted by a bit of action, and the same speech continues after the action description, you should use (continuing) to mark the second half of the speech:

```
                SNOOPY
     It was a dark and stormy night and I was
     alone with my dog bone.

   Boom!  An enormous and frightening lightning
   strike.

                SNOOPY
              (continuing)
     I wondered where my friends were hiding.
```

Most screenplay software formats such a section of interrupted dialogue incorrectly:

```
                SNOOPY
     It was a dark and stormy night and I was
     alone with my dog bone.

   Boom!  An enormous and frightening lightning
   strike.

                SNOOPY (CONT'D)
     I wondered where my friends were hiding.
```

It seems like a small thing. And a thing that most producers and studios have come to accept. But I continue to object to the confusion of these two markers.

For one thing, it's simply grammatically wrong. In one instance the speech is continued; in the other the speaker is continuing to speak.

The fact is, using the (CONT'D) method of marking an interrupted speech saves you a line. And everything that saves you space in a screenplay is a good thing, right? Not necessarily.

I believe that using this shortened way of marking an interruption tends to make the writer too comfortable with the device. And therefore it might be used where it is not really warranted. I would argue that using the old-fashioned way will put a pressure on you *not* to use interruptions unless they are worth the additional page real estate. Anything that makes you think before reaching for a device is a good thing.

Scene Endings

As a general rule you should not end a scene with a line of dialogue. It is more effective and gives the reader more of a sense of completion, more of a sense of anticipation of the next scene, if the last moment of the scene is an image—either of the arena or of one of the principals reacting to the last line of dialogue.

Try and think of the gesture. Imagine what you, were you directing, would ask of the actor. Or imagine you are the actor. What action would you perform to end the scene? However small, however subtle.

Give some thought to how the last image of the current scene will collide with the first image of the next. Is one in a brightly lit office and the next in a dimly lit bar? Is one day, the next night? This one at the beach, the next in a bedroom? This one a crowd scene, the next an intimate meal? Giving some thought to the visual collision of two scenes should help you decide how best to end one and begin the next.

Transition Breaks

A related question regarding the ending of a scene is whether or not you need to insert a transition cue (placed approximately 4.5 inches from the left margin).

Some beginning writers place CUT TO: between every scene. I think this is overkill—and a waste of precious script real estate.

Think whether or not a series of scenes are all related, or all a temporal unit. If so, the use of CUT TO: can be presumed.

If however, there is a jump in time, or a jump in geography—to the next day, from London to Paris—then using CUT TO: draws attention to the completion of one series of scenes and the beginning of the next, or to the shift in location.

I tend to use CUT TO: only to punctuate such shifts. It gives the reader a cue that something has changed. That they can take a breath and reorient themselves, ready themselves for a shift in the storytelling.

CUT TO: can also be used when you are uniting a series of short scenes, or intercutting between two actions. It gives the read an abruptness—which is what you are trying to generate in the reader—mimicking the rapid editing of a series of scenes.

Dissolve and Crossfade

If the shift is more pronounced—say the ending of one act and the beginning of the next, I usually draw attention to that fact by using DISSOLVE or CROSSFADE.

I tend to think of CUT TO and DISSOLVE as markers for the reader, helping them to feel the tempo and structure of the screenplay.

There are two other transition cues that you need to have in your arsenal to accomplish very specific cinematic effects. They are more specifically about the image generated in the reader's imagination.

Match Cut

When the final image of scene A is matched by the opening image of scene B, you mark it with MATCH CUT. It's a very specific cinematic device and is about as far as you can go with a transition mark in a master shot screenplay without seeming like you are over directing.

The match involves a rhyme between two objects placed at the same distance from the camera. Usually the objects themselves have some similarity.

```
EXT.  HELIPAD - DAY

Helicopter rotors whirr over Frank's head.

                              MATCH CUT:

INT.  HOTEL ROOM - NIGHT

The blades of a ceiling fan stir the humidity
above Gladys.
```

A good example of a match cut comes during the opening scenes of *Amadeus.* Salieri says how he had always known the name Mozart. Cut to a scene of the child Mozart playing harpsichord blindfolded. Match-cut to Salieri, blindfolded, playing blind man's bluff.

Sound Bridge

If the sound in the current scene continues over the transition and into the next scene, you mark this with the transition cue SOUNDBRIDGE.

```
INT.  FRANK'S HOUSE - NIGHT

Frank knits.

The piercing scream of a police siren.

                              SOUNDBRIDGE:

INT.  GLADY'S APARTMENT - NIGHT

The siren continues, then fades.

Gladys plays solitaire.
```

It's an interesting effect, and if that's what you imagine you don't want your reader to miss it. So in addition to using the transition cue, you should remark upon the sound effect at the end of the first scene and the beginning of the second.

A variation of the same idea:

```
INT.  FRANK'S HOUSE - NIGHT

Frank knits.

The piercing scream of a police siren.

                              SOUNDBRIDGE:

INT.  GLADY'S APARTMENT.  KITCHEN - NIGHT

The siren becomes a whistling tea-kettle.

Gladys enters and turns off the stove.  The
whistle fades.
```

The effect in this case is similar to that of a match-cut. The sound in one scene being echoed and replaced by the sound in the next.

Another variation of sound bridge is when the dialogue from scene B begins before scene A ends:

```
INT.  BEDROOM - MORNING

Alarm clock buzzes.  Frank bolts out of
bed.  As he struggles into his clothing--

          DRONING PROFESSOR (V.O)
     The poetry of Gerard Manley Hopkins
     presents in its very essence--

                              SOUNDBRIDGE:

INT.  CLASSROOM - MORNING

Frank dozes at his desk.

          DRONING PROFESSOR
             (continuing)
     --a perfect image of late Victorian
     obsession with...
```

Here the effect is to ever so slightly break the frame, draw attention to the fact that this is a film. The effective use of sound bridge can be found throughout Bunuel's *That Obscure Object of Desire*.

Character Cues

These are sometimes called parentheticals. They are brief qualifying directions to the actor as to how to read a particular line of dialogue:

```
            FRANK
          (wearily)
    I can't stand character cues.
```

There's a formula: the more parentheticals you find in a screenplay, the more inexperienced the writer. Nine times out of ten they are not needed. And almost always, they are not wanted.

Actors pay no attention to them. I think they resent them.

And they get in the way, really. They get in the way of the writer making sure the line of dialogue does all that it should. That it is shaped, and punctuated, and phrased so specifically that it doesn't need a character cue.

Your dialogue should contain the emotion. It should have all the cues embedded into it for the actors to find their own expression of the intent and emotion. Saying it should be ironic, or indignant, or tearful isn't going to help if the line isn't ironic or indignant or tearful.

If you do feel an irresistible need to use a parenthetical direction, resist it. And if you fail, at least have the good grace to only use it to specify the mood or tone or attitude or emotion of the dialogue. Don't use it to sneak in action:

```
            GLADYS
        (lighting a cigarette)
    I told you I wasn't going to do it.  And
    I'm not.
            (she moves to the sofa)
    And that's all there is to it.
```

That's so wrong in so many ways. First of all, if the action is important enough to specify, it should be in action description. Second, don't block the actors. Don't specify when they sit and where they sit unless it's really, really significant. And don't do it in a character cue. Do it in description.

Simultaneous Dialogue

There are times you will want to indicate that two characters are speaking over one another, or that they are speaking at the same time.

If the intent is to have them speaking so that one character's speech begins before the other finishes—that is, the impression is rapid-fire, interrupting, overlapping—you can indicate that with punctuation and the character cue:

```
          FRANK
    I told you not--

          GLADYS
         (overlapping)
    I'm not.  Really--

          FRANK
    --to pull on that string.
```

If, however, you really mean for the characters to be speaking at the same time, you need to format the speeches to display side by side:

```
        FRANK                    GLADYS
  Where have you been?     You never listen.  I
  I've been calling and    told you I had a
  Calling--                meeting.
```

This can be very effective in indicating a fight, or two distinct conversations happening simultaneously. It gives the impression of collision or conflict.

However, it does interrupt the flow of your script. It is a little harder for the reader to parse what's happening. And so should be reserved for those times when it is really called for. Side-by-side dialogue should never run more than a couple of exchanges. Use sparingly.

Beat

I'm not sure where it comes from. Beat. Some say it's from Stanislavsky and Method Acting. If it is, then it's one big misunderstanding. Stanislavsky was giving tools to take apart a scene that already existed, not to write a scene. In any case, you do see this from time to time:

```
          FRANK
    I love you.
         (beat)
    I really do.
```

Usually this is just an alternative to "pause:"

> FRANK
> I love you.
> (pause)
> I really do.

But it's not necessary. You get the point across just as easily with:

> FRANK
> I love you... I really do.

Sometimes you'll see this in action description as well.

> FRANK
> I love you. I really do.

Beat.

> GLADYS
> Wanna go for sushi?

What does this use of "beat" actually mean? What does it stand for? It means something has come to an end. A chunk of the scene's momentum has reached a climax and changed direction. It's a marker for something changing, ending.

It is also used to indicate a pause *during which* a character comes to some insight—they realize a bit of information or accept an emotion.

> FRANK
> You're finished with me. You're done.

Beat.

> FRANK
> (continuing)
> I'm not giving up.

In this case the *beat* stands in for "The realization sets in."

But how often do you need to mark such a change? Isn't that built into the scene? The dialogue?

It's a director's note. It's a tool for breaking down the scene into "beats" of emotional unity.

The writer should not be marking what they are making. Let the scene do its job.

A beat of dramatic action is a unified and related series of exchanges or actions that all concern a specific goal or intent or emotion. They

could be, for instance, rehearsed as a unit. And in rehearsal, scenes are broken down this way.

So the best interpretation of this character/action cue is to call it a punctuation. Here ends the beat.

But, really, it's not necessary to notate. To do so falls into the category of over specifying, over directing the scene.

And it's lazy. Instead of *beat*, write a gesture that signifies the change of direction, the intake of emotion or information. Write dialogue that surprises and jolts me to the new beat or makes me take in the shift along with the characters. Do not tell me *Now we are in a new beat of behavior* or *Now I understand*. Let me experience the new beat. Share the new understanding. If you fully realize the scene and the shift, then I will engage in the change, in the pause, in the shift, much more than I will if you *tell* me a shift has happened.

> FRANK
> I love you. I really do.
>
> Gladys retreats, gathering her things.
>
> GLADYS
> Wanna go for sushi?

Think through the moment of transition, of change of direction, and give it a gesture, an image that draws me into the action. Simply noting "beat" does nothing. Except tell me you were lazy in the writing.

Montage

A montage shows two or more simultaneous and related events, usually converging to a unity. The simplest example would be a chase scene, in which the two parts are the hunter and the hunted.

> MONTAGE - THE RESCUE
>
> --Snidely Whiplash carries Nell toward the
> railroad tracks.
>
> --Dudley Do-Right bolts from the cabin and
> leaps onto his horse.
>
> --A locomotive rounds a curve in the foothills
> of the Black Mountains
>
> --Snidely lashes Nell to the tracks.

```
--Dudley gallops over hill and dale.

--Snidely chortles.

--Train whistles.
```

You get the idea. Notice that each paragraph has a hanging indent. This makes it easier to read, but it's acceptable to have each line flush left:

```
MONTAGE - THE RESCUE

--Snidely Whiplash carries Nell toward the
railroad tracks.

--Dudley Do-Right bolts from the cabin and
leaps onto his horse.
```

You could also alphabetically sequence the shots:

```
MONTAGE - THE RESCUE

A) Snidely Whiplash carries Nell toward the
   railroad tracks.

B) Dudley Do-Right bolts from the cabin and
   leaps onto his horse.
```

I prefer the lettered version simply because it makes it easier, when discussing the screenplay, to refer to a specific shot in the montage.

A good example of montage would be the sequence in *The Godfather* showing a series of assassinations happening at the same time as a baptism. The car chase in *The French Connection*. And, of course, the granddaddy of all montage: the step sequence in *The Battleship Potemkin*.

Montage can do more than simply display simultaneous actions. It can generate meaning and elicit emotion by the combination of unexpected imagery, by colliding disconnected images to build to an emotion. Think of how a love scene was often done during the heyday of the Haye's Commission:

```
MONTAGE - LOVE SCENE

--Frank and Gladys embrace, kiss tenderly.

--The wheels of the train chugging along.

--Frank pulls Gladys toward the lower bunk.

--The train steams into a tunnel. Smoke.
  Whistle.
```

Even more extreme, and only appropriate in a more surreal film, would be the montage that moves the story forward entirely through the metaphorical collision of image:

```
    --A line of beauty pageant contestants.

    --Sides of beef hanging in a butcher shop
      window.
```

or

```
    --An empty chair.

    --Mist rising off of a placid pond.
```

The meaning of such a montage lies not in the individual images, but in the space between them, in their collision.

Any two images, placed sequentially, will have a meaning. We will look for meaning in the collision, in the contradiction. Like metaphor in language, the significance resides in the tensions between the two. We reassign meaning to image A after the viewing of image B.

A montage of colliding images is usually only found in nonnarrative, experimental films. Like the kind the Surrealists made. Or Dziga Vertov's classic *Man with a Movie Camera*. One instance where it does have narrative force might be the training sessions in *A Clockwork Orange*.

Such a montage in a master-shot screenplay is a big deal. Make sure it is warranted. Both by the occasion in the story and by the style and genre of the piece. Even if you don't use such a montage of discreet images, you should be aware that even in normal action description, the images in your sentences have a similar relation. With every two sentences, you are implying a similar such collision. And meaning is falling out between the lines, just as it would between the images.

Series of Shots

A series of shots conveys the passage of time, usually involves the main character, and has a more complex dramatic build and shape than a montage. The tempo of a series of shots is slower than that of a montage. The individual shots sometimes turn into mini-scenes, including dialogue. All the shots are related to the same dramatic action—figuring out the secret formula, falling in love, building a contraption.

The difference between a *montage* and a *series of shots* is subtle, sometimes confusing. Often they are used interchangeably. Perhaps this will help.

If Frank were being chased by the bad guys, and Gladys were waiting at home, and the series of shots concerned the chase and who was going to get to Gladys first—that would be a montage. Three distinct actions (running, chasing, waiting) that converge.

If Frank were running a marathon, you would show his progress in a series of shots. All related. About one thing, the race.

You format a series of shots as you do a montage. Either with dashes and hanging indents, dashes flush left, or lettered sequence.

As with montage formatting, I prefer the lettered option—perhaps even more strongly. It seems the right way to set off the little mini-scenes. Especially if there is dialogue.

```
SERIES OF SHOTS - STERLING LIBRARY

A) Frank browses the stacks.  Pulls several
   books from the shelf

B) Frank reads intently at a secluded cubby-
   hole.

C) Frank snores loudly, face down on a book.
```

If the sequence covers a longer period of time, with variations in location and light, you can note this with a succinct slugline after the letter:

```
SERIES OF SHOTS

A) EXT.  BEACH - DAY

Bright summer day.  Frank and Gladys
lounge,  facing the ocean, reading.

B) INT.  RESTAURANT - NIGHT

Snow falls outside the window.  Frank and
Gladys share a pizza.

                  GLADYS
       Mnnn.  Good tonight.

C) INT.  LIBRARY - DAY

Frank snores loudly, face down on a book.
```

You might ask: why use sequence numbering at all if you are going to give each mini-scene a slugline? Good question. The answer is: this kind of series is only relevant if the mini-scenes are truly a unit. Both dramatically and cinematically. That is, they should be seen as one thing—perhaps unified by music.

Flashbacks

There are three basic types of flashback:

- Quick Flash. A vision or a rapid image; not a full scene.
- Flashback. Leaving the present tense of the story to depict a scene from the past.
- Flashback Sequence. Leaving the present tense for an extended period of time. You stay in the past long enough that it becomes its own, alternative "present tense."

Each of these calls for a slightly different presentation in the screenplay so that the reader knows precisely what you intend.

```
INT.  MOVING CAR - NIGHT

Frank stares intently at the road, through
pouring rain.  Swish thunk of the wipers.

FLASHBACK:

The same stretch of road.  Different
car. Different driver.  A small boy cowers in
the passenger seat.

RETURN TO SCENE:

Frank slows and pulls over.  Catches his breath.
```

Usually a quick flash such as this returns to the present tense in the same place and time.

If what you are flashing back to is a full scene, then it should be marked in the slugline:

```
INT.  MOVING CAR - NIGHT

Frank stares off into the night...

INT.  KINDERGARTEN CLASSROOM - DAY (FLASHBACK)

A little boy finger paints...blah, blah... a
full scene...

INT.  MOVING CAR - NIGHT (PRESENT)

Frank wakes from his reverie, swerving back
into his lane.  Shakes his head.
```

The same format would be used if the flashback were to a more extended sequence of scenes. You might put the actual date of the

flashback into the slugline and use a transition cue to emphasize the shift from one present tense to another:

```
INT.  MOVNG CAR - NIGHT

Frank stares off into the night...

                                        FLASHBACK:

INT.  KINDERGARTEN CLASSROOM - DAY (1984)

A little boy finger paints...blah, blah...
a full scene...

INT.  CAFETERIA - DAY

Little Frank sits alone, playing with his
food.

                                        CUT TO:

INT.  CAFÉ - DAY (PRESENT)

Frank sits alone at a corner table.  Gladys
sits opposite.
```

Here we have returned from the flashback to the present tense, but not to a continuation of the scene that was left; that is, not to the same place and time when the flashback began.

The first two types of flashback—quick flash and scene flashback—typically occur within the body of a film a handful of times (sometimes only one extended sojourn into the past). The present tense of the film remains the narrative "now" of the story.

The use of extended flashbacks often occur in a film where the present tense is actually a framing device for the past story, and the past story constitutes the majority of the film. An excellent and effective example would be *Amadeus*. The present tense of the film is Salieri's confession to the priest. The body of the film takes place thirty-five years earlier and concerns the rise and fall of Mozart in Vienna. The movie continually returns to Salieri and the priest in the asylum as a kind of punctuation for and comment upon the sequences in the film.

A similar kind of alternation between a present and a past time occurs in *Godfather II*, where there are two parallel stories. In this case there is not the explicit framing of one time period by another. In a sense, there are two "present tense" stories intertwined.

Flashback can also be used to form a kind of temporal loop. This is where the opening presents a scene or image from the end of the story, then the body of the film takes place in a prior time frame, eventually catching up to the action presented in the opening and then

continuing. For instance, *Crash* opens with an event from day two of the story, flashes back to the previous day, continues until it reaches the events of the opening scene, and then continues with a coda. A similar structure is used in *Anne of the Thousand Days*. This structural use of time flexibility draws attention to the artifice of film. It also generates suspense by stating at the outset "this is where we're headed... hang on and we'll get there." Just be sure that the tone and content of your story warrants such a blatant device.

Dreams

A dream should be marked with a parenthetical appended to the slugline:

```
INT.  CAVERNOUS ROOM - NIGHT (DREAM)

Frank juggles bowling balls in the middle
of the room.  Gladys enters, dressed in
diaphanous white.
                                  CUT TO:

INT.  FRANK'S BEDROOM - NIGHT

Frank bolts upright.  Sweating.
```

As with flashbacks, there are times when the dream becomes a dream sequence. In such a case you might want to format it as you would a montage:

```
DREAM SEQUENCE - CAVERNOUS ROOM

--Frank juggles bowling balls.

--A monkey on a white horse.

--The room morphs into a circus tent.

--Frank's bowling balls become fish.
```

A note of warning. Now you know how to format a dream. But be careful. As in real life, telling a dream is rarely interesting. And it has to fit with the style of the screenplay. It can be jarring if you've gone along for forty pages of straight narrative and all of a sudden we enter a dream world. I find it rarely works and seldom adds anything to the flow of the story.

Most of the time, a dream inserted into a film is a blatant manipulation. It shows a fear or a desire, then bam, she wakes up and it's back to the reality.

We don't notice the manipulation so much in a horror film, where it's all about generating suspense and manipulating fear. But in a straight drama, dreams fall flat.

Unless it's part of the fabric of the story—and consistent with the tone and style—avoid dreams.

Phone Conversations

Phone conversations, especially since the advent of the cell phone, are ubiquitous in films (see *The Departed* for an example of a film that could not exist without cell phones).

I hate phone conversations in films. Writers reach for the cell phone a little too easily. It's pretty dull to watch someone talking on the phone. And more times than not, such conversations serve only informational, rather than dramatic, purpose. It's much better, and more dramatic, if you can put the phone scene face-to-face. Write a real scene.

If you must have someone on the phone in your screenplay, at least make it interesting.

What I mean is: give some thought to what the reader is imagining during the phone conversation. Take charge of the image.

Most commonly, a phone conversation in a screenplay will look something like this:

```
INT.  JACK'S APARTMENT - NIGHT

Jack answers the phone.

                JACK
     Hello?

                JILL (ON PHONE)
        Jack, I need to talk...

Intercut as needed between Jack's apartment
and Jill's.
```

The problem is that if this is a long conversation, the only image in the reader's mind is Jack and his apartment. It's very flat on the page. It often confuses the reader regarding what they are actually seeing.

Doing the phone call this way relegates to the director (and editor) all decisions about how the dialogue interacts with the image. Which is certainly what will happen if the film is made. But now, for this draft, it

is you, the writer, who gets to decide if the image compliments or comments upon or contradicts the speech. You get to decide who we see speaking and who we only hear muffled through the phone.

I maintain that the writer should take the effort to break down the phone call between the two locations. And tell me what line of dialogue is being heard over what image. What line of dialogue is "over the phone"—that is, muffled.

For instance:

```
INT.  JACK'S APARTMENT - NIGHT

Jack answers the phone.

                    JACK
     Hello?

                    JILL (ON PHONE)
          Jack, I need to talk...

INT.  JILL'S APARTMENT - SAME

Jill paces, her eyes red from crying.

                    JILL
                 (continuing)
          ...I need to tell you how sorry I am--

INT.  JACK'S APARTMENT - SAME

Jack smiles as a naked Bethany enters from the
bedroom.

                    JILL (ON PHONE)
          --and how much I love you.

                    JACK
     I love you too.
```

Here, the collision of image and dialogue generates tension. It moves the story forward. It has a purpose.

Note: Even less interesting than a phone conversation on screen is a series of text messages. This has become increasingly prevalent in student screenplays. Nothing is more visually stagnant than a close-up of a phone. It's certainly true that contemporary life is filled with texting. That doesn't mean it's interesting to watch. Use sparingly. Avoid if you can. And try to make it interesting.

Offscreen

There may be times where you want a character's dialogue to play over an image, or before the character enters the scene. This is distinct from voice-over. And needs to be marked differently.

Voice-over looks like:

```
            FRANK (V.O)
    It was the best of times, it was the
    worst of times...
```

The speaker resides in some nether world of narration—he does not reside within the frame of the film.

Off screen dialogue means just that. The speaker is part of the scene, part of the present tense of the world. But they are not visible in the frame of the shot. For instance:

```
Gladys reads a newspaper intently.

            FRANK (O.S.)
    What's the skinny, Ginny?

Gladys starts.  Frank plops down beside
her.
```

Located Voice-Over

In addition to what might be called "framing narration," voice-over is sometimes used within the course of the screenplay in order to say aloud what otherwise could not be articulated. For instance, a character receives a letter, or is writing in a diary, and we hear in voice-over what they are reading or writing. Or voice-over can be used to make internal thoughts audible. In such cases, the "source" of the language is within the frame as opposed to emanating from an unspecified narrative position.

Two things to know about such articulations of inner thoughts: they are formatted the same as narrative voice-over; they should be used sparingly, when truly called for and truly consistent with the tone and style of your screenplay.

Don't reach for it easily.

Format in Sum

The foregoing describes the most common devices found in a master-shot screenplay. They are the basic tools for film storytelling. They are your palette. And judicious use and combination should be sufficient to articulate your vision without resorting to terms and contrivances

more appropriate to a shooting script. Remember, you do not want to over direct the screenplay. You want it to read easily, while remaining grounded in a legible visual logic.

PROOFREADING

Proofreading is not simply a matter of finding typos and cleaning up grammar. As I've said previously, the task whenever you reread your work is to try and read it afresh, as if you were not the author. To be able to step back and see it as a new reader might. You must, when you go over once again what you consider a first draft, treat it as still in process, accessible to refinement. You must read with an eye for meaning, for consistency of intention, for clarity and precision.

At best, a close proofread of your screenplay will lead you to revision, to subtle changes that will have enormous impact on the final product.

Take it seriously. This is the last chance you have to truly finish your work before sending it out into the world.

Don't Trust Your Computer

Computers make writing a screenplay too easy. That is to say, they make what you type look a lot like a screenplay with much less effort than it took in the old days. There are dedicated screenwriting processors. Tap a key, click a toolbar—poof—everything is spaced properly. Not even remotely as tedious and painstaking as the typewriter and its infinity of tab-key presses. Let's not even try to throw ourselves back to the days when writers composed in long hand and then hired script services to render their scrawls into acceptable format.

When you typed a screenplay on a typewriter there were inevitable screw-ups. There were corrections and misalignments and pages with too many lines and pages with too few, and margins that were as erratic as the writer's lagging attention. The manuscript showed the scars of composition: white-out and correction tape; penciled-in emendations, an occasional razor-bladed erasure. And in extreme cases, the glue residue from a cut-and-paste.

A draft screenplay looked just that: a draft.

The problem with computers is that it makes every draft look finished.

Don't be fooled. Even if it's pretty, it's still just a draft.

As soon as I think I've completed a draft of my screenplay I print it out. And as soon as I print it out I take a well-sharpened No. 2 pencil and across the title page I scribble the date. I mark it as a draft. As unfinished.

And then I proofread. I scratch and scrawl. I take the pristine computer print-out and I turn it into what it is: a working draft. Filled with things to be finished.

There's something very satisfying in marking up a clean draft with copyedit notes. With emendations and corrections. I make a small x in the right hand margin in addition to any inline corrections, to make sure I don't miss them when I prop the edited draft up next my computer and page through in order to enter the edits into the computer.

Hard Copy

Please. Please don't proofread on the computer screen. Print out your manuscript whenever there is something to step back from and read and study.

You can never really see your scenes—the shape they make and the way they flow together—on a computer screen. Not for the purposes of editing. The reason is simple: computers are passive. We page through—click, click—recognizing the sentences and scenes without really reading them. We skim over the dialogue exchanges without really acting them out.

How many times, either in your own work or in another writer's, have you seen a misplaced paragraph, or the same sentence in two places? Or the wrong character name attributed to a chunk of dialogue? Or the same character having two bits of dialogue in a row? Or missing question marks? How many times have you found typos and homophones that the computer spell-checker missed? These are all artifacts of proofreading on the computer screen.

Don't do it. Emphatically. Don't proofread on the computer. Of course, there will be times when you read what you've already written on the screen. But when you are really ready to focus and read a chunk of pages, you must print them out. And use a pencil. And mark it up.

I'll go even further. You should print them out single-sided. Not duplex. Not two pages to a sheet. Single-sided.

It has become unfashionable, almost unethical, to print singled-sided hard copies of a manuscript. Printing anything single-sided strikes the current generation of student writers as absurd, if not criminal.

Curiously, these same students have no qualms about running through three or four plastic-topped Starbuck's coffee cups, complete with sleeve, every day.

If you feel bad about printing singled-sided, you can reduce your paper footprint by getting off some junk mail lists, canceling those catalogues you never buy from. Carry a travel mug for your *café lattes*. Plant a tree. Or sponsor someone else to plant it for you.

If you think of yourself as a writer, you need to think this through and not simply presume that reading on a computer is the same as reading a hard copy of your work.

Pen and paper, computer and printer, are the tools of your trade. You wouldn't expect a fine furniture maker to use recycled plywood. You wouldn't expect a painter to stint on colors or a sculptor to work only in driftwood and found objects.

Don't be wasteful, of course, but don't think of a draft of your screenplay, printed in a manner that allows you to work effectively, as a waste. It isn't. It's necessary to composition.

Print out your manuscript. Single-sided. Use three-hole punch paper (or get a good puncher). Put it in a three-ring binder. That makes it easy to flip through.

Single-sided is important for a working copy because you will often, as you edit, need space to write a new paragraph or a new scene. The blank back of the previous page is the perfect and convenient place to do so.

A binder allows you to remove your working copy and spread the pages of a scene or a sequence out on a table. You can then see, standing over the pages, the tempo and rhythm of the sequence. Some argue the same thing can be accomplished using index cards. I prefer being able to see the shape of each scene, each page. You can then see, for instance, long stretches of dialogue that need to be broken up with action. Or pages of description that might do with some dialogue or additional paragraphing.

There are three reasons to print your screenplay (or a portion of your screenplay):

- Working copy. In order to read and edit your own work.
- Reading copy. To supply a reading copy to a person who is not expected to write notes on the hardcopy—that is, they are just going to read.
- Presentation copy. Intended for a reader that may well be taking notes or proposing changes on the manuscript.

I strongly recommend that working and presentation copies of your screenplay be printed singled-sided. The reading copy—for seminars or for friends—do as you please. But for the rest, it is important to print single-sided.

The reason to give a professional reader a single-sided copy has as much to do with convention and expectation as it does with the convenience of having the blank page for notes.

The only copy I would suggest might be printed duplex is a copy that is intended for casual (not professional) reading.

Punctuation

The comma and the period and the ellipsis are your friend. These lines of dialogue have very different meanings on the page.

```
Come here now.

Come here.  Now.

Come.  Here.  Now.
```

Become sensitive—and reading aloud will help—to how minor changes in punctuation will help enact the dialogue as you hear it in your head.

```
                    FRANK
        I need.  I mean... I want -- I really do --
        to tell you.  I love you.  So much.
```

Okay. So it's not Oscar worthy. But it makes the point. The punctuation gives you some idea of how it might sound when acted. It gives the actor some guideline as to your intention: Frank is awkward, uncomfortable, perhaps even lying. You can almost see him shuffling his feet, or avoiding eye contact with Gladys.

Punctuation in dialogue is more about mimesis—trying to capture the lilt—than it is about grammar. You are trying to replicate on the page the music you hear in your head.

In action description, however, you need to follow the mundane rules of grammar. Your goal is clarity of thought and expression. The proper placement of a comma, the use of the semicolon, can go a long way to making your prose fluid.

Get a copy of Lynne Truss' *Eats, Shoots & Leaves: The Zero Tolerance Approach to Punctuation*.

Grammar

Grammar is not incidental. We don't have an idea and then move it into grammatically correct structures. Our grasp of grammar (and diction and punctuation) is *how* we think. It determines what we are able to imagine. Grammar is not a receptacle into which we pour imagination. It is the very thing itself. We can only conceive what we have language, language structures, the right words to conceive.

Don't think of grammar as some relic of third grade. Don't think of it as a layer applied on top of your inspired language. It is the language itself. Hone your grasp of grammatical structures and you will, inevitably, think better and compose better.

Dust off that ancient copy of Strunk and White's *Elements of Style*. Find a copy of Wilson Follett's *Modern American Usage*. And if you're really serious about being a writer, get a copy of H. W. Fowler's *Modern English Usage*. Anyone who puts pen to paper for public consumption should have these reference books. Dip into them at random from time to time. You'll be surprised how it will improve your grasp and control of language.

Homophones

Be sure that you catch the kind of typo that your spell-checker misses. Words that are easy to mistype and that sound alike in normal usage. *Lets* (allows) when you mean *let's* (let us). *Its* (possessive) where you mean *it's* (it is). That's a really big one. I see it all the time. I do it all the time. *Their* where you mean *there* or *they're*. *To* when you mean *too* or even *two*. *Bear/bare*. *Where/wear*.

It's a pretty clear sign that you didn't proofread your work when it is littered with such mistakes. And it's pretty insulting to the reader to expect them to take you seriously when you didn't do so yourself.

This is one of those things that takes no talent, no genius, no arcane rules of formatting. It takes nothing but time and attention. It's one of those things you absolutely can control. And you should. It makes you look careless and like an amateur if you don't.

Diction

Be wary of fancy diction. I can't tell you how many times a student writer has given me something like:

```
The sound of rock music emanates from the next
room.
```

What's wrong with:

```
Rock music blares from the next room.
```

Your diction should match the tone of your piece. So I suppose *A bright sunlight illuminates...* might work if you're writing a fairy tale, but in a straight drama it would stick out as over–written. A little precious.

When a common (and almost invisible) word will do, use it. Don't draw attention to your vocabulary.

In screenwriting the best style is the style that gets out of the way.

That is to say, your prose style should not draw attention to itself at the expense of the storytelling. Certainly, you want your voice to manifest in the writing. And, yes, it's good to aim for beautiful (and

sometimes surprising) language. But those graces must be in the service of narrative and emotional clarity, of mimetic enactment of the image and the action.

Repetition

This really bothers me. In part because it's the kind of error that should never survive a proofread. And the fact that it does usually means the writer did not print out a copy of the script. It's the kind of error that is easily missed during the passive reading on a computer screen:

```
Frank enters and sits at the table.  On the
table is a large bottle of gin.  He grabs it,
slugs it back, and sets it back on the table.
```

Aghh!! Drives me crazy. Happens all the time. And it's pure laziness. Three tables and two backs.

Read your work! You're expecting someone else to. I say again, if you don't take it seriously, why should I?

Is it really so hard to recast such a brain-dump series of sentences—and that's what causes this error: dumping down sentences as they occur to you—into an actual, readable paragraph?

```
Frank slinks in and slumps at the table.  A
bottle of gin sits there like a dare.  He
grabs it, takes a long slug, bangs it down.
```

Please, please go through your script looking for such paragraphs. Take the time to compose your initial thoughts into a considered image. I think you'll be surprised how revising away such repetitions will lead you to discoveries. In truly considering such passages, and making them more elegant, you will find new pieces for your scene, new gestures for your characters. Remember. Composition creates story.

Over Articulated Dialogue

Don't write two lines of dialogue when one will do. Remember that real speech is usually clipped. Full of incomplete sentences and pauses. That people in conversation interrupt one another and overlap.

The surest sign that you aren't really hearing voices is when you look down the page and almost all the characters speak in chunks of dialogue. Two or more complete sentences. Conversation doesn't proceed as a series of speeches. You must be sensitive to this.

If you see that all of your characters speak in pairs of sentences, check this. I bet that in most of those speeches you can cut one of the sentences and lose nothing.

What happens is this: you write one sentence for your character. What they would say. And then you write another sentence for the audience, to make sure the meaning of the first sentence is clear.

The result is stilted dialogue. Without flow.

 GLADYS
 I want to be home. I'm tired.

 FRANK
 We're almost there. Just another few
 blocks.

Even if you kept all the dialogue, it would be better:

 GLADYS
 I want to be home.

 FRANK
 We're almost there.

 GLADYS
 I'm tired.

 FRANK
 Another few blocks

Might be best just as:

 GLADYS
 I'm tired.

 FRANK
 Another few blocks.

Be aware of this rhythm: one for the character, one for the audience. And cut the one for the audience. Never explain dialogue. Let your characters talk in their own way and force the audience to catch up.

Multiple Adjectives

When it comes to adjectives, more is not better. A string of modifiers makes you seem indecisive. Or just lazy. It muddies your intention. It makes for sometimes confusing description. While the reader is trying to parse through your adjectives—perhaps contradictory, likely redundant—the story stalls. Precision is called for. Pick one. The most evocative.

We do love our prose. It's hard to let it go. But often that's what we need to do.

Adverbs

Don't overuse them. Instead of spending energy on finding an adverb, spend it on finding the right verb.

In fact, it might be a good exercise to go through your script and cut every adverb.

Sometimes, you'll find, the verb you have can do the work alone. That all the adverb accomplished was over directing the actor—

```
Gladys sips her wine slowly.
```

—or supplying information that is embedded in the dialogue or the context.

```
                GLADYS
        I hate you.

She stomps off angrily.
```

Or you'll discover that you need a better, more active verb. An adverb qualifies an action. It describes. A verb presents an action. If you find the right verb you will not need an adverb.

```
Frank walks gingerly through the flower-bed.
```

Isn't this more active with something like:

```
Frank tip-toes through the flower-bed.

Frank picks his way through the flower-bed.
```

Isn't—

```
Frank walks carefully through the mine field.
```

—less interesting than:

```
Frank inches through the mine field.

Frank sweats his way through the mine field.
```

Of course, there are times when precisely what is needed is the right adverb. It can add tone and tempo to a sentence. Sometimes even the right verb just doesn't get your intention. But. Be sure you have decided on an adverb and not simply reached for it out of laziness. Look for the right verb first.

Read Aloud to Yourself

Develop the habit of reading your work aloud. It's hard to find the solitude and discipline necessary for this, but it will pay off if you can do it. There are errors and awkwardness you simply don't see on the page (and certainly don't see on the computer screen).

Try and read as if you were the director. As if you were each of the actors. Be on alert for places where the writer cheated. Where the dialogue rings false. Be especially sensitive to those places in the dialogue where what you hear out loud (and in your head) does not match the punctuation on the page.

Table Read with Others

After you've proofread and cleaned up all the obvious stuff, and read to yourself and cleaned up a bit more of the subtle stuff—it's time to hear it aloud with other voices. Get a group of friends together. Buy them dinner. They don't have to be actors. At least enough for the principal roles. Assign one person to read the stage directions and all the minor roles. And let them have at it.

It's really instructive to hear someone who doesn't know the story read your words. Let it be a cold reading. That is, don't let them read the script beforehand. What you want to hear—in addition to the brilliance of your prose—is where they stumble. Where they get the lilt of the language all wrong (which they surely will). Mark those places as you read along with them. Go back and see what caused them to stumble and either fix it or cut it. (Or try a better actor...)

After it's done, if you have the stomach, let them hold forth. But chances are, the comments after the reading will be less instructive than the stumbles and laughter and silence during the reading.

But if you do solicit comments, try this one: ask the room "What was your least favorite part?" It's really interesting to see how people react to being given permission to find fault. And it's good for you to hear, as honestly as possible, which parts of your screenplay struck a false note.

You might also set ground rules if you are going to have comments after the read. No suggestions. That is to say, have people point out

the things they didn't believe or lines of dialogue that rang false. But do not let them actually suggest solutions.

I try to do that in my writing seminars. To keep the "What if..." type comments to a minimum. The point isn't how someone else would solve the problem. The point is locating the problem and solving it your way.

Even when working with professionals—producers and directors— it is a rare thing for their suggestions to be spot on. But it is equally rare that the place they found problematic couldn't be improved.

That's the first rule of taking notes and criticism. Look for what bothers you in the same place that someone else was bothered (and has a lame-brained solution). Don't focus on the sometimes idiotic suggestions. Focus on the point in the script that provoked the suggestion. Look at the scene or exchange or character moment that gave the reader an excuse to make the comment. Try and figure out why you think it bothered them, or more importantly, reread the passage and try and figure what's broken. And fix it. Your way.

Notes are often silly. My all-time favorite happened to a friend. She was writing a WWII script. Two of the principals were competing Nazi interrogators. One specialized in physical torture. The other in psychological torture. A studio executive note: "Could we make the Nazis less offensive." I kid you not.

Still. The point is: it's your job to make sense of the most absurd notes. Make them useful. Turn them to your own advantage by reading beneath the note to the possible chinks in the screenplay that allowed the reader to pause and object (and come up with such wonderful solutions). And know when to dump it because it really is just a dumb note.

The Habit of Respect

Trivial mistakes can turn a reader against you. Sloppiness screams that you are not to be taken seriously. Typos and tortured grammar signal that you don't care about your screenplay. If you don't care about your screenplay, why should your reader?

Respect your work. Your screenplay is part of you. Your brain/heart child. Treat it with the care and tenderness you would lavish on your own kid. Or your sister's. Or your favorite pet.

You want a reader to take your work seriously? Then take it seriously yourself. It's not that hard. Not nearly as hard as writing the first draft. It only takes a little bit of time and a little bit of focus.

Your screenplay wouldn't be out in the world if you hadn't sent it there. That carries with it some responsibility. As with an actual child, you have to protect your literary progeny, see that it's well dressed and properly fed and ready for its foray into the world. Because once it's out there, nobody's going to be solicitous.

─── SUBMISSION ───

Title Page

Keep it simple. Don't use fancy fonts. Don't use graphics or photographs. Title and name. And if you have one, your agent's contact information. Or your own.

Do not put in a copyright notice. Or the Writer's Guild registration number.[1] Makes you look paranoid.

Everyone assumes that you've registered your work. They don't need to be reminded.

Submission Copy

Digital

These days there is less call for printed copies of scripts for presentation because of the extensive use of e-mail. It's now acceptable to submit your screenplay to some readers as a digital copy.

You should still print for proofreading. And you'll still need to print for initial submissions or contests. But be prepared as well to create digital copies of your finished script.

I would not submit an editable copy of the screenplay.

Using the now ubiquitous format from Adobe Systems, Portable Document Format (PDF) is by far the best way. It allows you to control your document, to ensure that it will look on their computer as it does on yours. PDF can be read on Kindle, Nook, iPad, computer, and smart phones.

The latest version of *Word for Windows* allows you to save as PDF, as does *Final Draft* and *CeltX*. Printing to PDF is supported on all versions of the Mac OS/X. If you have an older version of *Word for Windows* you can find inexpensive PDF creation utilities on the Web.

Bound

However, blind submissions to agents or submissions to screenwriting contests, and working copies submitted to producers will still, often, be hard copy.

As I've said, they should be singled-sided.

And they should be properly bound.

If you have a powerful agency this is taken care of, as they copy and bind your script in a nice agency logo'ed cover.

If, however, you are sending the manuscript out yourself, you need to give some thought to the binding.

[1] Even if you aren't a member of the guild, you can register your script on the WGA Web site.

Hard cover cardboard binders—the kind used in academia—are forbidden. You can't easily crumple them up, fold over pages while you read. Same problem with the thinner, often clear–plastic, all in one binders.

You should not have your script velo-bound or spiro-bound at the local copy shop. Readers (especially producers once you get into pre-production) will want to put your screenplay into a three-ring binder (to allow inserts and notes and new pages). Can't be done with a per-manently bound manuscript.

You should not bull-dog clip or rubber band the script. Or leave it loose in a folder.

These methods will mark you as a neophyte.

The correct method is *The Brad*. Little brass fasteners that run through the script holes from the front and then bend in the back. They can be purchased at any good stationary store, or online.

It's important to get the correct size. Too long and there is too much leftover brass on the back of the screenplay (ominous bits of metal looking to get snagged on sweaters and book bags). Too thin and the screenplay will fall apart with the first page turn. The body of the brad needs to be thick, but not long. The head of the brad needs to be wide enough not to get pulled through the hole.

The correct size is 5R, 1.25 inch round-head brass fasteners.

Use two brads, not three. Why? Rule of Parsimony. Two is all you need.

Use washers. Most people don't. Perhaps they don't know they exist. Using washers on the back of the screenplay makes the bind much more secure. Turning the pages under, rolling the manuscript up, flattening on a desk to write notes—all of these actions will burst a brad-bound manuscript that doesn't have washers.

Covers. If you want a cover—they are optional, though they do give the manuscript a bit more finish and protection—use card stock. A single ream will last you a lifetime. You can print the title page and byline directly on the card stock or use a label. I like cream-colored card stock.

That's it. Question settled. Don't know why this isn't universally accepted. It makes a big difference to your reader.

And as we all know, making your reader comfortable enough to read to the next page is task one.

The End

There are few things as elating as coming to the last page and typing THE END and meaning it. You've completed a true First Draft (which likely means you've written two or three drafts to get it right). But now you're done. It does what you set out to do, it does more, one can hope, than you originally expected. And you feel great. There's a high associated with finishing that's hard to describe.

But it never lasts long. Inevitably, doubts will creep in. You'll wonder if it's good enough, interesting enough. You'll have moments of despair that no one will like it. You'll reread, with a puzzled optimism.

And then you have to figure out who to send it to. Who can read it and help it get out into the world and onto the arduous journey toward getting made.

If you are a beginner, if you have no agent, it's time to make a list of all the contacts you have that might be willing to read your work. All the contests you might think worth forking over the reading fee to enter. There you are, script in hand like a beggar with a beret: please sir, read my work. Alms for the writer. Alms for the writer.

It is ever so. The writer is—after the writing is complete—infuriatingly at the mercy of other people.

Even if you are seasoned and have an agent waiting for (who says they are waiting for) your next screenplay, you will still be in the position of supplicant, waiting on other people. Will she read it herself? Or will her assistant do coverage? If she does read, will she take her time, be in the right frame of mind, read it soon? Likely not. Weeks will pass waiting for the e-mail or phone conversation.

Even if the screenplay was a work-for-hire and there is a producer and studio waiting on the submission, you will be entering the twilight zone of waiting. Waiting for other people to read and respond.

This is the point at which the writer must become a businessman. Or a philosopher. You have done your part. You have written and rewritten. You have controlled all that you can in the making and presentation of your screenplay. Now you have to radically shift your perception and accept that filmmaking is an industry—and that most likely the people to whom you are giving your script have a very different view of the world than you do. They are not writers. They are in a business. You have to just accept that and let your script go—unprotected—into the world to fend for itself as best it can. You have given it the tools to thrive. Now it's a matter of finding the right partner to help shepherd your work forward.

And that could take years.

There's only one thing for it. Only one thing you can do to minimize the anxiety natural to waiting.

Start another script. As soon as possible. Get back to the writing.

7

GETTING READY AGAIN

——— PASSION AND PURPOSE ———

Be still when you have nothing to say; when genuine
passion moves you, say what you've got to say, and say it hot.
—D. H. Lawrence

A student once reacted to my comments about her screenplay with, "But that was how my first draft was… people told me to change it." She had added backstory, had started earlier in the fable, had added several characters for no apparent reason. All because the last semester's teacher and workshop told her to.

I was dismayed. I was a bit angry both for her and at her.

You need to hold onto what you believe is right. You should not easily change it because someone else—a teacher, a friend, a producer—tells you to change it. That doesn't mean you shouldn't be open to criticism. That you shouldn't try to understand why they are bothered, why they think something is wrong. You should be open. But you should also be committed to your purpose, and your view of how best to articulate that purpose.

A writer's job isn't to please other people. It is to convince them. And you cannot convince someone else of the virtues in your screenplay if you haven't first convinced yourself.

It's never going to come out right if you don't believe it yourself.

Writing is too hard a thing to do as it is. Don't make it harder by trying to second guess the entire possible audience. The only reason to do it is that you love doing it. And the only way you'll continue to love doing it is if you remain true to the things that amuse and move and anger you.

Be true to the original image that set you going. And do it without apology. Be extreme.

Be passionate about what you want. But realize passion is not sufficient. It has to be married to craft.

HAPPY ACCIDENT

Follow the accident, fear the fixed plan—that is the rule.
—John Fowles

The aim of this book has been to give you conceptual and mechanical tools to navigate the chaotic and uncharted terrain of story. It has outlined questions to ask and methods of rendering story into legible construct.

But let's look at the entire enterprise from a slightly different vantage. After a fashion, all the notes and questions and tips—from Aristotle to screenplay format—aim to loosen your grip on the material. That is, to help you read your work as if you hadn't written it. If you can set aside your narrative agenda, you will be able to risk new things, to open yourself to discovery.

Accept and embrace the mysterious and unpredictable nature of writing; the fact that it cannot be bent to formula; that analysis in the abstract cannot ensure inspiration.

Anything that helps you become even slightly more open to the unplanned and unexpected, anything that—in essence—gets *you* out of the way, is a good thing.

The goal is to develop habits of thought, and habits of discipline, that will maximize the chances of the happy accident of writing. Writing is most vibrant—and most fun—when what ends up on the page surprises even the author. When you write something you didn't plan.

In order for that to happen you must be open to accident. Otherwise it will pass you by.

INTUITION AND ANALYSIS

The upshot of what I've been saying about writing from character up rather than from the plot down lies in this simple idea: writing is first and foremost an act of intuitive discovery. Those who advocate extensive outlining, who speak of story maps and beat sheets, believe that writing should begin with analysis. That staring at the organized idea will lead to composition.

Of course, both talents—intuition and analysis—are necessary. And the more you write, the more those two distinct activities will merge. You will brain-dump and edit at the same time, you will discover and risk while analyzing the impact upon the whole.

Imagination is the act of opening your analytical self to the possible.

But at the start—of a story, of a script, of the long process of finding your particular voice—it is good to remember that the most fertile ground lies in the field of the intuitive. That you will find your story and your voice by giving free reign to your characters, by following their wants and needs—large and small—as you wander about the chaos of story. Remember and embrace the idea that plot only compels through its relation to character motive and behavior.

Your first job, as writer, is to create the circumstances—of thought and habit and fantasy—that will most readily lead to the happy accident of inspiration; that will leave you open to discovery; that will embrace risk and failure.

Imagination is the act of opening your analytical self to the possible.

Only after embracing the unknown and unknowable in your story, in your character, can you bring to bear the analytical side of your talent. You must, after a fashion, channel your characters, become them, give them free reign and voice, give them freedom to alter your outline, your plot, your agenda. Only after your world is fully imagined can it be articulated, revised, and revised again, with your editorial intellect. Then the job is to hone, to winnow, to carve and cull and arrange and rearrange until the object you are making articulates for the naïve reader your story and intention.

Intuition and analysis are two distinct tools brought to bear on the task of composition. Do not stint either. Rather, let them feed and refine each the other.

LESSONS

What sense have I made of John Huston's long ago condemnation of my work as "only writing?" What, after these years of banging out screenplays—produced and abandoned—and teaching several hundred hungry young filmmakers, have I learned?

That plot is insufficient. It must be inextricably linked to a fully imagined and deeply felt character.

That film is a present-tense medium. And that the most effective screenplays are those that work upon the reader at a visceral level.

That film is not comprehended as we comprehend a work of fiction. It happens to us. It is apprehended as we apprehend music. It touches us in the gut first and foremost.

That the surest way to engage an audience is to force them to empathize—identify—with the main character. Then put that character in jeopardy. Give that character a decision.

That seemingly trivial character quirks and gestures are not random. And they are not, in the end, trivial. Character aspect is what makes us feel at home. Makes us lean into the character and want what they want. It gives us a rooting interest in the outcome of the story.

I have learned that writing is hard. Much harder than most people think. Much harder than you think when you are starting out.

That ambition is not enough. You also need craft. And passion.

That a portion of the film industry looks upon the writer as a subcontractor. Like a plumber. They feel they could do the work themselves if they had time and inclination. Don't believe it. They are not writers. You are.

You must develop a thick skin. Carapace comes to mind. You have to be able to take sometimes silly notes and make them make sense. You have to weather rejection and the constant cycle of elation and dejection.

Most of all, you have to love writing. You have to love it "as the lion loves the gazelle," as Athol Fugard once told me. You have to need it as you need food and air and sex and love. Short of that kind of passion and need you will never have the stamina, the sheer stubbornness, to continually return to the blank page. And fill it. One more time. Fill it with new words. With new worlds.

INDEX